INTERNATIONAL PERSPECTIVES
on YOUTH MEDIA

Cultures of Production and Education

Edited by JoEllen Fisherkeller

PETER LANG
New York • Washington, D.C./Baltimore • Bern
Frankfurt • Berlin • Brussels • Vienna • Oxford

Library of Congress Cataloging-in-Publication Data

International perspectives on youth media: cultures of
production and education / Edited by JoEllen Fisherkeller.
p. cm. — (Mediated youth; vol. 12)
Includes bibliographical references and index.
1. Mass media and youth—United States.
2. Digital media—Social aspects—United States.
3. Technology and youth—United States.
I. Fisherkeller, JoEllen, editor of compilation.
II. Tyner, Kathleen R. Mapping the Field of Youth
Media Organizations in the United States.
HQ799.2.M352U65 302.230835—dc22 2010046187
ISBN 978-1-4331-0652-1 (hardcover)
ISBN 978-1-4331-0653-8 (paperback)
ISSN 1555-1814

Bibliographic information published by **Die Deutsche Nationalbibliothek.**
Die Deutsche Nationalbibliothek lists this publication in the "Deutsche
Nationalbibliografie"; detailed bibliographic data is available
on the Internet at http://dnb.d-nb.de/.

The paper in this book meets the guidelines for permanence and durability
of the Committee on Production Guidelines for Book Longevity
of the Council of Library Resources.

INTERNATIONAL PERSPECTIVES
on YOUTH MEDIA

mediated youth

Sharon R. Mazzarella
General Editor

Vol. 12

The Mediated Youth series is
part of the Peter Lang Education list.
Every volume is peer reviewed and meets
the highest quality standards for content and production.

PETER LANG
New York • Washington, D.C./Baltimore • Bern
Frankfurt • Berlin • Brussels • Vienna • Oxford

Contents

Introduction

International Perspectives on Youth Media: Cultures of Production and Education

JoEllen Fisherkeller

Introduction[1]

Whether in academia or in more mainstream circles, it is a cliché to discuss how children and adolescents (and all of us) today are surrounded by an array of media and communication technologies that are part and parcel of everyday life. While not all young people have direct access to all media on a daily basis—especially several newer media, particularly in impoverished communities around the world—many young people encounter, to some extent, television, movies, music, computer or video games, magazines, billboards, posters, comics, advertisements, e-mail, websites, instant- or text-messaging, and other digital networks as users and/or consumers in a variety of contexts. All of these media are made available through various software and hardware that quite often blur the boundaries of these media as distinct forms, as well as challenge traditions of literacy, aesthetics, identity, culture, and all of their interrelationships (see Appadurai 1996; Buckingham 2003; Hull and Nelson 2009; Ito et al. 2010; Jenkins 2006; McMillin 2009; Tyner 2009).

Given the ubiquity, power, and appeal of these media, and the roles they play in contemporary economies, politics, and cultures, a variety of youth media production and education projects and programs have been established. Educators, researchers, policy analysts, advocates, activists, artists, and young people are working within different youth media production and education contexts around the world. This introductory chapter aims to provide an overview of the tremendous

diversity of perspectives, principles, practices, and outcomes of youth media, and to explain, generally, how the particularities of regional, social, economic, and political situations and circumstances inform and shape youth media. The chapters that follow this introduction provide case study illustrations that will illuminate, specifically, the variety and diversity of youth media projects that have been researched by the international array of authors who have contributed these chapters, authors whose backgrounds, experiences, and education represent a wide variety of perspectives, practices, and intentions.

The contributors' comprehensive theoretical analyses, notes, and bibliographies sometimes overlap, but also span multiple disciplines as well as regional particularities, providing a rich and expansive resource for readers. Given this, my introduction is going to be short on citations. This is intentional on my part, as it allows more print space for the authors (and readers) to delve into the complexities of the projects and programs described and analyzed in the individual chapters—a difficult task when representing and conceptualizing the multiple social and cultural contexts of youth media in different parts of the world. In addition, given the diversity of purposes, frameworks, methods of analysis, and contexts of youth media, a full review of all relevant literature pertaining to youth media would turn this introduction into a tome in and of itself. Instead, I want the reader to explore and learn more from the individual chapters. Nonetheless, I here present an overview.

What Is Youth Media?

Broadly speaking, youth media includes projects and programs that engage young people as creators of media products, often within non-profit contexts such as schools, government agencies, or a variety of community-based organizations and, sometimes, the commercial sector. *Youth* and *young people* as terms span a large age range, and how different cultures and societies categorize people according to age varies; in other words, these categories are social constructions and are not "natural" or biologically determined (see Buckingham 2000; James and Prout 1997). Children who are pre-puberty, adolescents in their teen years, and young adults in their twenties are some of the categories of young people participating in youth media, and the different chapters in this book provide details on the ages and categories of youth in their specific regions. But overall, youth media projects and programs provide young people with a variety of intellectual, aesthetic, social, and technical knowledge and skills they need to use, comprehend, and evaluate media, and—especially—to create and circulate media that are variously critical, appreciative, and proactive in nature, thus providing youth with transformative opportunities. Given how many young people around the world do not have or have not had access to means of media production and distribution, youth media programs

and projects quite often provide media-disadvantaged youth with the means to produce media, and to distribute their creations through various venues. The kinds of media that youth might create within different contexts can vary considerably, depending on the resources available to the project or program, and the needs, interests, and capabilities of the stakeholders. The resources available, and the particular needs, interests, and capabilities of people located in specific places and times are rooted in the histories, economies, politics, and cultures of those locations. It is beyond the scope of this introduction to provide a complete history or geography of youth media, which would vary from region to region and in different times, and could be a topic for another book entirely. However, each of the chapters in this book provides a contemporary examination of youth media in a different place around the world, one that makes a contribution to that particular region's temporal history.

Several publications provide some background and overviews of youth media as a field (or subfield) worthy of current study. On the worldwide front, *Children and Media: Image, Education, Participation*, edited by Cecilia von Feilitzen and Ulla Carlsson (1999), was produced to respond to concerns about rapid changes in the world and within and across media: in particular, the processes of globalization that have been deregulating, privatizing, and consolidating many media across borders of all kinds. Globalization through media has long been and is still considered a threat to many local traditions and sensibilities, spurring public and private debates about the consequences of globalization in specific communities and regions, which sometimes result in various localities enacting policies and practices to regulate or counter global flows. A subset of issues concerning the global circulation of violence via media, and its relation to the violence in people's lives, led to studies and programs focused on the violence that is represented in global media, and the violence that children and adolescents actually experience in their everyday lives. The many contributions to *Children and Media* suggest how various constituencies have responded and might respond further to these issues. In this volume, the sections that most pertain to this introduction are those that describe and sometimes analyze programs and projects that provide young people with the means to analyze, create, and distribute various media, so that they are being provided with a means to counter their virtual and actual experiences of violence.

Another edited volume that pertains to youth media worldwide is *Empowerment Through Media Education: An Intercultural Dialogue*, edited by Ulla Carlsson, Samy Tayie, Geneviève Jacquinot-Delaunay, and José Manuel Pérez Tornero (2008). As described and analyzed by the editors and contributors to this collection, media education, broadly defined, is akin to youth media in that media education varies in terms of its meaning, purpose, and practices, for many of the same reasons that youth media varies: issues of perspective, intent, context, resources,

and constituencies. Just within the United States and Europe, media education is diverse because it draws on the fields and disciplines of media studies, cultural studies, learning and development, literacy, pedagogy, and critical theories (see Buckingham 2003; Tyner 2009). But generally speaking, media education can embody or be related to youth media in that media education examines the power and meaning of media in society and in everyday life on a variety of levels, and considers how youth can benefit from examining the power and meaning of media. Pertinent to my focus is the way in which many (though not all) media educators emphasize that young people should learn to be creators who have acquired critical and appreciative skills and knowledge about the media so that they can participate in production and distribution practices, thus allowing them to be part of the media and communication power structures that are part and parcel of commerce, politics, citizenship, and everyday life in both local and global environments. Often, but not always, youth media programs help young people to challenge the status quo and create change where necessary, and thus help youth to develop as powerful members of society, whether as workers, artists, citizens, activists, and/or leaders. So media education that involves youth in media production and distribution is not just about helping youth become part of the media industries and agencies that currently exist, and that, for the most part, are inequitable and exploitative in terms of their work practices, and are quite often creating content that represents stereotypes and biases of all kinds. Thus, the inequities and biases of media systems and situations have prompted the development of media education and youth media programs overall. Indeed, two other edited volumes provide looks into how young people can use media to address inequities and bias around the world: *Young People, ICTs and Democracy: Theories, Policies, Identities and Websites*, edited by Tobias Olsson and Peter Dahlgren (2010); and *Youth Engaging with the World: Media, Communication and Social Change*, edited by Thomas Tufte and Florencia Enghel (2009). While not every chapter in these volumes discusses youth media as defined previously, they do show how, given the means of production and distribution and various social supports, youth can and do become critical, appreciative, and proactive citizens within both local and global contexts.

Nonetheless, we must remember that various groups and cultures want to maintain their cultures and traditions, and resist or negotiate change in ways that are grounded in their local experiences. Change is often promoted—explicitly and implicitly through processes of globalization—in ways that are inherently Western, imperial, capitalistic, and individualistic. This has particular implications for youth throughout the world (McMillin 2009) and how they might envision, and enact, their power as youth media consumers, creators, and distributors. At the same time, some young people might be very interested in buying into the mainstream systems of media production and distribution in order to reap the eco-

nomic, political, or cultural benefits of these systems in their own regions, and so they might not be interested in rocking the boat, so to speak. And sometimes youth agendas are aligned with those of governments, non-governmental organizations, and community groups that are providing youth media programs, agendas that might be geared toward conventional (rather than transformational) sensibilities about youth, media, and society. This will be seen in some of the chapters in this volume.

Indeed, the emergence and spread of online social networks, blogspaces, wikis, and file sharing might suggest that youth with access to these media are part of a self-generated youth media movement, albeit one that is aided and abetted by commercial industries harnessing the interests of the many young people who want to be successful and powerful as communicators, and sometimes entrepreneurs, in this new media environment. For recent research on young people and their access to and uses of new media in the West, see the collection of edited volumes that MIT Press published in 2008 and that the MacArthur Foundation sponsored as free downloads (see my references list). See also *Hanging Out, Messing Around, and Geeking Out* by Mizuko Ito and 21 other authors and contributors (2010), and *Young People and New Media* by Sonia Livingstone (2002). Some of the chapters appearing in this volume will be discussing youth's own appropriation of new media outside of the formal contexts of youth media programs and projects as well. Researchers today must figure a way to account for the coexistence of alternative and mainstream youth media content and networks, and the systems and practices that support both, in developing the field of youth media (see, for example, Jenkins 2006).

Why and How Are Youth Media Implemented?

The conflict between mainstream and alternative media leads to a discussion of many different visions that people have for implementing youth media projects and programs. In the United States alone, there is no consensus about the purposes and practices of youth media. And as the chapters in this book demonstrate, there is no one reason for or way to implement youth media.

For example, in many regions, infrastructure access can be an issue. There are various parts of the world where it cannot be taken for granted that people have 24-hour access to the Internet or television, or even electrical power and other utilities. In these kinds of circumstances, providing youth (and adults) with low-power media such as radio, helping them create and distribute the written word on paper, and even supporting oral storytelling or songwriting can constitute youth media. This happens in many parts of the so-called developing world, but also in rural and impoverished areas of the Americas and Australia. In addition, many governments and non-governmental organizations are purposively suppor-

tive of particular youth media programs that promote their own vision, and so the systems as well as the content of youth media can be shaped by these governmental and organizational agendas. Many government agencies, non-governmental organizations, and community centers see themselves as filling gaps in the lives of youth, providing them with safe environments for coming together, and then letting others know about the everyday worlds youth deal with. Some of these initiatives are described in a report by Shirley Kinkade and Christy Macy, *What Works in Youth Media: Case Studies from Around the World* (2003). Furthermore, there is a history of religious, political, and civic and community groups developing young people's artistic and public expressions to support those groups' causes. The chapters throughout *International Perspectives on Youth Media* provide examples of these different kinds of initiatives and their specific goals and practices, using a diversity of conceptual frameworks and methodologies to analyze the process and outcomes of youth media projects.

And so, formal youth media programs support a variety of projects that can result in the following kinds of outcomes, which can interrelate and overlap: film and video festivals, citizen journalism, aesthetic expression, collective activism, political persuasion, and community representation and outreach.

In the United States, several initiatives herald the emergence of youth media as a field but also point to the diversity of youth media perspectives and practices, which again are rooted in issues of locale, resources, needs, interests, and capabilities. First, funding for youth media programs in the United States has been supported by government agencies and foundations in the last two decades in particular (the list is too long for this introduction, but organizations are referred to by some contributing authors). These agencies and foundations have been and are variously concerned with youth development, learning, health, safety, and progress toward successful adulthood in an environment where media of all kinds are pervasive—indeed, they are a given. The support of youth media by these agencies has contributed to a proliferation of programs and projects (Tyner 2008, 2009). Second, a journal dedicated to youth media was born in 2005, aptly named *Youth Media Reporter: The Professional Journal of the Youth Media Field* (see youthmediareporter.org). This journal features articles written primarily by youth media practitioners who work in a variety of contexts and regions, and those contexts and regional circumstances have a great deal to do with the kind of work that they do. Their work involves different media; varies in size and scope; exists in urban, rural, and suburban contexts; and their staff and leaders hail from multiple disciplines such as youth development, media arts, media education, community activism, and others. In addition, a number of academics across the United States, such as myself, are involved in youth media as researchers, advocates, and—when possi-

ble—providers. Indeed, the journal featured a slate of academic research into youth media in August 2008 (see the end of the references section).

In 2009, the *Youth Media Reporter* coordinated several virtual discussions in which those of us who are advisors to and reviewers for the journal talked about our goals and objectives and what we needed to accomplish given our different perspectives and interests, so that we could continue to build the field. One of the topics of discussion was how different programs and projects frame their youth media work. Kathleen Tyner, a leader in the youth media and media education fields (see Tyner 1998, 2009) and a contributor to this volume (Chapter 1), characterized these frames—or, as she put it, the aims and objectives—of youth media according to the list below. Note that these are not exclusive categories but can be interrelated, depending on the contexts of implementation.

- Social Justice: encouraging collective action to redress issues of inequity via messaging and storytelling
- Political Action: explicit promotion of agendas to benefit specific groups, especially youth and under-privileged communities
- Arts: support for individual self-expression, narratives, and non-narrative aesthetics and artistic movements
- Inter-Generational and Cross-Generational Communication: giving youth the means to interact with peers and adults
- Workforce Development: promoting economic development and career preparation for media and communication industries
- Academic Support: encouraging drop-out prevention and motivating for achievement, academic advancement, and college preparation
- Youth Development: support and prevention for health, well-being, and safety
- Recreation: enjoyment and entertainment
- Community Development: providing support, opportunities, and pathways; capacity-building.

(Tyner, personal communication, June 23, 2009)

As this list shows, the field of youth media encompasses many interests in the United States alone. And the edited volumes mentioned above that report on international programs and projects that include youth media production and education also represent a diversity of goals that can be broken down according to this list. Researchers looking into youth media programs and projects must be mindful of the diversity and the interconnections of these categories at the same time. Also,

researchers need to make sure that they investigate whether and how youth themselves are served and benefited, since often it is adults who design and implement programs for youth, sometimes without acknowledging what youth themselves would like to gain (Buckingham 2000).

What Do We Know about Youth Media, and What Do We Need to Know?

A good portion of the chapters and articles in the volumes or journals cited previously are descriptive rather than analytic, and this addresses a problem many youth media programs and projects face, no matter what the context: resources of time, money, and expertise are scarce if youth media practitioners want to reflect on and write about their programmatic work and its outcomes for various stakeholders (see Buckingham 2003; Goodman 2003; Tyner 1998, 2008). Most youth media programs and projects have relatively small budgets and are reliant on grants and non-profit funding of various kinds, and thus they are mostly involved in making sure they can implement their programs for youth and continue to seek out funds to provide their services and activities. As you can imagine, this funding issue has been exacerbated by the current global economic downturn. So issues of survival and maintenance are extremely urgent for youth media providers at any time, but are even more acute right now.

Researchers who are involved in policy and advocacy can help youth media by encouraging the support and maintenance of programs already in place, and by envisioning new kinds of creative and strategic partnerships and collaborations among youth media and researchers. Partnerships and collaborations can have multiple benefits.

As exemplified in many chapters within this volume, youth media organizations and higher education institutions can create partnerships and collaborations that give faculty and students opportunities to be participant observers, evaluators, and co-providers of youth media (see Hull and Schultz 2002; Fisherkeller, Butler, and Zaslow 2002; Tyner 1998, 2008; Seiter 2005; *Youth Media Reporter* 2008). The research emerging from such partnerships is absolutely vital to building the field of youth media, which can only benefit from publications and presentations that analyze and reflect on the best practices, outcomes, and processes, given the different goals and contexts of youth media work. At the same time, faculty and students in higher education can connect with the "real worlds" of youth interacting with media, communication, and everyday life in various contexts, contributing grounded research to the fields of media and communication studies, cultural studies, youth development, education, globalization, policy, and activism.

Thus, the value of this edited volume, *International Perspectives on Youth Media: Cultures of Production and Education*, is that it features research on youth

media projects hailing from nearly every continent of the world—regions within Africa, Australia, East Asia, South Asia, the Middle East, Europe, and North and South America. Contributors from these regions present research on the kinds of programs they are involved with, and the chapter contributions suggest that the aims and objectives, practices, and outcomes of youth media categorized by Kathleen Tyner on page 7 can apply to the variety of programs the contributors describe and analyze.

Before outlining the different sections of this book and their focus, and the chapters within each section, several notes on overall content and style issues are warranted. Multiple kinds of connections can be made among all of the chapters, connections that are related to some of the similar intentions and objectives of youth media around the world, as well as some of the common challenges and opportunities presented by local situations and global flows of media, people, and ideas. In other words, many of the contributions assume the general need for youth media that is laid out in this introduction. But the chapter authors will explain in particular why and how they do their work as researchers, educators, advocates, activists, and/or policymakers (or some combination of any of these roles). Also, certain scholarly perspectives and methodologies are shared by many of these researchers, even while they might be drawing on different theories and practices that are specific to their region and/or particular educational and professional background.

While many edited volumes have the different chapter authors referring to each others' work in the book where relevant, I have not asked for this for several reasons. First, there are issues of space. The chapter contributions are rich and complex on their own, and deserve more space than allowed to fully contextualize the work, so I did not want to burden the authors with adding more citations and connections than they have already provided. Second, I want readers to make these kinds of connections themselves, the nature of which will vary based on their backgrounds, interests, and contexts of experience. This further acknowledges the tremendous diversity and variety of people that, as mentioned previously, is a key principle of many youth media programs. Finally, the organization of the book according to section headings provides some thematic connections that I found. However, these sections could easily be "hyperlinked" thematically and topically in a number of ways, if this document were to appear in a non-linear Web 2.0 form, rather than this linear print form. Many of the chapters suggest that multimedia expressions and forms allow for people (not just youth) to communicate aspects of their experience that are not represented in spoken and written language alone. And so I invite all readers to contact any of the authors to discuss their own thematic questions, insights, and "hyperlinks" as they emerge while reading. This is in the spirit of many youth media programs and academia as well: encouraging en-

gagement with others about issues and ideas, and taking action as necessary, via multiple media and venues.

I need to explain that the "voice" or tone of the chapters varies because of differences across contexts and the diversity and variety of stakeholders in youth media around the world. This is fitting in a field that itself acknowledges the diversity and variety of youth voices and the different historical, socio-political, material, and cultural realities they experience. Thus while all chapters are based on research, not all of the pieces are necessarily "academic" in tone, and they do not follow any one model for laying out their conceptual frameworks, methodologies, findings, and/or implications and suggestions. Also, while the authors' texts all conform to the same writing format, some of the authors' spellings and punctuation are standard American, while some are standard British. I have allowed this variation, again to acknowledge the diversity of the contributors and their particular experiences and educational backgrounds. Even so, the variety of native languages of many contributors is not represented, though they are acknowledged here.

Outline of International Perspectives on Youth Media

In "Part One: Regional Analyses of Youth Media Programs, Purposes, and Needs," the chapters present youth media within four different areas of the world. The authors examine how the specifics of national, regional, and institutional contexts inform what, why, and how people do youth media and youth media education in these locations.

In "Mapping the Field of Youth Media Organizations in the United States," Kathleen Tyner draws on several years' worth of surveys she conducted on a national scale. Tyner designed the surveys and invited youth media program providers to respond to multiple-choice questions as well as to write comments elaborating on some of their responses. The findings of the final survey examined in this chapter show the variety of programs and projects in the United States whose aims, objectives, practices, and outcomes run the gamut laid out earlier. But the findings also reveal that many youth media providers agree that providing young people with a "voice" is important, and they face common challenges in terms of funding and resources. While Tyner claims that the surveys conducted over several years in the United States cannot be compared because different organizations were participating each time, these findings might be used to compare, in a more qualitative manner, the variety of programs and projects around the world and the role that contexts play in youth media as described in the chapters that follow. Tyner concludes that much more research needs to be done so that youth media practitioners, scholars, policy analysts, and funders can advance our

knowledge of effective program practices and successful outcomes for all stake-holders, including youth themselves.

In "Youth Media Imaginaries in the Arab World: A Narrative and Discourse Analysis," Sanjay Asthana takes us to the Middle East to consider some of the specific needs for and purposes of youth media outlined earlier: personal expression, political action, and community development. These needs and purposes are rooted in the particular context of Palestinian and Israeli experience, which is extremely complex and conflicted. Asthana shows how the youth media providers in this area might pursue agendas that go unexamined. They assume that what they are doing is connecting youth to discourses of development and participation, while ignoring what the youth themselves might need and want—although the youth do manage to challenge the organizational agendas via content. Asthana illuminates how youth media production provides Palestinian youth with a means of expressing themselves in both personal and political ways, a mode of expression that is not afforded by their local experiences. This illuminates globalization ideas about the translocal, where the local is transcended by the global via the affordances of media technologies, but the content and expression of digital/audio/visual media is still very much rooted in the everyday. In his analysis, Asthana says that we have to appreciate not only the rational and persuasive aspects of media, but also the affective and performative aspects of media production; these help us to understand the multi-dimensional meanings of these media and of real life.

In "Media and Christian Youth Groups in Brazil," Karina Kosicki Bellotti shows how young people are both consuming and producing youth media within the context of Christian religious organizations that have turned to popular media to appeal to young people in the contemporary context. Because participation in services and activities has dwindled in the last decades, Catholic and Protestant groups have created opportunities for young people to present their similar and divergent Christian beliefs and values through venues that allow youth to express their interests in popular music, dance, consumerism, and a variety of Internet forums and mediated communication. These venues blur some of the boundaries between institutions and groups while simultaneously forging "new frontiers" of religious group distinctions. Bellotti argues that this Brazilian expression of convergence culture affords youth new actual and mediated spaces for identity formation and sociability, and she makes suggestions for how adults in youths' everyday lives can both appreciate these spaces and encourage young people's critical engagements with these spaces.

In "Singapore's Experience in Fostering Youth Media Production: The Implications of State-Led School and Public Education Initiatives," Sun Sun Lim, Elmie Nekmat, and Shobha Vadrevu examine youth media initiatives in Singapore that

have been sponsored by the government, which wants to develop its future work-force to be able to compete in the high-tech, information, and communication industries. While government support has provided young people with opportunities to learn digital media production using a variety of tools in school as well as through industry-sponsored initiatives, the authors note that young people are not being encouraged to look critically at the media and technologies they are using to communicate and create. This is a problem of traditional pedagogies that focus on transmission of knowledge rather than on critical and appreciative reflection. The authors have policy recommendations to address this issue, calling for educational reforms that would not merely integrate new media into classrooms but also encourage young people to be both critical and appreciative of information technologies they are using to create media products.

In "Studying Research Capabilities of Youth Media: Analyzing Children's Audiovisual Expressions about Health," Richard Chalfen and Michael Rich look at the role that audiovisual media production can play in the case of young people dealing with chronic illnesses, and how their personal narratives can actually influence the healthcare process and system or, as the authors put it, the politics of healthcare. Because videographies allow for expressions that sometimes cannot be conveyed through words alone, young people in a Boston-area medical center project can inform healthcare providers about aspects of their experience that cannot be captured by surveys and interviews. One of the goals of youth media in general is to have youth create media that will have a positive impact on their lives and contribute to social change in the "real" world. The authors demonstrate how youth can feel like powerful participants in the healthcare system and so can ultimately impact how they are cared for, and how they can care for themselves as well.

"Part Two: Case Studies of Youth Media Identities, Voices, and Performers" includes chapters that feature some other specific programs in different locales, highlighting in particular how young people and youth media educators can learn to communicate and circulate their senses of self and their particular social situations through youth media projects.

In "Youth Media Production and Technology Skills Acquisition: Opportunities for Agency," Michael Dezuanni presents a case study of a video game design unit that he created and implemented at a school for pre-teen boys in Brisbane, Australia. The author challenges some of the assumptions media educators make about the role media production plays in encouraging young people's critical capacities, and brings poststructuralist theories to his analysis of students learning about multi-media technologies of video game design. He argues that skills acquisition using new media tools allows for young people to not only understand how video games are constructions, but also allows for their creative experimentation

and play with media as well as their sense of themselves within a particular community of practice. He suggests that media educators need to expand their theories and practices to accommodate new media production within formal school curricula, and to acknowledge the creative and agentive possibilities of designing with digital, multi-media forms.

In "'Because It's Not Really Me": Students' Films and Their Potential as Alternative Media," David Levin examines a student filmmaking project in a small Israeli town to illustrate the potential as well as the limitations of youth producing films both to express themselves and to investigate issues of social, cultural, and political relevance in their daily lives. Looking at the content and production of some specific student films produced in the context of a secondary school media production course over a two-year period, Levin highlights the advantages of creating audiovisual narratives for youth who are often disenfranchised from school as well as the larger Israeli society. At the same time, he notes that schools need to play a role in encouraging young people to examine issues of generational divides, social stratification, and gender discrimination in a critical and non-normative manner. This suggests that schools need to attend to learning that is social and cultural as much as it is technological and aesthetic in youth media projects.

In "Changing Hats: From Practitioners to Practitioner-Researchers," Ivana Espinet, with contributions from Katina Paron, Lisa Denerstein, and Sanda Htyte, presents research on a program based in New York City that addresses two questions in the field of youth media. First, how can youth media practitioners, a group as diverse as the variety of youth media programs and projects, help themselves to develop professionally, and so further help their youth and community constituencies? Second, how can youth media practitioners construct a network of collaborations in their own regions, as well as in the field at large? The author and contributors participated in a fellowship program that brought a group of youth media practitioners from different organizations together once a week over several months to discuss and reflect on their practices and to consider how to evaluate young people's learning and development within their particular programs. The practitioners themselves evolved over the year as they gathered observations within their organizations and learned from each other, a process that resulted in their thinking about themselves as practitioners within a larger community, and as researchers who can examine and reflect on their own organizational practices and outcomes.

In "Whose Story Is It? Being Native and American: Crossing Borders, Hyphenated Selves," Damiana Gibbons, Téa Drift, and Deanna Drift present an in-depth analysis and discussion of a video created by the second author, Téa, a nine-year-old girl who represents her personal and cultural identities by doing a "Fancy Shawl" dance onscreen and explaining via voiceover what the dance, and dancing,

mean to her as a member of a Native American community in a northern region of the United States. The third author is Téa's mother, who is an official in their particular Native community, and she, along with Téa and the researcher and first author Damiana Gibbons, who was a participant observer of the youth media project within which Téa created the video, make sense of the video. Téa's video is analyzed as a multi-modal representation of Téa's pride in her Ashininaabe identity, her connection to her Native community and its traditions, her knowledge of the Fancy Shawl dance steps, and her feelings about dancing. Gibbons introduces a method of analyzing video products, building on prior methods that account for the multi-modal aspects of video constructions, and helps to illuminate Téa and her mother's discussion of the video and their cultural identities. Such methods could be incorporated in youth media programs and projects to help young people develop their critical and analytic sensibilities as well as their technical and aesthetic knowledge and skills.

In "Transnational Childhoods and Youth Media: Seeing with and Learning from One Immigrant Child's Visual Narrative," Wendy Luttrell, Jennifer Dorsey, Carla Shalaby, and Julia Hayden present the case of a Kenyan girl immigrant to the Boston, Massachusetts, area. The Kenyan girl took part in a research project that asked children aged 10–12 to photograph meaningful aspects of their everyday lives at home, school, and in their communities, and also asked the children to discuss the images they produced. The authors analyze the content of this girl's photographs using her narratives about their meaning, and find that her discourse highlights the importance of "carework" in this girls' self-identifications and relationships, which is undervalued in society since the majority of carework is carried out by women at home, in school, and also in healthcare. The photographs reveal aspects of young people's lives that often go unnoticed and underappreciated by both researchers and educators (and other adults), who tend to overlook the affective experiences of young people's learning and development.

"Part Three: Cross-Cultural Youth Media Comparisons and Collaborations" includes chapters that look at programs, products, and contexts, as they compare and contrast, and sometimes work together, across regional and national contexts.

In "Interests in Motion: The Film Medium Through the Eyes and Lenses of Young Scandinavian Filmmakers," Fredrik Lindstrand, Lisbeth Frølunde, Øystein Gilje, and Lisa Öhman-Gullberg (of Denmark, Norway, and Sweden) provide analyses of three youth-produced films, each of which represents a particular stance toward film content and process. The authors use a "metafunctional" means of analysis to illustrate how young Scandinavian filmmakers regard certain aspects of their films as "satisfying" to themselves as creators of content and form. Sometimes it is the idea of the film that is satisfying; sometimes it is the process of creation that is satisfying; and sometimes it is the narrative or text itself that is seen

as particularly satisfying. Of course, all three aspects of filmmaking are important (the idea, the process, and the narrative), but the authors emphasize how different filmmakers in different contexts find these various aspects variously satisfying. This is important to the field of youth media in general, as it speaks to the potential of youth media in helping young people to be successful and fulfilled participants in contemporary storytelling and creative or performative arts using audiovisual and multi-modal tools.

In "Center or Margin? The Place of Media Play in Children's Leisure: Case Studies from Sweden and Australia," Karen Orr Vered examines how children use popular media such as video games and pre-recorded movies very differently in these two regions' after-school care spaces, and how these differences are related to adult perceptions and discourses about whether popular media can provide creative and meaningful activities for children in spaces that are neither school nor home. Vered provides a detailed description of each regional setting and the policies and structures that support after-school programs, and how these shape the ways in which children are allowed to use media and technologies. She found that even while both Sweden and Australia emphasize the value of play in after-school and daycare settings, Australian children have less restricted access to more media for play and recreation, both personally and socially. That is, Australian children have more opportunities to interact with various popular media in ways that are socially constructive and creative. In Sweden, adults are less inclined to see media play as constructive or creative, due to their expressed concerns about health, educational productivity, and media content. Vered argues that after-school and daycare programs should acknowledge the creative and productive potential of children playing with media, and also suggests that they be given opportunities to construct and reconstruct various media not only as socially interactive actors using media in playful ways, but also as technical and cultural producers of media as well.

In "All the World's an Album: Youth Media as Strategic Embedding," Elisabeth Soep investigates the reports produced by a youth radio program in 2009 about three cases: Oscar Grant, a young man shot by a police officer without explanation on an Oakland, California, train platform; a navy officer who reveals that he was subjected to sexual harassment by being ordered to make a video in which he has oral sex with his Persian Gulf supervisors; and youth coverage of the war in Gaza. Soep argues that "captured" digital media—via phones and other mobile media that can be engaged at the moment of a "real life" event—create pre–pre-production opportunities for youth media producers who can obtain such raw content for their initial reports, as well as post-production opportunities for commentary and analysis. She conceptualizes the captured media contents that are then re-purposed by youth to send a message to larger audiences about the sig-

nificance and consequences of the events as "double youth media." She suggests that since many youth have access to mobile digital media that allow them to document everyday events, youth need to be provided with tools and educational guidance that support their being able to embed raw content into constructed narratives and distribution systems that reach desired audiences.

In "Cosmopolitan Imaginings of Self and Other: Youth and Social Networking in a Global World," Amy Stornaiuolo, Glynda A. Hull, and Urvashi Sahni provide an in-depth look at the experiences of young people in India, South Africa, Norway, and the United States who are given multiple means of representing themselves and communicating with each other via a social network site created by the authors that is open only to participants in the project. The youth, who are often economically disadvantaged, gain access to tools and educational opportunities they would not have except for the project, an aspect of youth media that is common to many programs and projects around the world. The authors provide rich, contextualized descriptions of the young people's local lives and their means of and explanations for constructing various multi-modal texts, and analyze these using theories and concepts of cosmopolitanism, social capital, multiple media literacies, identity, and global and democratic citizenship. Their chapter reveals how youth from all locales are both challenged by their local and global experiences and benefit from the social and educational processes of participating in the project. The authors discuss how the youth learn to expand their repertoire of understandings about themselves, their lives, and other youth outside of their cultural and material situations. The authors argue that, given opportunities to communicate across cultures through social networking sites supported by educational guidance, young people can learn not only how to represent themselves and their cultures, but also to cultivate tolerance for and interest in the everyday lives of people whose experiences are both similar and different from them, which can nurture their sense of global citizenship.

"Part Four: Proposals, Recommendations, and Suggestions for the Future" includes chapters whose focus almost exclusively has to do with what we can do. Of course many of the other chapters in other sections of this book make recommendations, but the pieces in this section are explicit and detailed. This section's offerings point to many practical and strategic ways in which youth media educators, practitioners, policymakers, and advocates around the world might design and apply their programmatic work to meet their local needs and interests. Likewise, this section suggests how various constituencies and participants in youth media might work together in both the short and the long run.

In "Facilitating the Social Reality Challenge with Youth Filmmakers," Peter Lemish presents an argument and method for evaluating youth film narratives in terms of how they do or do not represent a critical perspective on issues of social

reality that relate to forces and structures of history, region, politics, economics, religion, and everyday life. In addition, he suggests how film educators can help engage young filmmakers in creating films that are critically reflective of various issues of social reality. Lemish proposes that four key practices of Paulo Freire—problematizing, *verstehen*, moral reflection, and knowledge-into-action—can be built into film education in a holistic manner, and can be used to assess the extent to which a film narrative successfully represents transformative actions and a deeply critical understanding. He proposes a rubric for rating films in terms of their critical and transformative representations of Karl Mannheim's different levels of knowledge (subjective, objective, documentary) and then applies his rubric to 65 films produced by Israeli secondary film students who submitted their collaborations to an annual film festival. Lemish's analyses of the films (which were independent of the festival judges' evaluations) illustrate the theoretical and practical value of his rubric and illuminate young Israelis' experiences of and perspectives on their everyday realities. He closes by suggesting that if film educators were to learn about and employ his analytic method in their teaching, they could develop film students' filmmaking practices and products to be of the highest quality in re-presenting the challenges of social reality.

In "Not Just Philosophizing: Producing Effective Youth Media/ Communication Projects," Stuart R. Poyntz and Michael Hoechsmann make a case for creating youth media programs and projects that address the following issues: vocationalism, youth voice, democratic participation, and pleasure. The authors draw on each of their 20 years of experience as youth media practitioners in North American contexts, as well as their comprehensive review of literature in the interdisciplinary field of youth media (which they regard from their current academic social positions within the fields of communication, media, and education). Poyntz and Hoechsmann make a case for how to create youth media programs that can engage young people effectively by taking these issues into account more than rhetorically, while also challenging some of the assumptions of youth media initiatives that have adopted this rhetoric. They suggest that youth media programs need to explore, critically and appreciatively, the pros and cons of media making as a vocation, as a means of expression, as a right of citizenship, and as an experience of pleasure. Their suggestions are not a step-by-step layout of procedure, but a discussion of principles and concepts that could be applied adaptively by youth media projects in many contexts.

In "Practicing Sustainable Youth Media," Antonio López makes a case for having youth media education integrated purposely within environmental studies and action. Bringing together theories of ecology, communication, media education, and constructivist pedagogy, he proposes an experimental model of doing youth media that engages young people in understanding the ecological conse-

quences of media forms and systems, or, how media themselves are connected to natural—not just technical and symbolic—activities of human society. His model of practice and specific suggestions for workshop activity are grounded by his many years of working with Native American youth, the Hopi in particular, whose connections to nature are for the most part opposed to the principles and practices of the industrialized, rationalized society of the modern world. He argues that if youth media education and environmental studies were integrated, students would develop their understandings and uses of media in a more holistic, or organic, manner, and they would be connected to each other as inhabitants of their natural and mediated surroundings as well.

In "'Mad Hard Fun': Building a Microculture of Youth Media in New York City Transfer Schools," Steven Goodman examines a project that involved applying the Educational Video Center's (EVC) model of youth media education into two New York City secondary schools. For over two decades, EVC has developed its pedagogy and curriculum for teaching youth documentary making, drawing on principles and practices that acknowledge the real world of media production as well as the everyday lives of youth of color, who are disadvantaged in many ways. In the real world of media making, participants see themselves as professionals who take on various roles and collaborate within a community of practice in order to reach a particular audience with their messages and images. In the everyday lives of youth of color and poverty, school is often a place where they feel disconnected and are not motivated to engage in teacher-directed activities that seem irrelevant. EVC worked with two secondary schools that serve youth who are getting a "second chance" at finishing their degrees, where the teachers and administrators recognize the advantages of working with youth as collaborators and "professionals" in a media production process that would result in their students feeling connected to each other and to the communities they wanted to reach. The detailed fieldwork Goodman presents and discusses illustrates the possibilities and challenges of bringing out-of-school best practices of youth media into schools.

In "Youth Media in School: Insights from a Professional Development Initiative in Media Arts and Media Literacy," Lisa Tripp presents a case study of incorporating youth media into the school curriculum that capitalizes on the positive aspects of media production while working within the structural constraints of public school settings in the Los Angeles, California, area. Based on a collaborative and resource-rich initiative, Tripp describes how a design and research team worked with teachers, administrators, media arts "coaches," and participant observers to support teachers in various subject areas in integrating media production and analysis activities that would support their curriculum mandates and students' learning. The research shows that the project was successful in that students were engaged in media production within the classroom, and that they en-

joyed the social and pleasurable aspects of making media with their peers using new digital tools. However, the students did not have opportunities to analyze their own or mainstream media as forms of communication, since the teachers regarded the use of media in an instrumental manner and not as subjects of study in their own right. This is understandable, given that teachers themselves do not learn to analyze media as symbolic objects. Also, Tripp notes that students' own interests in particular topics of study, a key aspect of many out-of-school youth media programs, were not addressed because of the constraints of a largely teacher- and adult-centered agenda. Tripp challenges media educators to work further toward integrating both media production and analysis within the schools and also suggests that schools and professional development efforts need to practice a student-centered pedagogy.

The book closes with an Afterword by David Buckingham titled "Youth Media Production in the Digital Age: Some Reflections—and a Few Provocations." Having worked as a youth media educator and also as a scholar and researcher within schools and media education contexts for many years, Buckingham is well aware of the benefits youth media can provide to youth who are not often given opportunities to express themselves, whether in schools, their communities, or larger public and civic spheres. At the same time, he suggests that youth media providers and supporters need to investigate the assumptions they are making about youth, media, society, and the various intended outcomes of their youth media projects. All too often, adults in the worlds of education, policy, funding, and youth development create youth media programs to fulfill their own agendas without considering the needs and interests of youth themselves, and without questioning their conceptions about learning and development, engagement and participation, creativity and expression, and the role of media and technologies in everyday life. Also, many youth media projects do not have a means of critically examining how to design, implement, and evaluate youth media processes and products, or the impact of youth media on society and culture. Many of Buckingham's recommendations follow up on the many specific recommendations provided by the book's chapter contributors. In particular, he suggests that youth media, in principle and practice, needs to incorporate the value of reflection and analyses throughout the processes of media making and distributing.

To conclude this introduction, I urge more researchers to seek out youth media programs in their region, to help them by examining what, why, and how they do their work, to support their work in whatever way they can, and to spread the word about them in appropriate venues. In addition, researchers can contribute to the field of youth media by collaborating with and supporting others who are conducting research in this emerging and evolving field. My very able and dedicated and reliable research assistant, Jennifer Johnson, developed a website database that

provides a comprehensive listing of all the programs and projects of youth media, as well as any research reports, publications, and youth media products that we can locate, including those presented in this book. Many thanks to Jen. In the spirit of knowledge production and sharing, we hope to keep this database up to date as much as our time, resources, and support systems will allow. This book and the database—http://internationalyouthmedia.wikispaces.com—intend to make positive contributions to youth media practices, scholarship, policy, and advocacy, and ultimately to help young people around the world to think, feel, and act like powerful and expressive participants in their local and global multi-mediated realities.

Notes

1. Parts of this introduction appeared in "Youth Media Around the World: Implications for Communication and Media Studies." *Communication Research Trends*, Centre for the Study of Communication and Culture. Volume 28, Number 3, 2009; pp. 21–42.

References

Appadurai, Arjun. 1996. *Modernity at Large: Cultural Dimensions of Globalization*. Minneapolis: University of Minnesota Press.

Buckingham, David. 2000. *After the Death of Childhood: Growing Up in the Age of Electronic Media*. Cambridge, UK: Polity Press.

———. 2003. *Media Education: Literacy, Learning, and Contemporary Culture*. Malden, MA: Polity Press.

Carlsson, Ulla, Samy Tayie, Geneviève Jacquinot-Delaunay, and José Manuel Pérez Tornero, eds. 2008. *Empowerment Through Media Education: An Intercultural Dialogue*. Göteborg, Sweden: Nordicom, International Clearinghouse on Children, Youth and Media.

Dahl, Ingrid, and JoEllen Fisherkeller, eds. 2009. www.youthmediareporter.org/2008/08/academic_issue_volume_2_issue_1.html; accessed June 25, 2009.

Fisherkeller, JoEllen, Allison Butler, and Emilie Zaslow. 2002. "It Means a lot of Stuff, in a Way": New York City Youth Interpret Other Youth-Produced Videos. *Journal of Educational Media*, 26:3, 203–216.

Goodman, Steve. 2003. *Teaching Youth Media: A Critical Guide to Literacy, Video Production, and Social Change*. New York: Teachers College Press.

Hull, Glynda, and Mark E. Nelson. 2009. Literacy, Media, and Morality: Making the Case for an Aesthetic Turn. In *The Future of Literacy Studies*, ed. Mastin Prinsloo and Mike Baynham. Basingstoke, UK; New York: Palgrave Macmillan.

Hull, Glynda, and Katherine Schultz, eds. 2002. *School's Out! Bridging Out-of-School Literacies with Classroom Practice*. New York: Teachers College Press.

Ito, Mizuko, Sonja Baumer, Matteo Bittanti, danah boyd, Rachel Cody, Becky Herr-Stephenson, Heather A. Horst, Patricia G. Lange, Dilan Mahendran, Katynka Z. Martinez, et al. 2010. *Hanging Out, Messing Around, and Geeking Out: Kids Living and Learning with New Media*. John D. and Catherine T. MacArthur Foundation Series on Digital Media and Learning. Cambridge, MA: MIT Press.

James, Allison, and Alan Prout, eds. 1997. *Constructing and Reconstructing Childhood: Contemporary Issues in the Sociological Study of Childhood*. London: Falmer Press.

Jenkins, Henry. 2006. *Convergence Culture: Where Old and New Media Collide*. New York: New York University Press.

Kinkade, Shirley, and Christy Macy. 2003. *What Works in Youth Media: Case Studies from Around the World*. Baltimore, MD: International Youth Foundation.

Livingstone, Sonia. 2002. *Young People and New Media. Childhood and the Changing Media Environment*. London: Sage Publications.

McMillin, Divya. 2009. *Mediated Identities: Youth, Agency, and Globalization*. New York: Peter Lang.

Olsson, Tobias, and Peter Dahlgren, eds. 2010. *Young People, ICTs and Democracy: Theories, Policies, Identities and Websites*. Göteborg, Sweden: Nordicom.

Seiter, Ellen. 2005. *The Internet Playground: Children's Access, Entertainment, and Mis-Education*. New York: Peter Lang.

Tufte, Thomas, and Florencia Enghel, eds. 2009. *Youth Engaging with the World: Media, Communication and Social Change*. Göteborg, Sweden: Nordicom.

Tyner, Kathleen. 1998. *Literacy in a Digital World: Teaching and Learning in the Age of Information*. Mahwah, NJ: Lawrence Erlbaum Associates.

———. 2008. Youth Media at the Threshold: A Research-Based Field Building Agenda. *Youth Media Reporter: The Professional Journal of the Youth Media Field*. Special Features Issue. New York: Academy for Educational Development, 110–119.

———. 2009. *New Agendas for Media Literacy*. New York: Routledge/Taylor & Francis.

von Feilitzen, Cecilia, and Ulla Carlsson, eds. 1999. *Children and Media: Image, Education, Participation*. Göteborg, Sweden: UNESCO/Nordicom.

http://mitpress.mit.edu/catalog/browse/browse.asp?btype=6&serid=170; accessed June 25, 2009.

Part One

Regional Analyses of Youth Media Programs,

Purposes, and Needs

1

Mapping the Field of Youth Media

Organizations in the United States[1]

Kathleen Tyner

Introduction

In 2003, the National Alliance for Media Arts and Culture (NAMAC) launched the Youth Media Initiative. The Initiative worked from the premise that formative and summative evaluation and research evidence was essential to the field-building efforts of youth media practitioners. In addition to establishing a database of organizational evidence through surveys to youth media programs in 2003 and 2005, NAMAC's Youth Media Initiative included evaluation toolkits, online salons, leadership training, case studies, consulting services, resource lists, and an intensive evaluation conference for youth media leaders, hosted by the Department of Radio-Television-Film at the University of Texas at Austin in 2004. Results of the baseline study of youth media organizations were aggregated in an online database and published in the organization's annual publication, *A Closer Look* (NAMAC 2004, 2005; Tyner and Mokund 2004).

In June 2008, 82 youth media organizations responded to a third follow-up questionnaire. The results contribute to a still limited, yet growing research base that can be used to shape, sustain, and build the emerging field of youth media.

Seminal international youth media case studies have contributed prominently to the research agenda for youth media (Asthana 2006; Fisherkeller, Butler, and Zaslow 2002; Goodman 2003; Maira and Soep 2004; Kinkade and Macy 2003). Anecdotal data from non-academic sources also provide intriguing directions for future research. However, at this point, the available research related to youth me-

dia programs in the United States consists of relatively small sample sizes and is disproportionately weighted toward case studies and other qualitative evidence. As a result, it is difficult to generalize about the characteristics of this emerging field, and many researchers cite the need to build a research foundation as a field-building strategy (Niesyto, Buckingham, and Fisherkeller 2003). In order to build a coherent research base, additional studies with diverse methodologies and broader samples are needed to understand the resources, capacity, practices, and social affordances of youth media production in a wide range of settings. Evidence of impact, lessons learned and best practices is especially useful as youth media practices migrate from informal learning environments and community centers to public school curricula (Butler 2010).

A 2004 study commissioned by the Open Society Institute and the Surdna Foundation, Social Policy Research Associates acknowledged challenges for researchers who study youth media. Designed as a mixed-methods approach, the study used telephone and online surveys to collect data about program impact, audiences, and distribution of youth media products. After a comprehensive literature review, the researchers noted the "relative shortage of youth media research, particularly that concerned with impact" and added:

> In the end, what we found was very scant research on youth media generally, on youth media impact specifically, and on how related fields might be of significant use in attempting to measure the impact of youth media. The nascency and sheer diversity of the youth media field contributes to this shortage, as do the key differences between (1) youth media and other youth-oriented fields, and (2) youth media and other media fields in the way they target and measure impact. These fundamental differences discouraged us from conducting a more exhaustive literature review of related fields for specific and transferable impact-measurement tools. (Inouye, Lacoe, and Henderson-Frakes 2004, p. 15)

In a 2004 study for the Stuart Foundation, researchers from Putnam Community Investment Consulting conducted focus group interviews with five youth media organizations to assess the potential impact of youth media programs (Pontecorvo, Bohlen, and Putnam 2006). The study defines youth media broadly as "media conceived, developed and produced by youth and disseminated to others" (Campbell, Hoey, and Perlman 2001). It begins optimistically by stating, "Make no mistake about it. Youth media is a field" (p. 1) and then goes on to discuss the challenges to a clear assessment of the impact, characteristics, spread, and future trends in this diverse field:

> As the field matures, older and more established youth media nonprofits emerge as leaders in the field. At the same time, a wave of new groups and programs are on the rise. The heterogeneous nature of the field makes it hard to have a shared vision, common principles and best practices, and makes it difficult to assess collective impact. (p. 7)

The range of media, genre, and missions across youth media programs also complicates a clear analysis of the supports and challenges inherent as isolated programs evolve from demonstrations of emerging trends to the degree of professionalism, sustainability, and spread that are evident in an established field of practice. Very little aggregated research evidence is available as the basis for theorizing and analyzing best practices and lessons learned across youth media programs in the United States. In addition to the need for ongoing research about youth media production in informal learning environments and community-based settings, there are also surprisingly few research studies related to the broad range of youth media practices in formal educational institutions. Results of the 2008 NAMAC survey are intended to establish some baseline information and grounds for future research related to the nature and impact of youth media production as an emerging field in transition.

Methodology

In 2008, a convenience sample of youth media program directors was targeted with assistance from NAMAC, which solicited responses from its mailing list of member organizations and community-based media arts advocates by email and newsletters. In addition, ListenUp!, the youth media program of Learning Matters, Inc., in New York, disseminated requests for survey completion by email to their network of youth media organizations. Finally, I made follow-up requests for survey completion to large youth media organizations by email and telephone in August 2009.

Data collection was conducted from July 9 through September 1, 2008. The research design also employed a rolling sample strategy. Upon completion, survey respondents were asked to send an automated email to other youth media providers in their networks stating their support for the survey and asking them to click on the link to also complete it.

The data collection instrument consisted of an online questionnaire used in the previous (2003 and 2005) studies. The instrument design employed forced responses, multiple responses, Likert scales, and open-ended responses for 28 items related to organizational capacity, geographic reach, client characteristics, organizational mission, program management, program characteristics, visibility, and challenges.

The questionnaire was again refined in 2008 to address respondent confusion or questions as stated in open-ended responses in previous studies. In addition, items were added to the questionnaire when clusters of topics or variables emerged in open-ended remarks. This was especially relevant for items related to changes in the uses of new media.

Although the majority of the 2008 questionnaire items were identical to the surveys in 2003 and 2005, the three samples were significantly different for each of these surveys. Only 29 of the organizations in the 2008 sample had responded to one or more of the previous studies. Therefore, aggregated responses to the 2008 survey cannot be compared to results of the two previous surveys.

To ensure the confidentiality of individual responses, the questionnaires were coded by number for tabulation. In the case of multiple responses, only one response per organization was tabulated. A team of graduate and undergraduate interns from the Department of Radio-Television-Film, The University of Texas at Austin, worked with me to tabulate and aggregate survey responses in Excel by frequency.[2]

Characteristics and Mission of the Youth Media Organizations

The 2008 sample consisted of respondents in leadership positions at 82 youth media organizations across the United States. Organizations in 22 states are represented in the sample. One other organization is primarily based in Mexico, with locations in Los Angeles and San Francisco. Nearly half (46%) of the responses came from youth media organizations based in California, New York, and Texas.

The majority of the sample consisted of community-based, non-profit organizations. Nearly half (46%) represented youth media programs within a larger non-profit organization. Twenty-four percent were stand-alone youth media organizations. Nine organizations (11%) represented public education institutions in secondary and post-secondary programs. One respondent conducted a youth media program from a for-profit media business. Table 1 addresses the overall organization mission of the lead organizations.

Table 1: Organizational Mission

We want to know more about the kinds of organizations that sponsor youth media programs. Please state the main function or mission of the SPONSORING organization.	Responses by Frequency* (n=82)
Art/Media Arts	36%
Youth Media Only	24%
Youth Development	5%
Formal Public Schooling	5%
Community Development	2%
Social Service	0%
Health/Prevention	0%
Other (please specify):	27%

*Responses may not total 100% due to rounding.

In open-ended remarks, 27% of the respondents specified that their youth media programs were part of a diverse range of larger organizations with missions related to alternative media, social justice, youth services, workforce or economic development, media literacy, or community access television. When asked specifically about their youth media programs, one third said that the primary mission for youth media was to "give youth a voice." Table 2 displays the results.

Table 2: Primary Mission of Youth Media Programs

It is difficult to choose only one reason, but you will be able to state many reasons in other areas of the survey. For this question, please tell us the NUMBER ONE reason that your organization is devoted to youth media:	Responses by Frequency* (n=82)
To give youth a voice	34%
To encourage creative self-expression	19%
To build and strengthen our community	11%
To prepare youth for negotiating a digital world	8%
To prepare youth for careers in media	8%
To provide alternatives to commercial, mainstream media	7%
To facilitate learning in academic subjects	1%
To offer youth healthy recreational activities	1%
To protect children from the harm caused by the media	0%
Other reasons	7%

*Responses may not total 100% due to multiple responses and rounding.

No one mission for sponsoring youth media programs was chosen by a majority of the sample. Seven percent provided open-ended "other" responses about the missions of these organizations. These positioned community development as an underlying issue "which includes both personal (youth development) and community development as a strategy." One respondent also stressed the need to "engage youth in social justice issues" in the other category. When asked to name multiple reasons for youth media work, some consensus emerges in the sample. Table 3 displays the responses.

In open-ended responses, commenters indicated that they hope to "educate youth on how this technology applies to all aspects of life" and also to "help young people find their passions, using media as a path to exploration of their interests." The open-ended remarks also pointed to missions related to arts education, social justice, civic participation, academic support, school improvement, vocational education, and general youth development for some of the respondents' organizations.

Table 3: Multiple Aims and Purposes for Youth Media Programs

Please tell us about ALL THE REASONS that your organization is devoted to youth media:	Responses by Frequency* (n=82)
To give youth a voice	96%
To encourage creative self-expression	96%
To build and strengthen our community	93%
To prepare youth for careers in media	81%
To offer youth healthy recreational activities	59%
To facilitate learning in academic subjects	27%
To prepare youth for negotiating a digital world	23%
To protect children from the harm caused by the media	22%
To provide alternatives to commercial, mainstream media	19%
Other	16%

*Responses may not total 100% due to multiple responses and rounding.

Organizational Capacity of Responding Youth Media Programs

In order to assess issues related to organizational capacity, the questionnaire addressed attributes related to organizational age, budgets, staffing, leadership, salaries, and funding. Table 4 displays the number of years that these organizations have conducted youth media programs.

Table 4: Length of Service for Youth Media Programs

We have been serving youth through our youth media program for how many years?	Responses by Frequency* (n=82)
1–5 years	25%
6–10 years	34%
11–15 years	13%
16–20 years	10%
Over 20 years	13%
No response	3%

*Responses may not total 100% due to rounding.

The majority of the youth media programs reporting in 2008 were ten years old or younger (69%). Table 5 displays results for all organizations' annual budgets that are specifically directed to youth media programs.

Table 5: Youth Media Annual Budget

The budget this year for youth media programs is approximately:	Responses by Frequency* (n=82)
No budget	11%
Under $10,000	17%
$10,000–25,000	18%
$25,000–50,000	5%
$50,000–100,000	10%
$100,000–150,000	12%
$150,000–250,000	7%
$250,000–500,000	10%
$500,000 to $1 million	4%
$1–5 million	6%
Over $5 million	0%

*Responses may not total 100% due to rounding.

Although a few organizations were relatively successful at fundraising, half (50%) of the respondents funded their youth media programs with annual budgets of $100,000 or less. Eleven percent reported no budget at all.

When asked to break down their budgets by line item, 35% reported that a large amount of their budget was allocated for staff expenses, in contrast to the 14% of respondents who reported no money at all for staff. Forty-seven percent of the respondents did not utilize paid consultants at all, or seldom (42%). Only one organization reported spending a large amount on consultants.

A large majority (70%) reported that a low percentage of the budget was dedicated to overhead expenses. Budget allocation for the purchase of educational materials, including media, was also low for over half of the sample (54%). The sample reported very low expenditures for travel, with only 5% reporting it as a medium or large percentage of their budget. Staff development constituted a small budget allocation for over half of the respondents (53%), and 43% reported no allocations at all for staff development. Budget amounts for exhibitions and distribution of youth work was a low expense, with 65% reporting it as less than one quarter of their budget and 28% reporting that they did not allocate support for exhibition and distribution at all.

In contrast, exhibitions and distribution were a major focus for 6% of the sample, with one reporting that two exhibitions per year took up 50% of their annual budget to produce. Stipends were a small budget item, with only 4% reporting it as a medium or high expenditure and 36% reporting no line item for stipends at all. In open-ended remarks, respondents reported other small expenditures for security, food, and fees for curriculum.

Items related to capacity also addressed staffing levels, leadership and salaries. All responding organizations reported some staff, although the staff size and capacity was generally small for this sample, with none of the organizations employing a staff of over fifty people. A few organizations reported no full-time staff (24%) or part-time staff (29%) at all, which indicates that 47% retain a composite of both full- and part-time staff. Although budget responses indicate that there is little money for consultants, 51% of the organizations used them to supplement staff levels.

The survey also addressed leadership as a capacity variable. A majority of the organizations in the 2008 sample reported a full-time leadership position (61%), and 17% reported that they retained a part-time director. Four percent of the leadership worked on a volunteer basis. The remaining 17% reported that the question was not applicable to their organization, either because they retained no director, because the organization did not have a hierarchical structure, or for other, unknown reasons.

The survey asked respondents about salary range for leadership positions in the youth media programs. One half (50%) of the 2008 respondents reported that their organization's youth media director earned a salary of under $45,000, with most of these (37%) under $35,000. Another 25% earned between $45,000 and $75,000 annually. Only 2% of the director/coordinators earned over $75,000. Twenty percent reported that the question is not applicable to their situation, either because the director is a volunteer, the staff does not work with a hierarchical structure, or because they do not employ a director for other unknown reasons.

In order to assess capacity issues related to resource development, respondents were asked about their funding sources and budget levels. In general, the respondents appear to receive small grants from a wide variety of individual, foundation, corporate, and government sources. Private foundations were the largest source of funding (22%) for their youth media organizations, although only 4% of the respondents rely heavily on foundation funding and 39% reported that they receive no funding from private foundations at all.

Small amounts of the budget were reported from individuals (30%) and corporate funders (39%), although 47% received no funding from corporate sponsors and 36% received no funding from individual donors.

The survey also asked about cost recovery for student products, showcases and exhibitions. Although the organizations produce media products for exhibition work and student showcases, they do not rely on these events for funding, with 69% reporting no revenues from sales, distribution, or "gate fees," and 33% receiving only small amounts. They also report low revenues for services (37%), although nearly half (49%) report that they receive no fees for services.

Client Demographics in Youth Media Programs

Anecdotal evidence suggests that youth media organizations often provide broad services to underserved communities (Campbell, Hoey, and Perlman 2001, p. 5). The survey attempted to measure the breadth of service to geographic areas, numbers of clients served, range of services, and client demographics such as age, ethnicity, gender and economic levels.

Most of the youth media organizations represented in the 2008 survey work locally (57%). Almost a quarter (22%) work regionally, and 6% work nationally. In open-ended responses, 7% worked in multiple states, although the states are not necessarily grouped in regional clusters. For example, one group reported work in Connecticut, Georgia, and New Mexico. Six percent reported working internationally on nearly every continent. In addition, those who conduct festivals receive submissions from around the globe.

When asked about the age range for their youth programs, most organizations (96%) worked with adolescents, with 65% reporting that grades 9 to 12 constitute the majority of their students. Middle school students represented the second-largest age group, with 66% of the respondents reporting work with grades 7 to 8. Nearly half (48%) also reported programs with students in grades 4 to 6, although in fewer numbers. An additional 22% worked with children in preschool through grade 3.

The respondents reported some work with adults, especially in the case of teacher training, with three organizations indicating a focus on teacher professional development. In addition, although youth media implies that elders are not the target audience, 18% of the sample reported some services for small numbers of elders.

The youth media programs are most likely to serve urban youth and least likely to serve suburban youth. Ten percent of the programs serve high percentages of rural youth. Females and males are represented almost evenly. Nearly half (47%) of the respondents report that a small percentage of their clients are disabled. Nonetheless, a majority (61%) report some work with disabled persons.

Three demographic groups dominated responses related to ethnicity. Twenty-five percent of the organizations reported a high percentage of service to Caucasian/White clients followed by high client levels for Latino/Hispanic (20%) and African American clients (12%). Asian Americans, Native Americans, and Pacific Islanders were much less represented, and thus were represented by low percentages of the clients reported. Gay/Lesbian/Transgender youth were served by 71% of the organizations, although in small percentages of the client base, with only one organization reporting a high percentage of clients as Gay/Lesbian/Transgender. Additionally, 58% reported service to clients who are not U.S. citizens.

As reflected in anecdotal data about youth media efforts, the youth media organizations represented in the 2008 survey work most extensively with youth from underserved communities and report high numbers of clients from primarily poor or disadvantaged (22%) or low-income/working-class (31%) economic levels. Eighty-three percent of the respondents also worked with lower-middle-class youth, and 3% reported that this economic level represented a high number of their clients. The organizations do work with upper-middle-class youth, although these youth represent a lower percentage of youth served. Thirty-one percent report no clients in the upper-middle-class income bracket. A majority (60%) reported no work with high-income or wealthy youth.

Characteristics of Youth Media Programs

When asked about the general types of activities that they support, the majority of organizations reported that they reach clients through training and community screenings. Forty-seven percent of the programs provide training for up to 100 youth per year and 26% for 100 to 500 clients per year. Two organizations reach between 2,500 and 5,000 clients per year for training opportunities.

Most of the community screenings reported audiences of fewer than 750 people, with the majority of estimates in the lower ranges of fewer than 100 (29%), between 250 and 500 (23%), and between 500 and 750 (7%). However, community screenings attracted large audiences for 14% of the sample. Exhibitions showed similar patterns, although 27% of the sample did not participate in exhibition work. Festivals reached large audiences for 15% of the organizations. However, 23% reported that their festivals served fewer than 50 clients, and 35% did not sponsor a festival as part of their program.

Results related to reported audiences for youth media products and activities in broadcast and online media were particularly difficult to verify and analyze. Therefore, more refined research beyond the numbers of audience members for face-to-face events is needed. It is also possible that audience measurement is different for each type of distribution, e.g., online, broadcast, and subscription models. The survey results for Internet-based media reflected the potential for broad client service and audience reach, although 30% of the sample did not engage in online distribution. Finally, the 55% of the sample who engaged in cable distribution reported the largest numbers for client service, although the metrics used by respondents to estimate audience size for broadcast media are unknown. Table 6 displays results related to the amount of time spent on a variety of activities.

Table 6: Youth Media Activities By Frequency* (n=82)

Please estimate the percentage of time your youth media program devotes to the following activities:	1–10%	11–25%	26–50%	51–75%	76–100%	None
	Low % of Clients		⟷		High % of Clients	None
Student/Youth Workshops/Training	10%	7%	14%	28%	34%	6%
Screenings/Presentations of Youth-Produced Work	51%	25%	2%	4%	6%	11%
Program Administration	34%	29%	17%	6%	1%	12%
Materials/Curriculum Development	36%	31%	7%	4%	2%	18%
Outreach	46%	19%	8%	4%	2%	19%
Program Evaluation	57%	16%	6%	0%	1%	19%
Distribution of Youth-Produced Work	49%	13%	6%	1%	5%	24%
Website Maintenance and Development	45%	24%	1%	1%	0%	28%
Staff Support for Youth Media Programs	41%	17%	7%	2%	2%	28%
Fundraising	27%	29%	8%	4%	1%	30%
Educator Workshops	52%	7%	4%	1%	2%	33%
Festivals	39%	11%	2%	1%	4%	42%
Conferences	43%	6%	1%	0%	0%	48%
Workshops for Media Artists/Trainers	27%	2%	1%	1%	0%	67%

*Responses may not total 100% due to rounding.

Ninety-four percent of the youth media organizations provide workshops and training, and the majority (62%) devote a high percentage of their time to these activities. Of these, over 66% conduct workshops for educators, although this constitutes a much lower percentage of their time. The majority (67%) does not conduct staff development workshops for media artists or other potential trainers. This corresponds with the low levels reported for general staff support. Although most spend limited amounts of their time developing curriculum for the workshops or training, 18% of the organizations—including the 4% who do not conduct workshops—do not develop curricular materials.

Exhibition and visibility activities are conducted by a large majority (89%) of the organizations, although most devote less than 25% of their time to screening

and presenting youth-produced work. Although most reported some conference attendance, these time estimates are at the lower end of the continuum.

In activities related to outreach and visibility, most maintain a website, although 45% of the organizations devote little time to developing and maintaining a website. In addition, 24% report that they do not distribute youth media products. However, 5% of the organizations that report time spent with distribution activities spend over three quarters of their time distributing youth media.

The majority of the sample spends time with distribution, screenings, and festivals of youth media work, although most spend small percentages of time conducting these activities. Respondents also reported relatively small amounts of time spent with a range of administrative tasks. Only 13% spend large amounts of time with fundraising, and 30% report no time at all for fundraising. Although the majority spends some time with evaluation activities (81%), the estimated percentage of time spent on evaluation is small. Fifty-seven percent report that they spend a very small percentage of their time on evaluation.

In keeping with the definition of youth media as production- and distribution-centered practices, the study measured the amount of time spent on production activities. In addition, an evaluation question attempted to measure activities associated with both individual and program assessment. Results related to activities with youth are displayed in Table 7.

The majority of organizations in the sample spend high percentages of time on production, engaging in both field and studio practice. Field production represented the highest reported percentage of time (27%), with only 12% of the organizations reporting that they did not go out in the field for production exercises. On the other hand, almost one fourth (23%) reported no studio production, although 11% reported high percentages of their time in the studio.

Table 7: Kinds of Activities by Frequency* (n=82)

What percentage of time does your program spend on the following activities?	1–10%	11–25%	26–50%	51–75%	76–100%	None
	Low % of Time		⟷	High % of Time		None
Field Production	10%	22%	28%	20%	7%	12%
Studio Production	19%	23%	23%	6%	5%	23%
Media Analysis/Critical Viewing	31%	34%	12%	5%	2%	14%
Distribution	46%	17%	6%	0%	2%	27%
Evaluation	58%	18%	8%	1%	1%	11%
Other (18%)						

*Responses may not total 100% due to multiple responses and rounding.

The organizations reported lower levels of media analysis (65%), although a few (7%) spend high percentages of time on media analysis. Fourteen percent did not engage in media analysis. Because "media analysis" is such a broad concept, it would be useful to measure more specific attributes in future studies.

Distribution activities were practiced by a majority of the organizations, although the time spent on these was relatively low (63%), and 27% of the respondents reported no distribution activities for their organizations. Also, the percentage of time spent on evaluation was low (76%), although most organizations (89%) reported some time spent on evaluation activities.

In open-ended remarks, some respondents preferred to list more specific questions related to their organization's youth media production activities. One respondent noted that these categories were not completely congruent with print publication. Others suggested that instead of these categories, the survey should attempt to measure pre-production, production, and post-production activities. Some organizations reported activity in the following categories: media literacy; job skills, academic enrichment, curriculum development; event production (e.g., a festival); story development, desktop animation, Web 2.0 training (e.g., blogging); policy development/legislation and research. Table 8 asks respondents to choose the medium that is most often used in their program. The majority of respondents ranked documentary, narrative media, non-narrative media, and public service announcements (PSAs) as the most-produced media for the sample.

Although most reported that they use computers and multimedia in the production process, the survey was limited to questions about game creation and website construction. When asked about genre, 34% reported low percentages of web production in their programs, and 59% reported none. The production of interactive games was barely addressed by this sample of youth media organizations, with 82% responding that they did not engage in game-creation tasks with youth in their programs.

Table 8: Primary Medium Used

Please select the primary medium used in your youth production work:	Responses by Frequency* (n=82)
Computer-based multimedia (e.g., web design, digital video/audio, etc.)	64%
A combination of analog and digital multimedia (e.g., audio converted to digital, analog footage edited on the computer, etc.)	20%
Radio	6%
Analog (e.g., film or tape-based audio/videotape)	5%
Photography	1%
Print	1%
Other: Film (Super-7 & 16mm), Diversified Media (Web, radio, print)	1%

*Responses may not total 100% due to rounding.

In open-ended remarks, respondents listed other genres such as animation, blogs, Internet television, jury work, event management, and the media coverage of educational events such as sports, concerts, and classroom activities. One respondent who reported youth media work with Web 2.0 applications listed their program's participatory media practices, such as the use of Google maps and social networking sites for social change projects. Future research is needed to explore a wider range of interactive, data-driven, social, and collaborative digital media production by youth.

Community Visibility and Outreach

The survey attempted to gather information about the ability of youth media programs to inform the community about their services through community events and outreach activities.

Respondents were asked to estimate the audience figures for all of their program activities, including exhibitions, showcases, screenings, distribution activities, and festivals. The majority (59%) reported that their largest audiences numbered fewer than 500. Forty-two percent reported audience sizes between 100 and 500, and 6% between 500 and 1,000. Eleven percent reported audience sizes between 1,000 and 5,000 people.

Those who worked with organizations with access to large distribution networks such as public access stations reported large audiences of over 10,000. One of these (1%) estimated that its smallest audience consisted of 10,000 to 25,000 audience members.

In addition to public distribution and showcases of student work through community events and distribution, the survey asks respondents to identify their other outreach activities. The majority (73%) use the web for outreach and visibility, and 62% take advantage of announcements at community events. They also relay through word of mouth (43%), publish their own newsletters (48%) and target mainstream press outlets (43%).

Challenges to the Missions of Responding Organizations

In previous studies, youth media organizations expressed challenges that were directly related to the capacity to serve their targeted communities (Tyner and Mokund 2004). This is especially true within the context of service to traditionally underserved, low-income youth. The 2008 survey asks youth media organizations to identify multiple challenges and then to identify their programs' biggest barrier to service and outreach. Results for multiple challenges for the organizations are displayed in Table 9.

Youth media organizations that responded to the survey in 2008 indicated that they worked with low-income students, and 28% included open-ended

remarks related to conditions of poverty in underserved areas that generally blocked career and academic opportunities and, specifically, proved challenging for the recruitment and retention of students. The organizations also cited factors related to low levels of organizational capacity. When asked to list various barriers to participation in their program, the transportation options for youth were cited by 60% of the sample. In a related issue, 28% reported that the physical locations for their youth media activities were problematic. Over half (51%) cited problems with technology access as a barrier.

Table 9: Multiple Barriers to Service and Outreach for Youth Media Programs

Please indicate some barriers to outreach and service for the youth media clients you serve:	Responses by Frequency* (n=82)
Poor transportation options	60%
Technology access issues	51%
Students have too many other activities to choose from	51%
Awareness of our program	51%
Student mobility/retention	31%
The physical locations for our youth media activities are problematic	28%
Staff need more support/training to work effectively with youth	27%
Language barriers	25%
Staff turnover	23%
Intergenerational communication (adult support/helping youth stay connected to the enterprise)	14%
Need for a curriculum	8%
Other	28%

*Responses may not total 100% due to multiple responses and rounding.

When asked to prioritize the "number one barrier to service and outreach," no single barrier received a high percentage of responses. The physical locations of their program activities were cited by 14%, poor transportation options by 13%, and technology access by 10%. Language barriers were the biggest challenge for 7%, program awareness for 5%, and the need for a curriculum for 4%. In open-ended remarks, 31% of the sample cited general funding and capacity issues as their biggest barrier. Other issues related to capacity, funding, and outreach were cited as the biggest barrier by a small number of organizations.

Discussion of Results

The organizations that participated in *Mapping the Field: The 2008 Youth Media Survey of Youth Media Organizations in the United States* are indicative of an emerging field with committed advocates and diverse program offerings. Qualitative and ethnographic studies provide a compelling picture of cross-program practices, yet the research base has yet to yield a coherent body of evidence to generalize about the definitive nature of the youth media field. The diverse characteristics of practice for these programs are represented in every aspect of the study, from the demographics of the clients served, to media and modes of production, to activities and audiences. When asked to articulate their missions, the organizations in this study also reported a wide range of aims and purposes for youth media programs. These run the continuum from individual to collective service and encompass both youth development and community development ideals. In this regard, their responses raise questions about youth media as its own field, as an outgrowth of general youth development work, as a strand of community activism, and as a core area related to the arts and cultural production.

What is clear is that these programs offer a "lifeline" for individual youth in underserved communities. In this sense, support for the individual young people who participate in their youth media activities is seen as paramount to the success and impact of these youth media programs.

Youth Development and Community Service

Most of the organizations in the study work with low-income communities with high levels of need. Community development activities are expressed, from general types of civic engagement to workforce development goals, for a majority of the organizations, with 11% reporting community development as their main purpose. Most of the respondents work in urban areas, although a small number reported work with underserved young people in rural areas. The study reflects the need to address the conditions of poverty by offering a structured place for youth to engage with media in social and recreational activities. In open-ended remarks, respondents expressed the need to mentor youth as change agents who invest and participate in their communities, and to guide them to career and academic opportunities that are not readily available in these communities.

In the process, the quality and rigor of their programs must balance high pockets of need and navigate the fallout from social trauma in some of these communities. Working primarily with adolescents, youth media organizations compete for teens' time and attention and deal with recruitment and retention issues common to many teen programs. But their work in underserved communities adds another dimension for these youth media organizations. They reported

difficulty in reaching students and said that "life difficulties make it hard for some students to commit to the program, to finish their work." One respondent remarked, "The majority of youth participants are grappling with significant personal and family challenges with few (to no) support services. [Our organization] is a rigorous training program in regards to production and critical thinking expectations. It is sometimes difficult to support youth in this learning process while also helping them respond to the very immediate personal problems they experience." Respondents remark that:

> Our youth have other "activities"—most of them have to have another job (we offer small stipends), take care of a sibling, or other personal and family responsibilities. Several youth are periodically homeless, or moving from one family to another.

> Students are pulled by family responsibilities and financial limitations. Because we work with high school students many of them would rather find a job where they can earn money.

> Students are not coming from stable home lives so it makes it really hard to reach them because they are often bounced around so much (from family member to friends, from apartment to apartment, from group home to group home, etc.).

Youth media programs in disadvantaged neighborhoods reported a range of other challenges related to the geographic locations for their work sites, including safety, the need for studio space, and chronic technology access issues. "Poor transportation options" was cited as a barrier by 60% of the sample. The diversity of their student populations is both a support and a challenge. One respondent remarked, "The youth that I worked with were from drastically different backgrounds. It was a challenge to produce media together and participate in storytelling when skill sets and life experiences were so divergent." The data from the 2008 study reflects previous results in the 2003 and 2005 surveys and also reflects youth media organizations' emphasis on service and social justice in underserved communities. The 2008 study demonstrates the ability of youth media organizations to provide an array of services for underserved communities, in spite of funding and capacity challenges.

Organization Missions and Activities

Many of the organizations see their mission as a way to use the media arts to provide social redress to communities in distress. These programs place an emphasis on participatory civic engagement with and by youth. They want the young people in their programs to "learn about media democracy/media justice and how you apply a social justice framework to understanding the media, and how this affects production, creation and distribution when it comes to diverse viewpoints." They

see their work as preparing "youth as digital citizens participating in democracy" and want to "encourage youth to create change within their own communities."

The majority of the organizations in the study also hope to prepare youth for career pathways and assume that digital literacy is tied to workforce development efforts, which have the potential to revitalize communities. In particular, they hope that media and critical thinking skills will prepare youth for potential career opportunities that "prevent brain drain" and keep youth in their home communities. The hope is that participation in youth media activities will help to build both social and economic capital for each young person in the program, and for their communities as well.

These organizations reinforce a wide range of youth development activities as they guide young people in their personal, academic, career and social choices. Over a third of the sample work from a media arts perspective, and nearly all of the organizations cited "creative self-expression" as a reason for sponsoring youth media organizations. One respondent explained this as a way "to help young people find their passions, using media as a path to exploration of their interests." There is near consensus in their commitment to "give youth a voice," a common refrain with multiple interpretations that roughly correspond to issues of confidence, efficacy, and social capital for the youth they serve. Following a long history of the arts as a vehicle for social change, these organizations link their service to youth with broader service to the community, expressed by one respondent as a way to "animate the greater community around the media arts."

Bridging School Culture

The surge of new-media tools and practices redefines what it means to be literate and challenges the established order of contemporary social institutions at every level. In particular, the elementary and secondary public education sector has been slow to respond to sweeping changes in the literacy practices of their students (Levin and Arafeh 2007; O'Brien and Scharber 2008). More important, the culture of schooling is often in direct contrast to the kinds of participatory, experimental, and innovative literacy practices seen online, in popular culture, and even as a mainstay in contemporary public spaces ranging from cafés, museums, shopping malls, and mass transit systems to government buildings. As a result, young people seek other, more compatible outlets for relatively unfettered use of their everyday literacy skills with friends, family, and networks, beyond the traditional classroom.

Early in the transition from analog to digital, community-based media programs focused on citizen media production as a pathway to civic participation through media literacy (Higgins 1999). Building on existing print, radio, and cable models, youth development organizations offered access to media production

equipment, training, and screening or distribution opportunities through community-based media programs that leveraged youth media skills and interest in popular culture for a diverse range of purposes, including vocational, academic, preventative health, and artistic. Community-based youth media programs continue to bridge the gap between formal and informal literacy practices and offer access, training, showcases, and soft-skill development through non-profit programs and in after-school settings, particularly in arts education (Sefton-Green and Soep 2007).

A majority of the organizations in the 2008 survey hope to prepare youth for careers in media (81%), yet only a few see career preparation as their primary mission (8%). Missions related to learning objectives were isolated to the relatively small number of respondents from educational institutions in the sample. When asked to express multiple goals, only a few expressed an interest in facilitating "learning in academic subjects" (8%), and only one organization chose academics as a main mission. In open-ended remarks, they linked their mission to developing "young people's capacities for critical literacy and civic engagement and to support[ing] their successful transition from high school to college."

Although there is an emphasis on media skill-building and analysis, results do not indicate an explicit identification with the educational sector. Nor do they articulate an explicit link from their programming offerings to the traditional academic subject matter learned in school. With an emphasis on youth voice and decision making, these non-profit programs tend to position themselves as a respite for youth to explore and express themselves outside the school's boundaries, rules, and hierarchies.

In open-ended remarks, respondents conveyed numerous affiliations with formal education through after-school programs, teacher professional development workshops, showcases, and other school partnerships. In many cases, youth media organizations serve as the bridge between formal and informal learning environments and their uses of media for a wide range of purposes. As such, these affiliations reveal interesting tensions between formal learning and informal training that provide opportunities for future research.

The study also raises questions about the degrees and kinds of opportunities for youth to participate in critical media arts activities offered in formal school settings. Many of the youth media non-profits come from a historical context of alternative media production and social justice, and it is possible that they bring these concepts into the design of the learning environment, thus positioning themselves as alternatives to traditional schooling. Even the physical classrooms are a poor fit for youth media programs, reflecting tension between the participatory, hands-on education pedagogies favored by youth media practitioners and

teacher-directed modes for group instruction. In an open-ended response, one respondent remarked:

> I would stress that the locations that schools have available for small group technology projects are minimal. This must change if children are to get the most out of media education in the early years.

When asked about challenges, several respondents expressed deep frustration with their attempts to interact with schools.

> [We have a] backwards school district, which needs to be brought into the 21st century.

> [We hope to increase] understanding with the "older" generation as to the importance of this technology to the up and coming generation.

> Administrators who are unwilling to get out of "their box" and let this generation experience the advancements of technology to their fullest potential.

Some see their affiliation with schools as a form of educational reform and community activism for school change. They hope to model programs that motivate "youth, business, public sector, nonprofit sector, education and the arts to convene the community around the need for media arts literacy to be taught as a core subject in K–12." In comments, they see an immersion in the arts, expressed as "digital technology," "media arts," or "visual arts," as key to the modernization of public schools.

The respondents noted that the emphasis on standardized testing pulls resources away from innovative programs. One commented, "With the emphasis on standardized tests in schools, and after-school remedial help, fewer students are allowed opportunities to attend experimental learning programs such as [ours]." Resource allocation and capacity issues in public education also limit their access to teachers who are willing to provide school partnerships for their programs. They cited "teacher operational limitations in skills, position, resources, administrative support and motivation" as barriers to their programs' penetration in public schools.

In spite of widespread digital literacy expertise across all sectors of society, recruiting, training, and integrating qualified teachers for new-media production courses in formal elementary and secondary school settings is still problematic. In an analysis of responses to a 2001 survey of media educators, researchers noted:

> Whilst media production appears to be gaining credibility [in public schools] in terms of the skills and competencies required in such work, the quality of production and the amount of production continues to be inhibited by the limits of teacher education. (Domaille and Buckingham 2001).

Unlike other disciplines, no explicit credential is currently awarded for teaching media education in the United States. Thus, most school media programs are taught by pioneering teachers who are certified in a wide range of disciplines in the arts, humanities, sciences, vocational education, and educational technology certification. Youth media practitioners, many of them from media production, arts or communication backgrounds, offer fresh and up-to-date practices in the field and are an asset to public school programs. Since there are few accreditation alternatives for practitioners, and most who work in the youth media non-profit sector do not have a traditional teaching credential, teacher partnerships offer supportive inroads to the school system. However, as public schools increasingly restrict courses to teachers who are credentialed in specific subject areas, the question of how to fill media arts programs with qualified staff looms large. Youth media providers in the survey reported that the certification issue creates barriers to the integration of the media arts into traditional school spaces at every level:

> Schools in NYC are very bureaucratic about how specialists can take children off of school grounds, for example, across the street to the park. The Department of Education should establish a field trip certification process for those educators who might be legally certified to teach, but just not on the full time payroll of the DOE. If that were done, special projects could take place without having to pull out full-time staff members to go with the small groups. The same amount of staff could go, but they could be all from the organization, not the school, if they were somehow "certified" to take kids out. This would make special projects so much easier to do.

Cross-training workshops between credentialed teachers and practitioners would be a great benefit, but while most conduct teacher professional development workshops, results of the survey show that resources for staff training and teacher professional development are low. Teacher partnerships are only one barrier to the kind of school affiliations that could build the youth media field. Comments noted a number of challenges, including scheduling priorities and a "lack of supported contexts for teacher training, credentials, relevant professional association existence, access to current tools, cross curriculum applications, and administrative support for the (non-existent) field of media and communication arts."

Sustainability and Capacity

The majority of youth media organizations in the study are relatively new organizations with small staff and low levels of funding. Although most of their funding goes to staff, not all can sustain a full-time staff or director. Many rely on part-time staff, volunteers, and consultants for administrative and programmatic activities. Activities beyond direct client service—such as staff development, student stipends, or curriculum resources—are a luxury that few can afford. Their funding is

diverse, primarily coming from foundations and individual donors. Few reported the expertise or capacity to apply for government funding, and fees for services, exhibitions and festivals do not represent significant avenues for cost recovery in low-income communities.

A few venerable organizations in the study buck this trend and demonstrate significant capacity for sustainability and growth. These programs have been around for at least a decade, receive most of their funding from a wider range of sources—including large, multi-year federal grants—and report higher staffing levels with more perks. Nonetheless, all of the organizations in the study struggle with the capacity to address their significant portfolio of work in high-need, low-income communities.

They cited challenges related to funding for overhead expenses and additional staff. Because of the demands and low salaries, staff turnover is a problem for some of them. Others suggested in open-ended remarks that a more flexible staff, such as consultants hired on an as-needed basis, might be a solution. Gaps in predictable funding have a direct effect on long-range planning and are one of the organizations' major roadblocks. As a result, the programs scramble to serve as many youth with as many programs as possible, under fragile and unpredictable funding conditions.

Those in charge of development at these organizations realize that funders want impact measurement. As a result, 89% of the organizations conduct assessment and evaluation as both a program-improvement and a fundraising strategy. Yet most have only limited capacity to engage in rudimentary evaluation and assessment activities for program improvement and grant reporting for their own activities. Because they must respond to more immediate concerns, it is not clear that they understand the relative value of impact measurement, research and evaluation as a cross-program, field-building strategy. More opportunities for funded technical assistance for youth media programs would go a long way toward enhancing the degree and kind of data collection and reporting needed for both local impact measurement and field building.

They also know that their programs would benefit from more visibility and see a lack of "awareness of our program" as a barrier. These activities take a back seat to direct client service, but through volunteers, youth activities, and staff they do their best to allocate resources to increase visibility on the Web, and through community events and newsletters.

With limited capacity, these organizations must remain highly focused on the day-to-day commitments to youth and the community. They welcome opportunities to learn from other youth media organizations and to see a broader vision for youth media, yet have few opportunities to convene and share their experiences with other youth media practitioners from around the world. As a result, only a

few non-profit organizations in the United States provide opportunities to display an aggregated picture of youth media organizations through online clearinghouses and common areas, showcases, organizational support, and convening opportunities.

Public Policy and Support

The youth media organizations represented in this study serve high-need communities with innovative and creative programming and high levels of commitment to both youth and community development. There is an acute awareness that even when highly visible gains are made at the program level, wider community support is essential to the organizations' goals for social change on a broader level. One respondent astutely noted that "Few advanced opportunities or avenues are available for alumni...to continue to practice their leadership and production skills—huge barriers to college and high school attainment frustrate program goals of positioning youth as leaders in their communities."

Given their capacity, these organizations are at a tipping point. As more people understand the need for youth media and its impact, organizations have increased opportunities to build sustainability through strategic partnerships with community development agencies, educational institutions, and the private sector. As a result, these organizations must reach out to consolidate their support with like-minded organizations in their communities and with youth media advocates outside their local areas.

Partnerships among the arts, industry, and schools are an uneasy match for some of these organizations, yet many hope to strengthen these partnerships as a way to build capacity and grow the field. One respondent commented:

> I believe that work needs to be done to make visible and understood the inter-relationships that exist and would transform the field were they to exist among the stakeholders in the digital media arts community. The roles and relationships that exist between industry/employers and the youth media field must be understood to successfully integrate youth media programs into formal schooling on a broader level.

Mapping the Field: The 2008 Youth Media Survey of Youth Media Organizations in the United States is intended as a contribution to field building in the belief that more research evidence is needed to provide a coherent analysis of the impact, best practices and lessons learned from youth media programs. As an organizational study, it addresses the services, supports, challenges, and capacity issues related to the respondents' collective mission to support and sustain youth media programs. In the process, results from the survey raise many more questions about the nature and impact of youth media programs for youth and their communities.

Many organizations and advocates are working diligently to implement proven strategies that can be used to sustain and spread youth media activities across the United States. It is hoped that this study will support the efforts of youth media advocates and stimulate the additional research and critical practices needed to strengthen and improve their chances of success with each new generation.

Notes

1. This study was excerpted from Tyner, K. 2009. "Mapping the Field: Results of the 2008 Survey of Youth Media Organizations in the United States." *Youth Media Reporter* 3, pp. 101–134.
2. Research support for this study was provided by a team of graduate and undergraduate students from the Department of Radio-Television-Film through a research assistance and mentorship grant from the College of Communication, The University of Texas at Austin. Special thanks to Maria Boyd, Matthew Beaman, Claire Dunn and Holly Griffin from the Department of Radio-Television-Film, The University of Texas at Austin.

References

Asthana, Sanjay. 2006. *Innovative Practices of Youth Participation in Media*. Paris: UNESCO.

Butler, Allison. 2010. *Media Education Goes to School: Young People Making Meaning of Media and Urban Education*. New York: Peter Lang.

Campbell, Patricia B., Lesli Hoey, and Lesley K. Perlman. 2001. *Sticking with My Dreams: Defining and Refining Youth Media in the 21st Century*. (February). Accessed May 14, 2009, from http://www.campbellkibler.com/youth_media.html.

Domaille, Kate, and David Buckingham. 2001. *Youth Media Education Survey 2001* (November). Brussels: UNESCO.

Fisherkeller, JoEllen, Allison Butler, and Emilie Zaslow. 2002. "It Means a lot of Stuff, in a Way": New York City Youth Interpret Other Youth-Produced Videos. *Journal of Educational Media* 26 (5): 203–216.

Goodman, Steve. 2003. *Teaching Youth Media: A Critical Guide to Literacy, Video Production, and Social Change*. New York: Teachers College Press.

Higgins, John W. 1999. Community Television and the Vision of Media Literacy, Social Action and Empowerment. *Journal of Broadcasting and Electronic Media*, (Fall): 624–645. Washington, DC: Broadcast Education Association.

Inouye, Traci, Lacoe, Johana, and Henderson-Frakes, Jennifer. 2004. *Youth Media's Impact on Audience and Channels of Distribution: An Exploratory Study*, November 8. Berkeley, CA: Social Policy Research Associates.

Kinkade, Sheila and Macy, Christy. 2003. *What Works in Youth Media: Case Studies from Around the World*. Baltimore, MD: International Youth Foundation. Accessed May 1, 2009, from http://www.iyfnet.org/uploads/WW%20-Youth%20Led%20Media.pdf.

Levin, Doug and Arafeh, Sousan. 2007. *The Digital Disconnect: The Widening Gap Between Internet Savvy Students and their Schools*. (August 14). American Institutes for Research for the Pew Internet and American Life Project. Washington, DC: Pew Charitable Trust. Retrieved November 16, 2008, from http://www.pewinternet.org/PPF/r/67/report_display.asp.

Maira, Sunaina, and Elisabeth Soep, eds. 2004. *Youthscapes: The Popular, the National, the Global*. Philadelphia, PA: University of Pennsylvania Press.

National Alliance for Media Arts and Culture (NAMAC). 2004. *Youth Media Archive.* Accessed May 1, 2009, from http://www.namac.org/youth-media-archive.

———. 2005. *Youth Media Archive Database.* Accessed May 1, 2009, from http://www.namac-ymi-survey.org.

Niesyto, Horst, David Buckingham, and JoEllen Fisherkeller. 2003. Videoculture: Crossing Borders with Young People's Video Production. In *Media Education: Dilemmas of Perspective, Policy and Practice,* ed. Robin Means Coleman and JoEllen Fisherkeller. Special Issue of *Television and New Media.* (November). 4(4): 461–482. London, UK: Sage Publishers.

O'Brien, David, and Cassandra Scharber. 2008. Digital Literacies Go to School: Potholes and Possibilities. *Journal of Adolescent and Adult Literacy* 52(1): 66–68. International Reading Association.

Pontecorvo, David, Nina Bohlen, and Kristen Putnam. 2006. *Youth Media: I Exist. I Am Visible. I Matter. Report for the Stuart Foundation.* (September). San Francisco, CA: The Stuart Foundation. Accessed May 14, 2009, from http://www.stuartfoundation.org/pdfs/stuart-youth-media.pdf.

Sefton-Green, Julian, and Elisabeth Soep. 2007. Creative Media Cultures: Making and Learning Beyond the School. *International Handbook of Research in Arts Education* 16: 835–856. Dordrecht, The Netherlands: Springer.

Tyner, Kathleen, and Rhea Mokund. 2004. Mapping the Field of Youth Media: A Study of Youth Media Organizations in the United States. In *A Closer Look 2003,* ed. Kathleen Tyner. San Francisco, CA: National Alliance of Media Arts and Culture.

2

Youth Media Imaginaries in the Arab World: A Narrative and Discourse Analysis[1]

Sanjay Asthana

"A new architecture for producing and sharing knowledge about globalization could provide the foundations of a pedagogy that helps to democratise the flow of knowledge about globalization itself. Such a pedagogy would create new forms of dialogue between academics, public intellectuals, activists, and policymakers in different societies."[2]

"We need to develop *habits of coexistence*: conversation in its older meaning, of living together, association...*practices and not principles* are what enable us to live together in peace. Conversations across boundaries of identity—whether national, religious, or something else—begin with the sort of *imaginative engagement* you get when you read a novel or watch a movie or attend to a work of art that speaks from some place other than your own."[3]

The above passages from Arjun Appadurai (2000) and Kwame Anthony Appiah (2006) frame the overall arguments of my chapter. A glimpse at the *imaginative engagement* of children and young people in the Arab world points to some interesting facets of creativity, exploration, and experimentation. A primary purpose of the chapter is to demonstrate how young people living in refugee camps in Palestine and as minority Palestinian Arabs in Israel appropriate and reconfigure old and new media in the process of creating personal and social narratives. Focusing on Arab and Palestinian identity and selfhood (in Arabic *dhatiya* and *hawiyya*), the chapter explores *how* and in *what* specific ways children and young people en-

gage with media forms to express their ideas of daily life through various personal and social narratives.

Palestinian youth share common legacies of socio-economic inequities, ongoing conflict, and the clash of religious and secular ontologies. However, their imagination is shaped not by despair but—to borrow Peter McLaren's (1993, 7) phrase—the "'arch of social dreaming'—that is, a forum for sharing pain but also for constructing new hope through efforts that arch toward and eventually unite those whose subordination appears to have minimized the possibility of their active struggle for an emancipated subjecthood." Mamadou Diouf (2003, 6) noted that African and Arab youth are uniquely positioned to mediate across the local and global contexts, particularly in light of the failures of national political enterprises. Furthermore, Diouf argued that "looking beyond national borders, young people appropriate new technologies (digital and audiovisual)" to produce new narratives of democratic engagement, and Appadurai (2002, 24), through his specific articulation of the idea of "deep democracy," explains how poor people in the city of Mumbai, India, mobilize and rework citizenship and "seek new ways to claim space and voice." Similarly, I argue that Palestinian youth living in refugee camps and in Israel as minority Arabs are engaged in creating numerous media narratives that articulate interesting ideas of the *political* that stand in sharp contrast to the dominant adult-centered understanding of politics (Bjawi-Levine 2009; Bulle 2009; Taraki 2008; Venn 2005).[4]

This chapter examines three Palestinian youth initiatives as case studies to explore how the praxis of media education is being carried out, especially among poor, underprivileged children and young people from Palestine.[5] These case studies span various media—magazines, radio, photography, video, television, and the new media—particularly the multiple uses of the Internet. Young people gain access to tools of media production in a variety of ways, from training and imparting basic-to-advanced technical skills using production facilities and equipment to learning about script writing, story boarding, lighting, set design, page design, layout, digital graphics, and computers. The acquisition of media-making knowledge and skills, embedded in the lived experience of young people, offers unique perspectives, a vision and a voice that need to be examined to understand how young people as authors and producers create imaginative ideas about themselves and the social world.

There are deeper issues at stake that relate to how young Palestinians engage with the media, and this chapter will identify and explore them. For instance, some of the issues stated earlier can be better grasped through concepts like embodied practices, affect, and narrative identity. The chapter takes up the question of creation and production of media content in terms of dialectic between the formal and cultural elements that go into the making of various media forms.

Drawing insights from postcolonial and feminist theories, media and cultural studies, certain strands of media education scholarship, and the philosophical writings of Paul Ricoeur, I probe the issues through a set of interrelated questions. What are the salient features of the Palestinian youth media practices? What kinds of media narratives are produced, and how do these relate to young people's notions of identity and selfhood? How do young people refashion the notion of the political? What do these media practices mean in different Arab cultural contexts and settings?

The chapter consists of four sections. In section one, I outline a theoretical framework for the study. Section two examines the three Palestinian youth media initiatives as examples of translocal engagements. Drawing insights from concepts like embodied practices, affect, and narrative identity, section three is an analysis of young people's media narratives, as well as other kinds of media making being pursued. Finally, in section four, the conclusions are situated against the background of the findings.

Media Education and Non-Representational Theories

Mindful of the several debates and discussions in media education and literacy over the role and function of the field, I argue that a "post-disciplinary" approach enables me to bring a range of conceptual and theoretical insights from diverse fields to media education. Indeed, leading scholars such as Rene Hobbs (1998) and Robin Means Coleman and JoEllen Fisherkeller (2003), among others, have already identified the importance of building such an approach.[6] Although recent scholarship in media education has called for developing new conceptual frameworks in the face of the increasing presence of digital media and information and communication technologies (ICTs), most concepts and perspectives are drawn from Euro-American contexts, pointing to difficulties in examining non-Western and postcolonial contexts (Buckingham 2007; Livingstone 2004).

Over the years, media education studies, largely influenced by representational theories, have focused on the constructed character of media production and reception and examined politico-economic and ideological dimensions of youth media, but none have broached the complex issues of embodied practices, affect, and narrative identity that go beyond the ideological.[7] In recent years, a body of work grouped as non-representational theories has emerged that takes into account the embodied nature of human experience[8] while foregrounding the flow of practice in everyday life (Thrift 2004, 2007; Thrift and Dewsbury 2000). As Kirsi Pauliina Kallio (2007) noted, in contrast to representational theories, non-representational research styles offer deep analytic insights, because social life is not just about representations but about performative elements as well. Drawing upon the work of the feminist scholar Judith Butler, Kallio (2007) indicated that

human agency is not expressed through language alone; rather, subjects make sense of their personal and social identities through specific "performances"—via daily behaviors, habits, and social norms. Kallio's line of inquiry has important implications for studying children and young people's understanding of politics, constitution of identity, and experience. Young people express politics through a set of performative acts, some intentional and some as intuitive actions. Thus, in order to grasp the full range and power dynamics of these performative acts that are not expressed in textual and linguistic forms, we need to draw upon concepts such as affect and embodied practices to analyze how human subjectivity is constituted.

Demonstrating the significance of the concept of affect for non-representational theory, Thrift (2007) traced the concept of affect in different philosophical approaches. In the phenomenological and hermeneutic tradition, affect is understood in terms of a set of embodied practices and is largely defined as an unreflective and unstructured feeling and experience that cannot be realized in language. In important ways, then, questions of human experience can be better addressed by drawing upon the two interrelated concepts, affect and embodied practices from non-representational theories. Thrift (2000 216) argued that "non-representational theory is an approach to understanding the world in terms of *affectivity* rather than representation; not the *what* but the *how*."

A powerful approach to understanding human experience via embodiment and narrative identity has been offered by Paul Ricoeur's (1996, 1998, 2004) philosophical hermeneutics. Ricoeur argued that a person's narrative identity can be approached via two interconnected and overlapping notions of identity: *idem* (sameness) and *ipse* (selfhood). While *idem*-identity refers to "sameness of body and character, our stability illustrated by genetic code," *ipse*-identity pertains to our "selfhood, the adjustable part of our identity." Furthermore, the two kinds of identities—of sameness and difference—offer coherence to the self and the possibility for change and reflexivity. Indeed, the notion of *ipse*-identity emerges in narrative. The notion of embodied subjectivity developed by Ricoeur offers analytic insights into the study of youth media pedagogies and experimentation, particularly because young people are involved in constructing personal and social narratives through creative and critical imaginaries.

In order to examine the kinds of media created by young people, and the arguments offered that human agency is constituted by a dynamic interplay between linguistic and performative acts, it is necessary to expand the notion of media texts. In the face of the increasing presence of digital media and ICTs, media texts have become more complex where the aural, visual, and sensory aspects overlap. It is in this context, Anna Everett (2003, 7) pointed out, that new media technologies have substantially refashioned our ideas of text. Thus, through the concept of digitextuality, she proposes that "new media technologies make meaning not only

by building new text through absorption and transformation of other texts, but also by embedding the entirety of texts (analog and digital) seamlessly within the new."

While Everett provides useful analytic strategies for examining a range of digitextual materials, I propose that Palestinian youth media producers construct meanings through *hermeneutic appropriation* of the digitextual materials. That is, the young Palestinian producers create and develop narratives and stories as collaborators. For instance, the narratives are infused with newer meanings and interpretations acquiring symbolic and phenomenological density marked by colloquial and vernacular idioms of culture and language. These narratives become material artifacts where language and writing is woven with the auditory, sensory, and visual imaginaries of young Palestinian practitioners. Rather than treating these as semiotic constellations of meanings, it would be useful to consider the wide repertoire of communicative and narrative modalities as embodied practices.

Thus, the two important concepts developed by non-representational theories, affect and embodied practices, can be usefully combined with Ricoeur's notion of narrative identity to examine youth media making in Palestine and Israel. Youth engagements with various media forms—from the formal processes of script writing, story boarding, lighting, set design, page design, layout, digital graphics, computers, and so forth, to the personal and social contexts within which they think, conceptualize, and create story ideas—can be understood at two overlapping analytic levels: representational and non-representational. Thus, media narratives are indeed constructed (per representational theories) and ideological; more important, however, the media narratives are shaped by a whole repertoire of affective registers like performative acts and embodied practices. Therefore, it would be analytically unsustainable to examine the media narratives by either one of the analytical levels. To demonstrate the significance of performative acts and embodied practice, the following section explores the three youth media initiatives by emphasizing the translocal nature of media making.

Palestinian Youth Media and Translocality

The three Palestinian youth initiatives, *Baladna* (http://www.momken.org/baladna/en), *Ibdaa* (www.ibdaa194.org) and *Lajee* (http://www.lajee.org/english/main.cfm), accord a central role to media that ranges from disseminating information about their activities to training young participants as future journalists. In fact, a significant amount of media work relates to developing creative and critical media narratives in printed, audio, video, and digital formats. Although the three initiatives point to the importance of media education and pedagogy, no specific guidelines are followed. The young participants learn media-making and production activities from local and international volunteers and mentors. Through an

exhaustive survey of various books, journals, reports, and online databases on youth media practices in the Arab region, I selected these three case studies—two from occupied Palestinian territories, and one from Israel. The criteria and rationale for selecting these three case studies is based on several factors: translocal nature of media production, engagement with a variety of media forms, collaboration with a range of institutions and dialogues between youth and their peers and mentors, and, more important, the creative and critical ways through which young people relate to the dominant notions of participation, citizenship, and politics through their media narratives.[9]

Baladna, founded in 2000 in Haifa, Israel, by the minority Palestinian Arab citizens of Israel, describes itself as a developmental and capacity-building organization. A main purpose of Baladna is to promote the interests of the marginalized Palestinian Arabs inside Israel and to seek a dialogue with larger Israeli society. An important part of Baladna's work relates to the articulation of Palestinian identity, wherein it is involved in "encouraging a Palestinian political culture based on pluralism and democracy capable of neutralizing factionalism and guaranteeing social and gender equity. [And we] work to cultivate a healthy balance of pride and self-critique as a framework for developing genuine, durable individual and collective identity, strengthening youth capacity and enabling young people to express their leadership, cultural and creative potential." The media projects developed by young people at Baladna involve the publication of a monthly magazine called *Shabab* and an online website, "Momken" (www.momken.org). In addition, youth participants at Baladna have produced a photography project with support from Anna Thomin, a French volunteer, and a short film, "Against All Odds," with the help of Orial Poveda, a volunteer from Spain.

The Ibdaa Cultural Center (henceforth Ibdaa; in Arabic *ibdaa* means "to create something out of nothing") was set up near the Dheisheh Refugee Camp in Bethlehem in 1994. The media initiatives of Ibdaa are broad-based, covering a range of grassroots activities, from the oral history and village documentation projects to digital storytelling and an online radio station called Radio 194. A popular dance documentary, "The Children of Ibdaa," featured an interesting mix of Palestinian folk genres such as *debke* to express the plight and struggles of Palestinian people in refugee camps.[10] Through an innovative use of computer labs across various refugee camps in the Middle East—Palestine, Syria, Jordon, and Lebanon—young people at Ibdaa connected thousands of Palestinian refugees to each other and their homeland.[11] Referring to the Across Borders project as a powerful alternative use of media, Edward Said (2004, 133) pointed out that

an enterprising group of young and educated refugees living in Deheisheh Camp, near Bethlehem on the West Bank, established the Ibdaa Center, whose main feature was the Across Borders project; this was a revolutionary way of connecting refugees in most of the

main camps—separated geographically and politically by impossible, difficult barriers—to each other through computer terminals. For the first time since their parents were dispersed in 1948, second-generation Palestinian refugees in Beirut and Amman could communicate with their counterparts inside Palestine. Thus the Deheisheh residents went on visits to their former villages in Palestine and then described their emotions and what they saw for the benefit of other refugees who had heard of, but could not have access to, these places. On 26 August 2000, all computers in Deheisheh were destroyed in an act of political vandalism that left no one in doubt that refugees were meant to remain as refugees. In any case, the Deheisheh camp dwellers immediately set about trying to restore the Ibdaa Center, and they seem to have succeeded in so doing.

The Lajee Center (henceforth Lajee; in Arabic *lajee* means "refugee"), located near the Aida Camp in Bethlehem, was established in 2000. Youth members of Lajee have been involved in producing a magazine, radio broadcasts (www.radiolajee.com),[12] and a series of children's storybooks and photographic projects with mentoring and help from the British creative artist and photographer Rich Wiles. The photographic narratives offer powerful accounts of daily life in refugee camps, the aspirations and hopes of children and young people for a better life, and observations of nature and landscape in and around their camps and villages. The photo exhibits and storybooks, *The Boy and the Wall*, *Dreams of Home*, *Our Eyes*, and *Flying Home*, were on display in several locations around the world. The highly acclaimed children's storybook *The Boy and the Wall* (http://www.lajee.org/english/doc/publications/boy.pdf), won several international awards. In addition, the film workshop Dreaming in Palestine resulted in several short films produced and directed by young participants at Lajee.

The three Palestinian youth initiatives—Baladna, Ibdaa, and Lajee—sponsored and supported by a wide range of local, regional, and international institutions and agencies, constitute dense nodes of relations between place and spaces, whether villages and neighborhoods or virtual environments through which young people engage in media making. These Palestinian youth initiatives can be considered as concrete examples of what Appadurai (1995) characterized as the "translocal," which examine the dialectic mediations between the local and the global. While the idea of locality is useful in describing the way in which young Palestinians deploy media forms to connect and relate with other youth from various locales around the world, it also complicates their sense of home and dwelling since they inhabit the spaces in refugee camps. Precisely for this reason, Appadurai (in Baldauf and Hoeller 1999) remarked, "we need to avoid assuming that sites are the same as communities or that localities are simply geographical locations. Especially for prisoners, refugees, asylum-seekers, and other highly vulnerable groups, both sites and journeys remain real and difficult." However, processes of globalization have also altered the relations between identity, subjectivity, and social imagination, and have enabled the rise of translocality among various social actors and

groups. The Palestinian youth media initiatives exhibit some interesting aspects of translocality. Ibdaa's innovative Across Borders project discussed previously is a translocal example in which Palestinians in the refugee camps inside Palestine and in various Middle East countries exchanged their sense of geography, place, neighborhoods, and villages. In doing so, Palestinians brought together individual and collective memories of dispossession and dwelling through their stories and narratives.

Another instance of "virtual" translocality is expressed through the Cyberbridge Project, which brought students from the Nathan Hale High School in Seattle, Washington, together with the teenagers of Ibdaa in live videoconference sessions. The Cyberbridge Project, developed by the Seattle-based humanitarian photographer Phil Borges, who had earlier founded the Bridges to Understanding (www.bridgesweb.org), is designed to "engage students worldwide in direct, inter-active learning and storytelling to build cross-cultural understanding." The theme of the videoconferences, "The Constructive Engagement of Conflict," led to crea-tive and critical exploration of daily life in refugee camps in Palestine and the United States. The American high school students and the teenagers from Pales-tine shared a range of media narratives using email, electronic slide presentations, and web videos to continue their conversations. Although geographically sepa-rated by thousands of miles and inhabiting very different worlds, the children were engaged in the sort of "imaginative engagement" expressed in Appiah's quote at the beginning of this chapter. And, as Appadurai indicated, processes of globaliza-tion, marked by an increasing presence of technological developments, have al-tered how we "think" about the relations among identity, subjectivity, and social imagination.[13]

Lajee's radio broadcasts, scripted and produced by children and young people, deal with a wide variety of subjects that include personal, local, and global topics. Although the radio broadcasts are available on the Internet as podcasts, they util-ize several low-tech applications through which children and young people pro-duce radio narratives. While we may perceive this as an instance of what Appadurai characterized earlier—in terms of technologies altering relationships among identity, subjectivity, and social imagination—a notable feature of Lajee radio is the production of specific aspects of Palestinian soundscape that become available to other Palestinians living as exiles in the Middle East and other parts of the world. These radio stories lead to the possibility of forging a network of trans-local relations where place, identity, and subjectivity all tie into multiple registers: memories of their homeland and a longing for return. As Edward Said (2004, 133) indicated, this is an important feature of Palestinian youth media production that has far-reaching pedagogic implications.

Similarly, various other media projects of Baladna, Ibdaa, and Lajee are involved in forging translocal networks of relations. Through such connections and networks, young Palestinians are involved in crafting new forms of political spaces while at the same time archiving their memories of displacement and dispossession. The political spaces—indeed, the very ideas of the "political"—are grounded in a range of performative acts that become visible in terms of embodied practices. Questions of identity and belonging, selfhood, and citizenship that the young Palestinians develop via the media-making process can be understood through concepts like affect and embodied practices. However, not much work has been done, either in media education scholarship or non-representational theories, in understanding how to translate these concepts to examine the specificity of non-Western and postcolonial contexts.

Despite this lack of attention, non-representational theories, combined with Ricoeur's hermeneutic approach, provide a way forward in exploring identity and selfhood in terms of embodied subjectivities. For instance, the notion of identity and self in Palestinian context is frequently expressed as *Hawiyya*—identity cards issued by Israel to Palestinians living in occupied territories. Thus, the long history of Israeli occupation of Palestinian land, the dispossession of Palestinians' homes, the refugee camps in which they now live, and the presence of checkpoints around their villages and towns are connected with *Hawiyya*. Similarly, the notion of self is expressed as *Dhat* in Arabic (*Dhatiya* for selfhood). Both *Hawiyya* and *Dhat* exceed a linguistic translation; rather, both notions are grounded in symbolic registers, and can be better understood as embodied practices (Abourahme and Hilal 2008, 43). Ricoeur's formulation of identity in terms of *ipse* and *idem* opens up the possibility of examining how identity and selfhood are expressed as embodied practices. In the following section I examine how, and in what particular ways, affect and narrative identity shape the youth-produced media narratives.

Palestinian Youth Media as Embodied Practices

The documentary Against All Odds, written and directed by the Spanish volunteer and mentor in collaboration with Baladna's youth participants, explores the Arab Palestinian minority identity in Israel. While the digitextual collage of forms and media created by children and young people can be examined in terms of the semiotics of meaning making and construction, embedded within the documentary are several narratives that acquire a powerful phenomenological density. The documentary begins with a narrator providing background and context to *al-Nakba* (the catastrophe) in 1948, when Palestinians were driven out of their homes and villages, which was also the moment when the state of Israel was established. The brief, four-minute lead-in and discussion of the intertwined and complex political genealogies of Palestine and Israel, interspersed with historical black-

and-white visuals, renders palpable the questions of identity and belonging. The narrator suggests that young Arab Palestinians living inside Israel as Israeli citizens and as members of Arab society have to contend with a series of contradictions: Israeli state oppression as well as Arab society's practices that perpetuate various kinds of social and cultural injustices. The remaining fifteen minutes of the documentary explore the issues outlined through six young people from different social and religious backgrounds.

As these individuals elaborate particular aspects of identity, they bring together larger issues of socio-political inequalities, gender discrimination, religious factionalism, treatment of minority groups, and so on, through a range of symbolic, vernacular, and idiomatic contexts. A closer examination of these, as well as bodily expressions, speech, gestures, and other performative acts, points to the importance of affective and embodied communication practices. Bashar, from the Druze Arab minority and a member of a circus ensemble, talks about how Druze men were drafted into the Israeli army to fight against the Arabs. Bashar started the circus group in a village near the Galilean sea, bringing members of different faiths—Muslims, Christians, and Jews—together in a village beset with religious strife and conflict. As Bashar continues his discussion, he is shown training with his circus ensemble. Safaa, a female Arab rapper belonging to the hip-hop band Arapiyat, explains that she has to contend with both the Arab and Jewish communities, who find it hard to accept the idea of Arab women as rappers. Rapping in Arabic, she addresses some key ideas about gender equality and the perception of women. Sawson, a young schoolteacher, talks about the exclusionary policies of the Israeli schooling system, lack of educational opportunities, and persistence of poverty, coupled with ignorance about learning on the part of the parents of Bedouin children from the Negev region in Israel. In these accounts by Bashar, Safaa, and Sawson there are discernible performative acts that become visible as the young people discuss the issues. For instance, the idea of "political"—whether in the ruminations of Safaa, the female rapper, or Bashar's own experience with fellow circus ensemble friends who are Jewish, Christian, and Muslim—is precipitated through the affective registers. As Safaa concludes her discussion by rapping, her voice and gestures acquire an evocative expressivity:

> Why does an Arab girl always get the blame? Don't say it's traditions; we are now in a new era. Where are the rights of the daughter? Correct. She needs to be protected, but where is the freedom? We feel like garbage thrown away. You make us feel like life is a tragedy, but life has lots of importance. We have the right to live as we wish; we will always keep searching for freedom.[14]

Toward the end of the documentary, the narrator points out that both Israeli and Arab societies need to respond to the changes by which young people's identi-

ties are increasingly influenced and mediated by a variety of social forces. And it is against this backdrop that the younger generation is realizing new ways of how to be an Arab Palestinian in Israel, and elsewhere, *against all odds*. As a media form, the documentary genre, with its own particular narrative structures, divided the stories into segments, wherein the individual stories narrated by the young participants emerged as a bricolage of experiences drawn from their daily lives. Thus, the *ipseity* of their identity (selfhood), through which affect and embodied practices are realized, enables the young participants to create and pursue media work as imaginative engagement. However, the sort of engagement that Palestinian youth have envisioned for themselves is related to McLaren's notion of the "arch of social dreaming" that is a form of self-critique and reflection.

Children and youth participants at Lajee pursued a series of media and photographic workshops over an extended period of time. After receiving training and mentoring from Rich Wiles, the young people undertook several photographic projects to document life in the refugee camps where they lived, interviewed their own grandparents about the villages from which they were forced to flee during the *al-Nakba* in 1948, later traveled to these depopulated villages to take pictures of the empty places, rocks, streams, cactus and olive trees, and the landscape, and talked about their dreams and nightmares. In all of these tasks, Wiles pointed out, it is not just the act of photography, but the entire process of collaborative thinking and creating media together that constituted learning and education. Children began to write and sketch out their deep-seated feelings, hopes, and anxieties, and gradually began talking to other participants and peers about their feelings and emotions. According to Wiles (2007, 2), initial workshops discussed the ideas of the project and what it was that participants wanted to say with their work. Basic notions of composition and light were discussed along with creative discussions about visual storytelling and creative photographic documentary work. Participants then worked daily, shooting images around Aida Refugee Camp and also neighboring Al Azzeh camp.

The photography project created by the children at Lajee—"A Window to Our World," a series of still images with short captions—was exhibited at several centers around the world. The photographic exhibits were also used as educational material in British schools to familiarize school children about the life of Palestinian children. Developed and published in photo-essay format, the images depict life inside a Palestinian refugee camp, showing cramped lanes and cluttered houses with adults and children working and playing. Although the images render palpable the misery and suffering of people, the gestures, sighs, and bodily dispositions of people in those images evoke steadfastness and fortitude that resemble what many have characterized as *sumud* (in English, resilience and steadfastness), which is seen as being a Palestinian approach to life.

Another photo project, "A Child's Rights in Palestine," explored the idea of human rights among the *Lajee* participants. The children, eight boys and twelve girls, students from the United Nations Relief and Works Agency (UNWRA) schools, participated in several sessions on children's rights. Later the young participants took pictures that depicted their ideas about children's rights. Describing the irony of the situation and the accompanying pain and anguish, Wiles (2007, 50) stated, "a couple of hours after the exhibition had opened in Aida Camp a 13 year old child was shot in the head with a rubber coated steel bullet by the Israeli army less than 100 meters from the gallery in which children had proudly showed their work discussing human rights protection for children, a child's rights in Palestine."

Yet another project, "Dreams of Home," is based on children's interviews with their grandparents who lived through the *al-Nakba* events of 1948.[15] Following the interviews, the children visited the eight villages around Jerusalem, Bethlehem, and Hebron to take pictures of the now-depopulated villages. Thus, each child explored his or her village and compared this with what they had been told by their interviewee. The project was published in the form of a photo book. The grandparents' vignettes as bits of memories and experiences in the villages, and the children's images along with brief comments, are a powerful commentary on the hermeneutics of everyday life then and now. The social imaginaries of the first generation *al-Nakba* survivors and the acute awareness of the young fourth generation portrayed in the photo book, although through the written and visual modalities, conveys Thrift's (2000) notion that the "space of embodiment [is] expanded by a fleeting but crucial moment set up by body practices which have complex and explicitly political genealogies." In Ricoeur's (1996) formulation of narrative identity as embodied subjectivity, the photographic projects of Lajee participants can be understood as a narrative modality of dialogue that does not seek consensus or impasse, where the act of distancing and appropriation of texts brings diverse perspectives into a state of tension—or, as Ricoeur would indicate, a "concordant discordance."

The widely acclaimed documentary "The Children of Ibdaa" is an exemplification of what Thrift indicated as "the flow of practice"—the spaces of affect and embodiment—through which children's aspirations and desires are expressed. Combining Palestinian music of *debke* and the dance performances by children of Ibdaa from the Dheisheh Refugee Camp, along with interviews of the children about their daily life in the camps, the documentary mixes a variety of symbolic, musical, and literary styles. The documentary's director, the American S. Smith Patrick, notes:

The children use their performance to express the history, struggle, and aspirations of the Palestinian people, specifically the right to return to their homeland. Through interviews

and documentation of the children, ages 12 to 14, the video offers insight into their families' displacement from their villages in historical Palestine, the physically and emotionally stressful aspects of life in a refugee camp, and the unique experience of participating in the politically motivated dance troupe. The story culminates in a visit by the children for the first time to demolished villages from which their grandparents were expelled in 1948. Through their performance, the members of Ibdaa bring the perspective of Palestinians to the attention of the Western communities that they visit. Ibdaa's use of traditional debke dance perpetrates the Palestinian culture while creatively and non-violently addressing a brutal political reality.[16]

Within the spaces of affect and embodiment, children's and women's bodies become a focus of meaning-making, and as feminist scholars Saba Mahmood (2001, 210) and Kirsi Pauliina Kallio (2007, 126) point out, the body can articulate specific forms of agency and resistance to dominant discourses. Furthermore, Mahmood argues that agency should be considered "more in terms of capacities and skills required to undertake particular kinds of acts," and Kallio notes that "agencies and actions appear as statures, sighs, gazes, and movements" that transcend language, hence the recourse to non-representational theories. Another interesting aspect visible in the documentary—and all other Palestinian youth media forms— is the collaboration and partnership among young people, and between youths and adults. Although this has been understood as peer mentoring, the collaborations forged between the youth and adults seem to transcend the conventional relationships between these groups. Michelle Stack (2009, 300), quoting Vivian Chavez and Elisabeth Soep's (2005) study on alternate radio production, argues that a high level of emotional and social involvement can be discerned in the collaboration. Indeed, "through their interaction, young people and adults have opportunities to develop different ways of understanding themselves and each other." The concepts of narrative identity, particularly the *ipseity* part of identity as selfhood, may also offer analytic insights in exploring the collaborations between young people and their adult mentors.

Concluding Remarks

This chapter has argued that non-representational theories, along with Paul Ricoeur's philosophical hermeneutics, offer deep analytic insights into media education practices that add to representational insights, particularly practices from non-Western and postcolonial contexts. Studying the three Palestinian youth media initiatives as translocal phenomena suggested particular collaborations between local and global media education practices, where the local remains salient. Furthermore, the Palestinian youth media as digitextual collages of media forms and narratives provided fresh insights into how children and young people engage with questions of identity, selfhood, and politics as performative acts and embod-

ied practices. Although the findings here are preliminary, I noted some interesting features regarding international media education practices. First, the idea of learning through the formal process of acquisition of skills and techniques, designing and layout of content, and sketching and developing the cultural and social ideas, are all linked in expressive ways. These remain important aspects of media education and pedagogy. The increasing presence of digital and computer-based media and the resulting combinations of media forms enabled the young people to creatively build media materials on a range of personal and social topics. The dialogues between the young people, their peers, media educators within the initiative, and the larger community pointed to aspects of participation and involvement that would not have been possible in other media and educational settings.

Notes

1. This chapter is based on my presentations at the International Conference on Multiculturalism and Global Community, Teheran, Iran, in July 2010, and the Cultural Studies of America Conference, University of California, Berkeley, in March 2010.

2. Appadurai, Arjun. 2000. Grassroots globalization and the research imagination. *Public Culture* 12(1):18.

3. Appiah, Kwame Anthony. 2006. *Cosmopolitanism: Ethics in a world of strangers.* New York: W.W Norton, xix and 85.

4. Since the 1990s, and more recently after the events of 9/11, Palestine (and much of the Arab world) has witnessed a rapid growth of media: state-controlled and private television, information and communication technologies, and the Internet. Thus, any discussion of youth media production should prefigure the political economy of media, institutional and global flows of capital, and consumer culture engendered by the various media forms when analyzing how young people appropriate and construct various media narratives.

5. Young people's media practices span a wide range of activities, from learning technical, production, writing, and reporting skills to developing and deconstructing media content, and is closely connected to the processes of media education and literacy. In contrast to the common understanding of literacy as acquisition of technical, analytical, and creative skills usually applied in classroom situations, curriculum development, and policy-related legislations, Colin Lankshear and Michele Knobel (2003) argue that the concept of media education and literacy is embedded in a range of social and cultural practices of reading, writing, and seeing.

6. Hobbs (1998, 17) pointed out that "the diversity of approaches, philosophies, and goals of media education may be the inevitable result of an emerging field." Coleman and Fisherkeller (2003) argued that "all media are experienced on multiple levels: functionally, aesthetically, narratively, and ideologically." I am in general agreement with Hobbs and Coleman and Fisherkeller; however, I point to some theoretical issues that need to be addressed.

7. Underpinning this sort of focus on "representation theories" are the five broad concepts developed by "media literacy movement." See Kellner and Share (2005) and Hobbs (1998) for specific articulation of these concepts, and Lewis and Jhally (1998) for a political-economic critique of media literacy.

8. While I use the phenomenological notion of "experience" instead of subjectivity, I am aware that experience is intrinsically related to subjectivity. In the subsequent pages, I distinguish

how, and in what ways, experience and subjectivity can be grasped through non-representational theories and Paul Ricoeur's philosophical hermeneutics.

9. A careful survey of numerous media education-literacy online resources (NORDICOM, http://www.nordicom.gu.se/; MAGIC-UNICEF, http://www.unicef.org/magic/; TakingIT-Global, http://www.tigweb.org/; UN, Alliance of Civilizations, http://www.aocmedialiteracy.org/; EU media literacy center, http://www.euromedialiteracy.eu/resources.php; UNESCO, EU, and UN-sponsored Mentor Association for Media Literacy, http://www.mediamentor.org/en/; UNRWA (the United Nations Relief and Works Agency for Palestine Refugees in the Near East), http://www.unrwa.org/; and the Middle East Children's Alliance, http://www.mecaforpeace.org/, among others); a literature search in printed materials such as books, journals, and other reports; and my own personal contacts forged through invitations to present my research at workshops in Spain, Saudi Arabia, Qatar, Iran, and Turkey enabled me to identify several case studies from around the Arab region.

10. http://www.cinesmith.net/children_ibdaa/ci_history.htm.

11. After the creation of Israel in 1948, Palestinians were split into three groups: the Israeli Arabs (Palestinians living inside of Israel), Palestinians living in the occupied territories, and Palestinians in diaspora (in Arabic, *Ghurba),* dispersed around the world.

12. In 2008, an Australian volunteer, Daz Chandler, discussed with Rich Wiles, who had been involved with the center for several years, the possibility of setting up radio—a weekly English-language podcasting—at the Lajee Center. Combining elements of the alternative "tactical media" strategies, Chandler organized a few radio workshops covering sound editing and fundamentals of podcasting for the young people living in the refugee camps.

13. Discussing life in various refugee camps in Palestine, Sylvaine Bulle (2009, 33) pointed out the importance of embodiment and affect: "Like a struggle for the recognition of what is 'already present' (déjà là)—the actors operate and recognize the current space of life, shaped by personal and affective attachments. These intimate actions widen and enrich the surroundings to produce a collective space marked by various ways of engaging people—a form of political reawakening."

14. http://www.rabble.ca/blogs/bloggers/nima-maleki/2009/04/against-all-odds-being-young-arab-palestinian-israel

15. http://www.1948.com.au/2008events/melbourne/DOH/DOH.html

16. "The Children of Ibdaa: To Create Something Out of Nothing," http://www.cinesmith.net/children_ibdaa/ci_synopsis.htm

References

Abourahme, Nasser, and Sandi Hilal. 2008. Intervention: (Self) Urbanization and the Contours of Political Space in Dheisheh Refugee Camp. *Jerusalem Quarterly.* 38: 42–45.

Appadurai, Arjun. 1995. The Production of Locality. In *Counterworks: Managing the diversity of knowledge,* ed. Richard Fardon, 225–238. London: Routledge.

———. 1996. *Modernity at Large: Cultural Dimensions of Globalization.* Minneapolis: University of Minnesota Press.

———. 2000. Grassroots Globalization and the Research Imagination. *Public Culture* 12(1):18.

———. 2002. Deep Democracy: Urban Governmentality and the Horizon of Politics. *Public Culture* 14(1): 21–47.

Appiah, Kwame Anthony. 2006. *Cosmopolitanism: Ethics in a World of Strangers.* New York: W.W Norton.

Asthana, Sanjay. 2006. *Innovative Practices of Youth Participation in Media.* Paris: UNESCO.

————. 2008. Religion and Secularism as Embedded Imaginaries: A Study of Indian Television narratives. *Critical Studies in Media Communication.* 25(3): 304–323.

————. 2009. Young People, New Media, and Participatory Design: A Study of *Cybermohalla* from India. In *New Agendas in Media Literacy*, ed. Kathleen Tyner, 11–27. New York: Routledge.

Baldauf, Annette, and Christian Hoeller. 1999. Modernity at Large: Interview with Arjun Appadurai. Translocation/new media/art. http://www.appadurai.com /interviews_baldauf.htm.

Benjamin, Walter. 1978. Author as Producer. In *Reflections*, ed. Peter Demetz. New York: Harcourt, Brace, Jovanovich.

Bjawi-Levine, Laure. 2009. Children's Rights Discourse and Identity: Ambivalence in Palestinian Refugee Camps. *Jerusalem Quarterly* 37: 75–85.

Buckingham, David. 2003. *Media Education: Literacy, Learning, and Contemporary Culture.* Cambridge, UK: Polity Press in association with Blackwell.

————. 2007. Media Education Goes Digital: An Introduction. *Learning, Media and Technology* 32(2) : 111–119.

Bulle, Sylvaine. 2009. We Only Want to Live: From Israeli Domination Towards Palestinian Decency in Shu'fat and Other Confined Jerusalem Neighborhoods. *Jerusalem Quarterly* 38: 24–34.

Chavez, Vivian, and Elisabeth Soep. 2005. Youth Radio and the Pedagogy of Collegiality. *Harvard Educational Review* 73(3): 309–327.

Coleman, Robin Means, and JoEllen Fisherkeller. 2003. Introduction: Media Education: Dilemmas of Perspective, Policy, and Practice. *Television and New Media* 4(4): 345–349.

Comaroff, Jean, and John Comaroff. 2005. Children and Youth in Global Era. In *Makers and Breakers: Children and Youth in Postcolonial Africa*, ed. Alicinda Honwana and Filip De Boeck. Dakar: CODESRIA.

Dewey, John. 2005. *Democracy and education: An Introduction to the Philosophy of Education.* New York: Cosimo Classics.

Diaz Soto, Lourdes, and Beth Blue Swadener. 2002. Toward Liberatory Early Childhood Theory, Research and Praxis: Decolonizing a Field. *Contemporary Issues in Early Childhood* 3(1): 38–66.

Diouf, Mamadou. 2003. Engaging Postcolonial Cultures: African Youth and Public Sphere. *African Studies Review* 46(2): 1–12.

Dolby, Nadine. 2003. Popular Culture and Democratic Practice. *Harvard Educational Review* 73(3): 258–284.

Everett, Anna. 2003. Digitextuality and Click Theory: Theses on Convergence Media in the Digital Age. In *New Media: Theories and Practices of Digitextuality*, ed. Anna Everett and John T. Caldwell, 3–28. New York and London: Routledge.

Feilitzen, Cecilia von, and Ulla Carlsson. 2002. *Children, Young People and Media Globalization.* Göteborg, Sweden: UNESCO International Clearinghouse on Children, Youth and Media, Nordicom, Göteborg University.

Freire, Paulo. 1972. *Pedagogy of the Oppressed.* London: Penguin.

Gaonkar, Dilip Parameshwar. 2002. Toward New Imaginaries: An Introduction. *Public Culture* 14(1): 1–19.

Göle, Nilüfer. 2002. Islam in Public: New Visibilities and New Imaginaries. *Public Culture* 14(1): 173–190.

Gregory, Derek. 2004. *The Colonial Present: Afghanistan, Palestine, and Iran.* Malden, MA: Blackwell Publishing.

Hobbs, Rene. 1998. The Seven Great Debates in the Media Literacy Movement. *Journal of Communication* 48(1): 9–29.

Honwana, Alcinda, and Filip De Boeck, eds. 2005. *Makers and Breakers: Children and Youth in Postcolonial Africa*. Dakar: CODESRIA.

Kallio, Kirsi Pauliina. 2007. Performative Bodies, Tactical Agents and Political Selves: Rethinking the Political Geographies of Childhood. *Space and Polity* 11(2): 121–136.

Kearney, Richard. 1989. Paul Ricoeur and the Hermeneutic Imagination. In *The Narrative Path: The Later Works of Paul Ricoeur*, ed. Peter Kemp and David Rasmussen, 16–30. London, Cambridge, MA: MIT Press.

Kellner, Douglas, and Jeff Share. 2005. Toward Critical Media Literacy: Core Concepts, Debates, Organizations, and Policy. *Discourse: Studies in the Cultural Politics of Education* 26(3): 369–386.

Lankshear, Colin, and Michele Knobel, eds. 2003. *New Literacies: Everyday Practices and Classroom Learning*. Maidenhead, UK: Open University Press.

Lankshear, Colin, and Peter McLaren, eds. 1993. *Critical Literacy: Politics, Praxis, and the Postmodern*. Albany: State University of New York Press.

Lewis, Justin, and Sut Jhally. 1998. The Struggle over Media Literacy. *Journal of Communication* 48(1): 109–120.

Livingstone, Sonia. 2001. *Children and Their Changing Media Environment: A European Comparative Study*. Mahwah, NJ: Lawrence Erlbaum Associates.

———. 2004. Media Literacy and the Challenge of New Information and Communication Technologies. *The Communication Review* 7(1): 3–14.

Mahmood, Saba. 2001. Feminist Theory, Embodiment, and the Docile Agent: Some Reflections on the Egyptian Islamic Revival. *Cultural Anthropology* 16(2): 202–236.

McLaren, Peter. 1993. Critical Literacy and Postcolonial Praxis. *College Literature* 19–20(3/1): 7–21.

Monterescu, Daniel, ed. 2007. *Mixed Towns, Trapped Communities: Historical Narratives, Spatial Dynamics, Gender Relations and Cultural Encounters in Palestinian-Israeli Towns*. Burlington, VT: Ashgate.

Ricoeur, Paul. 1980. Narrative Time. *Critical Inquiry* 7(1): 169–190.

———. 1995. *Figuring the Sacred: Religion, Narrative, and Imagination*. Minneapolis: Fortress Press.

———. 1996. *Oneself as Another*. Trans. Kathleen Blamey. Chicago, London: University of Chicago Press.

———. 1998. The Human Experience of Time. In *A Ricoeur Reader: Reflection and Imagination*, ed. Mario J. Valdes, 189–213. Toronto and Buffalo: University of Toronto Press.

———. 2004. The Creativity of Language (interview). In *Paul Ricoeur: The Owl of Minerva*, ed. Richard Kearney, 127–144. Hampshire, England: Ashgate.

Said, Edward. 2004. *Humanism and Democratic Criticism*. New York: Columbia University Press.

Said, Edward, and Jean Mohr. 1998. *After the Last Sky: Palestinian Lives*. New York: Columbia University Press.

Sefton-Green, Julian, ed. 1998. *Digital Diversions: Youth Culture in the Age of Multimedia*. London: UCL Press.

Sholle, David, and Stan Denski. 1993. Reading and Writing the Media: Critical Media Literacy and Postmodernism. In *Critical Literacy: Politics, Praxis, and the Postmodern*, ed. Colin Lankshear and Peter McLaren, 297–322. Albany: State University of New York Press.

Stack, Michelle. 2009. Video Production and Youth-Educator Collaboration: Openings and Dilemmas. *McGill Journal of Education* 44(2): 299–318.

Taraki, Lisa. 2008. Enclave Micropolis: The Paradoxical Case of Ramallah/Al Biereh. *Journal of Palestine Studies* 37(4): 6–20.

Thrift, Nigel. 2000. Afterwords. *Environment and Planning D*: 18(4), 213–256.

———. 2004. Intensities of Feeling: Towards a Spatial Politics of Affect. *Geografiska Annaler*, Series B 86: 57–78.

———. 2007. Immaculate Warfare: The Spatial Practices of Extreme Violence. In *Violent Geographies: Fear, Terror, and Political Violence,* ed. Derek Gregory and Allan Richard Pred, 267–286. New York: Routledge.

Thrift, Nigel, and John-David Dewsbury. 2000. Dead Geographies: And How to Make them Live. *Environment and Planning D: Society and Space* 18: 411–432.

Tyner, Kathleen, ed. 2004. *A Closer Look: Case Studies in Youth Media Production*. National Alliance of Media Art and Culture: San Francisco.

Venn, Couze. 2005. The Repetition of Violence: Dialogue, the Exchange of Memory, and the Question of Convivial Socialities. *Social Identities* 11(3): 283–298.

Wiles, Rich. 2007. Lajee vision. In *Dreams of Home: Children of Lajee Center with Rich Wiles*. Bethlehem: Lajee Center.

Williams, Raymond. 1989. *Resources of Hope: Culture, Democracy, Socialism*. New York: Verso.

Willis, Paul. 2003. Foot Soldiers of Modernity: The Dialectics of Cultural Consumption and the 21st Century School. *Harvard Educational Review* 73(3): 390–415.

3

Media and Christian Youth Groups in Brazil

Karina Kosicki Bellotti

Introduction

In this chapter I will analyze the use of media languages in the religious practices of Christian youth groups in Brazil in the 2000s, with emphasis on entertainment and education. In the past decade the religious engagement and activism among youth has increased in Brazil due to the massive investment of several churches in new strategies to attract their attention. As new communication technologies have become increasingly popular in Brazil, they have been used by youth to express their opinions and feelings about religious issues, to organize social events, and to interact with, dialogue with, and provoke youth of different religions. Given this ongoing change in the Brazilian religious field, it is important to ask the following questions: In what ways are youth transforming religion in Brazil? If youth are transforming the field by the use of media, what is the impact of this transformation on the larger society?

In one of the largest Catholic countries in the world, Protestant churches and parachurch organizations (non-denominational or inter-denominational Christian organizations) have been using media resources such as contemporary music (heavy metal, reggae, pop rock), material consumer culture, and spaces of sociability in which young people can feel welcome just the way they are. Given these Protestant initiatives, the Catholic Church started to invest in its own flock, promoting "Christotèques" (alcohol-free Catholic nightclubs for teenagers, with dance music and service mass), music artists, and young singing priests. My objective here is to compare Protestant and Catholic uses of media for young people, and discuss how these youth find their place in the Brazilian religious field.

The theoretical approach to this material is provided by scholarly studies on religion, media, and culture, in which religious media are considered to contribute to the creation of a religious autonomy, to the communication among converts and believers, to celebration, to evangelization, and to identity formation and affirmation. The last is the most evident attribute of the religious youth media.

Another historical and theoretical frame should be considered. Since the 1950s in Brazil there has been an increase in fierce religious competition among Catholics, Protestants, Spiritists, African-Diaspora religions (Candomblé and Umbanda), and New Religious Movements, among several others. After the Catholic Church lost its exclusive influence in the public sphere, media have been used by several religions, along with marketing strategies, to promote a pluralistic and competitive religious field in Brazil, according to historian R. Andrew Chesnut in his book *Competitive Spirits* (2003).

According to Peter Berger (1990), this competition leads to imitation, which also brings about branding. It is visible in the 2000s in that the uses of media, especially music and the Internet, have created a common ground upon which Catholics and Protestants constantly draw and blur the lines dividing Catholicism and Protestantism in their daily lives—for instance, Protestants who buy recordings by Catholic priests who sing Pentecostal songs adapted to Catholic terminology.

The religious autonomy can be expressed in several ways within and outside the religious institutions. My analysis examines the ways young people consume, process, and negotiate the religious messages produced by religious institutions and autonomous religious groups. I also focus on the use of digital media to discover how these youth become communicators, activists and evangelists themselves, and how this consumption, and production help to create a multifaceted religious field in Brazil.

After a brief introduction on the overall situation of youth and religion in Brazil, I analyze two main realities. First is the creation of the Christotèque by Catholics as a place of entertainment, fruition, and interaction with Evangelical gospel artists. The polemics that surround the acceptance of Protestant music in the Catholic space is debated in the virtual community Orkut,[1] which is as popular in Brazil as Facebook is in the United States. Through the forums and messages on Orkut, I analyze interesting youth views on religious consumption and the impact of media on the construction of religiosity in Brazil.

The second reality refers to the Protestant youth media, especially the use of the Internet (for example, blogs, and virtual communities) and contemporary music by different groups of Evangelicals in Brazil. If Catholics have been using media to attract youth because of the decrease in Catholic social influence in Brazil in the past decades, Protestants demonstrate a vigorous and creative use of media that propels their increasing presence as a religious minority in the country. In both

cases, the use of media primarily for entertainment and social purposes contributes to the blurring of denominational and cultural boundaries in the Brazilian religious field. Media also helps believers to create new frontiers, as the religious authority no longer belongs exclusively to the institutions themselves. Taking into account the ambivalences of this situation, and the agencies developed by religious youth in Brazil, I conclude with reflections for parents, educators, and scholars interested in how to deal with the impact of new technologies on everyday life.

One important observation should be made about the term "Evangelical" as used in this text. In Brazil, the word *Evangélico* refers to all Protestants—Reformed, Pentecostals, Adventists, and so forth. Therefore, its meaning is different from the American term in that it has a wider application. In this text I will use interchangeably the terms Protestants and Evangelicals in referring to all Protestants groups in Brazil.

Brazilian Youth, Religion, and Media in the 2000s: Catholics and Protestants

Because of the social activism of Brazilian youth during the military dictatorship (1964–1984; see Bellotti 2007), subsequent generations were frequently considered less active, less politicized, and more conservative than their parents. Such a romanticized portrait of Brazilian youth obscures two important facts: first, not all young people from that period were rebellious or revolutionary, although their struggles encouraged the breaking of traditional ties; and second, the current younger generation faces many problems that are hard to eradicate, such as poverty, teen pregnancy, drug abuse, a high rate of unemployment, and deficient public education. How Christian religions help to cope with this situation is the subject of this section.

In the past decade, news about new churches and Evangelical movements have called attention to how young people are active in the evangelization of their peers through rock concerts, marches for Jesus, and churches for surfers, for athletes, for punks and Goths. On the Catholic side, the 1990s were the decade of singing priests in animated Mass services broadcast on Catholic television and sponsored by the Catholic Charismatic Renewal (CCR). A young priest, Father Marcelo Rossi, was until recently one of the best-selling singers in Brazil. Unlike the progressive political activity of the 1970s, the 1980s and 1990s marked a conservative turn in the Catholic Church, as Pope John Paul II and the re-democratization process that began in 1985 diminished the combative role of the progressive part of the Catholic Church in Brazil.

While youth have been deliberately targeted by both Catholic and Protestant leaders, the 1990s and the 2000s have also been a period of popularization of new media technologies in Brazil, with a resulting enhancement of the relationship

between information and communication. Although there is still a great digital divide, middle- and upper-class Brazilian youth have generally embraced technology. However, young people from the lower classes, depending on the area of Brazil in which they reside, have access to "LAN-houses" or "cyber cafes" (stores where people pay by the hour to use computers with Internet connections) and are eager to consume digital technology, even if it is pirated. In terms of religion, this has allowed youth to become the producers of their own communications media, putting out blogs, websites, webportals, and chat rooms with religious content, in which they communicate with their peers, elaborating on and divulging events, discussing biblical and behavioral subjects, and reshaping and re-marking the frontiers of their faith.

Media scholar Henry Jenkins, in his book *Convergence Culture* (2006), argued that the phenomenon of convergence is not just about the convergence of information technology offered by computer-mediated communication, joining telephone/modem and personal computers, and bringing together multiple forms and modes. It is more a cultural disposition on the part of individuals to produce and transmit information through a collective process of consumption (Jenkins 2006, 3–4). This is reflected in the number of religious young people who promote parties, rallies, meetings, and debates through the Internet. In this sense, old cultural barriers are reshaped among religious traditions, denominational differences, and youth styles and languages considered mundane by Christian standards.

Brazil has seen a mutual remodeling of religious practices brought on by new demands of youth toward religions, new responses provided by the religious institutions themselves, and a religious autonomy experienced in Brazilian society since the 1950s. Media have played a crucial role in this remodeling, whether through the institutions or the believers. First, I will analyze the Catholic and Protestant appropriation of media in order to reflect on the abilities and sensibilities developed by today's youth.

Cristotèque: Catholics and Protestants in the Disco-Mass

One example of a curious convergence phenomenon is the creation of the Cristotèque, a disco club for Catholic youth—and anyone else who feels welcome—where alcohol-free drinks (called Cristodrinks) are served to the sound of dance or gospel music played by a DJ. The evening also includes a mass, and after that a band or solo artist may perform on stage.[2] Created in 2003 in the city of São Paulo, this was the initiative of Father João Henrique from the Catholic congregation Alliance of Mercy, in an effort to offer wholesome entertainment and a safe space for young people to socialize without drugs, alcohol, or sexual promiscuity. According to the official website, the justification for its creation—just as for any

new religious initiative in Christianity—rests in the "will of God" to communicate his message and his presence in any form and place

> The Cristotèque has always been in God's heart, but it was in a determined moment that He, Father of eternal love and mercy, decided that this instrument of evangelization would become real among us. And this is how this dream came true, which is today, without a shadow of a doubt, a grace from God.... Following God's calling, the project of the Cristotèque was released, a holy madness. The purpose was for us to be smarter than the devil! Offering an environment that is truly a discotèque, but in which the ruler is Jesus. Thus, we do not offer liquor, or licit or illicit drugs, or even promiscuity, raising the flag of the serious and sanctified dating (romantic relationship). In sum, our purpose is to attract the young person with everything that seduces him/her in the world—"*balada*" (night-dance), discothèques, vibe, rave—and use this means to get him/her to know Jesus, author of this life and work![3]

In the Christian realm—Catholic and Protestant—the use of elements of the "world" to attract young people to religion became a common practice during the 20th century. Historian R. Laurence Moore identified the origins of this practice among progressive Protestants in the United States in the late 19th century, when industrialization and urbanization brought consumption and entertainment as strong competitors for religious practices in American society. The incorporation of elements of entertainment, mass media and publicity in the religious practices and rhetoric of many Protestant churches and parachurch organizations increasingly became a feature during the 20th century, spreading this influence to other religions to varying degrees (Moore 1994).

In Brazil, this has occurred since the 1930s, when Protestant organizations started to use radio shows to evangelize. By the 1950s and through to the 1970s, Pentecostals used radio shows, itinerant tents and advertising. Faced with the growth of Pentecostal adherents in the 1980s and 1990s, the Catholic Church finally started to invest progressively and aggressively in mass media. However, Cristotèque is a more localized initiative, conceived far from the highest authorities of the church, yet attuned to the policy established by Pope John Paul II in the early 1980s that encouraged communication with youth.

The Cristotèque invites youth to run the nightclub, serving in different functions: creating liturgy, designing and implementing stage illumination and sound, providing "Christsubs and Christdrinks" (cafeteria), conducting intercession (volunteers who pray all night in the club with a string of beads at hand in order to "guarantee the victory in the spiritual battle"), performing face-to-face evangelization, and running the store, which sells books, apparel, strings of beads, CDs, and DVDs that offer tools of evangelization for its audience. The store and the cafeteria are responsible for raising funds for the maintenance of the Cristotèque, as it offers free entrance for all.

There are four ministries participating in the project: dance, arts, DJs, and music, which are responsible for programming the music and showing choreographies of street dance during the evening. The mobilization of the body by contemporary music also responds to challenges made by the Second Vatican Council (1962–1966), which prompted the Catholic liturgy to be more flexible and open to modern languages. This trend intensified with the growth of the Charismatic Catholic Renewal, implemented in Brazil in the 1960s. Its stunning popularity in the 1990s and 2000s has been due to the ministry of Father Marcelo Rossi. In his Mass services, it is common to see young people choreographing his songs, mobilizing multitudes to repeat his gestures during the songs.

One of the most powerful media resources developed by Brazilian Catholics in the 1990s is the TV network Canção Nova (New Song), at which singing priests and lay women run TV programs. One associated with the Cristotèque is the youth ministry hosted by Canção Nova, the *Jesus Revolution*,[4] a TV show that developed into a website that offers evangelistic messages written by young people, as well as a summer camp. Other partners of Cristotèque are the ministry/company Cristomix[5] (formed by Catholic DJs, who promote parties with electronic music), the magazine *Tribo Jovem*[6] (Young Tribe), and the website O Mundo Católico[7] (the Catholic World), which provides information about Catholic artists, events, celebrations, articles and reports on youth issues.

The website of *Jesus Revolution* includes an interesting idea that sums up several initiatives toward youth: "In a supercool language we show how it is possible to be a Saint being Young. Living with us, young people will find themselves revolutionary. We believe that love is the most powerful strength that exists. Who wants true love, wants 'Jesus Revolution.' That's the revolution of love, not a mere partisan, ideological utopia, that can actually change the world!"[8] In such initiatives, there are many articles on proper dating that reinforce the importance of preserving the body, the heart, and the soul against the temptations of a world in which casual sex and dating prevail.[9]

However, one hot topic in the debates of the audience of the Cristotèque is the presence of Evangelical bands in the nightclub. The discussion took place in the web forum of the Cristotèque at Orkut, a portal owned by Google that has become extremely popular among Brazilians since 2004, even after the rise of MySpace and Facebook. At Orkut, one creates a personal profile in order to add friends and communities to his or her page. At the community Agenda Cristoteca SP, members discussed which Evangelical bands they would prefer to hear after the Mass service. The question was not *if* they would like to have an Evangelical group at the Cristotèque, because this was already common practice.

The author of the question dated February 27, 2007 was the official profile of the Alliance of Mercy, the sponsor of the project. There were 132 responses to this

question; some gave suggestions for artists, complimenting their work, and others fiercely attacked the mere presence of Evangelicals in a Catholic space. The user "ANINHA" declared: "Our Evangelical brothers Toque no Altar...wow, this ministry is great, and if there is a spare time [the Evangelical ministry] Diante do Trono, then we put [the Evangelical singer] Ana Paula Valadão to sing with the [Catholic singer] Adriana...can you image the blessing...what anointment."[10] Many members suggested popular gospel and gospel hip hop and rap artists, as well as Evangelical missionaries and pastors preaching side by side with Catholic priests: "I WANT THE MINISTRY *APASCENTAR* FROM NOVA IGUAÇU!!! THEY ARE A BLESSING!!! IT CAN BE THE MISSIONARY ANTONIO CIRILO TOO.... THIS GUY IS PURE FIRE!!! MINISTRY HOLY GENERATION!!! WOW, IMAGINE ALL OF THAT AND FATHER ANTONELLO!!! MY GOD!!! WHAT A BLESSING."[11]

Others vehemently opposed this presence, reliving old controversies from the Reformation and expressing new problems with animosities that permeate the religious field. The user "Rodrigo Ferreira" posted this on June 3, 2007: "...nothing against Evangelicals, but against a people that does not live the true Christ, like us the CATHOLICS. [We] preach and live the body and blood of Christ. Now, if you think that you should have a ministry that criticizes our sacramented Jesus, and mock us, fine...more attention with whom and when you're going to invite...."[12] It is interesting to note the exclusivity of the deity—"our sacramented Jesus"—in contrast to the "unfaithful" Evangelicals.

The user "Wagner," on June 28, 2007, claimed always to respect the high quality of anointed Evangelical music and would have no problem hearing a gospel band at the Cristotèque, because "God is for everyone. Who knows they [the Evangelicals] (as many feel) don't feel the presence of our Eucharistic Jesus lol...."[13] Others posted the resolution from the Vatican prohibiting non-Catholic liturgical music at Mass. Even others, like "Júlio," on September 14, 2007, advocated that no one should impose one's creed on anybody, claiming that this is biblical truth.[14] The discussion went further, demonstrating that the boundaries between Catholic and Protestant faith at the Cristotèque—as well as in other spaces of sociability among young Brazilian Christians—are generally open to negotiation about common features such as musical events and products. The user "Washington" repeatedly reinforced the prohibitions of the Vatican, claiming that his colleagues were contesting the Pope, but few paid attention to him. Only one Protestant answered Washington's attacks. On January 12, 2008, "Branko Nowackz" argued that not all Evangelicals are the same, that the mistakes made by some cannot be attributed to all, and that he loves Catholic music and admires the ministries of several priests.

Another characteristic of religious youth groups emerges from these debates: religious autonomy. Sociologist Christian Smith observed that American youth analyzed by the National Study of Youth and Religion (NSYR) showed enormous influence from the Moralistic Therapeutic Deism, defined as "a widely shared, largely apolitical, interreligious faith fostering subjective well-being and lubricating interpersonal relationships in the local public sphere" (Smith and Denton 2005, 169). In addition, an individual religion in the private sphere also determines an eclectic personal set of beliefs and practices. Scholar of religious media Stewart M. Hoover also identified a general cultural and social tendency toward religious autonomy during the 20th century in the Western world, with the secularization and the weakening of authority in religious institutions (2001).

A similar phenomenon can be found in Brazilian life, where young people assume multiple attitudes toward religion. Some are religious radicals; others exist among them who participate in various practices of different or related religions, whether they profess a particular religion or not. The idea that Evangelical bands play at Catholic events, and that some (although fewer) Protestants listen to Catholic music, was defended by both sides because most of the involved youth chose to focus on what is common to both religions—the belief in Jesus and his evangelistic message expressed in the songs of Christian artists. This religious overlapping was also recognized by Father Marcelo Rossi, who adapted Pentecostal songs to Catholic lyrics in the beginning of his career in the late 1990s. In addition, scholars such as André Corten (1999), Ricardo Mariano (1997) and R. Andrew Chesnut (1997, 2003) have also explored the Pentecostalization of the Brazilian religious field in the past three decades.

However, if media can gather and encourage the intermingling of people from different creeds, it can also be used to define frontiers. In Brazil, unlike in America, Protestants are a growing minority in a Catholic country. With the spread of Protestantism, the number of Catholics actively engaged in religious practices grew, not only due to CCR, but also due to the active role assumed by youth and young adults within and outside the churches. According to historian Chesnut, the religious monopoly maintained by the Catholic Church in Brazil for almost 400 years, a vestige of colonial and imperial times, left a legacy of a high number of nominal Catholics and a low rate of active engagement and church attendance.

When Protestants, especially Pentecostals, began a fierce religious competition by using media, religious advertising strategies, and face-to-face evangelism, the sense of belonging for both Protestants and Catholics was stirred up. This has come about because religious media have, among other things, two main characteristics: they teach the "right" values to their believers, and they advertise the religion's main principles to non-believers (Bellotti 2005). Lay people and clergy in charge of spreading the word see themselves as guardians of a tradition for the rest

of society. Many examples of this attitude can be seen in the various manifestations of Protestant youth media.

Protestants: Christafaris,[15] Christarappers, Surfers and Bloggers of God

Brazilian anthropologist Airton Luiz Jungblut demonstrated in a study on religious digital media (2000) that Evangelicals were the first religious group to actively use the Internet in the late 1990s in Brazil. Before that, Evangelicals were the first religious group to appropriate contemporary rhythms such as rock and roll, heavy metal, hard rock, punk rock, reggae, and so forth, beginning in the 1970s. In the last two decades, churches such as Snowball Church have called the attention of the press to its young flock. Despite the polemics of its founders, the Hernandes (who were arrested in the United States for money laundering in 2007), the Reborn in Christ Church is known for the trademark "gospel" in several of its services, products, and events. The multiplicity of Protestant churches in Brazil speaks to and reinforces the plurality of cultural manifestations of their believers.

One of the most effective tools of communication in the digital media is the blog, and the Union of Evangelical Bloggers in Brazil, created in 2007, already had 7,000 blogs posted by February 2010 (suggesting that there must be other millions of unregistered Evangelical blogs and webpages). Created by three young bloggers, the Union provides support for bloggers, guiding them with an ethical code and technical assistance. According to the founders, the Evangelical bloggers must be conscious of their mission as Evangelists, whose primary purpose is the spread of the Gospel, not personal attacks on people who disagree with their opinions.

> The Union of Evangelical Bloggers (UEB) is an interdenominational virtual community formed by EVANGELICALS concerned with the mission of Christ and the defense of the Christian faith. All the knowledge about blogging that we have gathered is made available for you to create, edit, and publish Christian content in an Evangelical blog or website…. Since the UEB brings together bloggers of several Evangelical denominations, we need to exercise patience so that everyone works in peace and avoids war. We may disagree about certain points in our creeds, but this cannot cause an absence of love.[16]

Two of the four principles of the Union are that the Bible must be the source of faith and relationships, and that each blogger must preserve the peace and communicate respectfully with peers and readers. Also, piracy of songs and texts is strongly discouraged. To scrutinize this massive amount of information is beyond the scope of this chapter, but it is important to point out the criticisms that the blogger Matias Borba made in his blog and at the Union's blog, entitled *Opinion on the Christian Blogsphere*, on November 4, 2009:

I think that everyone has the right to express his/her opinion but, as Christians, we cannot use the opportunity of good critique to pour onto people our indignation, because as it is written in Romans 15.1–2, we need to know how to put up with each other, with care and wisdom.... The biggest example of this [intolerance is] the post about [former Presbyterian pastor] Caio Fábio, which causes certain embarrassment about the form that everything related to him is rejected, as many throw him insults as if they were not Christians. Well, if we do not know how to respect others' opinions, how should we edit a blog? Will we never learn how to analyze everything and apprehend what is good?[17]

Due to the strength of the Protestant faith in Brazil, there are arguments on various topics, from baptism, the personal life of leadership, money in the ministry and the Theology of Prosperity, and so forth. Even though associations such as the Union of Evangelical Bloggers try to establish a common ground and a minimum of rules, the deregulation is intrinsic to the Internet, one of the very reasons that Borba expresses his discontent with some of his peers.

However, while the use of communication might define denominational frontiers, it also can blur such boundaries, influencing the redefinition of Evangelical culture. From a recent study on Evangelical media for children in Brazil, I concluded that the investment of several churches and Evangelical companies in media products for children and families since the 1950s has been responsible for the patterning of a substantial production for Brazilian Evangelical audiences. In order to achieve a wider consumption, such production blurred denominational delimitations within the Protestant field, creating the Evangelical supermarket that took shape in the 1990s and 2000s.

Besides children, such a market also targets youth, as evidenced by the annual fair Expo Cristã[18] (Christian Expo), hosted at one of the most spacious exposition centers in Latin America, Expo Center North in the city of São Paulo. For a week every September since 2002, around 150 exhibitors have welcomed 150,000 people, ranging from clergy and retailers to individual believers.[19] The most popular attractions are the performances of gospel artists, yet the most remarkable thing about this fair is the mixture of different Protestant orientations in the same place, offering various products, such as counseling and self-help books, Bibles of all shapes, sizes, and translations, apparel for children and teenagers, school supplies, stationery, games, toys, biblical costumes, cosmetics, food, and many other materials for anyone looking to enhance his or her Evangelical lifestyle (Bellotti 2007).

Historian Heather Hendershot (2004) has described the creation of an Evangelical subculture for the young in the United States by conservative Evangelicals which aims to provide wholesome entertainment and controlled educational content drawn from popular secular formats of entertainment. Such adaptation of "worldly" formats into Christian messages became systematic, especially with the "culture wars" fought by the Evangelicals around "family values" in the 1970s and 1980s, in an effort to Christianize America in all social and political contexts

(Hunter 1992). Brazilian Evangelicals attuned to American Evangelicalism appropriated the idea of releasing wholesome Christian entertainment to the family, focusing special attention on each demographic.

Youth therefore has found its place in the Evangelical supermarket. From "churchwear" to trendy Bibles for boys and girls, young people are treated as autonomous individuals, not completely separated from their families, but capable of making choices on their own. Usually, the ideas targeted at young people by the religious advertising of these Evangelical companies are cheerful, energetic, vigorous, smart, and eager to appeal to youth. Instead of trying to adapt the young to the religious discourse, these companies, along with new and old churches, bet on adapting themselves to the multiple expressions of youth culture.

One outstanding example of this new trend is the Snowball Church, an Evangelical church born in 1998 and known as the "church of the surfers" due to its origins in a surfwear storehouse lent by the owner. Founded by the apostle Rina in São Paulo city, the name Snowball refers to the idea that Rina had for his ministry—a small initiative that would become huge, like a snowball. Two of the trademarks of the church are the long surfboard in the pulpit, and the presence of loud, electric contemporary music during the service. It is a fairly young and highly mediated church, run by young people and attracting youth without demanding any change in their way of dressing. The church's website is elaborate and interactive, announcing events, sponsoring ministries, and offering videos from its TV show *Bola TV*. The services can be watched live on the website on Sundays, Wednesdays, and Fridays. The church also edits the magazine *Crista*, which includes testimonies of athletes and musicians, some of them pastors of the church.

Although the church does not impose any dress code for its adherents, it acts as any other Protestant church does, offering a path to personal redemption from addictions and sexual liberation. This is visible in the story of one of the most popular members of the church, the rock musician Rodolfo Abrantes, formerly the lead singer of the hardcore band Raimundos, which is famous for songs with references to marijuana and containing strong language. Rodolfo converted to Protestantism in 2001, shocking everyone with his decision, and nowadays he records Christian rock and roll that offers his testimony of conversion and freedom from drug and alcohol addictions and promiscuity. The church offers a meeting place for the young and an opportunity to play contemporary music (mainly reggae and rock), meet their peers, and display their tattoos, piercings, and fashion wear in what is considered a safe environment. Day by day, this church attracts people from other urban "tribes"—skaters, motorcycle riders, martial arts fighters, and so forth. The young may come as they are, but many do not remain the same.

Another youth church, lesser known than Snowball Church, is the Crash Church Underground Ministry[20] (the name is indeed in English), founded by pas-

tor Juliana Batista and her husband, pastor Antonio Carlos Batista. Antonio Batista is also the founder of the Community Zadoque, a church for headbangers, that played loud heavy metal in the pulpit. (It closed in 2006 due to internal problems.) The existence of Crash Church, whose pastors play in the white metal band Antidemon, calls attention to the adoption of several contemporary music styles by more young Brazilian Evangelicals than Catholics.

Such diversity has been boosted by the Internet, which has facilitated the production and distribution of music. With a few key pieces of digital equipment, it is possible for anyone to record songs and make them available for download on pages like MySpace or personal websites. Besides the traditional white metal (Christian heavy metal), other rhythms were appropriated,—for instance, Brazilian funk music, a polemic style without any resemblance to the American funk music born in the 1970s. Brazilian funk was created in the 1980s as a musical expression of the youth in the *favelas* (slums) in Rio de Janeiro. With simple lyrics and strong language filled with sexual insinuations, funk music has been the soundtrack for rowdy parties, which sometimes are frequented by drug dealers. Thus the idea of a Christian funk band—Bless Funk[21]—is highly ironic, given the bad reputation of this music genre in the press. The Christian hard core has been spreading the gospel of do-it-yourself in the Evangelical and Catholic scene in Brazil,[22] as have rappers and hip hoppers. Such a phenomenon has its explanations: historian Barbara Claire Freeman (1999, 221–231) affirmed that Christian contemporary music focuses on the lyrics in order to "sanctify" the rhythms; Colleen McDannell (1995) attested that the use of religious symbols in secular art and the religious use of secular elements is possible in contexts in which the symbols have been distanced from their cultural and social origins, being displayed in a globalized cultural supermarket (Mathews 2000).

Conclusion

Within Evangelical circles, these youth-centered cultural manifestations may be considered a form of "banalization" of Christianity.[23] I would like to conclude this text by describing an argument that took place in the Evangelical blog of Daniel Moreira. On December 18, 2007, he strongly criticized a TV performance of an Evangelical pastor singing a Christian version of a Brazilian funk song:

> For me this is the banalization of Christian music. Christian music derives from the sanctification and inspiration of the Lord implemented in his servants. It just does not do to take the lyrics of a certain melody and put lyrics with the Christian point of view. The music has to have the fruit of gratitude of what Jesus does in your life and it needs to come from this relation of intimacy between Creator and Creature.

A protracted debate took place between the blogger and his readers, including the brother of the pastor. But one comment summarizes the counterpoint for the dislike expressed by Medeiros. A woman named Priscila wrote on October 1, 2009:

> I'm in Japan and read each one's comments. But what is important is that each individual has his/her function. One is called to clean bathrooms and another is called to preach and another, to sing. If singing funk, even if it is with the rhythm of the world, with the power and a pure heart, can evil be transformed into blessing!? Isn't that true? Many are trapped in music, but everything starts in something simple. When I heard it I liked it and thought it was interesting. It doesn't matter how the people think but if the person is giving his best to God. Tomorrow can be too late!!!

Historian McDannell (1995) has already problematized the appropriation of "mundane" elements by American Christians, especially in the material culture of retailing. What can be considered unfaithful by some can be studied as part of the expression of beliefs and practices in the light of human sciences, because they convey facets of this complex human phenomenon called religion. I demonstrated briefly in this text a methodology to analyze such a subject by considering the different voices involved in this youth religiosity, without judging them morally, but putting them into a historical and cultural perspective.

For parents, and religious and secular educators, some conclusions can be drawn from this short and primary analysis of a phenomenon in a developing country. What were described here were situations similar to many countries in which youth is in close contact with religious and cultural diversity, actively and intensely using the new technologies of communication. Historians Asa Briggs and Peter Burke (2002) have stated that in the 20th century entertainment, information, and education became increasingly intertwined in the media. There are thin lines dividing educational content from pure entertainment, to the benefit of entertainment.

The youth cultures examined in this text show the potential of the communications media in the 21st century: they can cross cultural barriers, promote intolerance, and stimulate dialogue. The nature of this communication depends on the attitudes that the people involved develop toward their interlocutors. Sociologist Anthony Giddens has demonstrated the power that communication has to provoke self-reflexibility—that is, the ability to reflect continually upon one's choices, thoughts, and tastes. Youth cannot be "immunized" from media, whatever they represent, because from now on they will use it more and more to produce their own visions and interpretations about their fragmented and multifaceted reality, whether playing Christian rock, writing their own blog, or talking to their friends.

It is important that school, family, church, and whoever else is involved in youth culture maintain open channels of communication with their youth, under-

standing that not only should the adults be prepared to use modes of contemporary communication, but also that the youth should be allowed to receive a constant media education, in order to comprehend deeply the languages of media, how reality is created and conveyed by them, how present worldviews are not natural, but historical creations, and how the study of the past may unveil different and exciting possibilities in terms of arts, culture, and ideas. Scholars such as Sut Jhally (2006), Kathleen Tyner (1998, 2009) and Sonia Livingstone (2009) have been exploring new paths of media literacy. May this exploration of our great cultural diversity in the present and the past provide elements for youth to build more creative religious, artistic, political, and social expressions.

Scholar Henry Jenkins asserted that the new technologies and the culture of convergence rely on collaborative knowledge. In the early 21st century, the potentialities of these media are being explored, mostly in terms of entertainment fruition, which nevertheless develops avenues of cooperation that might be used in a more active civic participation. Perhaps the use of new technologies to stir social activism may be the next crucial step for young people and adults toward improving our global-local world, whether for religious or secular purposes, or both.

Notes

1. See: http://www.orkut.com. Accessed May 14, 2009.
2. See the official website of the Cristotèque (*Cristoteca* in Portuguese), http://misericordia.com.br/cristoteca/. Accessed May 15, 2009.
3. Translated from Portuguese, available at: http://misericordia.com.br/cristoteca/index.php?option=com_content&view=article&id=1&Itemid=2. Accessed May 15, 2009.
4. See their official website. Accessed May 15, 2009.
5. http://www.cristomixdj.com/. Accessed May 20, 2009.
6. http://www.revistatribojovem.com.br/index.php?menu=home. Accessed May 20, 2009.
7. http://www.omundocatolico.com/#. Accessed May 20, 2009.
8. Translated from Portuguese: http://blog.cancaonova.com/revolucaojesus/revolucao-jesus-o-que-e-isso/.
9. Both Catholics and Protestants convey the same conservative message regarding sexuality. It is worth noting that Brazil does not have any planned parenthood policy due to the Catholic lobby at the National Legislative Congress. Although many Catholics use contraceptive methods, sexuality is still a thorny issue in public policy.
10. http://www.orkut.com.br/Main#CommMsgs?cmm=8443373&tid=2517974252904666255. Posted February 28, 2007. Accessed June 16, 2009.
11. http://www.orkut.com.br/Main#CommMsgs?cmm=8443373&tid=25179742529046662 55&na=3&nst=41&nid=8443373-2517974252904666255-2529491076689193646. Posted May 4, 2007. Accessed June 16, 2009.
12. http://www.orkut.com.br/Main#CommMsgs?cmm=8443373&tid=2517974252904666255 &na=3&nst=51&nid=8443373-2517974252904666255-2532713732424053887. Posted June 3, 2007.

13. http://www.orkut.com.br/Main#CommMsgs?cmm=8443373&tid=2517974252904666255 &na=3&nst=61&nid=8443373-2517974252904666255-2538113468348147907. Posted June 28, 2007.

14. http://www.orkut.com.br/Main#CommMsgs?cmm=8443373&tid=2517974252904666255 &na=3&nst=81&nid=8443373-2517974252904666255-2547729986050074297. Posted September 14, 2007.

15. Reference to the American Christian reggae band Christafari, which usually performs in Brazil.

16. http://www.ubeblog.com/2009/09/ube-quem-somos.html.

17. See http://www.ubeblog.com/search/label/Blogosfera%20Crist%C3%A3. Posted November 4, 2009. Accessed November 7, 2009.

18. Official website: http://www.expocrista.com.br/. Accessed June 14, 2009.

19. Interestingly, since 2003, in the same place, the ExpoCatólica (Catholic Expo) has occurred every August (see http://www.expocatolica.com.br/index.asp). By 2010, it will take place bi-annually.

20. http://www.crashchurch.com/index.htm. Accessed August 11, 2009.

21. http://www.blessfunk.com/. Accessed August 12, 2009.

22. http://www.dissonancia.com/135-03.htm. Article with Brazilian Christian punk rock and hardcore bands, posted March 8, 2003. Accessed August 11, 2009.

23. http://danielmoreira.blogspot.com/2007/12/funk-gospel-quer-orar.html.

References

Bellotti, Karina Kosicki. 2005. *Mídia Presbiteriana no Brasil—Luz para o Caminho e Editora Cultura Cristã (1976–2001)*. São Paulo: Annablume/FAPESP.

———. 2007. *Delas é o Reino dos Céus: A mídia Evangélica Infantil na Cultura Pós-Moderna do Brasil (1950–2000)*. Ph.D. dissertation in history, State University of Campinas-Brazil.

Berger, Peter. 1990. *The Sacred Canopy: Elements of a Sociological Theory of Religion*. New York: Anchor.

Briggs, Asa, and Peter Burke. 2002. *A Social History of the Media: From Gutenberg to the Internet*. Malden, MA: Polity Press.

Chesnut, R. Andrew. 1997. *Born Again in Brazil: The Pentecostal Boom and the Pathogens of Poverty*. New Brunswick, NJ: Rutgers University Press.

———. 2003. *Competitive Spirits: Latin America's New Religious Economy*. Oxford and New York: Oxford University Press.

Corten, André. 1999. *Pentecostalism in Brazil: Emotion of the Poor and Theological Romanticism*. New York: St. Martin's Press.

Freeman, Barbara Claire. 1999. Practicing Christian Rock. In *One Nation Under God? Religion and American Culture,* ed. Marjorie Garber and Rebecca L. Walkowitz, 221–231. New York and London: Routledge.

Giddens, Anthony. 1997. *A Vida em Sociedade Pós-Tradicional*. In *Modernização Reflexiva: Política, Tradição e Estética na Ordem Social Moderna, ed. by* Beck, Ulrich et al., 73–133. São Paulo: Editora da UNESP.

Hendershot, Heather. 2004. *Shaking the World for Jesus: Media and Conservative Evangelical Culture*. Chicago and London: University of Chicago Press.

Hoover, Stewart M. 2001. Visual Religion in Media Culture. In *Visual Culture in American Religions,* ed. David Morgan and Sally Promey, 146–159. Los Angeles: University of California Press.

Hunter, James Davison. 1992. *Culture Wars: The Struggle to Define America*. New York: Basic Books.

Jenkins, Henry. 2006. *Convergence Culture: Where Old and New Media Collide*. New York and London: New York University Press.

Jhally, Sut. 2006. *The Spectacle of Accumulation: Essays in Culture, Media, & Politics*. New York: Peter Lang.

Jungblut, Airton Luiz. 2000. *Nos Chats do Senhor: Um Estudo Antropológico Sobre a Presença Evangélica no Ciberespaço Brasileiro*. Ph.D. dissertation, Porto Alegre-RS: UFRGS.

Livingstone, Sonia. 2009. *Children and the Internet*. London: Polity.

Mariano, Ricardo. 1997. *Neopentecostais: Sociologia do Novo Pentecostalismo no Brasil*. São Paulo: Loyola.

Mathews, Gordon. 2000. *Global Culture/Individual Identity: Searching for Home in the Cultural Supermarket*. London: Routledge.

McDannell, Colleen. 1995. *Material Christianity, Religion and Popular Culture in America*. New Haven, CT: Yale University Press.

Moore, R. Laurence. 1994. *Selling God in the Marketplace of Culture*. New York and Oxford: Oxford University Press.

Smith, Christian, and Melinda Lundquist Denton. 2005. *Soul Searching—The Religious and Spiritual Lives of American Teenagers*. New York and Oxford: Oxford University Press.

Tyner, Kathleen. 1998. *Literacy in a Digital World: Teaching and Learning in the Age of Information*. London and New York: Routledge.

———, ed. 2009. *Media Literacy: New Agendas in Communication*. London and New York: Routledge.

4

Singapore's Experience in Fostering Youth Media Production: The Implications of State-Led School and Public Education Initiatives

Sun Sun Lim, Elmie Nekmat, and Shobha Vadrevu

With the widespread availability of information technology, young Singaporeans enjoy exciting possibilities for the consumption and production of media. Their government has introduced various initiatives through schools and public education campaigns to encourage more young people to acquire media production skills. This chapter reflects on the efficacy of these initiatives and their implications for the development of youth media production in Singapore. Two significant media education programmes and the media products that they have generated are assessed in detail. The chapter concludes that while state-led media production education programmes have succeeded in heightening young people's awareness of and competencies for media production, these should be complemented by private-sector-run programmes that afford young Singaporeans more room to exercise their creativity. At the same time, the current emphasis on imparting technical media production skills should be balanced by increased efforts to vest young Singaporeans with the critical literacy to consume and produce media in an informed, critical, and discerning manner. Above all, however, the infusion of the existing national curriculum with media production education would be best served by a shift in the pedagogical approach that underscores the current

education system, from one that is more hierarchical and individually oriented to one that is more heterarchical and collaborative in nature.

Introduction

From blogs to podcasts, digital animation to online games, Friendster to Facebook, young Singaporeans have been embracing digital media, albeit with the government holding their hands and watching for hazards as they scamper down the bustling information superhighway. Indeed, Singapore's avid adoption of information technology (IT) has been largely state-driven. The government has introduced a slew of business-friendly policies to grow local innovation and attract foreign investment in the country's IT and media industries, while also investing heavily in IT infrastructure. Singapore's IT infrastructure is among the most comprehensive worldwide, with household broadband Internet penetration at 99.9% (W. Tan 2009a), and complemented by an extensive free public Wi-Fi network (Infocomm Development Authority [IDA] 2008). Along with government investment in hardware have come concerted efforts by the state to intensify the use of information technology in the curriculum at all educational levels, from preschool to university. Students at all levels are regularly required to research, prepare and submit assignments using the Internet. Career guidance for young people is also offered through an online portal that enables students to take profiling tests that match professions to the students' skills, create electronic portfolios, track their academic achievement and acquire interview skills through online videos and quizzes (A. Tan 2009). Consequently, young Singaporeans are the country's most avid Internet users, with 90% of 7–14-year-olds and 96% of 15–24-year-olds having accessed the Internet in the twelve months preceding the survey (IDA 2008). The same study found that 96% of Singaporeans aged 15–24 access the Internet at least once a week, facilitated by its ubiquity and accessibility. The three most popular activities for this age group are communicating via email, instant messaging and/or social networking (83%); pursuing leisure, including online gaming, reading online newspapers and magazines, watching web television, and so forth (57%); and seeking information, including general web browsing and obtaining information on goods, services, job opportunities, health issues and so forth (51%). Among the Singaporean population, 15–24-year-olds are most likely to have engaged in creating online content, with one in four of them having done so, compared to one in ten for the general population. The leading online content creation activities for this age group are creating and maintaining personal blogs (16%), sharing one's own photos (6%), creating and maintaining personal websites (4%), and broadcasting self-produced videos via video-sharing sites (4%). Clearly, media production among young Singaporeans lags significantly behind their media consumption, and the government has introduced various initiatives

to encourage more young people to acquire media production skills in order to align with the government's overarching goals of developing the media industry. These include introducing media production skills training in schools, providing free or highly subsidised media production courses for the general public, and organising festivals, road shows, and competitions that centre on media production.

In light of the extent of this spate of initiatives, it is imperative to reflect on their efficacy and implications for the nature of young people's media production in Singapore. To this end, this chapter examines the state-led culture of media production in Singapore and concludes by making several policy recommendations. The chapter begins by explaining the various contextual specifics of Singapore, such as the government's role in the media sector and the local education system, and how these affect the development of media production among the young in Singapore. Two prominent cases of media production initiatives undertaken in Singapore are also highlighted to illustrate the current directions of media production among youths. The chapter concludes with a discussion of the repertoire of capacities that today's youths need to function effectively in an environment that requires them to be both consumers and producers, and considers whether the government's efforts in media production education help to nurture these capacities.

Singapore's Media Landscape

Singapore's media industry has grown significantly in the last ten years, spurred by the government's efforts to foster this sector as an engine of economic growth. From the early 1980s, the government of Singapore sought to restructure the economy through the widespread application of IT (Rodan 1998). Its goal was to develop the country into an IT production hub of global repute and, to this end, a succession of strategic plans have been implemented including Infocomm 21, Connected Singapore, and Intelligent Nation 2015 (IDA 2009a). These plans focused on developing a reliable and cutting-edge IT infrastructure to serve industry and society, boosting innovation and entrepreneurship, and nurturing a skilled and creative workforce. Additionally, the government of Singapore recognized that in order to encourage creativity, there was a need for less regulatory rigidity so that policies would not "unnecessarily impede the development of new and innovative services in the new environment" (IDA 2009b). Hence, unlike its approach toward the print and broadcast markets, which are closely regulated through licensing laws, indirect government ownership, content restrictions and censorship (George 2006), the Singapore government's light touch approach toward regulating Internet content centres on industry self-regulation and public education (Media Development Authority [MDA] 2009). This regulatory shift is aimed at giving industry players greater flexibility to operate and innovate within Singa-

pore's IT and media industries. At the same time, the government has sought to attract foreign media companies and provide grants to local start-ups to stimulate growth in the media industry. Various initiatives have been launched to ensure a pro-business environment, including setting out clear and consistent regulatory policies and guidelines, creating state-of-the-art infrastructure, promoting public-private alliances, and providing monetary incentives. For the media sector per se, the MDA is forecast to spend S$250 million to promote development in publishing, music, games, animation, and interactive digital media (Marketing-Interactive 2009). Given its small land area of 247 square miles, Singapore is completely bereft of natural resources apart from its people. Hence, its economy has been traditionally service-based and seeks to constantly explore avenues for diversification, with the expansion of the interactive and digital media sector as a key growth strategy (Singapore Media Fusion 2009). Partly as a result of these efforts, a host of leading media companies such as Ubisoft, Lucasfilm, Electronic Arts, Koei Entertainment, and DigiPen have set up operations in Singapore, contributing to a rising demand for skilled workers in the interactive and digital media industries which are projected to create 10,000 jobs over the next six years (A. Tan 2009). To meet these industry needs, and to better position Singapore for future economic growth, the government has also made efforts to establish specialist media production training institutes. For example, the DigiPen-Ubisoft campus was set up through the collaborative efforts of the DigiPen Institute of Technology, Ubisoft Singapore, and Singapore's Workforce Development Agency (DigiPen Institute of Technology 2009). Top animation schools such as Canada's Sheridan College have also set up campuses in Singapore (Contact Singapore 2007). There has also been a sharp increase in local entrepreneurship in the interactive and digital media industries. The government nurtures local companies through assistance programmes, such as fund injections of S$40 million for novel business initiatives and by organising strategic networking and tutelage sessions with international media giants (MDA 2008). In addition, the National Research Foundation has a S$500 million fund for awarding grants to research relating to the interactive and digital media sector (Government of Singapore 2009a).

Media Production Education within Singapore Schools

To support the growing adoption of IT in Singapore's rapidly modernizing economy, the government has sought to incorporate IT training into schools, from primary to tertiary levels. Within Singapore's schools, IT use is incorporated into at least 30% of curriculum time through its use in instruction, online learning portals, and interactive educational games (Koh 2007). The vast majority of schools from primary to pre-university levels are state-run and come under the purview of the Ministry of Education (MOE), which promotes IT use in schools by providing

network infrastructure, hardware, and curricular support. To this end, the first phase of the IT Masterplan was launched in 1997, and the move toward educating students as media producers was kick-started by training teachers to be IT-savvy and equipping schools with the necessary IT infrastructure. Teachers were encouraged to actively use ICTs as teaching and learning tools, form IT committees, and conduct extracurricular classes in IT. In the second phase of the Masterplan (2003–2008), the aim was to integrate IT more deeply into lessons, thereby increasing interactivity and engagement. In this phase, the goal was to actively involve learners in more participatory and collaborative media environments such as video production, virtual worlds such as Second Life,[1] blogs, and wikis. Teachers were expected to become media producers themselves, so that they could guide their students in this field. Notably, the winning entries in the teachers' category for the 2008 Schools Digital Media Awards, a competition that showcases the media production capabilities of its participants, included both video and animation productions. The third phase of the Masterplan (2009–2014) ambitiously aims to transform the learning environment, wherein learning experiences will be mobile and spontaneous, and customised to individual students' learning styles. Teachers will be urged to maximise their IT competencies in order to teach more effectively. One example of progress in the area of teacher media production was the West Zone Sharing of Resources Project, or WeSHARE, which was a digital repository project developed "for teachers by teachers" in 2006, in which teachers uploaded their own media productions to share with other teachers (Ng 2008). So successful was this venture that it was expanded to schools nationwide to form the Inter-cluster Sharing of Resources project, or iSHARE.

Clearly, teachers are key scaffolds in the Singaporean government's bid to intensify media production training within the education system. The student winners of the aforementioned School Digital Media Awards, for example, credited their teachers and schools for sparking their interest in and enhancing their experience with media production. Yet not all teachers are able to engage in media production at this level, and neither are they convinced that they need to. With the heavy emphasis on examination results in Singapore schools (Gregory and Clarke 2003) and the large class sizes of thirty to forty students per class at primary and secondary levels (Pong and Pallas 2001), most teachers tend to focus on the transmission model of teaching (Lim 2006), reflected in the proliferation of PowerPoint presentations and the slow uptake of other forms of media production. Hence, even if teachers have the motivation and interest to impart media production skills to their students, they have to overcome or seek to circumvent these limitations.

At this juncture, it is pertinent to consider the overall pedagogical approach adopted in Singapore's education system. While there have been discernible shifts

toward participatory learning in recent years (Tan, Tan, and Chua 2008), a hierarchical structure still pervades Singapore's education system, with teachers at the top dispensing knowledge to the students at the bottom (Ng and Smith 2004; Nguyen, Terlouw, and Pilot 2006; Fan and Zhu 2007). In the present digital age, in which the proliferation of media resources greatly enhances independent learning and vests students with potentially diverse skills and experiences (Davidson and Goldberg 2009), a heterarchical structure with teacher and students working together to shape the learning process is synchronous with the resulting transformation of knowledge frameworks, whether the instruction be in math or media production. In addition, the inculcation of media production skills would be more effective within an environment of collaborative learning, given that media production is often a collaborative enterprise. In a top-down, authority-centred educational setting, basic media production skills may well be imparted, but higher-order critical thinking skills that empower students as media producers are less likely to be developed.

Access to facilities for different types of media production is another issue. While computing facilities are well-provided, with the ratio of computers to pupils in primary school at 6.6:1 and 5:1 for secondary and pre-university pupils (Ministry of Education 2004), not every school is equipped with specialised media production facilities. However, in line with the government's interest to boost the media industry and stimulate domestic media creation, steps have been taken in recent years to enhance resources and awareness related to media production in schools. A case in point is Innova Junior College, which has a New Media Arts Room, a mini-studio that is equipped with lights, video cameras, a music keyboard, and even a blue screen for special effects. The students are taught to put together portfolios of their media productions to facilitate their applications for media courses in tertiary institutions. Beyond helping to pique students' interest in media production, such resource provisions give students a hands-on experience of media production that is invaluable. For example, a team from Shuqun Primary School, which won one of the top prizes in the Schools Digital Media Awards 2008, attributed their interest and ability in media production to their teachers' guidance and the facilities provided by the school, which included video cameras, GPS devices, tablet PCs, and a podcasting studio. Indeed, the school's website is peppered with delightful student-produced videos which showcase their skills in videography and claymation.

Given the broad-based nature of the curriculum at primary and secondary levels, the attention given to media production education is less focused than at tertiary levels, where options for specialized media courses abound. Increasingly, however, schools are seeking to integrate media production education into the mainstream curriculum. For example, Northland Primary School has a compre-

hensive programme that incorporates media production into the overall curriculum of the school and sets out training stages for each level. Over the six years of their primary school education, students learn touch typing, digital art, word processing and presentation software, Internet literacy modules, video editing, and multimedia presentation creation (Northland Primary School 2003).

Case Study: N.E.mation!

An interesting example of a media production education programme that is centred in Singapore schools is the N.E.mation! competition. We chose to focus on this competition because it systematically reaches out to all young Singaporeans via the national school system, as opposed to smaller-scale competitions organised by private companies. The competition also focuses squarely on National Education, which is a critical component of the curriculum at all levels and thus impacts all students, rather than a media production programme that focuses on a specific academic subject or that involves only a particular group of students. To this end, we collected secondary information about N.E.mation! from relevant websites and media reports.

The significance of N.E.mation! is best appreciated with a preliminary discussion of the National Education curriculum within the context of Singapore's entire education system. Apart from obvious economic imperatives, the government's control over education is also motivated by an interest in fostering and maintaining a harmonious multi-racial society. As Koh (2005) argues, the Singapore government's control over education policies and curriculum is influenced by its view of schools as effective "ideological state apparatuses" for the creation of national identity in a multi-ethnic, multi-religious, and multi-lingual society (76). In this regard, a key component of Singapore's school curriculum is the compulsory National Education program. Launched in 1997, and consistent with Singapore's concept of Total Defence, National Education aims to develop national cohesion and confidence in the future, and to instill in young Singaporeans a sense of belonging in the country. This is achieved by instilling a set of core values in the Singaporean way of life and fostering a sense of identity, pride, and self-respect as Singaporeans (Wang et al. 2006). These messages are disseminated through formal curriculum subjects such as social studies, civics, and moral education, and informal activities such as compulsory yearly participation in Total Defence Day and National Day parade rehearsals, as well as Community Involvement Programmes (CIP) involving voluntary work around neighbourhood and community areas (see Koh 2005; Han 2000). This implementation of National Education in schools has at times been viewed as a manifestation of the government's propaganda and control over the education system, where schools are regarded as the best arenas for socializing the young into adopting future roles of "active citi-

zens" (Koh 2006; Han 2000). In short, the focus on National Education can be seen as the government's exertion of control over education with the aim of producing citizenship (Ong 2005).

More recently, the heightened exposure of students to IT has shifted the propagation of National Education in schools from one of consuming and experiencing nationalistic sentiments to one of participation and media production. The best example of this is the government-organised, industry-sponsored national competition N.E.mation!, where students work in teams to produce animation that captures their patriotic feelings for the country, as part of Singapore's overarching National Education programme (N.E.mation! 2008). At the root of the N.E.mation! competition is Total Defence, a concept aimed at protecting the Singaporean way of life by drawing on the abilities of the community to "augment [the] defence capability" of this "young nation with a small population and a conscript of armed forces" (Government of Singapore 2009b). Introduced in 1984, Total Defence was based on a projection that threats to a country might be more than military in nature, and thus incorporated branches of military, civil, economic, social, and psychological defence. In 2006, five Total Defence animation clips were featured in the Singapore prime minister's National Day Rally speech, a widely watched event that is often used to announce key national policies. The enthusiastic reception to these clips prompted Nexus, a government agency established for the specific purpose of "[driving] a comprehensive and coordinated nation-wide National Education effort" (Government of Singapore 2009c), to organise the annual N.E.mation! competition from the following year to "provide a creative platform for students to express their personal ideas about Total Defence" (N.E.mation! 2009).

Against this rhetoric of defence, survival, and community engagement, the N.E.mation! competition links Total Defence and National Education, and is given much attention in schools. It is open to students from secondary schools, junior colleges, and centralized institutions only. Students with no prior skills in animation are given the requisite training, and the winners are rewarded with trips to notable animation studios such as Studio Ghibli in Japan and Dreamworks in the United States.[2] Significantly, only Singaporean citizens and permanent residents may enter. At the final stage, public voting on a website where the ten best videos are featured contributes to the marks awarded, ensuring the appeal of the competition to the YouTube generation. The students register their teams online with a teacher in charge. Optional content development workshops help teachers and students with story creation skills, storyboarding techniques, and ways to develop the competition theme.

Teams build their productions around a common theme that changes yearly. In 2007, the theme was "Resilience," followed by "What Makes Us Singaporean"

in 2008 and "Why I Care About Singapore" in 2009. The increasing focus on developing a national identity is unmistakable. The website for the competition provides detailed explanations about the latest theme in a format aimed at attracting net-savvy young people. While the training in media production skills attracts many young people to the competition, the clear emphasis is on National Education. Under the rules and regulations, participants are reminded about the need to respect intellectual property rights, but apart from this, no other non-technical media issues are highlighted.

Forty shortlisted teams are each assigned an animation coach to mentor them in their production. At this stage, attendance at workshops becomes compulsory, presumably to ensure that the standard of competition is high (although no reason is given on the website). Ten finalists are then chosen to receive further training. Teachers are not permitted to get involved in the production stage, though they are expected to guide their students in developing the theme into a story. Evidently, the National Education part of the competition fits in with curricular strategies, and hence requires teacher input. The media production part, however, is dissociated from the mainstream curriculum, and teachers do not have a hand in it. Instead, external coaches act as mentors to provide technical advice.

Response to the competition has been fairly enthusiastic. According to a Ministry of Defence website, 560 entries were received in 2008. While there is no compulsion to take part, participation adds credit to the portfolios of both teachers and students. Students may need the credit in their applications for entrance to certain courses, while teachers find that their performance reviews are enhanced by involvement in such events. In addition, each school has a National Education committee, which is responsible for ensuring that National Education aims are met in various ways both intra- and extra-curricular, and participation in N.E.mation! helps to fulfill this responsibility to some extent.

The results of the students' efforts are often creative and witty, with impressively high production values. Various entries utilise innovative animation techniques and reflect a certain youthful vigour. For example, one entry entitled "Feel in the Blank" capitalises on the artistic skills of the team members, who fill in a blank sheet of paper with freehand sketches of what they think makes them Singaporean, shaping the icons and institutions, as they are mentioned in the voice-over, into a map of Singapore. The team used a camera to capture the action and linked up the frames for their completed animation sequence. Another team, whose entry is entitled "The Singapore Symphony", used a collage effect with their animation and set it to music that incorporated sounds commonly heard in Singapore, from those of construction sites to outdoor food courts.

However, given the goals and boundaries of this competition, the winning entries have a somewhat didactic tone that extols the virtues of being Singaporean,

while glossing over and even ignoring the realities on the ground. Of the three winning entries, one entitled "Our Home" used Lego blocks to create various structures, animating the building process to show how housing has improved over the years in Singapore. The message is that the close-knit ties among neighbours that characterised the traditional *kampong* houses of pre-independence Singapore have been sustained even in the government-built apartment buildings that mushroomed after independence in 1965. Yet the reality of the situation is that many people living in such apartment blocks do not actually know their neighbours well, and campaigns have been conducted to encourage Singaporeans to be more neighbourly (Ministry of National Development 2009).

In another winning entry entitled "Within Us Seeds of Love", local symbols that resonate with viewers were cleverly woven into the animation. The students used the bright crimson seeds of the indigenous saga tree to create various vignettes depicting how Singaporeans are united in the love they show one another. Again, the reality is very different from the idea expressed in the production—"four million hearts connected as one". In multi-ethnic Singapore, race is a sensitive issue and is delicately dealt with in the mainstream media and in public discussions. Children are taught in primary school about how damaging racial riots can be to the stability of the country, and much of the National Education syllabus centres on the need to maintain "racial harmony". While there are few outward signs of racial discord in the country, the sort of blanket unity expressed in the video is at best hopeful and at worse naïve. The fact that this is a winning entry clearly points to the focus on putting across an ideological message through the media used. This objective is underscored by the subsequent production of a teacher's resource package that includes the videos as part of lesson plans to teach National Education messages (Government of Singapore 2009d). The focus is very much on National Education, rather than media production per se. There were more creative entries in terms of media production skills than those that were awarded prizes, but the message of National Education was not as explicitly framed. The teacher's resource package is a planned outcome of the competition. Thus, videos that explicitly convey policy-friendly messages are privileged over those that are technically superior, but have less explicit National Education messages.

Public Education in Media Production

Supplementing the efforts within the education system to foster media production skills are an extensive range of media education campaigns and programmes that are open to the public and targeted primarily at the young. Again, the government plays a steering role, but with considerable support from the private sector. Government agencies such as the Infocomm Development Authority, the Media Development Authority, the National Heritage Board, and the National Library

Board have taken the lead by organising workshops, courses, road shows, exhibitions, and competitions relating to different aspects of technology use and media production, while roping in relevant corporate partners. Given the strong economic imperative for raising awareness and skills relating to media production, state funding for such public education efforts is generous, and corporate support is forthcoming. For example, Media Fiesta 2009 was a month-long public education event featuring more than forty activities on which the Media Development Authority spent millions of dollars and enlisted the participation of multiple industry players (Yeo 2009). Geared toward stimulating the local media industry, Media Fiesta included events designed to impart skills in and foster knowledge of new media platforms, but notably also had talks explaining the career options that the media production industry could offer to both fresh graduates and mid-career individuals seeking to explore alternative fields. Indeed, job opportunities in the media industry are expected to grow from 10,000 to 50,000 within the next six years (W. Tan 2009b).

Efforts are also made to tailor public education programmes to particular segments of the population. For example, in 2009 the Infocomm Development Authority organised a Silver Blog Contest to encourage blogging among Internet users aged 60 and above, and "The 'Loving Moments with My Kids' New Media Challenge" saw parents compete to chronicle memorable life events through creating Facebook or Twitter pages and status updates, personal blogs, or family videos shared via YouTube. To avoid preaching to the converted, such competitions are typically supplemented with free workshops where the relevant media production skills are taught to members of the public. Besides these targeted events, the bulk of public education programmes are usually open to the general public, but appear to be primarily designed to appeal to the young. Foreign and local media companies have organised a repertoire of media production programs that are targeted at students from primary to tertiary levels, including talks in schools, content development projects, content creation competitions, and internships. These programmes straddle different sectors of the industry, with companies such as Ubisoft and Electronic Arts steering programmes in digital games, Lucasfilm in movies and Animagine in animation. Through these initiatives, the private sector helps to enhance young people's understanding and knowledge of media production across a diverse range of media platforms. The involvement of these media companies infuses the programmes with a "hip" factor and affords young people insights into the media production industry as a potential career choice.

Case Study: Media Fiesta

To better understand government-run initiatives to drive public education in media production, the most extensive, well-funded, and high-profile programme to

date, Media Fiesta, will be discussed in greater detail. We collected secondary information about Media Fiesta from the websites of its organising agency, the Media Development Authority, as well as those of corporate partners, and newspaper and television news reports about the event.

Launched in February 2009, Media Fiesta was a month-long public education event that sought to promote interest in both consuming and producing local media content across all media platforms and to enlighten the public on career opportunities in the local media industry. Although the event was targeted at the general public, there was a discernible emphasis on young people, judging by the types of programmes offered and the media skills that it aimed to foster.

Activities were organised for five media genres—animation, games, publishing, film, broadcast, and interactive and digital media (MDA 2009). The animation programme comprised three workshops providing training in the principles of animation, claymation, and manga art, and an open house at CreativeBITS, a homegrown media education company that offers training in interactive, animation, video, graphic, and web design. The game programme was dominated by the four-day Funan Inter-School e-Gaming Challenge, which saw teams from secondary schools and tertiary institutions pit their skills in games such as *DOTA* and *Halo 3*. While not directly fostering media production skills, heightening interest in gaming also serves to further another economic goal: to nurture the local gaming community and raise its professional standing, thereby further generating player interest and stimulating innovation in the local game design industry, which has potential economic payoffs should domestically produced games attract a worldwide following (Channel NewsAsia 2009). The Singapore government thus hopes to make the consumption–media production cycle as virtuous and as profitable as possible. In this regard the Singapore government is seeking to replicate the South Korean experience in which its domestic gaming industry has been successfully internationalized—Korean online games are distributed and played throughout Asia, Europe and North America (Chung 2009). Another gaming event at Media Fiesta was the Mission DarkStar Game Design Competition that challenged participants to design educational games through which players could learn about Singapore's heritage and history. The winning teams, most of which were composed of polytechnic or technical institute students, produced games of diverse genres, artistic styles, and narrative structures that integrated notable individuals, historical milestones, famous landmarks, and popular legends into the gameplay. For example, in *Back in Time*, an adventure role-playing game designed by three students from Temasek Polytechnic, players have to counter the threat of a vengeful terrorist seeking to change Singapore's history; they do this by solving tasks while travelling through different time periods in the country's development (Mission DarkStar 2009).

The interactive and digital media programme was the most extensive, comprising fourteen activities. Apart from exhibitions showcasing locally produced content, there were workshops offering instruction in claymation, podcast, film, and animated feature production, along with competitions to test participants' skills in using digital media tools and platforms. Again, National Education was a part of the agenda via the N.E.wAuthor Competition, which challenged contestants from schools of all educational levels to develop an interactive digital book. The competition sought to "engage the interest of the technologically savvy young students and [connect] this interest more closely to the promotion of National Education through the use of new IDM (Interactive Digital Media) application tools and platform [sic]" (N.E.wAuthor 2009). The competition seems to enjoy considerable support, with the 2008 competition attracting over 1,400 students from 64 schools. For the 2009 competition, the winning entries had such titles as "Singapore's story from the eyes of a mouse" and "Rising above our challenges." The social policy agenda was also at the forefront in the National Schools Podcast Competition, where the winning podcasts focused on issues such as drug abuse, maintaining a healthy lifestyle, environmental awareness, and online safety (National Schools Podcast Competition 2009). Media production events that are government organised tend to produce creations that, albeit creative, are somewhat preachy. One competition that seemed to run against this grain was HP Lightropolis, where Hewlett Packard offered an interactive online tool for contestants to create designs using light, with the winning creations displayed on LED screens that line the exit of ION Orchard, Singapore's newest mall (Pandey 2009).

Overall, Media Fiesta's events seemed to focus more on the dissemination of technical skills than on inculcating any form of critical literacy. Some exceptions included "A Day with the Board of Film Censors", which sought to explain to students the different categories in Singapore's film classification scheme, classification criteria, and the social role of classification and censorship (Chee 2009), and the FREEDOM Challenge: National T-Shirt Design Competition, which aimed to promote the use of open-source alternatives for media in Singapore—both of which are promising nods to a growing recognition of the need for fostering critical literacy, and should be further developed in future iterations of the Media Fiesta.

Conclusion and Reflections

While the advent and accessibility of information technologies such as the Internet and mobile phones provides exciting possibilities for Singaporean youths in the consumption and production of media, it also creates the need for newer forms of literacy. In this regard, media literacy—the ability to "decode, evaluate, analyze and produce messages" in a variety of forms (Aufderheide 1993, 1)—is being increasingly challenged. One key challenge in this new media climate is the proliferation of

multimodal representations in today's media landscape. With the widespread availability and deployment of different media, modalities, and materials, each with its own logic and affordances, users are faced with the complex processes by which meanings can be "consumed" and "produced" in the world today (Kress and van Leeuwen 2001; O'Halloran 2004). Besides multimodal media literacy, various other literacy frameworks have also been proposed to encapsulate the expanse of knowledge and skills required for users to consume and produce media. These include information literacy (Association of College and Research Libraries 2000; Town 2000), visual literacy (International Visual Literacy Association 2006; Kress 2003), e-literacy (Martin 2000), digital literacy (Martin 2006; Eshet 2002), and multiliteracies (Cope and Kalantzis 2000; Leu et al. 2004), to name a few. Indeed, in an environment such as Singapore's, where media production is so actively encouraged, young Singaporeans need to possess a diverse array of literacies to maximise benefits of media engagement in both receptive and expressive modes of communication.

Cognisant of this significant shift in today's media landscape, Bruns (2007) proposed the "produsage" framework, where instead of the focus on literacies, the capacities to harness the various literacies are the crucial foci. In produsing, where "participants are users as well as producers of information and knowledge", the traditional form of media production has evolved with four new characteristics: (1) a broader-based, distributed generation of content by a wide community of participants; (2) fluid switches of produsers between roles as leaders, participants and users of content; (3) generation of information not as products in a traditional sense, but always unfinished, and continually under development; and (4) location within a framework of permissive regimes of engagement that are based more on merit than ownership, frequently employing copyright systems that acknowledge authorship and prohibit unauthorized commercial use (Bruns 2007, 3). Bruns (2008) goes on to argue that pedagogical approaches to media education must respond to the growing emergence of produsage by equipping individuals with (1) *creative,* (2) *collaborative,* (3) *critical,* (4) *combinatory,* and (5) *communication* capacities. The creative capacity refers to the ability to co-produce creations with others in flexible roles and to appreciate that the shared product enters the creativity cycle where it will be used and re-produced by others. The collaborative capacity involves the appreciation for fluid and multi-nodal collaborative partnerships and the ability to identify individuals and opportunities for collaboration. The critical capacity comprises the aptitude for identifying beneficial collaborators and for benchmarking one's creative abilities against others', as well as the ability to offer and receive constructive feedback while engaging in collaborative produsage. In both receptive and expressive modes, produsers should also be able to critically assess the relative value of alternative perspectives on a particular issue.

The combinatory capacity encompasses the skill to disaggregate collaborative projects into their constituent components and to combine and re-combine them in a fluid and cooperative manner with partners. Finally, the capacity for communication is the ability to critically and creatively align one's produsage skills with those of collaborators and to effectively convey one's opinions and ideas during the creative partnership. Bruns's C5C framework offers a useful vanguard for assessing the efficacy of media education in a highly mediatised environment where platforms and opportunities for produsage abound.

To what extent, then, does media production education in Singapore's schools and public education initiatives develop these five capacities? Overall, it would appear that the government has succeeded in heightening awareness of media production through different genres of activities that help to inculcate diverse media skills and require varied collaborative modes, thus broadly fostering the five aforementioned capacities. The considerable financial and resource provisions also aid in raising the level of sophistication of the skills being imparted. Commendably, the government has also been able to obtain the support of corporate partners, and such industry involvement lends the government's media production education programmes greater depth, thus enhancing the learning experience for participants.

However, the government could perhaps go a little further in pushing the boundaries of its media production education initiatives. In a media environment where opportunities for produsage are more prevalent and intense, young people would benefit from a more active nurturing of each of the five capacities. The creative capacity in particular can be cultivated in more innovative ways. Notwithstanding the benefits of competitions such as N.E.mation! and N.E.wAuthor, the participants' autonomy and creativity in such media production ventures is circumscribed by clearly defined rationales which must be acceptable to government and society. Admittedly, Singapore is a young, syncretic nation that needs to actively engage in nation building (Hill and Lien 1995). However, while competitions and activities such as N.E.mation! have their place and value, they should be balanced with activities where young Singaporeans can enjoy and exercise more creative freedom, in the process furthering the government's interest in developing a skilled and creative workforce for the country's burgeoning media industry. In this regard, the government may wish to occasionally retreat from the forefront and let industry players and civic organisations play a more prominent role in organising media production competitions that offer more of a blank canvas for media produsers to flex their creative skills. A good example is the HP Lightropolis contest held during Media Fiesta 2009.

In this way, young Singaporeans' critical capacity can also be enhanced. Of the five capacities, it would appear that the critical capacity is the least developed. Given the strong economic motivations for promoting media production and de-

veloping a skilled workforce, it is perhaps unsurprising that media production education in schools and public education programmes tend to emphasise the inculcation of technological skills and industry experience rather than "softer" aspects of critical media production and usage. This is potentially inadequate for the inculcation of media literacy that requires a certain level of critical appraisal in media consumption and production. Hence, media education production programmes should not be dominated by activities that transmit technical skills, but should put equal emphasis on both technical competencies and critical literacy. Indeed, this is a pedagogical issue that is pertinent not only to media education. While developing young people's critical, informed, and discerning sensibilities about anything is at issue, in the contemporary media environment developing these sensibilities about media consumption and production is both vital and necessary so that young Singaporeans will possess the skills to consume and produce media in an informed, critical, and discerning manner, enabling them to recognise media biases, assess information credibility, impression management in the online world, understand media effects, and so forth. However, such efforts need to proceed in tandem with overarching institutional changes in the educational system, where the top-down, transmission mode of instruction is gradually transformed into a more level, participatory style of learning. With these broad shifts and a more active nurturing of creative and critical capacities, young Singaporeans will be better placed to derive maximum benefits from media production and consumption.

Notes

1. Second Life is "a free 3D virtual world where users can socialize, connect, and create using free voice and text chat" (from secondlife.com).
2. Dreamworks is an animation film studio that has produced animated movies that are technically renowned and commercially successful. Studio Ghibli is a similar studio in Japan.

References

Association of College and Research Libraries. 2000. *Information Literacy Competency Standards for Higher Education*. http://www.ala.org/ala/acrl/ acrlstandards/standards.pdf.

Aufderheide, Patricia. 1993. *Media Literacy: A Report of the National Leadership Conference on Media Literacy*. Aspen, CO: Aspen Institute.

Bruns, Axel. 2007. Produsage: Towards a Broader Framework for User-Led Content Creation. *Creativity & Cognition* 6: 13–15.

———. 2008. *Blogs, Wikipedia, Second Life, and Beyond: From Production to Produsage*. New York: Peter Lang.

Channel NewsAsia. 2009. Recession Provides Opportunities for Gaming Industry to Grow. February 28, Local news section.

Chee, Kenny. 2009. Be a Film Censor at S'pore's First Media Fiesta. *MyPaper*, February 26, News section.

Chung, Peichi. 2009. New Media Globalization in Asia: A Comparative Study of Online Gaming Industries in South Korea and Singapore. In *Games of Locality: Gaming Cultures in the Asia–Pacific Region*, ed. Larissa Hjorth and Daniel Chan, 23–34. London: Routledge.

Contact Singapore. 2007. One of World's Leading Animation Schools to Set Up Campus in Singapore. http://www.contactsingapore.sg/home/index.php/eng/news/one_of_world_s_leading_ animation_school_to_set_up_campus_in_singapore.

Cope, Bill, and Mary Kalantzis. 2000. *Multiliteracies: Literacy Learning and the Design of Social Futures*. London: Routledge.

Davidson, Cathy N., and David T. Goldberg. 2009. *The Future of Learning Institutions in a Digital Age*. Cambridge, MA: MIT Press.

DigiPen Institute of Technology. 2009. DigiPen, Home. https://www.digipen.edu/news/digipen-Singapore-ubisoft-singapore-and-the-singapore-workforce-development-agency-establish-special-game-development-training-program/.

Eshet, Yoram. 2002. Digital literacy: A New Terminology Framework and Its Application to the Design of Meaningful Technology-Based Learning Environments. In *Educational Multimedia and Hypermedia*, ed. P. Barker and S. Reblesky, 493–498. Norfolk, VA: Association for the Advancement of Computing in Education.

Fan, Lianghuo, and Yan Zhu. 2007. From Convergence to Divergence: The Development of Mathematical Problem Solving in Research, Curriculum, and Classroom Practice in Singapore. *ZDM Mathematics Education* 39: 491–501.

George, Cherian. 2006. *Contentious Journalism and the Internet: Towards Democratic Discourse in Malaysia and Singapore*. Singapore University Press/NUS Publishing.

Government of Singapore. 2009a. National Research Foundation Interactive and Digital Media. https://rita.nrf.gov.sg/IDM/default.aspx.

———. 2009b. What Is Total Defence? http://www.totaldefence.sg/imindef/mindef_websites/topics/totaldefence/about_td.html.

———. 2009c. Our Role and Mission. http://www.nexus.gov.sg/imindef/mindef_websites/topics/nexus/about_us/role_mission.html.

———. 2009d. School Resource Packages. http://www.totaldefence.sg/imindef/mindef_websites/topics/totaldefence/resources/srp.html.

Gregory, Kelvin, and Marguerite H. Clarke. 2003. High-Stakes Assessment in England and Singapore. *Theory into Practice* 42: 66–74.

Han, Christine. 2000. National Education and 'Active Citizenship': Implications for Citizenship and Citizenship Education in Singapore. *Asia Pacific Journal of Education* 20: 63–72.

Hill, Michael and Kwen Fee Lien. 1995. *Politics of Nation Building and Citizenship in Singapore*. London: Routledge.

Infocomm Development Authority. 2008. Annual Survey of Infocomm Usage on Households and Individuals for 2007. http://www.ida.gov.sg/Publications/20061205092557.aspx#usage.

———. 2009a. The Government's Infocomm Journey. http://www.igov.gov.sg/Strategic_Plans/Our_Journey.htm.

———. 2009b. Legal and Policy Environment for Information Economy. http://www.ida.gov.sg/Policies%20and%20Regulation/20060418215057.aspx.

International Visual Literacy Association. 2006. What Is 'Visual Literacy'? www.ivla.org/org_what_vis_lit.htm.

Koh, Aaron. 2005. Imagining the Singapore Nation and Identity: The Role of the Media and National Education. *Asia Pacific Journal of Education* 25: 75–91.

———. 2006. Working Against Globalisation: The Role of the Media and National Education in Singapore. *Globalisation, Societies and Education* 4: 357–370.

Koh, Thiam-Seng. 2007. The Use of ICT in Singapore Schools. http://info.worldbank. org/etools/docs/library/243155/day1Session2_Thiam%20Seng%20Koh.pdf.

Kress, Gunther. 2003. *Literacy in the New Media Age.* New York: Routledge.

Kress, Gunther, and Theo van Leeuwen. 2001. *Multimodal Discourse: The Modes and Media of Contemporary Communication.* London: Arnold Publishers.

Leu, Donald J., Charles K. Kinzer, Julie L. Coiro, and Dana W. Cammack. 2004. Toward a Theory of New Literacies Emerging from the Internet and Other Information and Communication Technologies. In *Theoretical Models and Processes of Reading,* ed. Robert B. Ruddel and Norman Unrau, 1570–1611. Newark, DE : International Reading Association.

Lim, Cher Ping. 2006. *The Science and Art of Integrating ICT in Singapore Schools.* Singapore: iT21 (Singapore) Pte Limited.

Marketing-Interactive. 2009. Local Media Gets a $250m Boost. http://www.marketing-interactive. com/news/11465.

Martin, Allan. 2000. Concepts of C&IT Literacy in Higher Education. In *Final Report of Phase I of the Citscapes Project,* ed. Allan Martin, 8–11. Glasgow, UK: IT Education Unit, University of Glasgow.

———. 2006. Literacies for the Digital Age: A Preview of Part 1. In *Digital Literacies for Learning,* ed. Allan Martin and Dan Madigan. London, UK: Facet Publishing.

Media Development Authority (MDA). 2008. MDA Launches Mentorship Programme for Singapore Media Companies to Learn from International Experts. http://www.mda.gov.sg/ wms.www/thenewsdesk.aspx?sid=906.

———. 2009. Internet. http://www.mda.gov.sg/ wms.www/devnpolicies.aspx?sid=161.

Ministry of Education (MOE). 2004. Masterplan for IT in Education: Computers and Notebooks. http://www.moe.gov.sg/media/parliamentary-replies/2008/08/financial-assistance-schemes-f.php.

Ministry of National Development. 2009. My Neighbour, My Friend, It Begins with Me. http://www100.hdb.gov.sg/GoodNeighbour/index.html.

Mission DarkStar. 2009. Back in Time: Game Synopsis. http://www.missiondarkstar.com.sg/index. php?option=com_content&view=article&id=100&Itemid=107.

National Schools Podcast Competition. 2009. The Results Are Out! http://www.elchemi.net/ nspc09/podcasts/Results.html.

N.E.mation!. 2008. About N.E.mation!. http://nemation.sg/about.php?id=1.

N.E.mation!. 2009. Why I Care About Singapore. N.E.mation! n.d. http://nemation.sg/about.php.

N.E.wAuthor. 2009. N.E.wAuthor Competition 2009. http://www.newauthor.sg/about.aspx.

Ng, Aik Kwang, and Ian Smith. 2004. Why Is There a Paradox in Promoting Creativity in the Asian Classroom? In *Creativity: When East Meets West,* ed. Sing Lau, Anna N.N. Hui and Grace Y.C. Ng, 87–112. Singapore: World Scientific.

Ng, Eng Hen. 2008. Opening Address: Proceedings of the International Conference on Teaching and Learning with Technology. http://www.moe.gov.sg/media/speeches/2008/08/05/opening-address-by-dr-ng-eng-h-1.php.

Nguyen, Phuong-Mai, Cees Terlouw, and Albert Pilot. 2006. Culturally Appropriate Pedagogy: The Case of Group Learning in a Confucian Heritage Culture context. *Intercultural Education* 17: 1–19.

Northland Primary School. 2003. IT Programmes. http://www.northland.acesolution.biz/www/ departments.asp?sect=DIFT§ID=18.

O'Halloran, Kay L. 2004. *Multimodal Discourse Analysis.* New York: Continuum.

Ong, Aihwa. 2005. Ecologies of Expertise: Assembling Flows, Managing Citizenship. In *Global Assemblages: Technology, Politics, and Ethics as Anthropological Problems,* ed. Aihwa Ong and Stephen J. Collier, 337–353. Carlton, Australia: Blackwell.

Pandey, Rayana. 2009. HP Gets Creative with Online Contest. Marketing-Interactive.com. March 12. http://www.marketing-interactive.com/news/11421.

Pong, Suet-ling, and Aaron Pallas. 2001. Class Size and Eighth-Grade Math Achievement in the United States and Abroad. *Educational Evaluation and Policy Analysis* 3: 251–273.

Rodan, Gary. 1998. The Internet and Political Control in Singapore. *Political Science Quarterly* 113: 63–89.

Singapore Media Fusion. 2009. Singapore Media City: Gateway to the World. http://www.smf.sg/SingaporeMediaCity/Pages/SingaporeMediaFusion.aspx.

Tan, Aaron. 2009. Career Website for Students. *The Straits Times*, February 23, News section.

Tan, Kelvin H. K., Charlene Tan, and Jude S. M. Chua. 2008. Innovation in Education: The "Teach Less, Learn More" Initiative in Singapore Schools. In *Innovation In Education*, ed. Jasmine E. Larkley and Viola B. Maynhard, 153–172. Singapore: Nova Publishers.

Tan, Weizhen. 2009a. Singapore Is Most Wired Nation. *The Straits Times*, February 19, News section.

———. 2009b. Media Sector Still on the Talent Hunt. *The Straits Times*, March 6, News section.

Town, J. Stephen. 2000. Wisdom of Welfare? The Seven Pillars Model. In *Proceedings of the Conference of the Society, College and National University Libraries Held at the University of Warwick, July 6–7, 2000: Good Practice in Information Skills Development*, ed. Sheila Corall and Helen Hathaway. London: SCONUL.

Wang, John C. K., Angeline Khoo, Chor Boon Goh, Steven Tan, and S. Gopinathan. 2006. Patriotism and National Education: Perceptions of Trainee Teachers in Singapore. *Asia Pacific Journal of Education* 26: 51–64.

Yeo, Jessica. 2009. Prospects for Media Industry Still Good, Says MDA Chief. *Business Times*, February 26, News section.

Zakaria. 2009. Festival to Raise Media Literacy Among Singaporeans. *Bernama Daily Malaysian News*, February 25, News section.

Website Links to Youth-Produced Content

Ministry of Education. The Best of Student Digital Videos.
http://www.schoolbag.sg/archives/2009/04/the_best_of_student_digital_vi.php

Mission DarkStar Heritage and History Games
http://www.missiondarkstar.com.sg/index.php?option=com_content&view=article&id=111&Itemid=106

National Schools Podcast Competition "09. 2009. The Results Are Out!
http://www.elchemi.net/nspc09/podcasts/Results.html

N.E.mation!. 2009. Why I Care About Singapore. N.E.mation!. n.d.
http://nemation.sg/about.php

N.E.wAuthor. 2009. N.E.wAuthor Competition 2009.
http://www.newauthor.sg/about.aspx

Schools Digital Media Awards
http://sdma.edumall.sg/sdma/slot/u140/sdma2010/index.html

Shuqun Primary School
http://www.shuqunprimary.net/cos/o.x?c=/wbn/pagetree&func=view&rid=14094

5

Studying Research Capabilities of Youth Media: Analyzing Children's Audiovisual Expressions about Health

Richard Chalfen and Michael Rich

Cinematography has found a wider application in medicine than in any other science.
—Anthony R. Michaelis, 1955

Introduction

By inviting young people to produce media using today's sophisticated video and digital technologies, researchers have gained unprecedented access to youth culture and life experience. The videos created as part of these participant-created youth media (PYM) projects reveal youth perspectives on hard-hitting topics such as education, poverty, and human rights. But researchers are increasingly using this approach to zoom in on a topic on which youth are rarely heard: health and medical issues. Video Intervention/Prevention Assessment (VIA), a research project whose lens focuses on young people's experience of illness, uses PYM to explore healthcare through the eyes of young people who live it. VIA not only reveals new information about how adolescents live with chronic health conditions, but also explores how this information can be used to improve medical outcomes.

Our strategy—offering cameras to young participants who have a medical diagnosis in common—is a new way of accessing the perspectives of patients without requiring that they take the time or have the insight to translate experience into text, surveys, or interview answers. One theoretical justification for the shift from

spoken or written communication to visual and audiovisual expression is that images can bridge some of the limitations of language. They can show what words cannot say, revealing ideas, feelings, emotions, and concerns that are difficult to express or that the participants may not even be aware they have. The original goals of using video were to reveal the experience of illness "from the inside out" and to elicit information that other forms of expression tend to miss. Young people have been historically more problematic communicators than adults in healthcare situations. In pursuing this health research, however, another goal arose—to explore the effect of the medium itself, to explore how pictorial (rather than verbal) representation can be used to communicate information in more fundamental, commonly shared ways.

Comparing Apples to Crab Apples: Diversity of Approaches to Participant Media Research

Diversity of Topics

Creating a comprehensive inventory of PYM projects examining health issues is challenging for several reasons. First, a variety of significant variables have contributed to a tremendous range of difference among PYM projects about health problems that involve young people. For example, projects have varied in degree of formality, including both informally realized projects and formally conceived and developed research projects. They have focused on different age groups, including both adults and young people. They have occurred in a wide range of academic disciplines, including anthropology, sociology, social work, fine art photography, and medicine, and have used all kinds of technologies, including still photographs (chemical and digital), instant cameras, one-use or throw-away cameras, and motion pictures, including both analog and digital forms of film and video (Chalfen 2008). In this report, we will restrict our commentary to PYM projects that used digital video technology.

Variables in Methodology and Analysis

Projects that have used youth media as research data have used a range of methodologies, both in how the fieldwork is done and in how the work is analyzed. Great variation has been reported in how the participants were trained and motivated to create visual documents, how they were introduced to the "basics" of photography or filmmaking, the kinds of instruction they were offered, e.g., with or without discussion of content, style, or technique, aesthetic information, or the provision of "good" images made by professionals or any explicit comparisons with mass media or art. Some approaches offer participants freedom of choice and a raw na-

ïveté of individual vision over production quality by allowing participants to select content, themes, people, topics, and settings for their images, in contrast to recommending or assigning specific topics and/or types of content.

Other important variables are found in how PYM is viewed, evaluated, understood, or otherwise analyzed for how young people have expressed themselves via audiovisual media in an orderly and cogent manner. Description and analysis of results must consider alternative post-production activities. Many projects included a protocol for soliciting participant feedback, often returning the images to the participants and asking for their comments, insights, and questions (Harper 2002).

However, in many cases, explicit statements by project directors of *what* has been expressed, what youth have shown and told, are often missing. As a result, analysis of PYM has tended to be limited. In many informally developed projects, there have been no meaningful analyses; visual results have been allowed to "speak for themselves," left to the realm of "common sense" based on an implicit assumption that everyone views images the same way. This attitude prevails among the less-academic, informal projects throughout the world (Chalfen 2008).

The tremendous variation outlined in this overview demonstrates that there is no single right or wrong way to structure a research project that uses PYM. The choice of research design, methodologies, and participants depends on what you want to learn from the inquiry. As it should be, the research question comes first, the method of study follows.

Video Intervention/Prevention Assessment (VIA)

At the Center on Media and Child Health at Children's Hospital Boston, Video Intervention/Prevention Assessment (VIA) uses PYM with its detailed, method-specific protocols of strategies for field collection of audiovisual data, analysis, and application. VIA asks research participants to reflect on the psychological, social, and cultural realities of living with chronic illness. Acknowledging patients as expert witnesses to their own illnesses, VIA draws on patient experiences and accumulated wisdom by asking them to collaborate in the search for improved medical information and management options, with the goal of helping patients assume greater ownership of their own medical conditions. Objectives of this research include learning more about patients' personal knowledge of their illnesses, including a personal theory of sickness, disease, and healing; identifying major and minor experiences of suffering and survival; and examining the use of a personal network of medical information sources, in which doctors are only one member of the team. In these ways, we solicit "explanatory models" of illness (Kleinman 1980, 1988; Rich, Patashnick, and Chalfen 2002) to be analyzed for similarities to and differences from dominant bio-medical models of disease.

Methods of generating and analyzing participant-created visual illness narratives have been described in detail previously (Rich, Lamola, Amory et al. 2000; Rich, Lamola, Gordon et al. 2000). By having participants create their own visual narratives of their day-to-day lives with their medical conditions, VIA limits the reactivity brought about by the presence of an outside observer in their lives. More importantly, VIA adds the subjective dimension—the patients' perceptions of their life experiences—to the objective evidence that the video captures.

Ethical considerations

Certain ethical dimensions of participatory media should never be ignored (Wiles et al. 2008), and the sensitive and intimate nature of much of what VIA participants revealed made issues of privacy paramount. We treated VIA participants as research collaborators and felt serious obligations to protect these young people and their families from any perceived or actual risks. Important in its own right, this protection of the participants was important to build their trust and allow them to share important personal information and insights. We protected VIA participants by using a two-stage consent process. The informed consent required of all human research by the Institutional Review Board (IRB) at Children's Hospital Boston explicitly stated that VIA participants would create their own visual illness narratives to do video tours of specific environments; they would interview family and friends, and talk to the camera in a personal monologue about their experiences, thoughts, and feelings each day. Participants agreed that their resulting videos would be seen only by their research and clinical teams. Participants understood that we would provide them with a complete copy of their videos; they would be asked to review it and, if they agreed, to release any or all of their visual illness narrative for use by the researchers in publications, public presentations, and even broadcasts about the research.

Participant audiovisual data collection

Using indirect teaching methods originally developed by Sol Worth and John Adair (Worth, Adair, and Chalfen 1997) and further refined by Richard Chalfen (Chalfen 1981, 1989), we sought to give VIA participants competence in the technical aspects of shooting video without teaching them visual style, video-making techniques, or otherwise influencing the way that they saw and portrayed their lives (Rich, Polvinen, and Patashnick 2005). We trained participants in the fundamentals of operating standard consumer video camcorders, which were mounted with directional microphones and wide-angle lenses and modified so that they could be used to record, but not rewind or play, video. Participants could hand off the camcorder for documentation of an activity in which they were engaged and thus could not film themselves.

Participants carried camcorders for a period of eight to twelve weeks, recording anything and everything that was important to them. They focused on people, places, and situations that defined their lives as they knew them. We provided a standardized list of "video assignments," universal situations that could be compared and contrasted across participants to record at least once during their visual narrative period. These included activities of daily living, tours of their homes and neighborhoods, daily self-care and medical management, and interactions with the healthcare system, documenting their own and their family's relationships with clinicians.

For example, we asked VIA participants to interview family members, friends, teachers, clinicians, and anyone else with whom they had close contact. To help participants get started with these interviews, we provided a list of prompt questions, such as, "Do you think I'm treated in special ways because of my [asthma, cystic fibrosis, etc.]?" and "What do you think when I have problems or have to go to the hospital?" These questions were designed to motivate spontaneous conversation about the interviewee's perceptions of and experience with the participant's medical condition, the limitations it may or may not impose, and observations, beliefs, and feelings about the VIA participant from those closest to her or him.

To explore the participants' internal lives, we asked that they set up the camcorder once a day and speak to it directly about their experiences, observations, thoughts, and feelings. In this "personal monologue," subjects could relate the day's events and whatever else came to mind, speaking out loud their reactions and reflections, their concerns, hopes, and fears. Because this task was often the most difficult one for participants, we provided prompts like "Tell us about your day."

VIA Model of Analysis

VIA and other academically oriented projects demand explicit and clear statements of methods, results, and findings. But since no PYM effort can address problems equally or answer all questions, all projects, including our VIA efforts, have important limitations. VIA visual illness narratives focus on general and condition-specific health issues, revealing psychological, social, and cultural responses of participants and those around them. The visual narratives created by VIA participants were analyzed using a qualitative analysis method that was built upon principles of visual analysis and evolved through several applications of VIA to different study populations (Rich and Patashnick 2002; Patashnick and Rich 2005). This analytical approach was designed to understand what is shown as well as what is told in verbal forms, and to answer the how and why of human behavior that qualitative methods have established in the social sciences.

In order to proceed from VIA-generated footage to description and analysis of media production and content, we developed a creative integration of grounded

theory (Glaser and Strauss 1967; Glaser 1992) and epidemiology to help us develop, structure, and analyze an array of prevalent themes. We linked qualitative software programs (NVivo and Transana) for logging and coding youth-produced visual narratives (for an example of a logging page, see http://www.cmch.tv/via/images/loggingsample.jpg). All video created by study participants was first screened in real time to provide a general sense of what each tape portrayed. With the aid of teams of research interns, the visual and audio content was logged in detail, locating each "scene" by a unique video time code. Loggers described the objective features of each event and transcribed dialogue verbatim in one stream; in a parallel stream, they described the subjective qualities of the scene, including its emotional or psychological tone and its meaning in relationship to the VIA participant and his or her health status.

We coded the logged visual narratives in NVivo qualitative data software (QSR International, Melbourne, Australia). Using repeated viewings of the audio-visual data and several successive coding passes, we gave specific attention to such themes as participants' medical self-management strategies, medication use, relationships with the healthcare system, and health-affecting features of their physical and psychological environments. Coders noted social issues, such as barriers to and facilitators of health, access to and ability to pay for medical care, and the nature of interpersonal and family dynamics around the participants' conditions. We assessed psychological factors, such as locus of control and feelings of competence, helplessness, fear, or depression. We identified emerging psychological themes and explored their relationships and meaning to the participants. We also explored how participants understood, structured, and made meaning out of their illness in the context of their families, friends, communities, and belief systems.

Regular meetings of project personnel and research interns (from medicine, psychology, sociology, and anthropology) facilitated discussion of what the data was showing and telling us. Grounded theory helped us develop, structure, and analyze an array of prevalent themes. This process allowed us to organize emerging themes and generate tentative findings and recommendations for additional discussion, inquiry, comparison, debate, and review through several iterations.

Three Examples of VIA Youth Media Research

Having asked patients to show us what was most important in how they live with illness, we as researchers must now say what *we* find to be most important in their visual narratives. The emergence and development of themes is central to the success of applying grounded theory. Logged and coded data, personal observation, and intuition congeal at this stage of participatory media research, producing an exciting period of discovery. We regularly found that our refinement and clarifica-

tion of themes led inevitably to unanticipated speculation, new questions, and directions both in line with and departing from the original problems.

The following discussion focuses on themes that emerged from three particular VIA projects. These projects include our work with young asthma patients, with adolescent patients transitioning their healthcare from pediatrics to adult medicine, and with teenagers living with obesity or overweight.

VIA–Asthma

Asthma is the most common chronic disease of childhood. Although significant improvements in pharmacology and medical care strategies have improved over the past twenty years, the prevalence of asthma has increased, and most agree that the disease is an ever-worsening public health problem (Rich and Chalfen 1999; Chalfen and Rich 2004). We wanted a better understanding of how this disease affects young people day to day, to get a glimpse into their personal worlds and a clearer idea of how they saw themselves living with asthma (for additional information, see http://www.cmch.tv/via/ourwork/asthma.asp).

Patients with moderate or severe asthma (by National Institute of Health [NIH] standards) were recruited from urban pediatric and adolescent clinics. The nineteen VIA–Asthma patients were between eight and nineteen years old (eleven males and eight females); ten were black, seven white, two mixed race; and six were of Hispanic ethnicity. This demographic distribution is characteristic of asthma epidemiology.

The nineteen participants produced a total of 489 hours of video, with a median of twenty-two hours. The verbal and visual texts they created generated discussion and additional exploration of the following observations and themes:

1. Revelation of previously undisclosed data: The majority of the house tour tapes revealed significant risk factors for precipitating asthma exacerbations. These factors were not always revealed in clinical histories or intake interviews, more often because they were unnoticed by or unknown to the participants than because of any intentional diminution or obfuscation.

2. Unanticipated scary realities: An asthma attack can produce a dramatic and seldom-acknowledged fear of sudden death, a topic that medical staff tend to avoid discussing but that many, if not most, asthma patients experience.

3. Inappropriate, ineffective medication use: When participants recorded themselves using asthma medications, the majority demonstrated inappropriate or ineffective use, such as improper inhaler technique, overdosing, or discontinuing medications without discussing it with or informing their physician.

4. Lack of awareness of asthma triggers: These triggers included household dust, passive smoke, noxious volatile solvents, hair sprays, and household pets, among others.

5. Social isolation: Many participants experienced unwelcome feelings of being kept from normal, expected social interaction, due to being isolated as "different" or out of fear of dangerous health consequences.

6. Extensive media consumption: Frequencies of TV watching and video game playing, often alone, were very high.

7. Anxiety: Patients felt anxiety about getting special attention or special treatment because of asthma and about failing to fit in as normal teenagers.

8. Embarrassment: Many participants expressed feeling embarrassed by having asthma and receiving negative judgments about the need to take medications in front of others in social situations.

9. Poor body image: Many youth expressed dislike of their own bodies due to side effects of drugs, including unwanted weight gain and depression.

10. Varying notions of control: Participants expressed a range of feelings, from being in charge of their asthma to their asthma being in charge of them. This often verged on ideological conflicts of free will versus fatalism.

11. Correlation between control over visual narrative and control over asthma: Participants who took active charge of their taping assignments seemed to feel more in charge of their medication schedules and treatment plans than those who didn't take active charge.

These themes produced a broader frame of reference for understanding asthma, and many are not found in medical textbooks or contemporary medical education. The visual narratives produced access to new and previously unseen details of the young asthma patient as a whole human being. Using these insights, we have been able to introduce improved pedagogical materials for both medical schools and continuing education. These materials help broaden and deepen clinicians' understanding of asthma as an *illness* that is lived with on an everyday basis (Grüntzig and Rich 2008).

VIA–Transitions

The VIA–Transitions Project examines how chronically ill youth understand and manage the challenges and choices they encounter as they transition from pediatric to adult-oriented healthcare. For a young patient with a function-limiting condition, the transition from childhood to adulthood and the transfer from pediatric to adult healthcare are affected by a wide array of social, psychological, economic,

and cultural factors. Previous studies have been conducted from healthcare professionals' points of view, but little has been said about how patients experience and respond to this transition. Research on this process from the perspective of the young person who experiences it is ideally served by the inductive approach of qualitative inquiry (for additional information about the complexity of this project, see http://www.cmch.tv/via/ ourwork/transitions.asp).

To explore this issue, we worked with adolescents who had been diagnosed with a congenital, function-limiting medical condition that had historically proved fatal in childhood or adolescence, but who were now living well into adulthood. As they entered adulthood, these young people were faced with the dilemma of seeking age-appropriate care from health providers and systems that had little experience with their primary diagnosis, or sticking with pediatric care that was not able to provide for their adult health needs. For this project we worked with participants who had cystic fibrosis (CF), a condition where vital organs, particularly lungs and pancreas, become clogged with mucus, inhibiting function and increasing risk of infection, or spina bifida (SB), an incomplete formation of the spinal cord before birth that causes partial or complete paralysis below the lesion. We asked young people with one of these diagnoses to use VIA to document their everyday lives at three points as they transitioned from pediatric to adult-oriented medical care: preparing for transition with pediatric providers, transitioning, and one year after the transition attempt (since some participants were frustrated by adult care and returned to pediatrics). Problematic nodal points emerged as obstacles to individual maturation and healthcare independence. Most notably, these included interpersonal enmeshment and/or conflicts with family members, peers, doctors, and hospitals, which influenced changes in healthcare personnel, institutions, and therapeutic technique, regardless of clinical indications (Rich et al. forthcoming a; forthcoming b).

The 25 patients in the VIA–Transitions project generated 699 hours of visual illness narratives. The following key themes warrant additional exploration and study:

1. Quests for normalcy: Participants professed a desire to live life as if they never had their illness. This can lead to the practice of non-adherent and risk-taking behaviors.

2. Denial of medical condition and rebellion: Some CF participants denied their condition as a way to "normalize" their lives. This led them to defy medical recommendations (e.g., maintenance medication), which led to a worsening of their condition.

3. Personal autonomy: Patients with both diagnoses expressed a quest for personal autonomy, but this was more prevalent among CF patients than among

their SB counterparts. It was often coupled with independence from caregivers, family members, and illness and medications.

4. Need for control: Some patients compulsively followed their medical plans to keep themselves as healthy as possible.

5. Feelings of co-dependence and psychological enmeshment in intra-family relationships: This reaction occurred more commonly among SB participants than among CF patients. This is likely because SB participants had more complicated care regimens, such as the need to catheterize themselves to urinate, and often required help due to their physical and cognitive disabilities.

6. Patients are the experts: Patients' life experiences with a disabling condition trumped the knowledge provided by members of the healthcare community. Participants felt that they knew more about their own conditions than did their doctors.

7. Discrimination: Participants related experiences of being treated as "other" or "less" by society, particularly when trying to pursue sports, jobs, or romance.

8. Adult medicine as unequipped to care for them: Participants leaving pediatric care felt that their adult medicine physicians and medical institutions were not ready for them, and that they were being treated as guinea pigs in a disorganized process of transition.

9. Difficult transition process: The transition process was remarkably confused, messy, and idiosyncratic. It appeared that transition was conducted to meet the needs of the healthcare system, rather than the needs of patients.

Understanding these patient experiences, we are now on firmer ground to develop feasible patient-centered recommendations that can support, facilitate, and enhance a realistic and systematic transition process, specifically addressing key issues such as self-management, patient-provider communication, and barriers to success. These patient insights, motivations, and strengths are potent assets to improving the transition process.

VIA–Optimal Weight for Life (OWL)

One of our recent projects focused on ways that overweight adolescents understood their weight problems, or whether they saw being overweight as a problem at all. VIA–OWL sought to better understand what it means to live as an overweight person in contemporary American culture (Rich, Huecker, and Ludwig 2001). We asked how VIA methodology helped us see and interpret an "ethnologic" associated with young people classified as overweight or obese. We also explored how successful VIA methodology could be in eliciting and revealing a detailed understanding of an obesity subculture, clarifying what barriers exist toward

developing a healthier and safer lifestyle. (For additional information, see http://www.cmch.tv/via/ourwork/overweight.asp.)

Adolescents classified as overweight or obese by Centers for Disease Control and Prevention criteria were recruited from urban pediatric and adolescent clinics. The twenty-one participants were between twelve and twenty years old (seven males and fourteen females). They produced a total of 396 hours of video with a median of 20 hours. As part of our logging and coding procedures, we again developed a series of major and minor themes from the verbal and visual texts generated by these young, overweight participants. These meetings generated discussion and additional exploration of the following observations and themes:

1. "Appearance" trumps "health" and "now" trumps "later": Current appearance and looks were repeatedly evaluated as being more important than creating a current or future healthy life.

2. Expressions of weight normality: Participants often expressed a sense of weight normality and denial, meaning that current heavy body weights were seen as normal. This aligned with an indifference toward change. "I don't have a weight problem, so why act on it?"

3. Benefits of being overweight: Many participants expressed that their weight enhanced the immediate control of personal circumstances, relationships, and environment (e.g., one could protect oneself better from sexual advances or physically overcome adversaries).

4. Weight is sexy: Many youth expressed that being heavy improved physical attractiveness in a sexy kind of way, as in having "more to love."

5. Male adolescent bravado: Many male participants expressed bravado by frequency of eating and quantity of food consumed.

6. Food pride: Many participants expressed "food pride," or superiority of one's own ethnic food and recipes.

7. Fast food as social identity: The daily consumption of fast food was an important part of peer-group social identity. More attention was given to *where* and *with whom* one ate than to *what* one ate.

8. Procrastination: A preference for procrastination was expressed when acknowledging that change was needed, sometimes with an explicit plan to "do it later."

9. Personal control versus fate: Participants questioned the value of personal control versus fate in being overweight. They often summarized their views as "Whatever happens, happens" or "That's what it is."

10. Coping strategies: Personal and social strategies for coping with an overweight condition were accompanied by avoidance, ignorance, aggression, and/or humor.

Analysis of the VIA–OWL visual narratives revealed that, while most medical programs take a problem-focused approach aimed at changing nutrition and life-style, the VIA participants demonstrated an approach that was emotionally driven, aimed at distracting themselves and others from their obesity, thereby ignoring need for change. Analyses demonstrated that the majority of the adolescent participants developed coping strategies for living with obesity (Karczewski, Sherman, and Rich forthcoming) and that most felt little motivation, from themselves or from their medical providers, for change (Corrado, Patashnick, and Rich 2004). These and related results have immediate implications for medial approaches to weight control.

Discussion

Using Grounded Theory to elicit common themes of experience afforded us the opportunity to take a fresh look at what is in this extraordinarily rich collection of data derived from our model of participatory youth media. Several features deserve special attention. In all cases, we noticed that young people enthusiastically accepted our requests to use a camera for their autobiographical recordings. There was little, if any, hesitation to use this technology and never any fear or worry they would "break it." Camera use appeared to be a very familiar activity, and participants' facile participation in their own multi-dimensional visual culture facilitated our projects. A powerful feature of the VIA approach was that we asked these young people to make their own images and let them know that we would be paying careful attention to what they expressed in words and images. Participants appreciated that their personal knowledge was valued and being taken seriously; they knew that someone who cared about their ideas was listening—often, as several participants stated, "for the first time!" (Chalfen and Rich forthcoming). We learned how much VIA participants appreciated being assigned the role of teacher, feeling that doctors really needed to hear what they knew about themselves and their lives. One CF patient said, "I think that's really cool that someone actually takes the time to watch it. I respect your job a lot. The thing with doctors is they think they know everything." In other cases, they valued their participation as research collaborators because they felt that they were helping themselves and others with similar illnesses. One patient with SB offered:

...this project's helped me through a lot. I'm grateful for the project, I'm grateful for this camera. I'm grateful to know you, [VIA Field Coordinator].... I'm glad that other people

are going to eventually see this when I sign papers. I'm not ashamed of anything. I didn't do this for no reason. So, if anybody wants to learn, let them learn.

We are convinced that the VIA model of PYM and qualitative analysis yielded information that could not be gained in any other way. Most of this information could not have been picked up by the necessarily superficial quantitative methods of questionnaires and surveys. Many of the ideas and perspectives would have been missed by qualitative methods such as semi-structured interviews or focus groups, and the images and dialogue recorded by following participants with a camera would likely have been constrained and stilted by the presence and gaze of a stranger. Perhaps the most compelling element of each of our studies was the revelation of significant conflicts and miscommunications between adolescent subcultures and medical cultures. VIA narratives showed and told of vastly different objectives, misunderstandings, and incongruent reference points and value schemes. These missed connections and opportunities are particularly harmful in managing chronic conditions, where patients and physicians must be partners in the healthcare process. In revealing their experiences and perspectives on video, young people created visual illness narratives to communicate their health experiences in very meaningful ways. This would not have occurred without the presence—and participants' awareness of that presence—of eyes to see and ears to hear their narratives through the camera.

Concluding Thoughts

The universe of youth media is expanding. This fact may call for a re-examination and re-definition of "media." Relationships between young people and technologically mediated expression are evolving at a rapid pace. Dominant patterns of communication are undergoing revision and innovation as we witness a narrowing of the gap between interpersonal and mass communication. The speed of development and change in youth media has been facilitated by several factors: (1) the willingness of adults to put cameras in the hands of young people and to encourage youth-directed productions; (2) the arrival and endorsement of modern scopic technology, including now-ubiquitous camera phones; (3) the willingness of media outlets to experiment with screening examples of youth media; and (4) the introduction of Internet opportunities for mass exhibition, such as the enormously popular image-sharing sites at YouTube, Facebook, and MySpace, the international BeBo (UK-related countries) and Mixi (Japan), and others.

Young people have been offered innovative ways of personal expression. They continue to innovate by inventing their own uses for technology that is available, playing with dominant models of media use and adopting them to personal uses. Some of these applications can be subversive and, at times, border on the unlawful

or illegal as in cases of violent "happy-slapping" videos (Jenkins 2005) and sexually explicit video-streamed web sites. The recent explosion of sexting imagery, for example, has drawn critical attention from parents, schools, police, lawyers, psychologists, psychiatrists, and even the American Civil Liberties Union (Chalfen 2009).

But media production by young people is implicitly offering important lessons that are easily ignored. Most efforts offer valuable skills in media literacy, as well as demonstrations of how youth can more actively participate in what gets shown and seen. This is a dramatic departure from previous generations, when people generally accepted what media professionals provided. Today, the politics of media production and reception have changed, and young people have been offered new opportunities for power and influence in direct and indirect ways.

The participatory element of our work has been particularly poignant in two related contexts. We have asked young people to collaborate in media projects with their healthcare providers, without whose participation and cooperation there would have been no project. In a larger context, we are asking young people to take on an active and central role in their healthcare and to participate in the treatment, maintenance, and sometimes healing and curing of their own health conditions. In this case, we are advocating a change in the politics of healthcare, recommending a true partnership, a co-ownership of an illness in which the patient's knowledge of his or her illness is matched by the healthcare professional's biomedical expertise in the patient's disease. Participatory youth media in the form of VIA has demonstrated the potential for this approach to healthcare.

Our health-centric approach to youth media may differ from other concepts of media found in this book. The audiovisual products are treated less as "a film" and more as data, as visual illness narratives, as personally motivated and intentional communication (Worth 1966). How these young people organized themselves to meet this video-making challenge, how they approached this opportunity and attacked their assignments, and what they said along the way were all crucial to the analysis we brought to their visual narratives. In our ongoing explorations of the potential of VIA, we consistently ask whether we have given appropriate attention to what is being "said," knowing that young patients have a lot to tell us about their lives. We would do well to see and hear what youth are teaching us, integrate it into our care, and engage them as valued partners.

Acknowledgments

We express our thanks to Laura Sherman for her identification of key VIA findings, Isabel Lopes for her help with bibliographic references, and Lauren Rubenzahl for editing the manuscript.

References

Chalfen, Richard. 1981. A Sociovidistic Approach to Children's Filmmaking: The Philadelphia Project. *Studies in Visual Communication* 7(1): 2–33.

———. 1989. Native Participation in Visual Studies: From Pine Springs to Philadelphia. In *Eyes Across the Water: The Amsterdam Conference on Visual Anthropology and Sociology*, ed. R.M.B. Flaes, 71–79. Amsterdam: Het Spinhuis.

———. 1997. Foreword to the Revised Edition. In *Through Navajo Eyes: An Exploration in Film Communication and Anthropology* by Sol Worth and John Adair, ix–xxi. Albuquerque: University of New Mexico Press.

———. 1997. Afterword to the Revised Edition. In *Through Navajo Eyes: An Exploration in Film Communication and Anthropology* by Sol Worth and John Adair, 275–341. Albuquerque: University of New Mexico Press.

———. 2008. To See What It's Like to Live Like You: The Popularity of Making Kids Make Pictures. Paper prepared for Emergent Seeing and Knowing: Mapping Practices of Participatory Visual Methods presented at the Radcliffe Institute for Advanced Study, November 13–15, Cambridge, MA.

———. 2009. It's Only a Picture: Sexting, "Smutty" Snapshots, and Felony Charges. *Visual Studies* 24(3): 258–268.

Chalfen, Richard, and Jay Haley. 1971. Reaction to Socio-Documentary Film Research in a Mental Health Clinic. *American Journal of Orthopsychiatry* 41(1): 91–100.

Chalfen, Richard, and Michael Rich. 2004. Applying Visual Research: Patients Teaching Physicians About Asthma Through Visual Illness Narratives. *Visual Anthropology Review* 20(1): 17–30.

———. Forthcoming. Sharing Information about the Pain: Patient-Doctor Collaboration in Therapy and Research. In *Collaborative information behavior: User engagement and communication*, ed. Jonathan Foster. Hershey, PA: IGI Global.

Corrado, Stephanie P., Jennifer Patashnick, and Michael Rich. 2004. Factors Affecting Change Among Obese Adolescents. *Journal of Adolescent Health* 34(2): 112.

Glaser, Barney G. 1992. *Basics of Grounded Theory Analysis: Emergence vs. Forcing*. Mill Valley, CA: Sociology Press.

Glaser, Barney G., and Anselm Strauss. 1967. *The Discovery of Grounded Theory: Strategies for Qualitative Research*. Hawthorne, NY: Aldine de Gruyter.

Grüntzig, Patricia and Michael Rich. 2008. Through the Patient's Eyes—Teaching Human Illness from the Inside Out. Paper presented at the *Association for Medical Education in Europe* Congress, September 2, Prague, Czech Republic.

Harper, Doug. 2002. Talking about Pictures: A Case for Photo Elicitation. *Visual Studies* 17(1): 13–26.

Harrison, Barbara H. 2002. Seeing Health and Illness Worlds: Using Visual Methodologies in a Sociology of Health and Illness: A Methodological Review. *Sociology of Health & Illness* 24(6): 856–872.

Jenkins, Russell. 2005. Happy-Slap Gang Put Girl in Hospital. *The Times*, May 20, News section.

Karczewski, Sabrina A., Laura Sherman, and Michael Rich. (Forthcoming). Do Medical Obesity Approaches Fail Because They Don't Meet Adolescents Where They Are? Obese Adolescents' Strategies for Coping with Their Weight. *Journal of Adolescent Health*.

Kleinman, Arthur. 1980. *Patients and Healers in the Context of Culture: An Exploration of the Borderland Between Anthropology, Medicine, and Psychiatry*. Berkeley: University of California Press.

———. 1988. *The Illness Narratives: Suffering, Healing and the Human Condition*. New York: Basic Books.

Michaelis, Anthony R. 1955. *Research Films in Biology, Anthropology, Psychology, and Medicine*. New York: Academic Press.

Patashnick, Jennifer and Michael Rich. 2005. Researching Human Experience: Video Intervention/Prevention Assessment (VIA). *Australasian Journal of Information Systems* 12(2): 103–111.

Rich, Michael and Richard Chalfen. 1999. Showing and Telling Asthma: Children Teaching Physicians with Visual Narratives. *Visual Sociology* 14(1): 51–71.

Rich, Michael, Daniel Huecker, and David Ludwig. 2001. Obesity in the Lives of Children and Adolescents: Inquiry Through Patient-Created Visual Narratives. *Pediatric Research* 49: 7A.

Rich, Michael, Steven Lamola, and Colum Amory. 2000. Video Intervention/Prevention Assessment: A Patient-Centered Methodology for Understanding the Adolescent Illness Experience. *Journal of Adolescent Health*, 27(3): 155–165.

Rich, Michael, Steven Lamola, Jason Gordon, and Richard Chalfen. 2000. Video Intervention/Prevention Assessment: A Patient-Centered Methodology for Understanding the Adolescent Illness Experience. *Journal of Adolescent Health* 27(3): 155–165.

Rich, Michael and Jennifer Patashnick. 2002. Narrative Research with Audiovisual Data: Video Intervention/Prevention Assessment (VIA) and NVivo. *International Journal of Social Research Methodology* 5(3): 245–261.

Rich, Michael, Jennifer Patashnick, and Richard Chalfen. 2002. Visual Illness Narratives of Asthma: Explanatory Models and Health-Related Behavior. *American Journal of Health Behavior* 26(6): 442–453.

Rich, Michael, Julie Polvinen, and Jennifer Patashnick. 2005. Visual Narratives of the Pediatric Illness Experience: Children Communicating with Clinicians through Video. *Child and Adolescent Psychiatric Clinics of North America* 14(3): 571–587.

Wiles, Rose, Jon Prosser, Anna Bagnoli, Andrew Clark, Katherine Davies, Sally Holland, and Emma Renold. 2008. Visual Ethics: Ethical Issues in Visual Research—An ESRC National Center for Research Methods review paper.

Worth, Sol. 1966. Film as Non-Art: An Approach to the Study of Film. *The American Scholar* 35(2): 322–334.

Worth, Sol, John Adair, and Richard Chalfen. 1997. *Through Navajo Eyes: An Exploration in Film Communication and Anthropology*, 2nd ed. Albuquerque: University of New Mexico Press.

Ziller, Robert C. and Douglas Lewis. 1981. Orientations: Self, Social, and Environmental Percepts Through Auto-Photography. *Personality and Social Psychology Bulletin* 7(2): 338–343.

Part Two

Case Studies of Youth Media Identities,

Voices, and Performers

6

Youth Media Production and Technology Skills Acquisition: Opportunities for Agency

Michael Dezuanni

Introduction

The production cultures made possible by young people's use of new media technologies have changed the game for media educators. Previously, media education's main goal was helping young people to become critically reflective users and consumers of media. For many media educators, the focus is now on helping young people to become responsible and ethical media producers. Media education is undergoing a shift as a curriculum intervention away from its focus on decoding, or reading, to one more interested in encoding, or production. This shift is highlighted by the changing terms used to describe young people's relationship with media. Discourses of consumption, effects, influence, and critical response are being replaced by discourses of participation, play, and experimentation. Despite this potentially fundamental change, the overriding objective for most media educators remains addressing the perceived power imbalance between young people and media. Questions of agency persist. Indeed, young people's use of new media technologies involves a whole new range of potential concerns for media educators, including privacy, self-representation, cyber bullying, the distribution of inappropriate materials, and copyright infringement. More than ever, it might be argued, young people need to learn to be critically reflective in their production and use of media.

Youth Production and Media Education

Helping students to become critical about media has been a defining characteristic of media education, distinguishing it from other curriculum areas like multimedia education (Buckingham 2003; Luke 2001; Turnbull 2006). Multimedia education largely focuses on skills acquisition, with the goal of helping students gain knowledge and understanding of the software resources available for making digital media (Burn 2009; Schwartz 2006). As a curriculum field, media education generally focuses on developing students' conceptual understandings of media and placing media production and use in its social and cultural contexts. The goal is for students to become more critical about the role of media in society, particularly their own use of media. Some media educators claim to be able to empower young people with knowledge about media (Giroux 1994; Masterman 1990). Indeed, media education has a long history of aiming to intervene in the relationship between young people and media, to redress the supposed power imbalance between the two. In this context, student agency is a key concern of media educators. However, there is not always a clear definition of what agency entails for young people in relation to the media. The role of student production work in developing agency may be even less clear, as I explain in this chapter.

Within media education, production work has often been presented as a practical application of conceptual understandings. In the internationally accepted 'key concepts' approach (Buckingham and Domaille 2009), a framework is used as the basis for the knowledge to be developed through a combination of critical reading and production work. Production work is presented as a complement to critical reading, or as a necessary step for students to gain deep understanding of media education's key concepts. These concepts[1] include *languages*, the codes and conventions of various media genres; *representations*, which focuses on media portrayals of people, places and ideas; *institutions*, which considers the organisations that produce, distribute, and regulate media; *audiences*, the people who use the media; and *technologies*, which are required to produce, distribute, and access media. Theorists (Buckingham 1995) claim that through producing media, students experience the practical application of these concepts. For example, David Buckingham and Julian Sefton-Green (1994) suggest that the relationship between theory and practice allows students to develop new knowledge as they transfer concepts and ideas among written, spoken, and practical modes.

Traditional media forms have allowed the connection between conceptual understanding and practice to seem reasonably straightforward. For example, when students make a documentary with video technologies, it is clear that they need to understand something about the codes and conventions of documentary genres, which they are likely to gain through analysing documentaries. If they design and write a newspaper report, they will deal with processes of selection, con-

struction, and representation. They are likely to begin these conceptual under-
standings through close textual analysis of newspaper reports. The same dynamic
between theory and production is likely to exist for forms such as narrative story-
telling with video, radio production, photography projects, advertising campaigns
and animations. This dynamic forms the basis for curriculum development in
many media classrooms. The first part of a formal learning sequence in media
classrooms is often dedicated to theory about specific media forms, and the second
part is then a practical application of this theory. However, the idea that making
media somehow leads to a critical understanding, rather than simply a repetition
of existing codes and conventions, needs to be investigated further.

One of the main claims for student production in media education is that it
allows students to get behind the façade of media production to better understand
how media products are constructed, resulting in a demystification of the media
production processes. I want to problematise this claim in a couple of ways. First, I
want to challenge the idea that using technologies to make media products neces-
sarily leads students to become more critical about media. There has been an ongo-
ing debate about this issue, particularly among scholars in the United Kingdom
(Buckingham and Sefton-Green 1994; Masterman 1985, 1990). This debate has
centred on questions of student agency, particularly about the extent to which
production work incorporates students into dominant media discourses. In this
context, I want to consider the particular implications for media education of
production work with new media technologies such as video games. Second, I
want to explore the ways in which production work might relate to young people's
relationship with media and whether or not a critical framework is the only—or
even best—way to consider young people's agency.

Video Game Production in a School Context

Production with new media forms presents a range of challenges for media educa-
tors. The technological processes and cultures associated with new media are often
quite different from those involving more traditional forms of production. For
example, although student video production now involves digital work, it draws
on processes and practices established within film production pedagogy over sev-
eral decades. Media teachers are used to scaffolding students' experiences of the
pre-production, production, and post-production phases of video production,
even if some teachers remain somewhat uncertain about digital video editing.
More importantly, however, teachers are familiar with the genres and products
produced via video production. In contrast, both the production processes and
products of new media remain relatively unfamiliar to many media education spe-
cialists. Websites, digital animations, podcasts, and video games are often consid-

ered to be the realm of multimedia educators, despite these forms being important popular cultural experiences for young people.

In a school context, the cultures of multimedia production are likely to be quite different from the cultures of traditional production. For example, there is a culture of multimedia training, in which students acquire technology-oriented skills that must be mastered to a high standard before media products can be produced. Furthermore, these 'products' are often mere fragments of new media texts, rather than complete productions. For example, students are unlikely to produce any more than a few artefacts, such as characters, weapons, or level scenery for a 3D video game. From a media education perspective, this may seem to have limitations. It is legitimate to ask what kinds of knowledge and understanding students gain from this type of production work if they cannot produce whole products. While media teachers might see the value of students producing a short narrative video, as a completed product with its own integrity, they may not see the value of students producing fragments of video games. It is legitimate to ask what sort of knowledge and understanding students gain about the media education key concepts through the acquisition of technological skills.

This was one of the key questions I asked in relation to a classroom-based video games project I implemented and taught alongside a technology education specialist. The Video Games Immersion Unit project was conducted at Independent Boy's College (IBC), a middle-class Catholic boys' school in Brisbane, Australia. The project involved eighteen students, all fourteen to sixteen years of age, and was offered as part of the school's middle years and boys' education curriculum reforms. I collaborated with the head of Information Technology Studies to offer a combined media and technology studies unit that included a range of online and classroom-based activities focused on designing and producing video games and critically reflecting on some of the social and cultural issues associated with this popular medium. During the three weeks, the students did not attend usual classes, wear uniforms, or have specific lesson times, and they were not assessed using the school's usual reporting structures.

The first week of the unit introduced students to an online learning environment, and they were able to establish both individual and group spaces in this environment. They were introduced to video game genres, conventions, and design principles through a design activity, game play, and decoding work. They considered issues related to games, including games violence and gender representations in games. The students conducted a survey of eleven- and twelve-year-old students from their school to ascertain the younger students' games preferences, and then worked in teams to design a concept for a game targeted at those students. In the second week, the students undertook intensive Flash animation training at an off-

campus multimedia training institution. In week three, the students undertook training in the software programs Game Maker, Bryce, and Wings 3D. They then worked in teams to produce digital artefacts based on their design concepts. These 'productions' were then shared with parents and the younger students for whom the games were designed. As a researcher, I collected the students' blog reflections, written after each learning episode, and artefacts produced by the students as they designed and produced their games.

The work conducted in the unit therefore combined the development of knowledge associated with media education with the type of technology training undertaken in multimedia courses. The work on game genres, the decoding process, the focus on game audiences and issues are all typical media education activities that draw on the key concepts framework of languages, representations, audiences, and institutions. However, the technology training process focused heavily on skills acquisition. The Flash animation training, in particular, used a very specific process in which students watched demonstrations and then attempted to emulate the instructor's steps. Even where multimedia training was less structured, for example when the students learned to make 2D games with Game Maker, the process focused heavily on skills acquisition rather than on developing understanding of concepts like narrative, audiences, and representation. From a media education perspective, it was not immediately clear how the skills acquisition further enhanced knowledge of the key concepts. More generally, it was not obvious how this type of production work developed students' critical capacities, provided students a voice, or how it led to empowerment.

Theorising Agency in Media Literacy Education

Media education has generally been motivated by the assumption that young people have a diminished capacity to act on the world around them, as a result of the power and influence of media and popular culture. This has been common across different, even contradictory, theoretical and socio-cultural traditions informing media education. It has been assumed that young people are susceptible to the corrupting (Leavis and Thompson 1933; Thompson 1973), trivialising (Hall and Whannel 1967/64), and mystifying (Barthes 1972; Marcuse 1986; Masterman 1985, 1990) influences of media. Media education has therefore cast into doubt young people's agency. The role of formal media education has been to address this perceived problem. Media production has aimed to provide young people with a 'voice', where it is believed they have none (Goodman 2003); it has aimed to give young people power over media technologies, where it is assumed they are at its mercy (White 2003); and it has aimed to provide young people with access to the means of production, because it is assumed that they are excluded from it (Kearney 2006). There is a common-sense assumption that 'having a voice' or hav-

ing access to the means of production will logically lead to students having more power or being able to act upon the world through media.

These claims about media production and agency are problematic on two levels. First, within media and cultural studies it has become well established that young people's relationship with media is not characterised by media dominance. At the very least, young people have complex relationships with media in which they may be able to resist, read 'against the grain', re-purpose, and make their own media products, without the intervention of formal education. Despite this, media educators, including this author, insist that formal media education has an important role to play in helping young people to become more productive with their use of media. Second, young people are just as likely to resist and re-purpose formal education. Media educators cannot assume that young people will take up opportunities to produce media in preferred ways. For students, the opportunity to have a voice through media production may become an opportunity to resist formal schooling through producing unsanctioned media. There is a question, then, about what it means to 'possess' agency.

One way to investigate these dilemmas further is through the application of post-structuralist theories that challenge the didactic approach often used to think about the relationship between young people and media. However, to appreciate the value of post-structuralist theory, it is necessary to consider structuralism and its limitations. Structuralism has been the predominant theoretical framework informing significant strands of media education teaching and learning over the past two to three decades. In particular, decoding practices, in which students learn to critically 'read' media texts, have been informed by structuralism. As a theoretical tradition, structuralism combines the Marxist focus on social structure (Althusser 1971) and linguistics' concern with language as a science (Barthes 1972). Media teachers' use of semiotic analysis, which aims to have students analyse media texts to identify the processes of selection and construction, and the deeper layers of meaning in texts, is informed by structuralism. In terms of agency, structuralism assumes that individuals are incorporated into dominant social ideologies through language. Individuals become 'mystified' (Barthes 1972) by language and ultimately experience a 'false consciousness'. Individuals have very little opportunity to resist mystification, unless they learn to read critically.

The problem with structuralism is that it underestimates individuals' capacities to be productive and creative with language. It assumes that using language necessarily involves repeating and reinforcing the social and cultural norms established within language. However, post-structuralist theorists like Michel Foucault, Judith Butler, and Jacques Derrida provide other possibilities for considering how language is used in creative and disruptive ways. These theorists suggest there may be ways to consider agency and young people's use of media, particularly media

production, by acknowledging their capacities to be productive and creative with language. From this perspective, student media production might be understood not as an opportunity to reinforce or complement conceptual understandings and critical capacities developed through decoding processes. Rather, it might be understood as providing students with the opportunity to productively act upon their social and cultural worlds. Three post-structuralist concepts that are useful for investigating this further are Foucault's concept of 'technologies of the self' (Foucault 1987/84, 1988/84, 2000/84), Butler's theorisation of 'performativity' (Butler 1990, 2004), and Derrida's use of the term 'bricolage' (Derrida 1990/78). Each of these will be explained through examples of analysis outlined later.

Post-structuralism suggests that agency is not something that can be attained and retained by individuals. Rather, as Davies (2000, 68) argues "...agency is spoken into existence at any one moment. It is fragmented, transitory, a discursive position that can be occupied within one discourse simultaneously with its nonoccupation in another." From this perspective, media education may be productive where it provides young people with opportunities to creatively use the languages associated with various media forms through experimentation and technological play. The next section of the chapter considers the implications of this claim in relation to production with new media technologies.

Agency and New Media Production

As noted earlier, my observations of the students' production work with multimedia software technologies in the Video Games Immersion Unit raised some questions about the notions of agency and critical thinking associated with media production. Most of the time students spent on production processes involved the acquisition and use of technological skills. For example, when the students learned to use the Flash animation software, they were provided with a set of tasks that had to be achieved to tell the story of a cartoon dog, Bippo, driving from the city to the countryside. The students spent three full days following the instructors' lead in completing each step, and there was very little opportunity for the students to add their own ideas to this process. As I will show in the second part of this chapter, there was little sense in which the students felt empowered by this process. However, I want to suggest that there may still be opportunities for this type of skills acquisition to create opportunities for agency.

A post-structuralist conception of agency is useful for considering young people's involvement in new media production because new media production is often more fragmented and skills-oriented than more traditional forms of production. I use the post structuralist concepts of technologies of the self, performativity, and bricolage to explore the role of skills acquisition in processes of student production. In particular, I want to investigate skills acquisition as an as-

pect of technological play and creative practice with technologies. This reading relies on the-post structuralist formulation that individuals use language for productive purposes to bring themselves into being in social contexts, and therefore to act upon the world. For example, as students make aspects of video games, they use the language of video games in ways that are recognisable to other members of the community. However, according to both Butler and Derrida, there are opportunities for students to achieve this in variational and playful ways. Furthermore, to make aspects of these games, students have to undertake technological work upon themselves, so that they have the skills to use the language of video games. From this perspective, being creatively productive and playful with technology may lead to scenes of agency.

'Technologies of the Self' and Opportunities for Agency

In this part of the chapter I introduce students' voices in the form of blog reflections written after each learning episode of the Video Games Immersion Unit. The students wrote a total of about forty blog reflections throughout the three weeks of the unit. These reflections are interesting in relation to Foucault's concept of technologies of the self in two ways. First, Foucault discusses how writing is in itself a 'technology of the self' when it involves reflection. Writing about the self can be part of the process of self-governance, and the blog reflections can therefore be considered examples of the ways that students aimed to bring themselves into being in the Immersion Unit community. Second, the reflections outline the technological work the students conducted upon themselves, to make themselves 'intelligible' to other members of the Immersion Unit community. Through discussing these examples, I will consider the implications for student agency. The following reflection was written by "Big Nuttz[2]" after one of the Flash animation training sessions and illustrates how technologies of the self may be operating, and how this may be instructive for understanding student agency:

> Well, before I had started doing flash in this session I had already had previous knowledge of the flash macromedia programs. In grade 8 I was very much into going into the library and making short films in flash. I have flash 5 at home on my computer so I have practise on this program. My flash skills have improved greatly since I have been working on my assessment. I have learnt ALOT of new skills and things I thought couldn't be done on flash. These skills are definitely going to help in our game design. (Big Nuttz)

There are autobiographical aspects of "Big Nuttz's" reflection that tell the story of his development as a Flash user, which connect his past use of the software, his current training, and his imagined future use of it to work on his group's game production. He tells the story of his development as a Flash user and his improvement in gaining new skills that will be useful to him and his Immersion Unit

team. Keeping in mind that "Big Nuttz" was an upper middle school student who had previously worked independently on his Flash animation skills, it is instructive to consider why he was motivated to undertake this work. Until the Immersion Unit experience, he had been learning informally and had not required the demands of formal curriculum and assessment to motivate him to learn. The explanation for this is likely to be "Big Nuttz's" desire to enter a community of practice. Foucault suggests that subjects conduct work upon themselves that allow them to be recognisable in particular communities of practice, and "Big Nuttz" certainly seems to desire to be part of a community of Flash users.

The focus on skills acquisition highlighted by "Big Nuttz" is therefore important because these skills allow him to work on his subjectivity by bringing himself into being in a community of practice that he desires to be part of. Therefore, the Flash skills are not merely instrumental, but are important to "Big Nuttz's" subjectivity and allow him to gain legitimacy in a specific community. From this perspective, gaining skills is an important aspect of "Big Nuttz's" viability in a specific community.

The question of agency is interesting in this context. It might be asked to what extent "Big Nuttz" simply repeats normative practices and processes, and therefore becomes incorporated into the community's existing knowledge systems. That is, can "Big Nuttz" experience agency if he merely repeats processes to master particular skills? In Foucault's terms (1984/77), there is a danger that "Big Nuttz" simply repeats the norms of a particular 'truth regime'. By truth regime Foucault means a set of accepted practices and knowledge. The problem with truth regimes is that they have the potential to be restrictive and exclusionary. In the case of Flash animation, this could mean that creative and variational ways of using the Flash software might be discouraged, leading to a lack of creativity and nonconformity. However, Foucault's technologies of the self is informative here. Foucault argues that although subjects often repeat the norms of truth regimes in order to be recognisable in specific communities, this does not have to be the case. He argues that subjects can exercise their 'freedom' to be creatively productive. The following reflection by user "Nicodemus" reflects the possibilities for this type of freedom:

> This has been quite a good week. I have learned a lot that I didn't know about Flash, including masks, motion guides, shape hints and the best way to interact with the Flash interface. Friday afternoon, when I went home, I used the skills I had learned to create an X-ray type image, in which the user could drag a mask to see an X-ray of a person's body. I feel that the skills I have learnt can be used for this and in many other situations. This week has also made me more curious about the wonders of action scripting, and what can be achieved through this feature of Flash. (Nicodemus)

"Nicodemus" discusses the skills he has acquired in terms of how they allow him to be creatively productive. A key point here is that he suggests that these skills are transferable to other situations and have possibilities for other tasks. The acquisition of skills allows "Nicodemus" to be experimental and creative with Flash in ways that expand upon the skills training process. Having these skills has opened up possibilities for him to be creative and have created the possibility for agency.

Performative Variation and Opportunities for Agency

Butler's theory of performativity takes up Foucault's technologies of the self by focusing on the repetition of norms. However, she goes further than Foucault to suggest that subjects only ever have the option to repeat norms. There is no possibility to escape norms to exercise 'freedom' in the manner Foucault suggests. Subjects bring themselves into being in the social world through the ongoing repetition of norms, which she calls performativity, and these repetitions make individuals 'recognisable' to others in the community. Butler suggests that individuals who fail to repeat acceptable norms run the risk of being unrecognisable, and potentially 'inhuman'. Heterosexual norms exemplify this. Individuals who fail to repeat heteronormativity risk being excluded from particular communities. However, there is the opportunity for agency in Butler's theorisation because she argues that norms are never totally faithfully repeated. There is always the opportunity for variation in both subtle and not-so-subtle ways. She calls this 'performative variation'.

Performative variation is relevant to work with new technologies in media classrooms because it suggests that even where students are required to repeat particular processes or conventions, there are opportunities for variation. These variations provide the possibility for agency. In Butler's terms (1990, 147), they become potential 'scenes of agency'. In this section I draw on the students' reflections to discuss examples of repetition and variation to explore the possibilities for agency in the students' work. In the first example, "Woodstock" discusses his work on a Flash animation 'walk cycle'[3] for a cartoon dog called Bippo (Figure 1). The students completed various tasks, following the instructor's lead, using the Bippo template as part of the skills acquisition process. Skills were acquired in a linear manner, with increasing complexity. There was little opportunity for students to vary from the template. Once or twice the students were able to add their own creativity to this process, but the focus was on acquiring a skill and moving on to the next one. A consequence of this was that there was a specific method for acquiring the skills through repetition, and failure to acquire any particular skill led students to feel disempowered. "Woodstock" found the process difficult

...besides from the taxi scene we had to do the Bippo walk cycle. This was by far the hardest thing I've ever done in Flash. Having to animate 13 frames of a dog taking steps was very frustrating and I got lost, a lot. I was the third last person to finish and was very behind. (Woodstock)

Figure 1. Bippo walk cycle produced by "Woodstock"

Butler's theory of performativity may be productively used to understand the frustration "Woodstock" intimates in his reflection. The training process the students are required to undertake involves normative repetition that excludes most possibilities for creatively completing the task. Completing the task requires the students to take on the role of successful students in a very specific way. They have to respond well to time pressure and have to understand and internalise the technological process following a quick demonstration. There is a strong element of efficiency that comes into this training process. To 'perform' success as a student in this situation, "Woodstock" is required to conform to a specific training regime and mode of learning that he believes he has failed to master. Alternatives to this mode do not seem to be possible. For example, there are few opportunities for peer tutoring or self-mastering of the techniques due to time constraints.

In contrast to the first three days of working on the Bippo assessment, the last two days of Flash training provided the students with greater opportunities for experimentation and customisation. The students' new instructor took a different approach to the training process, relying less on emulation and more on providing students with opportunities to explore. Of these two days "rbimdxe" says:

Going into the fourth day of the week with a new instructor, I was unsure what to expect. When I learnt we were making a 2D fighting game, Flash became my favourite program. First up we started creating the walk cycle and idle scene for our characters in the game. This

was exciting because although it was virtually the same as Bippo, we were customising how the character moved, looked and anything else we wanted him/her to do. (rbimdxe)

There are two aspects of "rbimdxe's" reflection that have implications for agency. The first is that the opportunity to work on a fighting game is exciting for him. This is probably because it provides him with an opportunity to undertake the type of technological work that allows him to be part of the community of Flash games producers. This is similar to points I made in the section on technologies of the self. Unlike the 'Bippo' work, which seemed irrelevant and tedious to most students, the 2D fighting game provided an exciting opportunity. Secondly, "rbimdxe's" reflection emphasizes the opportunity for variation of norms that working on the game provides. "rbimdxe" points out that the technological process is similar to the 'Bippo' work, but that the new process allows much greater autonomy. Therefore, while there is repetition in the technological process, there are opportunities for variation in the ways in which the fighting character can be created. "Costay" makes a similar point:

I think the whole idea of making a game and having a large amount of freedom over what we made our character do in the game was what appealed to us most and made these two days a whole lot of fun.... Making the character was fun because we got to create his attacks, his hits and everything about him completely to what we wanted. (Costay)

The possibility for agency that comes through these reflections is that the opportunity to be creative with the games characters is important to the students and provides them with pleasure. In terms of variation of norms, this process provides the potential for students to draw on games characters they may be familiar with, but also to vary these. This provides more possibility for variation than the 'Bippo' work did. From this perspective, the potential 'scene of agency' is created through the provision of a less restrictive training environment than the one they experienced in the first three days. It is a training process that allows the students to be creative and experimental through productive 'doing' rather than 'knowing'. In this sense it reflects Foucault's theory that knowing often involves the repetition of norms, while doing may provide more possibilities for freedom. In Butler's terms, it provides the opportunity for performative variation. However, a key point is that these possibilities for agency rely on the students' interest in the genre being worked on, in this case a 2D fighting game, and this has implications for how students use language to make meaning with these genres. This is important to media education because this is where technology education and skills acquisition merge with media education's key concepts, as I will explain.

Bricolage and Opportunities for Agency

The third post-structuralist theory I draw on here to explore opportunities for agency in technology skills acquisition is Derrida's use of the term 'bricolage'. Derrida uses this term specifically in the context of talking about how processes of signification operate. Signification is a central concept in media education that aims to explain how individuals make meaning with media products. The media education key concepts of languages, audiences, and representations have traditionally been underpinned by the structuralist conception of signification and its tripartite relationship between sign, signifier, and signified. Media educators generally apply this to the reading, or decoding, process to suggest that audiences 'make meaning' with media texts. Media products (signifiers) generate meaning (the signified). Derrida's use of bricolage challenges this process in a manner that is quite productive for understanding students' creative multimedia production work.

Derrida argues that in 'freeplay' in processes of signification, there is no central signifier because a process of signification always adds something more, an excess. Freeplay suggests there is never a pure process of signification that is a completely loyal repetition of a norm. Therefore, Derrida challenges the notion that signification is a relatively stable process and suggests that meaning is never complete and is always in a process of becoming. All signification might be seen as creative in the sense that each signification is an innovation. Derrida borrows the concept of the 'bricoleur' from Claude Lévi-Strauss to argue that language users never repeat stable language processes but use language creatively and productively to add something novel to the process of creating meaning. This is relevant to technological skills acquisition and multimedia production because it suggests that creative production work that students undertake in media classrooms has the potential for 'disruption' because, at the level of signification, it may be characterised as a form of language 'play'.

The following reflection by "Link" shows how a technological process involving experimentation and play is used to create a symbolic object for a game. This reflection was completed after the students had received training in the software Bryce and Wings 3D, which are both tools for making digital objects

> The whole of this session was used to make a particular weapon in the game design, the flame sabre. This is a sword, which has a silver blade, crystal blue hilt and a brown handle. The thing that separates this from other swords are the striking flames that surround the blade. I first made the blade by making a square-based pyramid, stretching it at the tip, then squished it. After that I made a hilt by combining two square-based pyramids (one that is upside down) and chopping some bits off by using positives and negatives. Trying to make complicated objects using Bryce 5 was a challenge, so I tried using Wings 3D, but it took too long to load, so I used Bryce 5 after all. From the skills I learnt previous such as positives and negatives, the edit tools and the xyz co-ordinates, I was able to make half the flame sabre. (Link)

Figure 2. Flame Sabre design and production by "Link" for Team "Random"

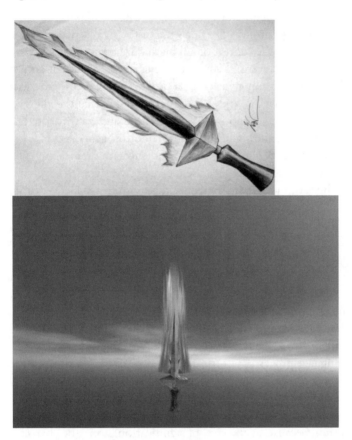

This reflection by "Link" outlines part of the technological process he undertook to make the Flame Sabre (Figure 2). He discusses his ability to use the skills he has acquired in creative ways to solve a design problem. His skills allow him to problem solve and to creatively conceptualise the digital artefact. Figure 2 shows "Link's" original, drawn design and then the digital version of the sabre. "Link's" newly acquired skills allow him to produce a digital artefact for his team's design and bring part of his team's game into being. "Link" operates as a kind of digital bricoleur using the software to bring together digital elements to make the sabre, experimenting with different processes and resources to achieve his goal. Importantly, this work was completed in an attempt to realise the production of an element from his team's game design. Although the sabre is based on conventions from the fantasy genre, it is his unique invention. In Derrida's terms, "Link's" production is not a mere repetition of the genre conventions; rather, it is a unique

contribution to the ongoing development of the genre. "Link's" team outlined the following as the broad narrative for their game:

> It was once a peaceful country, but then, everything was ruined. All the clouds, the sun and the sky disappeared, the country no longer had weather, it was only night...but there is hope. You must seek out the person responsible for this and find the four elements wind, water, earth and fire. These elements are locked away in four different corresponding areas and with the 4 elements combined together peace can be returned back to the country. (Team Random)

This is a typical post-apocalyptic narrative scenario that is similar to many video game narratives. Read from a structuralist perspective, it might be argued that this type of repetition is likely to incorporate the students back into the dominant discourses of the genre. From this perspective, the students lack agency. In contrast, Derrida's concept of freeplay suggests the students' use of these conventions may be a form of experimentation and play. Therefore, "Link's" production work is not merely a multimedia production exercise to demonstrate his ability to apply skills. Although the end product of his work is a fragment of an overall game concept, the process he undertakes to produce it allows him to have some control over both the technological process and the game's genre conventions. The work has, therefore, provided him with an opportunity to experience agency.

Conclusion

This chapter has investigated the opportunities for agency for students in media education classes as they work on digital media production and acquire technological skills. It is important to consider these possibilities because media education increasingly occurs in digital media production contexts. Many educators have long held the position that the key goal of media education is to help students to become more critical, and this capacity has often been developed through critical reading and decoding practices. Where media production has occurred, it has been considered a practical application of critical reading. It has not been my intention to suggest that critical reading and decoding are unimportant; they clearly still have an important role to play. Rather, I have argued that there may be other opportunities for agency that do not rely on critical thinking. Within the download and remix cultures of the Internet and through processes of digital media production, young people are playing with, experimenting with, and producing a range of media that offer opportunities for agency.

These changing cultures of production suggest it is necessary to change the culture of formal media education. Post-structuralism offers lenses for considering the relationship between young people and media that are different to those provided in the past. Media educators may be able to provide students with opportu-

nities for agency by giving them access to skills and by allowing them to experiment with genre conventions. Analysis of work conducted within the Video Games Immersion Unit suggests that skills acquisition is necessary for students to have some control over production processes, and where this allows them to participate in video game design and production, there are likely to be opportunities for agency. Students have opportunities to experience agency as they conduct technological work upon themselves and enter communities of practitioners where their skills are recognised and valued. They may experience agency through the variation of norms, and they may have opportunities for agency as they work as digital bricoleurs, experimenting with both technological processes and generic norms. Media and young people's relationships with media will continue to evolve. Formal media education must also continue to evolve, seeking out new explanations and new opportunities for the ways in which young people can use media to productively act upon their social and cultural worlds.

Notes

1. There are different versions of the media education key concepts framework.
2. For anonymity, I have used the pseudonyms chosen by the students for use in the online space used during the Immersion Unit. For a discussion of the implications of these pseudonyms see Dezuanni (2010).
3. A walk cycle is an animation technique used to create the impression that a character's legs are walking. They are often complex and time consuming to create as they require numerous single images to be created.

References

Althusser, Louis. 1971. *Lenin and Philosophy and Other Essays*. New York: Monthly Review Press.

Barthes, Roland. 1972. *Mythologies*. New York: Noonday Press.

Buckingham, David. 1995. *Making Media: Practical Production in Media Education*. London: The English and Media Centre.

———. 2003. *Media Education: Literacy, Learning and Contemporary Culture*. Cambridge: Polity Press.

Buckingham, David, and Kate Domaille. 2009. Making Media Education Happen: A Global View. In *Media Education in Asia*, edited by C.-K. Cheung. New York: Springer.

Buckingham, David, and Julian Sefton-Green. 1994. *Cultural Studies Goes to School: Reading and Teaching Popular Media, Critical Perspectives on Literacy and Education*. London, UK and Bristol, PA: Taylor & Francis.

Burn, Andrew. 2009. *Making New Media: Creative Production and Digital Literacies*. New York: Peter Lang.

Butler, Judith. 1990. *Gender Trouble: Feminism and the Subversion of Identity*. New York: Routledge.

———. 2004. *Undoing Gender*. New York: Routledge.

Davies, Bronwyn. 2000. *A Body of Writing, 1990–1999*. Walnut Creek, CA: AltaMira Press.

Derrida, Jacques. 1990/78. *Writing and Difference*. London: Routledge.

Dezuanni, Michael. 2010. Digital Media Literacy: Connecting Young People's Identities, Creative Production and Learning About Video Games. In *Adolescents' Online Literacies: Connecting Classrooms, Media, and Paradigms*, ed. D.E. Alvermann. New York: Peter Lang.

Foucault, Michel. 1984/77. Truth and Power. In *The Foucault Reader*, ed. P. Rabinow. London: Penguin.

———. 1987/84. *The History of Sexuality Volume 2: The Use of Pleasure.* Harmondsworth, Middlesex: Penguin.

———. 1988/84. *Technologies of the Self: A Seminar with Michel Foucault.* Amherst: University of Massachusetts Press.

———. 2000/84. The Ethics of the Concern of the Self as a Practice of Freedom. In *Ethics, Subjectivty and Truth*, ed. P. Rabinow. New York: Penguin Books.

Giroux, Henry. 1994. *Disturbing Pleasures: Learning Popular Culture.* New York: Routledge.

Goodman, Steven. 2003. *Teaching Youth Media: A Critical Guide to Literacy, Video Production & Social Change.* New York: Teachers College Press.

Hall, Stuart, and Paddy Whannel. 1967/64. *The Popular Arts.* Beacon series in contemporary communications. Boston, MA: Beacon Press.

Kearney, Mary Celeste. 2006. *Girls Make Media.* New York: Routledge.

Leavis, F.R., and Denys Thompson. 1933. *Culture and Environment.* London: Chatto and Windus.

Luke, Carmen. 2001. New Times, New Media: Where to Media Education? *Media InternationalAustralia Incorporating Culture and Policy* 101 (November): 87–100.

Marcuse, Herbert. 1986. *One-Dimensional Man.* London: Ark Paperbacks.

Masterman, Len. 1985. *Teaching the Media, Comedia Series; no. 26.* London: Comedia.

———. 1990. *Teaching the Media, Comedia Series.* London and New York: Routledge.

Schwartz, John. 2006. Reinventing the Media Classroom: Arguments from Both Sides. *Australian Screen Education* (42): 48–52.

Thompson, Denys. 1973. *Discrimination and Popular Culture.* 2nd. ed. Harmondsworth: Penguin.

Turnbull, Sue. 2006. Teaching for the Revolution: The Long March of Media Studies. *Media International Australia Incorporating Culture and Policy Journal* 120: 181–190.

White, Shirley A. 2003. *Participatory Video: Images that Transform and Empower.* New Delhi, Thousand Oaks, CA, and London: Sage Publications.

7

"Because It's Not Really Me": Students' Films and Their Potential as Alternative Media

David Levin

In this chapter, I wish to illustrate the potential for political education to be found in the production of student films. I would like to suggest that this may be done by connecting students' production processes to concepts of alternative media and cultural public sphere. I propose to convey this point while analyzing some case studies taken from ethnographic research that I conducted with the aim of examining cultural identity among adolescents living in an Israeli town called Zur Hodaya.

Student films in this study made it possible for new voices to be heard, and to talk about a relevant and sometimes subversive agenda. Their creators made use of the positions of implied writer or a character, along with the special relations made possible in this genre between producers, actors, and audience, in order to discuss issues like sex roles, ethnicities, and school culture.

Nevertheless, this discourse was intellectually infertile and although the potential to create a dialogue exists, the creators preferred to speak as if in a monologue without really listening to one another. From this we can see the importance of instruction in order to strengthen students' social knowledge and improve their conversational abilities.

Introduction

It happened in one of the tenth-grade production lessons, when all twenty students aged fifteen to sixteen were asked by their teachers to transmit a message through the camera. Some of the female students were matched up to illustrate a

"fashion show." In one of the shots, the photographer moved her camera along the body of her friend, who was lying on the grass and rolling up her shirt. In another film the actress, wearing red lipstick, bent down and acted as if she were about to kiss the camera. After the projection of these short movies, the teacher asked the girls to explain what was going on in their minds. Without hesitation they replied "modeling" and "sexiness."

From a feminist point of view, it is clear and also problematic that the girls used the camera to announce the centrality of the "look" in their identity "above and beyond any other possible role" (Lemish 2003, 27). However, close observation of the contextual meaning of their acts offers a different perspective. The freedom to counter the cultural industry definition upon their personal body was an alien experience to these girls in a school context. In daily life, they were subject to surveying gazes and sometimes insulting remarks, all with the purpose of imposing chaste clothing and behavior upon them. In other words, the production enabled them to make themselves heard, employing a voice that they had not used before. The would-be actresses could escape their daily, politically correct selves by the performative statement of "we are making a movie" (adding periodic exaggerated body movements to make sure that no one thinks that it's really them). They also tended to defend themselves from criticism by making sure that only girls were involved in the production process and even hinted that boys and male teachers were unauthorized voyeurs and thus actually had no normative stance to discuss the girls' actions.

This event demonstrates the aim of the chapter: to examine the potential that students' films have as alternative media, which involves creating a cultural public sphere—a space in which students could discuss, in a modus of dialogue, relevant matters by using a fresh and authentic voice. I'll also discuss the limitation of production that takes place without a learning process and, finally, I will suggest the conditions by which one may use this genre effectively as part of political education.

Cultural Public Sphere, Alternative Media, and Student Films

Public sphere is a key term in democratic theory. Jürgen Habermas (1962) defines this term as meetings for the sake of political discussion in which participants are normatively obliged to put aside their private interests and statuses. They are allowed to express their opinions freely after paying close attention to others. The end result is an agreement on basic opinions that lead up to political action.

A close reading of the theory of public sphere shows a distinction between the political public sphere, in which people negotiate and delve into problems of the here and now, and the cultural public space, in which people discuss deep and fundamental problems of identities and representations in society. In the latter

model, popular culture contents and fictional characters can be used to discuss what is made through suspension of disbelief (McGuigan 2005). The public sphere model in general has been subject to criticism as being a conservative, elitist and old-fashioned model that legitimates discrimination (McQuail 2005).

Nancy Fraser (1990) pointed out that the heterogeneous statuses and differences in rhetorical abilities of participants cannot be the sole reason why they prevail or not. Not everyone can invest the time needed to participate in public discussions or have the ability to make their voice be heard and ensure that everyone takes them seriously. Also, Fraser states that the definition of "what a public matter is" is not obvious. For instance, at one time marital violence by husbands against their wives was denied or treated as "not a public matter."

The ideal model of Habermas refers to face-to-face interaction, but even he believed that in mass society the role of mediated communication in creating a public sphere must be taken seriously. He criticized the current situation, naming it re-feudalization of the public sphere (Habermas 1962, 193), meaning the lack of access ordinary people have to the public sphere, and the lack of rationality and mutuality that exist among the participants in the mass media arena. Where public sphere discussions are controlled by public relations experts, the aim is not to maintain dialogical relations with their partners and audience but to enforce their opinion by using rhetorical and even irrational devices.

Mass media, which works by the principles of the "professional model" (McQuail 2005), has also been subject to criticism as taking part in the discrimination game. Media discussions make it abundantly clear to ordinary people that their opinions count less than those of the reporters, the professional interpreters or other experts (Hallin 1994). In most instances, ordinary people are not allowed to represent themselves or to take part in any interaction based on dialogue and mutuality.

In conclusion, the idea of the public sphere—as well as its supplements and criticisms—revolves around these common principles:

- *Voice*: are all relevant voices being heard?
- *Subjects*: what are the relevant subjects to be discussed?
- *Modus*: how can it be ensured that everybody listens to everyone?

One of the solutions to grappling with the problem of silent voices in media arenas is to create sphericules (Gitlin 1998), that is, contexts in which participants with specific similarities feel more comfortable expressing themselves.

For example, the "indigenous movie" projects made thirty years ago in Third World communities (including inhabitants of the Brazilian rain forests or Australian aborigines) asserted a unique political voice by using audiovisual means (Chal-

fen 1991; Turner 1992; Ginsburg 1991) in issues that were important to the creators and their audience, such as cutting down the forests in Brazil.

Finding an alternative way to create a voice for a relevant agenda does not necessarily solve the problem of relation and interaction among the participants. There remain questions that concern not the content of communication but the actual process of exchange. Is there a conversation? Are people really sharing opinions? Are people committed to listening to one another? Are there people whose opinions count less or more than those of others?

Hans Enzensberger (1972) refers to those questions by suggesting an operational model of an "alternative media" that allows for producing programs from everywhere (meaning that everyone who has opinions on a certain matter can join in as a producer). Additionally, he focused on intense interaction between the participants that makes for a production of a collective nature (although even in this sort of production, the democratically elected editor still has the "last word"). I'll use this framework to discuss students' films.

Students' Films as Tools for Self-Expression

One of the major aims of filmmaking in educational contexts (formal or informal education) is to help students to express themselves. Through filmmaking, students are expected to find their voices that have been silenced, or to frame their own place in society and raise their personal or collective agenda (Mayer 2000; Packard, Ellison, and Sequenzia 2004; Fleetwood 2005; Ranker 2008; Tinkler 2008; Podkalicka and Thomas 2010).

For instance, the "critical pedagogy" legacy (Shor and Freire 1987) regards this authenticity as a way to promote a revolutionary agenda in school for the following reasons. First, it makes the producer's daily knowledge and audio-visual material relevant in school. This will help to empower the creators and challenge school institutional power, all the while employing a tool of high culture. Second, challenging school knowledge by making use of the movie technology makes for a different literacy from the hegemonic printed word. Third, self-production symbolically challenges the images produced by the media industries (Hodge and Tripp 1986; Apple 1990; Higgens 1999; Stack and Kelly 2006).

There is some criticism of those approaches that focus on empowering through "voicing" (Orner 1992; Soep 2006). On the one hand, when "student voice" is proclaimed as a major aim, teachers tend to ignore the quality of that voice and—even worse—to ignore the creators' racist or sexist opinions that might be expressed in the film. On the other hand, if teachers prefer to instruct the students on the nature of the "proper voice," teachers lord their own cultural capital over students, as regular school educators tend to do.

Besides that, because filmmaking (unlike songwriting) is by nature a collective process, we must keep on asking: Which "voice" are we hearing—the director's? the actor's? the teacher's?—as the implied audience? This is especially true for students' films, in which the definition of roles and hierarchies between team members are not clearly enforced by the legal power of a contract. This emphasizes once again the importance of the modus of interaction between the participants.

Film Producing: Is It Really Me?

Filmmaking is one of the special contexts in which people can go beyond their regular identities while trying on different ones. Literary analyzers suggest useful distinctions between the "implied writers" of a production, meaning personas or implied images of writers inside the text and the "real authors," that is, the writers themselves (Booth 1983) or, in the case of movies, the personas of the crew members (Kozloff 1992) who actually create the film. The implied authors have much more freedom in identity experimentation as compared to the real identity each one of us holds in our daily lives. They can change their "identity" from story to story or "split" their thoughts between themselves and their narrator or characters.

Gerry Bloustien (1998) makes a connection between identity experimentation and students' films when he assists ten adolescent girls in producing video diaries about their lives. He learns that by using the camera and adopting televised conventions (such as televised interviewing or hidden camera scenes), the girls can try on possible identities and also construct a reflexive gaze on the self they made for the camera. Julian Sefton-Green (1993) has also demonstrated the identity relations between a teenage boy's daily concerns and a hero of his script. He projected his hesitation about his abilities to fulfill the demands of masculinity that are dictated by culture onto the character he wrote, who thinks that he never has enough weapons to arm himself against all his enemies.

It seems that students' films can be studied through analysis of their pragmatic side. The content has much to do with the ongoing relationship between the participants and the researcher/photographer or the teacher. In other cases, the relationship to be considered is that which takes place among the production team or between them and their day-to-day acquaintances. For instance, if we are to return to the beginning, the girl "models" make sure by their over-provocative behavior that everyone will understand that they are not really serious.

That means that, all in all, identity experimentation is allowed in making students' films, but the practice is limited. This balance is one of the things that makes students' films unique and worthy of study as social expression, as compared to writing in diary fashion or even identity experimentation in Internet chat.

Research Field and Methodology

This work aims to define and demonstrate the potential of producing students' films to fulfill the utopia of alternative media and to help, in a way, to transform school into a cultural public sphere and thus make a contribution to political education.

The research took place in the film department of the local high school of Zur Hodaya[1] over a period of two years. Zur Hodaya is a small town with about 30,000 residents. It is a microcosm of the problematic ethnic split among Israeli Jews, "Western" Jews who immigrated to Israel from America and European countries, and "Eastern" Jews who came from Asia and Africa. In this setting, Western Jews are the economic and cultural elites based on every social measurement, including income and education; also, they have a crucial influence on maintaining the Western cultural orientation of Israeli society.

Many of Zur Hodaya residents are poor Eastern Jews. They arrived in Israel from Muslim countries during the 1950s and from the Islamic republics of the former USSR in the 1970s. They hold conservative religious beliefs that express themselves through the control of religious parties in the local coalition and through conservative norms concerning gender roles.

The town had a bad reputation, and the residents were on the receiving end of insulting remarks on a daily basis. The media also helped to maintain this image by reporting the town only in connection with poverty and crime stories. The local youth, born mostly in Zur Hodaya, had to distinguish themselves from the negative image of Eastern Jews and also from the perceived image of their hometown. Girls were further burdened with their inferior social status in the local religious setting.

The core of the study was a two-year participant observation that took place in the film department at Zur Hodaya High School. This department was the biggest one in the school, with a population of 250 students. One-quarter of the school's students were studying film.

I focused on day-to-day interaction as well as on production processes. I held informal interviews with four teachers who worked in the department, with executives and instructors from the youth department of the local authorities, and also with the students–creators. I also did a semiotic analysis of eighty films.

I was introduced to students as a media teacher doing research about students' films to aid me in my work and also in the work of other teachers. Adopting this role, and my actual engagement in the day-to-day activities of the department, made the students treat me as a teacher-researcher.

Previous research (Sefton-Green 1993; Gillespie 1995; Levy 2008, Stack 2009) has shown that the role of teacher helps an adult to get close to youth culture by being a natural part of the surroundings. Playing the role of a non-formal

teacher (being an "outsider") helped me to minimize the possible problematic relations between student and teacher and to play the "least adult role" (Mandell 1988).

I attempted to find homological relations (Willis 1978) among the content of the films, the production discourse, and the regular discourse of schoolyard and classes. This triangulation helped me to create a comprehensive "thick description" and to offer contextual interpretation (Lather 1986; Seale 1999) of the types of discourse enabled by filmmaking.

The Case Studies

In order to introduce the potential and the limitations of this genre, I have chosen case studies for this chapter that were taken from the first two years of the study. I'll also focus here on my experiences with students from the "Kidum" project. This project (*Kidum* means improvement) was the last chance for twenty boys and girls who were in danger of dropping out of school and being forced into premature employment in the labor market. They were tired and frustrated from many years of failure in schools and were very wary of their future. They were dealing daily and intensively with questions of identity, yearning for self-expression but short of literary skills. This may explain why they became fruitful film producers who, in a period of two years, were involved in producing thirty films. Many of the films deal implicitly with questions of gender, ethnicity, and school knowledge

The Films of Meital

Meital,[2] a fifteen-year-old girl, was one of the active producers in the Kidum class. Her works dealt mostly with questions of generation gaps and sexuality and aimed to produce a provocative voice that she hesitated to employ in daily life. In her first year of study, she produced and acted in a studio improvisation called "The Snobbish Girl."

In the first scene, she approached a couple of boys who were playing cards at a café while listening to music by Zohar Argov (a popular Eastern Jewish singer who died of a drug overdose at a young age). The boys were also shown cracking sunflower seeds and dropping the shells on the floor. She made fun of their choice of music and recommended that they listen to better music, such as songs by Aviv Gefen, Ramy Klienstein or David Broza (mainstream Western Jewish singers).

Boy: You are just stupid.

Meital: Shut your mouth, you and your friend are worth no more than the Iraqis. (The older generation, immigrants to Zur Hodaya from Iraq)

Boy: What do you have against those Iraqis?

Meital: Nothing, but I guess that you look like them and will grow up to be exactly like them.

The boys pushed her out, and she declared that she had to go to work and strutted away, swinging her bottom as she went. The boys looked after her, and one of them made an insulting remark in Arabic about her manner of walking.

Everybody in this set was using the floor to make a "voice." The introduction of the studio as a café and the boys' behavior were aimed at challenging school rules that forbid card-playing, eating, and drinking during lessons. Listening to Zohar Argov was not considered legitimate in the daily school context. When the teachers did show a popular movie about his life, it was in the context of an anti-drugs day.

But while Meital's friends used the stage for "making movies" to display a rather automatic gesture of resistance against school order, Meital mocked their resistance. She made the connection between the lower cultural taste and lower social strata. "Those Iraqis" she mentioned were the café regulars in Zur Hodaya, a group of exclusively male members of the older generation, all of them unemployed, frustrated, with no hope for a better future. They just sat there all day long, listening to music from the old country and playing cards. The singers that she included under the label of "better singers" were all mainstream performers, all regularly chosen to perform during national ceremonies and on prime-time television shows.

Meital challenges both the hegemonic control of the boys in her class and the patriarchy in school and in Zur Hodaya as well. She reminded the boys of what they wanted to forget, that is, that male hegemony in Zur Hodaya (represented in the term "the Iraqis") had become pitiful from the point of view of someone from the outside. This reminder made the boys' blood boil, but they had no good retort for Meital, so they decided to change the subject and pay her back by mocking her on the basis of sex roles.

Surprisingly, Meital herself, after challenging the boys, began to dance according to their tune. While the improvisation continued, she began to give reflexive clues toward the character she was portraying. She made herself talk funny and began to move her body using sharp movements. After some rehearsals, she decided to call her piece "The Snobbish Girl." While asking for my help to find the proper light to shoot the caption, she said, "What do you say, David? Don't you think it's a good name for this girl?"

Meital used the "it's not really me" situation to challenge the boys who make her feel inferior in daily life. But she did not have the knowledge or courage to persevere, which she might have done by expressing the ambivalence she felt about the Eastern music singer.

In daily life she herself used the Eastern music as a common ground with the boys: They used to frequent clubs that specialized in Eastern music on weekends and talk about those performances afterward.

She prefers to relinquish her pre-movie position as a fan of Eastern music, and used the flexibility she is allowed as both author and character to undermine her provocative character. Nevertheless, she tried to get my approval of the movie she made, and maybe empower herself, so that she would be able to go back and handle the crucial cultural debate she started.

Meital continued to deal with questions about gender and locality in another film she made during the documentary project of the second year of her film studies. The film opened with a shot of Meital's grandmother working in a kitchen washing dishes. We hear Meital asking, "Granny, it's boring to be alone, isn't it?"

This question triggered a scene that centered on the grandmother relating the story of her life. She described how she had suffered in her marriage until she decided to get a divorce and raise her nine children by herself. She told the camera how today, in her old age, she is left alone unless she takes care of her grandchildren. She invited the crew to her bedroom and showed them her huge collection of family pictures hanging on all the walls that functions as a tool to tide over many years of lonely nights. The movie ended with a shot of her sitting in the balcony and introducing to the camera her plants, which she refers to as "her best friends."

At the beginning, the "voice" that Meital used to frame her grandmother's life story was cold and alienated; it conveyed both her opinion about the inability of the older generation to serve as a role model and her fantasies of being a "reporter." The grandmother was portrayed as a mother and housewife who was used and manipulated.

The implied failure in Meital's eyes of the grandmother both as a spouse and as a mother was very meaningful for her. In daily discourse, she asked herself constantly if the traditional image of a woman could serve as a source of empowerment for her, as a girl who was very pessimistic about her future employment career.

She informed everybody that she was in charge of all housework in her family and did it well. In one of our talks she criticized a mother whose children had been injured and burned because she "did not keep her eye on them." "What kind of a mother was she?", she wondered. One day she even criticized me for my scruffy shoes and suggested she "clean them up" for me. Nevertheless, in her movie Meital expresses her disappointment in her grandmother by positioning herself at the beginning of the film as a tabloid journalist who tries to create a "negative human story." She objectified her grandmother by asking her, among other things, to tell the camera horrifying stories about her life with the missing grandfather, but later

she allowed the old woman a lot of space to deliver her message to the other members of the family. For example, the grandmother directed the shot of herself with the plants. She also initiated a phone call to one of her friends, complaining that she was punishing her by not paying her a visit.

In other words, during the production the journalist's voice became weaker and the voice of the grandmother was amplified so that it seemed for a moment that Meital and her grandmother had created a protest document against the grandmother's present marginality. Nevertheless the last version of the film still holds both contradictory voices—that of the journalist and that of the grandmother—and Meital refuses to take a stand.

I learned more about that ambivalent feeling that Meital had toward her grandmother's "voice" when she asked me to review her film before she showed it to her teacher and peers. I said that I did not understand her ambiguous message and asked her to add a vocal statement about her relationship with her grandmother.

Meital: What can I say?

Me: Say something like: this is my Granny and I love her so.

Meital: I can't, I'm a bit embarrassed.

Me: Don't you like your granny?

Meital: Of course, everybody loves their granny.

I suggested that she conclude her movie with a shot of an initiated family reunion in which everybody would be asked about their feelings toward the grandmother, and she answered that it would be very hard for her to organize such a meeting because everyone is far away

In retrospect, I understand that the ambiguous message was the message itself. Meital did not want to produce a "voice" but preferred to introduce "voices." She wanted to reflect a discourse that included both love and disgust with her grandmother and maybe with the older generation of Zur Hodaya (as in her previous work), but once again did not have the intellectual resources to express her complicated thoughts. In what follows I shall examine another example of using film-making to transfer and broaden daily discussions about cultural identities, locality, and ethnicity.

In-between "Eastern" and "Arabic" identity

One day I was asked to help two male students, Motty and Shmulik, to create a script for their project. Motty told me that he wanted to make a video clip for an Eastern song by Yossi Atar. He added that he had chosen this song on purpose,

because everybody in school, who hesitated to challenge the teachers' Western cultural tastes, preferred to make video clips on rock and roll music of highbrow Israeli singers.

First, he tried to see how far he could go with his assertion. He asked if I was familiar with the singer, and sang a snatch of one song while looking intently at me, trying to locate a hint of disgust. When I said I was not familiar with this singer, he replied that it did not matter because not many people really know who Yossi Atar is.

Motty decided to use Atar's song to support his "voice" challenging school, similar to his friends playing visitors at the local café while listening to Zohar Argov.

But the choosing of Yossi Atar was even more provocative. Unlike Zohar Argov, who was accepted as a legitimate performer even among certain Western audiences, Yossi Atar was a "depression songs" performer, a sub-genre of Eastern music treated by middle-class Israelis as the lower level of bad taste. Using this kind of song was designed to provoke the school's middle-class culture that distinguishes between "artistic" and "bad taste."

From this point, he started to tell me the story of his video clip. The story began with a card game in which the hero lost all of his worldly goods one after the other: first his money, then his gold chain, and finally his car. After that, the hero went home. Shmulik (Motty's quieter friend) joined the discussion at this point and described the way the hero climbed up the stairs while "dragging his legs." When he paused by the mezuzah (a scroll of parchment containing biblical verses fixed on the doorposts of a Jew's home), Shmulik suggested that he kiss it hard because "in this kind of situation people tend to become religious."

Motty was embarrassed by his friend's reference to becoming religious in a bad situation and insisted that his hero would be satisfied with just a perfunctory kiss of the mezuzah. A friendly fight ensued, and Shmulik gave in. Motty concluded the first part of the story with a description of a short interaction between the hero and his wife that ended when the hero was ordered to leave his home. His wife even threw a small suitcase after him.

Motty's voice represents authentic, local concepts. The car was a sign of wealth and freedom, the complete opposite of stark daily life in the seedy, small town. The chain symbolized the connection to the parental generation. Every boy in Motty's class had a golden chain (called a Gurmat) around his neck, given him in his Bar Mitzva or other family ceremonial circumstances.

Shmulik's voice offered the world of religion—a familiar alternative in local terms to the world of material objects. During the years of the research, I discovered that religious spirit and missionaries were part of daily life in the Zur Hodaya. Nevertheless, neither Motty and Shmulik nor their friends displayed any form of

religious life or began to dress like religious persons (for instance, wearing a skull-cap). Becoming religious remained an option, symbolized by the quick kiss to the mezuzah but not a last word in identity discourse.

The removing of all familiar and desirable objects and accessible identities can be interpreted as a plea such as "what can the world offer us if we don't possess these?"

The second part of the story began with the hero wandering among stands in the local market ("where the poorest guys hang out"). Here, Motty suddenly paused and asked me if I had an idea for additional music for this scene, because the song "All My Life Is Trouble" was too short. Speculating at that time about the cultural roots of Eastern music, I recommended that Motty choose a song of the Egyptian singer Um Kultum. Motty was embarrassed and refused. Finally he turned and informed his friends, half jokingly, half humiliated, "Hey, listen. David wanted me to make a clip with Arabic music."

Here Motty exposed the limits of "it's not really me," showing that the gate is not open to every possible experience. Motty was ready to use film production to vocalize a challenge of school culture. However, he was not ready to adopt the older generation's identity based on Arabic culture.

The decision about the nature of the complementary music was abandoned and Motty moved on to describe the last scene: The hero found two shekels (half an American dollar). After that, he listened to the sports program in the local café. At the end of the program, the hero learned that he had won the big prize in the soccer lottery. In the last scene, he was seen driving a Mercedes and parking near his new house in a rich neighborhood, climbing out of the car along with his wife, and showing her their new home. They hug and kiss.

The ideological stance implied at the end of the story, the one that Motty wanted to deliver to his friend and teachers, was "let us count on luck and money." The expulsion of the hero from his home and family, as well as his salvation, was made on the basis of his ad hoc fortune. This is implied by the order of events suggested in the narrative. The loss of property preceded the loss of his family's affection, and he wins his family back only after winning back his money. By using that order, Motty asserted that he preferred this stance over any act of solidarity with family, the religious system, or mobility through education.

A week after that, Motty introduced me to his friend "Tomer the musician" and informed me, as part of his rebellious stance, that they had both agreed not to enlist in the army when the time comes, even though it is obligatory to do so. Then they began to play the music. All of a sudden I found that the "rebel" had been persuaded to enhance his movie with Western trance music. Motty explained to me that his friends had suggested that he soften his provocation.

Then I heard the voice of Zehava Ben (who is considered a more mainstream Eastern singer, like Zohar Argov), and Tomer explained: "At this point, the hero lost his property and he had the 'evil eye,' and I want to show through music what was going on in his mind."

The combination of Zehava Ben with trance music still indicated that Motty and his friend wanted to use the genre of students' films to be heard making a point. At the same time, it also taught me about their unclear and unstable position in a cultural debate that may eventually lead to submission to basic hegemonic assumptions embodied in Israeli culture. The expression of this is found in Motty shunning Arabic music and thus connecting Eastern music not to respectful or even ordinary behavior but only to a criminal state of mind, to "dark feelings" or to "getting out of control."

In conclusion, the discourse concerning the production of "My Life is Full of Trouble" demonstrates how students' films enable their creators to think of vocalizing in public discussion even taboo subjects in the context of school culture. Nevertheless, I also learned that there are difficulties that prevent films from becoming meaningful tools in a political debate. I'll discuss that in the closing section.

Discussion: Students' Films, School as a Public Sphere, Alternative Media and Education for Active Citizenship

According to my observations, students' films had the potential to fulfill the conditions of alternative media and help to create a cultural public sphere inside school. Because of this potential, the process of production can serve as a part of political education.

The components of the students' films relevant to the idea of alternative media are as follows:

Relevance: The films introduced here—as do many others in my corpus—deal with relevant issues for adolescents living in Zur Hodaya, such as the intergeneration relations, cultural strata, and gender roles. I found meaningful homological relations between daily talks and the films' messages.

Voice: The films enable students to express opinions that are rarely heard on other occasions. This was demonstrated when creators and actors (using the mask of "it's not really me") tell the stories of unacceptable characters in the school context, like playing models or Eastern music fans.

From the perspective of the critical pedagogy legacy, making movies in itself was an alternative to school-printed literacy. It allowed boys and girls who find school literacy difficult to make their voices heard by using other means and also

to assert their views against Western-oriented school culture, local orthodox culture, or patriarchal culture.

Leveling boundaries in relations: Because of the stance of "it's not really me" that is enabled by film production, it is possible to level some hierarchies discussing public matters. This is apparent in comparison to mass media discussion about public matters and also, more importantly, in comparison to the daily discussions between the participants, such as students and teachers or boys and girls.

In other words, producing students' films had the potential to transform school into a cultural public sphere in which people with different agendas and cultural tastes can talk relatively freely about identity politics and other public matters. This might not be seen as "making movies change school" but as part of a more open attitude to students in the educational system, represented, among other things, by the idea of teaching media literacy in formal education (Buckingham et al. 2004).

Nevertheless, as I observed, "feel free to make your voice" is not synonymous with political education. Several obstacles must be overcome for this to be achieved.

Simplicity: Although the students I observed got the opportunity to make a voice for themselves, they didn't have much to say. Their claims were banal, and they were easily silenced or preferred to silence themselves.

Meital had no resources to keep up a feminine and liberating dialogue with the boys. I also would have been happier if she could have used the film to deal with the structural difficulties that her grandmother had to face (as an old, Eastern, female Jew) in the present, as well as in her past.

The girl models as well as Motty used only cultural industry solutions. The models had only their bodies to assert. Motty finished his film with a rather banal and melodramatic ending in which the hero climbed up from the depths of trouble and went on to his salvation as he arrived at the peak of a mountain of money, which he gained by chance.

Enriching the films discussed here, and many others, in points of view and narrative complexity can become a general aim of social science studies in high schools. I would be pleased if Motty and his friend were to use filmmaking to delve into a deeper critical discussion about the issues that bother them: the cultural status of certain music or the reasons to ignore the nomination of local youth to desirable army units.

Modus of interaction: The leveling of relation did not create a dialogue. The models challenged social norms, but they did not discuss them with their teachers

or friends. Meital didn't really discuss her grandmother's life. The boys and Meital (in "The Snobbish Girl") were using their voices only to insult one another.

In other words, rich and meaningful political discourse based on mutuality cannot be achieved by asserting "we are making films." Several educational measures must be taken:

- First, participating in a cultural public sphere and searching for possible voices must function as a regular framework for judging daily news and media materials.
- Second, the producers must reach a relevant and deep knowledge about the roots and different meanings of problems that are part of their lives. Making films must be supported by knowledge obtained from book reading, surfing the web, and social science lessons or any other academic context.
- Third, although students' films support a modus of dialogue among participants, in order for those films to actually fulfill their potential, the participants must be obliged to follow common rules of the public sphere and the alternative media and be prepared to have conversations, not only make assertions.

 They must realize that although school encourages them to use films to make their voices heard, they must also listen carefully to other participants and comment seriously about their opinions[2].

Notes

1. The writer wishes to thank Tamar Liebes, Haim Hazan, and Dafna Lemish for their theoretical contributions and also Dorit Ballin and Yoram Shapira for their help during the research.
2. All names and places were changed for ethical reasons.

References

Apple, Michael W. 1990. *Teachers and Texts: A Political Economy of Class and Gender Relations in Education*. New York: Routledge.

Bloustien, Gerry. 1998. It's Different to a Mirror 'Cos it Talks to You. In *Wired-Up: Young People and the Electronic Media*, ed. Sue Howard, 115–133. London: UCL Press.

Booth, Wayne C. 1983. *The Rhetoric of Fiction*. Chicago: University of Chicago Press.

Buckingham, David, Shaku Banaji, Andrew Burn, Diane Carr, Sue Cranmer, and Rebekah Willett. 2004. *The Media Literacy of Children and Young People,* vol. 70. London: Center for the Study of Children, University of London.

Chalfen, Richard. 1991. Picturing Culture through Indigenous Imagery: A Telling Story. In *Film as Ethnography*, ed. Peter Ian Crawford and David Turton, 222–241. Manchester: Manchester University Press.

Enzensberger, Hans M. 1972. Constituents of a Theory of the Media. In *Media Studies: A Reader*, ed. Denis McQquail, 99–106. Harmondsworth: Penguin Books.

Fleetwood, Nicole. 2005. Authenticating Practices: Producing Realness, Performing Youth. In *Youthscapes: The Popular, the National, the Global*, ed. Sunaina Maira and Elisabeth Soep, 155–172. Philadelphia: University of Pennsylvania Press.

Fraser, Nancy. 1990. Rethinking the Public Sphere: A Contribution to the Critique of Actually Existing Democracy. *Social Text*: 56–80.

Gillespie, Marie. 1995. *Television, Ethnicity, and Cultural Change*. London: Routledge.

Ginsburg, Faye. 1991. Indigenous Media: Faustian Contract or Global Village? *Cultural Anthropology*, 6 (1): 92–112.

Gitlin, T. 1998. Public Sphere or Public Sphericules. In *Media, Ritual and Identity*, ed. T. Liebes and J. Curren, 175–202. London: Routledge.

Habermas, Jürgen. 1962. *The Structural Transformation of the Public Sphere: An Inquiry into a Category of Bourgeois Society*. Cambridge, MA: MIT Press.

Hallin, Daniel C. 1994. *We Keep America on the Top of the World*. London: Routledge.

Higgins, John W. 1999. Community Television and the Vision of Media Literacy, Social Action, and Empowerment. *Journal of Broadcasting & Electronic Media* 43(4): 624–644.

Hodge, Robert, and David Tripp. 1986. *Children and Television: A Semiotic Approach*. Cambridge, UK: Polity Press.

Kozloff, Sara. 1992. Narrative Theory and Television. In *Channels of Discourse, Reassembled*, ed. Robert Ellen, 67–100. Chapel Hill: University of North Carolina Press.

Lather, Patti. 1986. Issues of Validity in Openly Ideological Research: Between a Rock and a Soft Place. *Interchange* 17(4): 63–84.

Lemish, Dafna. 2003. Spice World: Constructing Femininity the Popular Way. *Popular Music and Society* 26(1): 17–29.

Levy, Leanne. 2008. The Skinny on This Is My Body: Filmmaking as Empowerment Intervention and Activism. *Visual Culture & Gender* 3: 7–29.

Mandell, Nancy. 1988. The Least-Adult Role in Studying Children. *Journal of Contemporary Ethnography* 16(4): 433–467.

Mayer, Vicki. 2000. Capturing Cultural Identity/Creating Community: A Grassroots Video Project in San Antonio, Texas. *International Journal of Cultural Studies* 3(1): 57–78.

McGuigan, Jim. 2005. The Cultural Public Sphere. *European Journal of Cultural Studies* 8(4): 427–443.

McQuail, Denis. 2005. *Mass Communication Theory: An Introduction*. New York: Sage Publications.

Orner, Mini. 1992. Interrupting the Calls for Student Voice in "Liberatory" Education: A Feminist Poststructuralist Perspective. In *Feminisms and Critical Pedagogy*, ed. Carmen Luke and Jennifer Gore, 74–89. New York: Routledge.

Packard, Becky Wai-Ling, Katherine L. Ellison, and Maria R. Sequenzia. 2004. Show and Tell: Photo-Interviews with Urban Adolescent Girls. *International Journal of Education & the Arts* 5(3): 1–19.

Podkalicka, Aneta, and Julian Thomas. 2010. The Skilled Social Voice: An Experiment in Creative Economy and Communication Rights. *International Communication Gazette* 72(4): 395–406.

Ranker, Jason. 2008. Composing Across Multiple Media: A Case Study of Digital Video Production in a Fifth Grade Classroom. *Written Communication* 25(2): 196–234.

Seale, Clive. 1999. Quality in Qualitative Research. *Qualitative inquiry* 5(4): 465–478.

Sefton-Green, Julian. 1993. Depressed and Violent: A Boy's Own Story. In *Reading Audiences: Young People and the Media*, ed. David Buckingham, 135–158. Manchester: Manchester University Press.

Shor, Ira, and Paulo Freire. 1987. *A Pedagogy for Liberation: Dialogues on Transforming Education*. South Hadley, MA: Bergin & Garvey.

Soep, Elisabeth. 2006. Beyond Literacy and Voice in Youth Media Production. *McGill Journal of Education* 41(3): 197–212.

Stack, Michelle. 2009. Video Production and Youth–Educator Collaboration: Openings and Dilemmas. *McGill Journal of Education* 44(2): 299–319.

Stack, Michelle, and Deirdre Kelly. 2006. Popular Media, Education, and Resistance. *Canadian Journal of Education/Revue canadienne de l'éducation* 29(1): 5–26.

Tinkler, Penny. 2008. A Fragmented Picture: Reflections on the Photographic Practices of Young People. *Visual Studies* 23(3): 255–266.

Turner, Terence. 1992. Defiant Images: The Kayapo Appropriation of Video. *Anthropology Today* 8(6): 5–16.

Willis, Paul. E. 1978. *Profane Culture*. London and Boston: Routledge and Kegan Paul.

8

Changing Hats: From Practitioners to Practitioner-Researchers

Ivana Espinet,
with contributions from Katina Paron,
Lisa Denerstein, and Sanda Htyte

Introduction

This chapter focuses on two cohorts of the Youth Media Fellowship (YMF), a professional development program for youth media educators developed by the Youth Media Learning Network (YMLN) in New York City. Each of two cohorts of fellows represented a range of professionals teaching in different contexts: public schools, community-based organizations, youth media centers, and after-school programs. They varied in the type of media that they taught, as well as in the model of youth media to which each organization or school subscribed. They represent the diversity of approaches, settings, and goals that is typical of the youth media field in the United States (Tyner 2003, 2007).[1]

The YMF was set up as a professional development effort, using a model of fostering professional inquiry communities that looks closely at pedagogical practices. Over the course of nine months (September to May), each fellowship cohort participated in biweekly meetings in which they explored their personal philosophies, ideas, values, beliefs, and core assumptions about youth media and education, as well as their practices, using various individual and collective inquiry methods. In addition, individual fellows pursued their own individual inquiries

and shared their processes and findings with the group. At the end of nine months of work, the fellows published their findings online through the use of a wiki, a collaborative tool for online content management.

Most youth media organizations have experience with outside researchers who come to do program evaluations or pursue their own research interests (Tyner 2007). While those relationships are important, and there are many examples of great collaborations, it is also essential for practitioners to have the opportunity to look at their own practices. Through YMF, participants recognized their expertise as practitioners and started to see themselves not merely as receivers of evaluation and research reports, but also as actors who engage in making sense of their experiences (Keenan and Fisherkeller 2008). They assumed the role of knowledge makers, rather than just consumers of knowledge generated by others.

In this chapter, I share my experience as the YMF facilitator,[2] and include contributions from three fellows in which they provide a window into their process at different times in the fellowship.

The Design and Method of the Fellowship

The design and method of the fellowship curriculum was informed by the "Critical Friends" model, which uses a methodology that fosters professional inquiry communities as a form of staff development for educators (Nelson et al. 2008; Curry 2008; Himley and Carini 2000). It was also influenced by the Educational Video Center's (EVC) study group model (Goodman 2003, 2006) that engages the staff in ongoing discussions about the theory and practice of their craft. "The EVC Study Group builds and sustains a culture of a 'learning organization,' a place where learning is collaborative, public, non-threatening, and is integral to the daily experience of both students and staff alike" (Goodman 2003, 6).

Teachers' collaborative inquiry groups have been part of school reform efforts for many years, yet this type of professional development is not as common in after-school environments and in the youth media field. Some organizations (Goodman 2006; Melillo 2008) have made an effort to have regular meetings or study groups in which they look at their practice or at general issues that they face as organizations. However, there are not many forums for youth media educators from different settings to share their practices and examine their experiences collaboratively (Keenan and Fisherkeller 2008). The YMLN was established as a collaborative effort between the Educational Development Center (EDC) and the Educational Video Center (EVC), with support from the Open Society Institute. The YMF was an attempt to address the need for media educators to have a long-term forum in which to come together and examine their work with young people.

In a 2005 survey of youth media practitioners done by the National Alliance for Media Art and Culture (NAMAC Youth Media Survey Database), 42 percent

of respondents identified that "staff need more support/training to work effectively with youth" as one of the main challenges. The same survey indicated that 42 percent of staff members of youth media organizations had had a length of service between zero and five years. Since the youth media field tends to have high turnover, there is a need for sustained staff development efforts that can support individuals as well as organizations and provide a forum for sharing practices. In addition, many youth media educators emerge from professional backgrounds as media producers or artists and with no training as educators (Dorsey 2007). While having media educators with professional backgrounds has many advantages, it also means that many practitioners feel that they need support in thinking about pedagogy.

Youth educators can often feel isolated in their work sites because of a lack of time in which to share their practices with each other. In addition, teachers who are working in schools and staff from organizations that work after and outside of schools do not often have the opportunity to exchange ideas and learn from each other's expertise. One goal of the YMF was to foster a community in which, through collaboration with others, the fellows could find a crucial source of support to sustain and enrich their work.

The foundation of YMF was built on the assumption that practitioners are experts in their field and are in the unique position of being able to make regular observations of their sites. It was based on the idea that knowledge is co-constructed and places a strong emphasis on the use of oral inquiry as part of the methodology. Describing the power of such a collaborative process, Margaret Himley explains that "through oral inquiry, teachers build the 'thick descriptions' that deepen their understanding of the local situation, while also opening up larger implications of their work" (Himley and Carini 2000, 200). Participants bring data that they collect at their site to share with the group as a means to deepen their own interpretations of the data and to examine implications related to their work. Through this process, they engage in the joint construction of knowledge.

During the course of the fellowship, we took notes during the meetings and collected artifacts produced by the fellows, such as brainstorming newsprints, feedback sheets, and responses recorded in writing, audio, and video. As the facilitator, I transcribed and brought back many of these materials during key moments for the fellows to reflect on their processes. In addition, they provided me with data to write this paper.

Sprouting Questions

As educators, asking ourselves questions during our practices is as natural as breathing. The hard and messy part is how to keep track of these questions and how to systematically pursue them.

The first part of YMF was dedicated to generating wanderings and identifying themes. For example, a common theme was the tension between process and product. A question that came up when the first cohort brainstormed challenges in the programs was "How do we meet the needs of youths with different learning styles and different levels of experience?"

We wanted to raise and frame questions without the pressure of selecting a single one to pursue. In order to do this, we introduced various tools (map making, journal writing, non-judgmental observations) that helped generate discussions about what it means to be youth media educators. The first step in the process was for the fellows to examine their own positioning.

Examining Ourselves as Researchers and Educators

Research is an interactive process, shaped by the researcher's own personal history, biography, gender, social class, race, and ethnicity and by those of the people in the research setting. Because we believe that it "is impossible to conceive knowledge without thinking of the knower" (Kincheloe 2003, 48), it was necessary for us to consider questions that the fellows needed to explore as "knowledge builders" to scrutinize their positioning: How do they identify themselves as educators and learners? And how do those characteristics influence their location as practitioner-researchers?

We started with the basics: describing what each fellow's work looked like, drawing and mapping their organizations, schools, programs, and workshops to better understand the context for their work. Some chose to map the physical space of their organization. Others created visual maps of their core beliefs. All of the fellows unearthed tensions and questions that were part of their everyday work.

The second task was to do some personal digging and reflecting on themselves as learners and educators. The goal was to get to know each other and to help to uncover the values, beliefs, and experiences that underlie and shape their work as educators. They explored questions such as: Who are we as educators? What experiences have shaped how we came to be youth media educators? What are the values, beliefs, and assumptions that guide our work?

Creating a space for fellows to examine themselves as knowers and educators proved to be extremely valuable. Through this space, we were able to uncover our definitions of the work we do. In one of the discussions with the first cohort, we talked about the word *teacher*. While we had some public school teachers in the room, some of the media educators talked about how they did not think about themselves as teachers. For them, the connotations of the word did not fit their organizations' models. Many of the fellows who worked in youth media organizations saw themselves as mentors, bosses, or supervisors. The word *teacher*, for

them, was connected to formal schooling. We were forced to rethink our assumptions about what teachers do and what teaching means.

Based on our experience with the first cohort, we decided to ask the second cohort to write a personal education philosophy. After sharing them, one of the fellows reflected:

> What stood up [sic] today was the space to think about our work in the context of our own ideology. I think that it was very valuable to hear people identify themselves and their history in the realm of youth work. I think that being knowledgeable of a group's history is the first step in becoming a family. (Fellow's journal reflection, November 21, 2008)

As this passage points out, one of the key aspects of the evolution of an inquiry group is the process of building trust and developing some common language and understanding about our work with young people and the media. Particularly important is "naming." A great deal of what we do as educators, the choices we make or do not make, we do unconsciously or semi-consciously as we borrow or adapt from our experiences in previous educational experiences. But the more we can explicitly name our understandings, perceptions, and assumptions, the more we can discuss and analyze our choices of strategies and methods.

What Are Some Important Questions in My Work?

> When we all realized that we had actual projects to complete, probably somewhere around month 3 or 4, there was a bit of panic in the conference room. Many of us had come in with one idea of what we wanted our project to be, but through the reflections, sharing and work we had done in the fellowship, [we] had become utterly confused and changed our focus many times. (Tene Howard, YMLN Presentation of Learning keynote, May 16, 2008)

The process of looking at and sifting through questions can be frustrating. As Tene pointed out, many fellows entered the process thinking that they already knew what they wanted to study, but instead found themselves puzzled and unsure after some of our explorations.

In order to enable the fellows to get deep into the "muck" of finding questions and deciding what and how to pursue them, we tried a number of strategies: They did class observations of their own programs and other people's programs, they observed individual participants in their programs, and they wrote about "critical incidents." (Critical incidents were short written pieces that attempted to capture a moment in the fellows' practice that was critical, either because it represented an essential aspect of their practice or organization/school, or because it was so unusual in the everyday routine of their program that it needed to be examined.)

Midway through the fellowship seminars, we spent one session looking through their notes, journals, and transcripts, figuring out what trends were emerging, as well as what concerns and ideas had persisted in their minds through the process of exploring their identities as educators, and looking closely at their settings as researchers. Some emerged with a clear query; others had to keep digging.

Both cohorts were composed of people with different levels of expertise in the field of youth media. A few fellows were doing a new project for the first time. In their case, we decided that the best thing was for them to document their process and see what emerged from what they collected. For this group, their queries emerged later in the process.

Sanda Htyte, a fellow from the second cohort who is an associate producer from Radio Rookies (http://www.wnyc.org/radiorookies/index.html), a youth media program in which young people (aged fourteen–eighteen) create radio stories for National Public Radio, describes in the following piece some of the tensions and challenges in figuring out what questions to ask.[3]

<div align="center">***</div>

Searching for a Question

by Sanda Htyte

Prior to my work with Radio Rookies, I worked in the field producing media on multiple platforms. However, I didn't have extensive experience working with youth from ages twelve–seventeen.

I came into the seminar not having a specific question I wanted to ask. One thing I knew for sure was that I wanted to be better at what I do. Still the question lies—what is it that I do? I wasn't quite sure of it myself, since I've been questioning my abilities, my teaching methods, and my work as a youth media educator/producer. I was still trying to define my role and understanding my purpose. As a youth media producer with Radio Rookies, we emphasize youth development and teaching high journalistic standards, through having students' voices heard by a mass audience. The role we play extends into many hats, from confidante, to therapist, to social worker, to mentor, to producer, to teacher—sometimes this can create confusion for the youth as well as the staff.

I had a difficult time focusing on one question since I had so many questions. My professional training was in media production. I was never formally trained to be a teacher or to work with young people. I learned almost everything about working with youth at Radio Rookies and from my colleagues.

During the beginning of the fellowship, I kept worrying: What is the focus of my research idea? One of the things that helped me was to place myself as the

learner. This helped me to try to define my role in my organization, in my own teaching philosophy, and in the field of youth media.

I also mapped the key moments in the workshop/production process. It helped me break down the parts of production, as well as see how they are supported by the teaching process. In my day-to-day work, I know what I have to do, but sometimes it becomes a routine and I don't reflect on what's happening. It was good to step back and really deconstruct the moments and collect examples of each step of our process.

In the end, I decided to look at the challenges of story development. From the very beginning of the workshop, we're working on the students' story ideas, getting to know them and making sure that their authentic voice and ownership of their story comes across to the listener. And throughout the whole process, the Rookies are developing critical thinking and analytical skills by reflecting on the information they've gathered and putting the pieces together for their final radio documentary. My questions were:

1. What is the appropriate balance between the authenticity and ownership of the Rookie's voice, while maintaining a collaborative approach between Rookie and Producer?

2. How can we adjust our approaches to working with individual Rookies on their stories according to their personalities, strengths, and weaknesses?

Some of the other fellows found their questions early in the process. For me, I had to investigate my work through the entire fellowship. Overall, the process of coming up with the research question helped me understand my role as a youth media producer-educator, critically reflect on the work that I do, and make sure to create a time for reflection.

Harvesting Data and Analyzing It

Some of the initial questions that the fellows raised about doing research were: How could they, as practitioners, do their work in their youth media organizations while also observing and gathering data? How could they keep track of what happened in their programs? Some of them decided to keep journals, others did interviews, many did observations of their programs and used video cameras and audio recorders to record different moments in the lives of their sites and their activities. Almost everyone collected student work in a variety of media formats.

One strategy that we used was the writing of critical incidents as a format to support their practice as researchers without interfering too much with their workday. The fellows wrote their critical incidents as an assignment and brought

them to one session to share and analyze with their peers. Writing critical incidents also allowed them to look closely at their work and find out how to tease out issues for further and sustained study from the business of the everyday. They wrote critical incidents early in the process and, for some, this strategy was key in shaping their questions.

Below, Katina Paron, who was the Editorial and Program Director for Children's PressLine (http://www.cplmedia.org) at the time she participated in the fellowship, shares her experience with gathering and analyzing her data and how recording a critical incident came at a key moment in her research.

Using Critical Incidents as a Framework to Inquiry

by Katina Paron

There are a lot of great things about using a collaborative approach in a youth media program—especially one that combines kids of different ranges and different experience levels in one team. At Children's PressLine, the youth journalism program I directed, this methodology provided opportunities for youth leadership and mentoring that fit naturally into the ethos of the organization. But after reviewing the data, it was evident that we were expecting the teen editors to be leaders and guides for the younger reporters, but that we didn't always provide the necessary training. Furthermore, we required experienced teens to assume the role as trainer based on their personal experiences, without giving them skills-based training that would make them feel more prepared in their roles.

I spent some time interviewing participants, analyzing work samples, observing team interactions, and reflecting upon current training methods. I made sure to involve youth journalists at all levels—younger reporters, older editors and members of all ages who were relatively new to the process. The goal was to understand how each member experienced the program in order to create a plan for improvement.

Interviewing the reporters, aged eight to thirteen, was the most revealing part of the process. They knew exactly what their editors' job was: "If I'm confused and I can't seem to find where I want to go with my questions, they'll give me a couple of example questions and put me on track and where I should be going," said Gabe, twelve.

Divya, twelve, saw the editors as "big sisters or brothers." "They don't make fun of us or insult us. They say, 'That's a great question.' Or, 'That's really good. You might wanna think about adding this.'"

Hearing the reporters talk about the editors in this way felt like a huge success. They were aware enough of the roles to understand that the editors were there to

guide them, but this meant they also caught editors who weren't so great at their job. "Sometimes they tell us the answer and it's not really the best way 'cause, like, the whole idea of doing this is so you can really develop your skills as a reporter," said Divya. "So I think they could teach us a little bit more, like guiding us rather than telling us the answers."

The methodology used at Children's PressLine had assigned strict responsibilities to each role. The teen editors do not take an active role in the interviewing process. The reporters actually conduct the interview while the editors manage the process, run the equipment, and monitor the reporters' involvement. Later, the editors write the articles. But for many editors, especially ones who have graduated from reporters to editors, the act of not asking questions during the interview is a huge challenge. "Now that, like, I'm more confident at CPL, I have ideas for really good questions but I realize when I step back and not get involved, some reporters step out of their shell and do their own thing, which is great, but I need to learn how to encourage them without getting frustrated that they let a really good opportunity go by," said Rachel, fifteen.

This challenge was evident in one of the critical incidents I analyzed for the study. A pair of editors, one more experienced than the other, worked with their reporters in such an unsatisfactory way that a reporter quit the organization. The student's mother said to me in an email, "Jordan does not want to continue because he felt like he was not being listened to or his ideas were not being considered." Since all CPL interviews are audio recorded, I went back to review the interviews the team had conducted prior to the reporter quitting. The evidence showed particularly poor editor behavior—consistently interrupting the reporter, asking questions during the interview, and breaking promises to teammates. This was an extreme mark of failure for the organization. However, because I was going through this research process at this time, it allowed for serious moments of reflection and goal planning for the youths. While the interviews gave a sense of dimension and reflection to the analysis, the observations and the work samples provided a more realistic view of what was happening in the field. Critical moments like this set high and low benchmarks that provided a framework to the analysis and the lynchpins to my wiki.

Once all the data was laid clearly on the web page, I reviewed it several times and wrote myself notes: The editors need to be reminded of their personal strengths and weaknesses. They need to set goals for themselves. The editors need to learn group management skills. New editors get turned off in the briefings. Briefings can be really boring if you are watching someone think of questions for ninety minutes.

Before the fellowship and before my study project, any changes I established to fix issues that came up in the program were based on my own experiences. For

instance, when I noticed that the reporters didn't see their editors as their supervisor, I introduced a 360-evaluation process halfway through each session. Performance reviews in the workplace establish boundaries and authority between workers and supervisors, so I figured that would work for participants of a youth media program as well. And it did work, but I admit it may not have been the best way to accomplish the goals of the program. But after being given a chance to understand myself as a student and as a learner, I was able to find creative solutions that served a variety of learning types. As a teacher, this process was valuable to me, not only because it added to my toolbox of knowledge, but also because it challenged me to allow for moments where young people can learn about themselves and led me to see how these moments of reflection and inspiration can prepare young people to service their peers and their community.

Collaborative Analysis

Each fellow chose different tools for collecting data. Many of them conducted interviews with students and staff members. Others did observations, kept journals, and collected student work and organizational artifacts.

Even though individuals in the group pursued their own projects, they collaborated with the group in sharing their data, analyzing it, and developing new questions and strategies for how to proceed. All fellows led at least one presentation where they brought their data to the group and received feedback. Again, one of the core principles in our fellowship program was knowledge construction. In all aspects of the research process, we created spaces for fellows to develop their knowledge together. This was especially important in the analysis stage. One of the keys of collaborative inquiry involves a position of "knowledge negotiation" (Nelson et al. 2008) among group members. "Employing dialogue grounded in shared experiences and a shared focus, group members question ideas, actions, and artifacts; examine varying perspectives and beliefs; and work toward a co-construction of understanding about the focus of their collaborative work" (Curry 2008, 737).

To facilitate fellows' feedback to one another we relied on protocols. This was true with almost every piece of evidence that the fellows brought into our meetings. Protocols, or structured conversation tools, have been used by Critical Friends groups that foster teachers' professional inquiry communities. Protocols have the virtue of "constraining participation in order to heighten it" (McDonald et al. 2007, xi). Because the model for the YMF was one of collaborative research, the use of protocols helped us facilitate our discussions and provided the kind of feedback that each presenter felt was most useful to them at a particular point in

their process. For example, one protocol that we used frequently was "non-judgmental observation": after a fellow shared a piece of his or her work, we went around the room, and each participant had a chance to share a descriptive observation about the work. After a few rounds, we opened up the discussion to the implications of what we had just observed.

Alexis Neider was a second grade teacher[4] in a dual-language program while she was doing a media project for the first time in her classroom. Before presenting to the group, she was feeling stuck, and didn't know how to proceed with her study. Having a community to share some of the artifacts that she had collected helped focus her and gave her ideas on how to continue. Alexis explained:

> About two months ago, Ivana sent me an email asking if I could share my research so far. I panicked and told her that I was way behind, and did not really have any research to share. She encouraged me to present just a few lesson plans and the work my students had produced. She promised that the other fellows would help me come up with ideas on how to continue my research. The fellows took notes on what they thought my students had learned.... Dan shared a thought about levels of translation—that my students are translating from Spanish to English to poems to images. Others added comments about the reinforcing of skills, seeing technology as another means of communication, learning technical skills, ownership, and use of authentic language.... I was unaware of how much learning was going on in my own classroom until my peers were able to point out everything happening there.
>
> During this same look at my work, we engaged in a long, serious discussion on how I could go about my research. The fellows suggested that I use case studies, compare different contexts in which students learn English, and develop a rubric to record how and when the students use different types of language. (Alexis Neider, YMLN Presentation of Learning keynote, May 17, 2008)

Building Time for Reflection

An important aspect of this kind of work is to build in time for reflection. Throughout the process, we did oral and written reflections. However, the favorite reflection format among fellows was the "video confession" booth. My colleague Jeremy Engle came up with the idea of using the confession booth model from popular TV reality shows to facilitate some of our reflections. Throughout the year, we asked people to do a "confession" during key moments of the process.

We set up a camera on a tripod in a space separate from the seminar meetings, and each fellow "confessed" to the camera at the end of a session. We shared the confessions in the following meetings and used some of the transcripts to scaffold parts of the research process. We used the confession booth both to bridge the connection between what was happening at workplaces and our discussions in the fellowship, as well as to reflect on some of the challenges, discoveries, and new ideas that were emerging. Confessing to a camera opened up some unexpected

conversations and created a forum for spontaneous reflections that people might have otherwise felt shy in bringing up in front of the whole group.

Lisa Denerstein, an English teacher at the High School for Media Communications in New York City, recalled her interactions with the confession booth in the context of YMF, and subsequently when bringing this strategy to her school.

The Confession Booth

by Lisa Denerstein

While the little red light blinked, I stared hopelessly into the eye of the camera, and with no director to yell "action," the control was left to me. "He," I said, smiling nervously. Nervous because I was alone in a room with a device constructed to capture time. Nervous because my mind was only drawing blanks when it came to expounding on the purpose of youth media. Nervous because "He" was the student that everyone loved to hate. Nervous because at that moment, all I could question was my purpose as a teacher. Smiling, I continued to speak. "You see, last night was parent-teacher conference and this student...he's special ed.[5] He's totally out of control." I felt the shame of being an imperfect teacher rise, and fought back the lump that was steadily trying to silence me. And before I knew it, I had forgotten about cameras, fellowships, criticisms, and just spoke from my heart. "His mother was enraged...high...and smacked him...right there, in room 146, in front of everybody." With this admission the tears finally broke free as I explained that it was not just any slap but the kind that leaves scratches and scars, the kind that I had let myself become immune to seeing. As the red light continued to blink, my final words were, "What am I doing?... What am I doing?"

What *was* I doing? All my education and experience had taught me that a child's behavior at school is generally based on what is occurring in his personal life. Yet I chose to ignore this fact until my student's personal life was brought to room 146.

So I confessed, and when my fellow cohorts and I watched the video confessions at our next workshop, there was no judgment or quiet whispering about who said what, only a mutual respect for one another and for the challenges and rewards we encounter in each of our diverse settings.

I was so moved by this experience that I wanted to bring the "confession booth" back to my high school. My principal agreed and suggested we should rename it the "reflection booth" and invite teachers and students to share their strengths in the classroom as well as their weaknesses. Many wanted to participate and became very excited at the prospect of filming themselves, while others felt

uncomfortable sharing their weaknesses on camera, as if the permanence of film would somehow be used against them. For an entire day, faculty and students who were willing adjusted camera angles and took control without anyone yelling "action."

Together we watched our unedited video reflections and concluded that each of us took pride in our school, our work, and ourselves. I often view my high school as one big dysfunctional family. Teachers and students experience life's trials together, managing to stay consistent while trying to achieve standards developed by people who have never set foot inside an inner-city, public high school. Consequently, we need to be motivated and reminded that we are connected and a community. Everyone in the audience was inspired by the influence of combining self-reflection and media.

What I valued most during my exploration into youth media was best expressed during my own teacher self-reflection booth taping. The video highlighted my teaching practice, unlike any staff development meeting or casual conversation between colleagues ever could.

<p style="text-align:center">***</p>

Building the Wikis

The final stage and product of the fellowship was the construction of a wiki. Each fellow shared the results of his or her projects in the Youth Media Learning Network wiki (http://ymln.wikispaces.com) and in a public presentation of learning.[6] A wiki is a piece of server software that allows users to freely create and edit web page content using any web browser. One of the main reasons why we chose a wiki as a platform is because it features open editing. Open editing allows all members of the wiki to edit content that has been posted.

While for the most part fellows worked on their individual projects, they were all able to help each other with crafting the content of the wiki, and with the technical aspects of how to share multimedia.

As Katina Paron described earlier, the process of working in their wikis and analyzing their data was a fluid one that allowed for some fine-tuning and rethinking for the projects that the fellows had been working on for several months. For some of the fellows, this was the time when their projects took shape. In some cases, they took a different direction than they had originally planned.

Another fellow, Padmini Narumanchi from Reel Works, a program where high school students work one on one with filmmaker/mentors creating a documentary, shared pieces of her journal in the wiki and used them as evidence of the discoveries that she made about who she is as an educator and how she made meaning of her experiences with the young people with whom she worked.

I initially wanted my Project to explore how Media Educators balance their own artistic development while helping students cultivate their voices and visions. As time progressed, I felt that I should be focusing this project on my students—on what was happening in the classroom. I feared that by focusing on the Educator, my project would seem "selfish."

During the course of the Fellowship, I decided to keep a double-entry journal.... Once it came time to "mine" our data, I pored though my journal and was surprised to discover what a haven it had become. Yes, there were the reflections on my classes & students, but what I found even more interesting was how I was detailing my own teaching philosophy and values. My journal began to tell me a story." (Padmini Narumanchi, http://ymln.wikispaces.com/The+Double-Entry+Journal)

As in the case of most of the fellows, Padmini's project in the wiki doesn't only describe her YMF study project, but also provides a window into the work of Reel Works and, in particular, into her own workshop practices. Many of the projects in the wiki give detailed accounts of the different processes and approaches of each organization or school. For example, Alexis Neider presented three case studies of her second grade students to document how participating in an after-school media program had influenced their learning of English as a Second Language. In her portion of the wiki, she included print as well as video work of her students that showed their process throughout the semester. Since Alexis also wanted to be able to replicate her project, she included lesson plans and handouts for other educators to use (http://ymln.wikispaces.com/Alexis-+Research+Question).

We had fellows from the same organizations who participated in different cohorts of the fellowship. The second cohort of fellows was able to link their projects to those of their colleagues and tap into them to enrich their explorations. Kaari Pitkin, from the first cohort, explored the retention issues at Radio Rookies. In order to investigate the retention issues, she had to look at the process that young people at her organization went through. In her wiki, she laid out the Radio Rookies process, providing examples of student work and segments of interviews. Sanda Htyte, also from Radio Rookies, participated in the second cohort of fellows and concentrated on the challenges of story development (one of the steps of the process). While creating her portion of the wiki, she made connections between her work and Kaari's work and was able to build on it (http://ymln.wikispaces.com/Radio+Rookies+ Project+Overview+-+Story+Development).

While in the context of the seminars the fellows always commented on how enriching it was to hear and understand how other youth media organizations work and face similar issues, the wiki provided a mediated platform for documenting publicly the struggles, discoveries, and approaches to youth media that many practitioners share.

Full Circle

"As soon as I started working on the Wikispaces, I said, 'Oh I should have done this question!' Even now, I find myself thinking of other things that would be useful study questions." (Katina Paron, debrief session, June 11, 2008)

As many of the participants expressed in the final debrief session, the process becomes a full circle of inquiry. As they put together their final pieces and presented their work, they couldn't help but think about all the other questions that they would like to explore and wonder whether they had asked the most significant questions about their work.

The process of becoming a practitioner researcher is one that requires the courage to examine our own practices and beliefs in the context of looking for research questions, exploring them, and sharing our findings. The fellows' wonderings were based on the everyday practices of their work. Reflecting on and examining their practices allowed them to bring back to their organizations what they had learned about themselves and what they had learned from each other's experiences.

One of the strengths of the design and method of the fellowship is the emphasis on sustained collaborative inquiry. Yet this is also a characteristic that makes it challenging to reproduce this model. It requires time and commitment for the organizations and schools, as well as for the participants. Many youth media organizations have small numbers of staff or staff who work on a part-time basis. Schools tend to have schedules that make it hard for teachers to spend a morning away every other week. In order for this model of professional development to take place, the schools and organizations needed to be invested in supporting the work of the fellows and, at a minimum, provide the time for fellows to come to the meetings. While many of the aspects of this work rely on the individual commitment to pursue an inquiry, the home youth media organizations also needed to be open to the kind of close scrutiny that their projects demanded.

For youth media educators, it is important to have access to professional communities. Marnie Curry describes how "teachers learn through situated and social interactions with colleagues who possess distributed expertise and with whom they have opportunities for sustained conversations related to mutual interests" (Curry 2008, 738). In addition, to learn what it takes to pursue a practitioner researcher project, it is necessary to conduct one and fully experience the frustrations and the surprises that every stage in the inquiry process brings. Sanda Htyte mentioned in her piece how she had so many questions when she began the fellowship that she could not settle on what she wanted to study. As practitioners in the field of youth media, the fellows were constantly sifting through the questions that are part of their everyday work. As practitioner researchers at the end of

the process, they identified new or old questions that they would like to pursue in a systematic manner.

This model of professional development requires a certain level of flexibility and willingness to make adjustments not only for the participants, but also for the facilitators. While we had a general curriculum that we followed, nothing was set in stone, and we made many adjustments as each fellowship progressed. As the facilitator of the fellowship, I also had to learn to adapt to the needs and questions that each group brought to the process. Having time to reflect with my colleagues—and process the issues, questions, and ideas that came up in the YMF meetings, as well as in the site visits and individual conversations with the fellows—was important in shaping how we tailored each session to the needs of the group. One of the challenges of replicating this model is that while we had a set of strategies and protocols to guide our design, ultimately most of the sessions were shaped by the work that the fellows brought in.

This chapter presents one model for professional development in the youth media field based on fostering professional inquiry communities. At the moment, there is not much research about different models for professional development in youth media (Keenan and Fisherkeller 2008). It would be beneficial for the growth of the field to document how capacity-building efforts in the field are implemented and to look closely at how professional development efforts can support the development and growth of communities of practitioners in youth media.

Notes

1. Tyner's first chapter in this book is a further update of these articles.
2. The curriculum for the fellowship was designed in collaboration with Jeremy Engle, the Manager of Curriculum Design for the Youth Media Learning Network. Tim Dorsey, the director of the YMLN at the time, participated in most of the meetings.
3. For the purpose of this paper, I asked three different fellows to write about their experiences in the YMF. I provided a loose list of suggested topics, and we exchanged ideas.
4. In the New York City public school system, second grade is composed of students who turn seven years old in the calendar year in which the school year starts.
5. Lisa is referring to students in special education. This is a controversial issue in the United States because minority students are overrepresented in special education programs.
6. Not all fellows completed the publication of a wiki. For personal and professional reasons, two of the fellows did not publish their work on the wiki, even though they participated in the full fellowship, pursued an inquiry project, and shared it with their colleagues.

References

Coryat, Diana, and Goodman, Steve. 2004. Developing the Youth Media Field: Perspectives from Two Practitioners. http://www.soros.org/initiatives/youthinitiatives/articles_publications/articles/whitepaper1_200403 (accessed December 5, 2008).

Curry, Marnie. 2008. Critical Friends Groups: The Possibilities and Limitations Embedded in Teacher Professional Communities Aimed at Instructional Improvement and School Reform. *Teachers College Record* 110(4): 733–774.

Dorsey, Timothy. 2007. What We Talk About: Youth Media as a Community of Reflection. *Youth Media Reporter: The Professional Journal of the Youth Media Field.* Special Features Issue, Vol. 1: 68–74.

Goodman, Steve. 2003. *Teaching Youth Media: A Critical Guide to Literacy, Video Production, and Social Change.* New York: Teachers College Press.

———. 2006. Cultivating a Field Youth Media Reporter. *Youth Media Reporter* (December 18, 2006).

Himley, Margaret, and Carini, Patricia. 2000. *From Another Angle: Children's Strengths and School Standards.* New York and London: Teachers College Press.

Keenan, Sara, and Fisherkeller, JoEllen. 2008. Making Meaning of Media Education: Professional Development among Youth Media Practitioners. *Youth Media Reporter: The Professional Journal of the Youth Media Field.* Special Features Issue, Vol. 2: 165–188. New York: Academy for Educational Development.

Kincheloe Joe L. 2003. *Teachers as Researchers: Qualitative Inquiry as a Path to Empowerment.* 2nd ed. London and New York: RoutledgeFalmer.

McDonald, Joseph, Mohr, Nancy, Dichter, Alan, and McDonald, Elisabeth. 2007. *The Power of Protocols: An Educator's Guide to Better Practice*, 2nd ed. New York and London: Teachers College Press.

Melillo, Sara. 2008. Making Networking Work for Youth Media. *Youth Media Reporter* (April 15, 2008). http://www.youthmediareporter.org/2008/04/making_networking_work_for_you. html.

NAMAC Youth Media Survey Database. http://www.namac-ymi-survey.org/ (accessed July 7, 2009).

Nelson, Tamara, Slavit, David, Perkins Mart, and Hathorn, Tom. 2008. A Culture of Collaborative Inquiry: Learning to Develop and Support Professional Learning Communities. *Teachers College Record* 110(6): 1269–1303.

Tyner, Kathleen, ed. 2003. *A Closer Look: Media Arts 2003—Case Studies from NAMAC's Youth Media Initiative.* San Francisco: National Alliance for Media, Arts, and Culture.

———. 2007. Youth Media at the Threshold: A Research Based Field Building Agenda. *Youth Media Reporter: The Professional Journal of the Youth Media Field.* Special Features Issue, Vol. 1: 110–119. New York: Academy for Educational Development.

9

Whose Story Is It? Being Native and American:

Crossing Borders, Hyphenated Selves

Damiana Gibbons, Téa Drift, and Deanna Drift

Introduction

Hi my name is Téa Drift. I love working on videos because it lets me express who I want to be and who or what I honor. I became a part of In Progress to make videos to do these kinds of things. Also a good friend of my mother's is doing this program. Her name is Kris Sorenson. Doing In Progress is a lot of fun. My current video is about me dancing in my Fancy Shawl and saying things in my language, which is Indian. I wanted to film in front of the most important island to me, which is Spirit Island. But I'd have to talk to the elders to see if I could include Spirit Island in my video.

(Téa Drift, a youth filmmaker and co-author of this chapter)

Téa Drift's words speak to compelling issues in youth media production, such as self-expression, fun, and honoring her community. With youth in general, we know that they are often promised voice when producing youth media (Soep 2006), and media can offer more options for youth voice in general (Buckingham 2006; Fisherkeller 2002; Jenkins et al. 2006). But her words also speak to how it is becoming clear that youth voice is a negotiated entity in media production (Chan 2006), and this negotiation becomes even more complicated when the voices are those of historically marginalized youth (Fleetwood 2005; Stein 2007). In order to explore these complications, Damiana Gibbons has worked over the past five years on a research project studying media literacy in youth media organizations that serve marginalized youth (Native American youth in the Midwest; poor, white youth in Appalachia; and urban youth in large cities in the Midwest and North-

east). What this research is finding is that by tracing key moments in the pedagogy that the youth media arts organizations share, researchers and facilitators can trace the learning that is occurring in the youth media production process. They do this by studying how youth are demonstrating their knowledge of media literacy in key moments, such as when youth must present their story ideas for their movies before filming them in what is called a "pitch" (Halverson and Gibbons 2010). Also, this research has found that how identity is expressed in youth videos differs among organizations, depending on whether fostering an individual or a collective identity is the goal (Halverson et al. 2008). What this means is that we know that learning is taking place in these spaces and that youth identity is being expressed, but we still wonder how identity expression is operating for individual youth. Given this, Damiana's[1] work, specifically, explores the ethics of media literacy education by attempting to make sense of the interplay of multiple discourses and voices that determine what and who can be represented, to whom, and why.

This chapter is an attempt to understand how one youth expresses herself in video within the context of the organization and her own community. It rests on the foundation that the voices of youth, the members of the youth media organizations, and the youths' communities matter. This became readily apparent when Damiana was researching a youth media arts program in a community of Anishinaabe people who are often considered a subset of the Ojibwe nation but are actually a related yet different group of Native Americans. In order to respect the multiple voices in the youth media production she observed, this chapter will be a dialogue between Téa Drift, an Anishinaabe girl, Deanna Drift, her mother, and Damiana Gibbons, the researcher, as they discuss the final version of a video that Téa created.

This chapter is focused primarily on an in-depth analysis of a video Téa created as part of Ogichidaakweg (Sisters In Leadership), a program developed by In Progress, a youth media arts organization in St. Paul, Minnesota, "to help young Ojibwe girls [and boys] see their potential and act upon it" (http://inprogress. viewbook.com). Although this program began in the 1980s as a program for girls, it is now a program for all youth on the reservation. In creating a dialogue about one of the girls' video and story, this chapter is also an attempt to "work the hyphen" by "creating occasions for researchers and informants to discuss what is, and is not, 'happening between,' within the negotiated relations of whose story is being told, why, to whom, with what interpretation, and whose story is being shadowed, why, for whom, and with what consequence" (Fine 1994, 135; see also Sirin and Fine 2007; Zaal, Salah, and Fine 2007).

This chapter is a layering of multiple voices. To do this, Damiana, Deanna, and Téa, each of whom had a separate yet interconnected part to play in the writing of the chapter, have attempted to mix their voices. This was a complicated process, as each came with her own set of perspectives, time constraints, and limitations for collabora-

tive writing. For example, Téa was not allowed Internet access at her elementary school and they did not have Internet at home, and Damiana was out of the country for some of the writing time. Therefore, we had to change from email to phone calls as our primary tool of collaboration. As the person most familiar with the genre of book chapter writing, we agreed that Damiana would serve as the organizer of the writing of this chapter and would do most of the writing itself. As a mixed-race (Chicana[2]/Irish American) researcher who grew up in a working-class, single-mother household in the rural West, Damiana has deep empathy and respect for Téa, a youth participant who is Anishinaabe growing up in the rural Midwest. But empathy is not the same as understanding. Nor is scholarly research, although it is present in the mix as well, as Damiana summarizes some key "voices" of scholars who study Native American identity in general and Native youth filmmaking in particular, along with the "voices" of social semiotic theorists who analyze youth videos (Burn 2009; Burn and Parker 2003), and marginalized youth in particular (Stein 2007).

The academic voices must be balanced, then, by others. The scholarly voices and Damiana's analysis of Téa's video serve as supplement, not as substance. Therefore, Téa's words flow into and through the chapter and create her own story of her video. Although Téa's written words are woven into this chapter, her most significant contribution to it is her video. This video is the focus of this chapter, but due to limitations of the medium, it is the part that cannot be included in the chapter itself. (Her video can be found on YouTube, however, and the link is provided in the video analysis section.) Therefore, although Téa contributed much to this chapter, it is important to note that it is in her video that Téa's voice is expressed most strongly. Also included are words from Téa's mother, Deanna, who was one of the original youth participants in the Ogichidaakweg program when it began in 1988, as she provides not only an understanding of Téa's background but also a cultural understanding of the Anishinaabe community.

What we found, then, in the mixing of these voices and in Damiana's analysis of Téa's video, is that as Téa navigates multiple expectations placed upon her as she creates her film, she holds open the tensions between different identity-makers: girl/director, Native American girl/"American" girl, self/member of her community, and so forth. Through her videomaking, Téa is finding a new place for identity in both mainstream society and her own community.

Scholarly Voices

We begin this chapter with what is currently known in scholarly research about Native American identity and Native youth filmmaking. We begin here not to have these scholarly voices seen as definitive; rather, we begin with these voices in order to add our own voices more specific to Téa and her community to the rest of the chapter. In other words, these voices begin the conversation.

Of course, all people speak from their own place and their own perspective. Media production is no different. Stuart Hall (1996) summarizes this point when he states that we need "a recognition that we all speak from a particular place, out of a particular history, out of a particular experience, a particular culture, without being contained by that position as 'ethnic artists' or film-makers. We are all, in that sense, *ethnically* located and our ethnic identities are crucial to our subjective sense of who we are" (Hall 1996, 447, author's italics). This perspective helps us to remember that no ethnic group is monolithic, and it is unreasonable to expect people to represent everyone in their community.

In terms of people in Native communities, this is also true. Not all Native people are the same, and—importantly—not all people in a given Native community are the same, either. Some live on reservations; some do not. Some people speak their Native language; some do not (Uran 2005). "It is misleading to assume that all indigenous people experience a Native cultural identity in the same way just because they were born into a Native community. This glosses over the multi-faceted and evolving nature of identity as well as cultural differences among and within Native nations"[3] (Weaver 2001, 243). Native people have the same multi-faceted characteristics that other groups have, and this is important to recognize.

Yet, while not all the same, it is also true that Native people do have some commonalities within their communities as well as some key differences from mainstream populations. Although Damiana's larger study focuses on a youth media arts program in general, a program that served both boys and girls in a three-week digital arts workshop,[4] for this chapter we were focusing on how identity expression operated in Téa's videos, the videos of a young Native girl. Therefore, we were interested in what contemporary scholarship had to say about this population. In a study of Native girl identities in an Ojibwe community, researchers found that Native girl identities are not monolithic, either, nor are they the same as white girl identities in key ways. Carol A. Markstrom and Alejandro Iborra (2003) focus explicitly on the Navajo Kinaaldá, a coming-of-age ritual for Navajo girls, and how this ritual impacted young Navajo girls. Yet they also make the case for a broadening of the definition of "Native American" identity (or, rather, they advocate making the differences among Native groups explicit—a narrowing and contextualizing view of Native American identity).

In terms of studies about Anishinaabe girls specifically, we found only one, and it is only tangentially related because it focuses on another community in the Ojibwe nation, the larger group to which Téa's Anishinaabe community is related. Catherine McCartney et al. (1992) focus their study on Ojibwe girls specifically to recreate Carol Gilligan, Nona P. Lyons, and Trudy J. Hamner's (1990) study, which offers the idea that moral decision-making in girls is determined through a sense of connection and separation from their communities.[5] McCartney et al. test the conclusions of the Gilligan and colleagues (1990) study by replicating it, in part, in a

new population of girls: Ojibwe early adolescent girls from the Turtle Mountain Reservation in Belcourt, North Dakota. Although the researchers struggled with the fact that they were white researchers investigating a Native population, they decided to pursue their study in the hopes of understanding Native culture better.

Through a series of interview questions and the coding scheme from the Gilligan et al. study, McCartney and her colleagues gathered data about the types of reasoning the girls used to make decisions about moral conflicts and found that some of the original research could not apply to the Ojibwe girls. Gilligan and colleagues found that the conflicts that white girl adolescents faced were internal, coming from within, with a struggle between maintaining one's individual self or being connected to others. "From this perspective, choosing means that something personal is lost" (McCartney et al. 1992, 18). In contrast, McCartney and colleagues found that with the Ojibwe girls, the conflict does not come from within the girls but rather from outside. "For the Ojibwe girls, the desire to remain connected (by virtue of being Indian) comes into conflict with the expectation that they become independent (by virtue of being individualistically American). From this perspective, choosing means that something cultural is lost" (18). What this means is that these Ojibwe girls had connections to their communities as part of their identities; they were not solely individuals.

When it comes to representing Native identities in media texts, things become increasingly complicated. Native filmmakers and artists are often pushed in two directions. The first is that Native people are expected to "put their indigeneity on display," an expectation that "Indians play Indians" (Siebert 2006, 532). The second push comes from a drive to represent themselves as distinct from non-Native people but as a part of their own Native communities (Leuthold 1997, 1998, 2001; Singer 2005). But how to navigate these both is an open question. Elizabeth Bird's "Imagining Indians: Negotiating Identity in a Media World" (2003) explores how Native identities are mediated by studying both Native and non-Native responses to media representations of Native people. In this piece, Bird asked focus groups of white, Native, and mixed groups of both ethnicities to create a fictionalized television show that included at least one white, one Native, and one female character. What she found in analyzing the transcripts of the group interactions was that the groups of whites only created white characters that were fully developed and believable and Native characters that were based on "naturalized familiar stereotypes" (94). An example was one group's character, who was taken wholesale from the television series *Northern Exposure* and given occasional one-liners that would make her seem wise, reflecting a common positive stereotype about Native Americans. The Native-only groups tackled issues of ethnicity directly, and they attempted to balance the desire to create role models ("a show like what Cosby did for blacks") with a more realistic depiction of Native life, such as a show "on the rez [reservation]" (105),

where living conditions are far from ideal. What Bird found was that the whites could draw on existing media in which they could recognize themselves, but the Native people had to imagine media in which they would be recognizable as well as countering stereotypical depictions.

But imagining media that represents people's lives is exactly what youth media production aims to do. Kathleen Tyner (1998) asserts that "...media production gives voice to students who are otherwise silenced in their schools and communities. It allows students to represent their experiences and their communities as cultural insiders, instead of the incessant representation and misrepresentation of them by media producers outside their communities" (184). In fact, a key component of youth media arts organizations that work with marginalized youth is that they also value the way in which youth can find and express their experiences through video (and other media) production (Goodman 2003).

This is just as true with organizations that work with Native youth. Antonio López (2008), a digital media educator working with Native youth, calls this new way "media mindfulness," stating that "at a minimum students should be critical participants of media systems and at best be active producers of their own content, reflecting an engaged awareness of media environments in the context of their community needs, values, and their own personal realities" (118). In practice, this type of media mindfulness has been in place in charter schools and non-profit organizations for several years. *Through the Eagle's Eye* (Buckanaga and Sorensen 2007) describes the curriculum in place to teach young Native filmmakers in three different charter schools teaching urban Native youth. The driving force behind the teaching and learning is that implementing a media arts program in schools will empower Native youth to tell their own stories and to become young leaders in the process.

Deanna's Response to the Scholarly Voices

Téa and I live in a small, remote community in Northern Minnesota. We call it the "village" because our population is approximately 300. I was born and raised here. I have lived all over the country but always find myself back home. Téa was born in Tennessee, and we moved back home in 2002. I mention this because we moved back to the reservation specifically for Téa to be near her people. I wanted Téa to return to the reservation because throughout my college career and in learning of our history, I realized that we are in fact a "dying race," so to speak. In our society we are Anishinaabe (a type of Indian), and the language we speak is Ojibwemowin. But our community is in jeopardy of losing our Anishinaabe language. In fact, we only have a handful of fluent elderly speakers. Additionally, I have witnessed a constant decrease in youth practicing our cultural ways over the years.

Many speak of living in two worlds, which is difficult to put into words for those who do not understand. I can only speak of my experiences: I was raised in a

small, close-knit community where we identified as Indians. We were proud children who often enjoyed playing games with each other, and there really wasn't a gender difference, as women are treated equally in our society. On the reservation we are enclosed, we are almost "sheltered" from any type of racism, meaning we exist and that is all we pretty much see.

However, once we were introduced into mainstream society after we completed sixth grade, we were treated as though we were lower class. In addition to this type of treatment, we were introduced to the white concept of hierarchy, and the ideologies that men were of higher class than women. Once we got to seventh grade we were integrated with non-Indian children, who often made racist remarks or put us down for our skin color. Our worlds were often turned upside down because we weren't accepted as who we were. We either had to change our ways of being respectful to others and fight back, or accept the put-downs and let it attack our self-esteem. (Not all non-Indian children were this way, though.) Another huge difference was gender roles. As a female, there was no difference from the males in our society, no hierarchy, in this way. In mainstream there is, which I still cannot understand to this day. I believe this is where the living in two worlds stems from. We lived our way of life but had to adapt to another way of life, one we did not fully understand but had to get accustomed to in order to become successful in life (i.e., in college or employment).

Times have changed since then. My daughter is now living in three worlds: mainstream society, American Indian society, and Hispanic society.[6] I can only offer her guidance in two of those worlds because I am not of Hispanic heritage. I can teach my daughter to hunt, gather rice, put her in touch with those who can teach her our language, and prepare her to become a scholar. I want Téa to learn her culture and heritage firsthand because I have high hopes that if our youth begin to practice our ways of life, our culture will be reborn. I want our children to grasp our Anishinaabe identity and be proud of who we are. For many years, mainstream society has taught us, whether intentionally or not, to be ashamed of our language, our skin color, or of being Indian. Ultimately, the path Téa will choose in life is hers, and hers alone. However, I believe everything happens for a reason, and I am confident Téa will play a major role in the regeneration of a nation—a Bois Forte nation.[7]

Téa's Video

I was naturally thinking how fun it would be to make a video important to our elders and to our whole town. I chose fancy shawl dancing because all my friends do it and I do it. I was thinking about doing a video about jingle dress dancing, but I decided to do a video about fancy shawl instead. Before fancy shawl I was jingle dress ever since I was a baby, and I just wanted to let people know how important fancy shawl and jingle dress are to me.

 I decided to film on the dock of the lake with Spirit Island in the background because Spirit Island is special to our people, and I thought the lake was really pretty and would add nice special effects to the video.

 I kind of edited out the parts where there was too much wind blowing and you couldn't hear what I was saying. I tried to film some of it again. I edited out the parts where I tripped and fell and the bloopers. I kept the music in there so it would seem like people were actually playing drums like in the arenas. I kept all the dancing in there to show them how I danced and how it is different from how other people dance. And, I was going to show the foot steps to dancing, but we didn't have time to film it.

 (Téa Drift writing about her video *Nature's Beauty,* her final version)

As part of a larger project studying youth identity and digital media, Damiana was a participant observer in a three-week workshop during the summer of 2007 facilitated by In Progress and held on the Bois Forte reservation.[8] Téa participated in this workshop along with approximately thirty other youth. The participants in this program produced either digital video or photographs about their community and their own lives. All of the youth conceived of their own projects, but those who were doing video work filmed in groups, as many of them practiced the skills of camerawork, interviewing, and editing in order to produce their films.

 The focus of this program was to "pave the way for youth voices" (http://inprogress.viewbook.com). Kristine Sorenson, the director of In Progress and a co-facilitator of this program, summarizes the need for media production programs in Native communities when she states, "In this world where so many of our stories come through a digital medium...the opportunity that is afforded to young people to tell their own stories is rare.... And, those opportunities, I know they're not everyday here [on the reservation]" (personal communication, August 8, 2007). Kris feels that what youth have to contribute to their community is valuable, and she works hard to make sure that she respects their traditions, such as offering a blessing to the Spirits every time the young people film. This workshop balanced lessons on media critique with hands-on lessons in media production as youth worked toward the completion of their video or digital photography pieces. They did so in a workshop jam-packed with youth aged nine to twenty-one and a variety of projects throughout the entire three weeks.[9]

 Téa was nine years old at the time of this 2007 workshop, and she was already a digital artist in that she had produced a documentary video in a workshop held the year before. In this workshop, Téa wrote, directed, and starred in a video about fancy shawl dancing. She did not do the filming; rather, an older youth did the camerawork and another youth asked the interview questions. She did some camera work of another youth dancing to practice her skills, but for this video that was not her main role. Her job as director was to have the vision for the piece and—with Kris' guidance and the help of the other youth—to turn that vision into reality.

Téa, however, was the main editor on two versions of her video, including the final version. She edited this video several times over the next two years, once while she was filming a year later during a trip to the In Progress headquarters, and once for the final version during a workshop held in her community in 2009. Damiana was a participant observer in the first workshop, and she interviewed Téa and Deanna after the editing of the second version of Téa's video. By the time of the third and final version, Damiana, Téa, and Deanna were writing this chapter, and it is this version that will be discussed. (That version of the video can be accessed on In Progress's YouTube channel at http://www.youtube.com/watch?v=wG7NOVd4_U0.)

Damiana's Analysis of Téa's Video

Scholars who study youth video production are finding that youth are affording themselves of digital production technology in order to express much about their communities (Bing-Canar and Zerkel 1998; Mayer 2000) and that youth are able to use these tools effectively: they have agency (Burn and Parker 2003; Hull and Nelson 2005). Scholars are just now beginning to ask questions of youth agency. However, when it comes to youth video production with historically marginalized youth (Fleetwood 2005; Hull, Nelson, and Roche-Smith 2008), there is still much to learn. My questions for this analysis, then, assume the following: (1) Téa is capable of using the affordances of video production to express what she wants to express; (2) who Téa is and who her community is matters; and (3) tracing how Téa uses the various modes available—image, music, time, action, speech, shot level, transition, music, dialogue, language used, written text, and regalia—will reveal much about what meaning is created and what identities are expressed. Therefore, the two questions that I sought to answer in this analysis were: Does Téa use modes in her videos to assert identity? How does she use modes to assert identities and to what end? This analysis, paired with the responses from Téa and Deanna, will provide a rich understanding of how Téa created her video and what it means.

In terms of youth video analysis, there have been key studies in how to analyze youth-produced videos (Burn 2009; Burn and Parker 2003; Halverson 2010; Hull and Nelson 2005; Hull, Nelson, and Roche-Smith 2008), yet the methods for doing so are still relatively new. The best way to trace modes through youth videos is Andrew Burn and David Parker's (2003) coding for kineikonic mode, which is the mode of the moving image or, in other words, how the modes work together to create a video. In a new work on multimodality and youth-produced texts (videos, websites, and games), Burn and Parker (2003) attempt to create a framework for analyzing visual forms of media using social semiotics (see also Burn 2001). As I began to trace these codes in Téa's videos, I found that, although they were useful for the most part, there were other aspects of her video that could not be accounted for simply with these codes.

Based on Burn and Parker (2003), then, I created a multimodal microanalysis method to trace the following modes in Téa's video: time, image, action, speech (how something is said, e.g., voiceover), shot level, transition, music, dialogue (what is said), language used (Ojibwe or English), written text, and regalia (Téa's fancy shawl). I created a multimodal transcription for the codes (see Figure 1). I placed each new expression of a code with its own color. For example, for the speech code the voiceover was shown in green, while the speech from video footage was shown in turquoise. When there was no expression of the code, I put this in gray. The color changes allowed me to see shifts in the patterns within each code. After completing this multimodal transcription, I used it to narrativize the codes in a description and, combining this with my other data, I analyzed the patterns found.

From my time in the workshop with Téa and from my many discussions with her, I knew that Téa's goal with her video was to respect tradition. She describes her purpose in an interview: "And, I'm doing this video because I'm actually a current fancy shawl dancer, and I think it would be really cool if people outside of our village would recognize how special the traditions are to us" (personal communication, February 8, 2009). Therefore, I knew going into my analysis to expect that traditions would be a significant part of the video, but I was still curious about how Téa would express these traditions, to what extent, and what else she might express. What I found was that not only is Téa using modes to express traditions, she is also expressing different identities as well.

By using and combining modes, Téa shows two Anishinaabe traditions. The first tradition that she expresses is an Anishinaabe blessing in which Anishinaabe people recite a prayer and offer tobacco to their Spirits. The first twenty seconds of this video are this blessing in speech, dialogue, and image. There is a combination of images of Téa dancing, her speech as voiceover, her dialogue as the blessing, and the language used as Ojibwe. Next is a transition with an overlaying of video footage (image and time) of the action of Téa dropping tobacco into the lake as an offering. Concurrent with this action is a switch in language to an English translation of the blessing. The shot level is a close-up of Téa's hand as she drops the tobacco into the lake, then the camera pans out slightly to show part of Téa's body as she completes the action of putting tobacco in the water. Kineikonic mode, the mode of the moving image (Burn and Parker 2003), is as much about how the modes interplay as it is about tracing them individually. Therefore, what is happening here is that Téa is showing the blessing in many ways. For example, she is expressing it in her community's native language of Ojibwe in voiceover, but this is combined with the images of her dropping tobacco in the lake as a traditional offering, with transition serving as a way to combine the blessing with the offer of tobacco. These modes combine, then, to show the blessing fully.

Figure 1: An excerpt of the multimodal transcript of Téa's video (without color codes)

Time	2.05	2.10	2.15	2.20
Image				
Speech	Voiceover	Voiceover	Voiceover	Video footage
Shot Level	Long	Long	Long	Long
Transition	Fade	Fade	Fade	Fade
Music	Singing voices	Singing voices	Singing voices	None
Dialogue	"The other dancers inspire me to do the best I can."	"I love meeting new people. We all learn from watching each other."	"It's how we honor our traditions."	(at 2.19) "I love to dance cuz it's like..."
Language used	English	English	English	English
Written language	None	None	None	None
Regalia	Full regalia	Full regalia	Full regalia	Full regalia

The second tradition that Téa respects is fancy shawl dancing. After the blessing, the rest of the video is almost entirely about Téa's fancy shawl dancing. In terms of image, the only times Téa is not shown dancing are the scenes in which she is giving the blessing and when she is being interviewed. Before the filming, Téa and Kris, the director, had discussed what Téa would talk about during her video. Téa formulated the basic questions she wanted to answer, and because she wanted to be interviewed on film, another youth asked her those questions (with Kris's guidance). It is interesting, though, that Téa chooses to include interviews, although she is not conducting them. It seems that she is choosing image over dialogue at this point. (At other points in the video she includes voiceover recorded later, which gives her even more control over the content.)

But the content of the dialogue keeps to Téa's vision in that—except for the blessing—all of the dialogue is about fancy shawl dancing. First, Téa establishes how long she has been dancing ("technically nine years") and why she switched from jingle dancing to fancy shawl ("to try something new" and to dance like her cousin, whom she'd found to be beautiful). Then she discusses fancy shawl's symbolism, which is that the fancy shawl represents a butterfly. She returns to herself as a fancy shawl dancer as she discusses how she likes to dance at pow-wows, which are festivals in Native communities in which Native people gather together for ceremonies and dances to preserve their culture. Deanna felt that it was vital for Téa to learn about her culture from participating in pow-wows from a very young age (personal communication, February 8, 2009). Téa expresses this same belief as she explains that she likes to participate in pow-wows because she can meet new people, be inspired by the other dancers, and learn from them. She continues by stating how fancy shawl represents her people, but she also enjoys dancing because "it's really fun and you can lift your wings up and fly." Through fancy shawl dancing, she becomes like the butterfly. She honors this tradition both through the image and her discussion of how it represents her culture and how she feels as a dancer.

There is more going on in this video, however, than simply expressing cultural traditions. Téa is also expressing herself as a member of her community, along with the traditions themselves. Media scholars are now realizing that media texts produced by youth are also performances of self: "Whenever a child makes a text, they are saying something about themselves. In moving image texts, especially when it is their own voice or face they have framed, modeled, and edited, such a representation is strongly performative" (Burn 2009, 81). Téa's presence in the video is deliberate. As the director of the video, she chooses to put herself in it. This is due in large part to the fact that she is the one who knows how to perform the fancy shawl dancing, but she had other options if she'd simply wanted to show fancy shawl dancing itself. For example, she could have filmed footage at a pow-

wow, shown footage she had shot of another youth dancing, interviewed other fancy shawl dancers, or even located and incorporated archival footage of fancy shawl dancers. But she chose to represent the blessing and the dancing herself. This choice makes me wonder who she is representing and how.

Figure 2: Screen capture of image and regalia at thirty seconds

The way that Téa expresses identities is through "functional load." Functional load describes how, in a video, one or more of the modes carry most of the representative power in the text (Burn and Parker 2003). For instance, at a given point in the video, the image combined with music might be the most salient features in a scene, and they have the most impact on the meaning that is created from it. In Téa's video, for instance, in this screenshot at thirty seconds (see Figure 2), there are several modes occurring at once: the action is Téa dancing, the music of Native flutes is continuing, the shot level is a mid-range shot, the image is of Téa dancing, the regalia is the entire shawl, and Téa is stating in voiceover, "It's my favorite thing because it's our culture. It's what we have to do." What is carrying and conveying the most meaning, however, are the modes of image, dialogue, and regalia. The showing of the shawl's design symbolizes the dancing, which is emphasized by the dancing itself and the dialogue about its importance.

Through functional load, Téa also shows two main identities. The first identity is Téa as a Cultural Preservationist. Téa shows that she is a person who respects her traditions. Although this identity is shown most readily in her interviews, in her video she shows this by including the blessing as part of the

video. She could have chosen to say the blessing without filming it (this is common in most of the videos that were filmed during this workshop[10]), but she chooses to highlight the blessing in both speech/dialogue, in using both Ojibwe and English, and by showing footage of the actions of the blessing. Moreover, the act of fancy shawl dancing, as both Téa and her mother discussed with me several times, is dying out, as few young people are learning it. Téa's presence as a dancer in the video is an attempt to preserve this tradition. Also, her shawl is another attempt to preserve the fancy shawl tradition, which she discusses quite readily throughout the process of filming and editing. In fact, Téa designed and made her regalia in a program Deanna created that attempted to help young people preserve the tradition of dancing. This goes to show that Téa is respecting her culture in many ways at once. She designs and sews traditional clothing, in this case her fancy shawl (with help from the other members of her community), as she learns to honor her community through fancy shawl dancing. Moreover, in some ways, this documentary is an extension of her mother's teaching about respecting one's own culture, something that Deanna tries to instill in Téa (personal communication, February 8, 2009), and this respect for her culture is something that is readily apparent in Téa's modal choices in her video.

The second identity is Téa as a Fancy Shawl Dancer. Although the video is supposed to be a documentary about fancy shawl dancing, the focus is not on dancing but rather on the dancer—or, rather, on parts of the dancer. First, there is her reaction to dancing, which is shown through her facial expression in the first part of the video. There is her connection to tradition through the blessing, which is shown through speech and dialogue with the voiceover of her giving the blessing and through the image of her hand and body at the edge of the lake as she gives the tobacco to the Spirits. Téa, in her video, combines many modes: music, with songs including Native flutes and chanting; image, with the combination of Téa, her regalia, and Spirit Island, a sacred site; action, with Téa dancing; and Téa's own voice and words as she tells about fancy shawl dancing in speech and dialogue.

This combination continues throughout the video as she is interviewed, providing her insights on what it means to be a fancy shawl dancer both personally and culturally. It is not just *that* she discusses fancy shawl dancing; it is *what* she says about fancy shawl dancing. She begins with her personal experience, such as when she states, "I've been dancing since...for...since I was a baby," and "I started dancing shawl a few years ago when I first noticed my cousin and how beautiful she looked in her outfit. It made me want to dance exactly like her." She couples this dialogue with images of herself both in interviews and dancing. But she extends it to her culture as well when she discusses what fancy shawl represents: "I started the fancy shawl cuz it takes the place of the butterfly. So, every time you see a butterfly...some people say it's a fancy shawl" and "I love fancy shawl dancing. It's

my favorite thing because it's our culture. It's what we do." Fancy shawl represents both nature and her culture, but it is also something that is meaningful to Téa as a person. She holds both those possibilities simultaneously, and she expresses them through her use of modes, such as image, speech, and dialogue.

Conclusions

In the spirit of the multi-voiced nature of this chapter, we will end with our three different perspectives on Téa's video.

Damiana's Conclusions

We see, then, that in this video Téa is holding open several identities at once: She is both an individual and a member of a community; she is a cultural preservationist and a girl who just loves to dance for the joy of it; she is a filmmaker and a fancy shawl dancer. Téa conveys all of these and more by a meaningful combination of modes, but she herself would not describe it in this way.

What is also readily apparent in my analysis and in Téa and Deanna's words in this chapter is just how much of a push-pull can be present when Native youth are creating their media. Téa's situation is similar to the girls in McCartney and colleagues' (1992) study in that she must represent both her own identity and represent her community. It is not a matter of representing solely herself.

But Téa's video and writing tell of how complicated this actually is. For instance, when thinking about gender dynamics, one can see how Téa represents herself as a young girl who is trying to figure out how to be a young woman in this culture. She puts two strong markers of gender in her video. The first is her fancy shawl that she made with her own hands and that represents both her community and herself (she has even labeled the shawl with her name). The second marker is her fancy shawl dancing, which is a dance for girls and women. Deanna addresses gender dynamics by stating that it is the influence of mainstream, white culture that gives a sense of gender implications to the Anishinaabe. But in this case Téa's expressing herself as a girl is seen not as a negative but rather as a positive expression, because she is still within the bounds of the Anishinaabe community.

Moreover, in terms of Téa being a Native youth creating media, I never get the sense from my analysis that Téa is "putting [her] indigeneity on display" (Siebert 2006, 532). In reality, Téa is representing a part of her people's traditions in her video. Both the organization's mission to foster Native youth identity within the community and Deanna's wishes that Téa learn about her Anishinaabe community are both strong influences on Téa's work. But one cannot escape the fact that Téa wants to represent her community. In our work about the larger study, we found that we need to question the idea that identity is solely an individualized construct. In reality, respecting the youths' productions means respect-

ing that some youth find maintaining their relationships to their communities to be more valuable than fostering a separate, individualized sense of identity (Halverson et al. 2008). Just as space must be made for youth to resist their communities' ideologies, so must we make space for youth to respect them. Sometimes, in the push to see media texts critically, we forget that for some youth respect is more valuable than rebellion. Téa's honest desire to represent her community reminds us to value this as well.

This is not to say, however, that Téa's video is solely about her community or her relationship to it. Téa's video is ostensibly about the tradition of fancy shawl dancing, but the multimodal microanalysis shows that, in actuality, her modal choices indicate that the video is as much about Téa as it is about fancy shawl dancing. Téa is visually present in almost all shots, and those shots show just Téa or Téa and nature. The shot levels emphasize Téa and her personal reactions to fancy shawl dancing; this documentary is clearly about Téa as a dancer. And the dialogue in the final video tells Téa's story as much as it tells about fancy shawl dancing's contribution to her community. All of these point to Téa as a person who defines herself through her dancing *and* through her video production. The way that Téa is able to navigate these complexities to make a video of which she is proud shows how powerful media production can be, which makes her mother's and her own analysis of it that follows all the more compelling.

Deanna's Conclusions

Téa is what one would call mixed breed (two different cultures) and has always been told to be proud of both of her cultural heritages. I have given her the opportunity to follow her heart, whether it was to follow American Indian traditions or Hispanic traditions. I think it's obvious that Téa has taken her American Indian cultural identity in stride. I believe Téa's video shows us the pride she has and carries in her heart when she is practicing her traditions. More importantly, Téa is leading by example. Téa often spends time with local elders, and whether or not she realizes it at this point and time in her life, she is preparing to be the teacher of our ways.

Téa's Conclusions

Now that the film's all done it means a lot to me because I know that a lot of people are watching it. I'm sure that Kris will show it to other people, and I'm glad that they can see my perspective of the video. I think the movie turned out great. Some parts there were wind but mostly it was clear and beautiful. It feels super cool to have a video [on YouTube] that I am in and that I helped film and to know that almost everyone and anyone can watch it.

My new project is to get together some of the people who still talk Ojibwe and to get them in my video. I want to help them describe what they are saying in English with them saying stuff in Ojibwe and then translating what they said into English. It would be pretty cool if other cultures…would know how to say at least a little bit of Ojibwe so that they could start saying it and we could communicate sometime. And, so that we can preserve it to help our culture stay alive.

Notes

1. In this chapter we will be referring to the co-authors by their first names. This is partly logistical in that two of the authors are mother and daughter and share the same last name, and it would make the writing cumbersome to have to refer to each by last name and initial. More importantly, however, we made this choice of a certain level of informality so that the chapter would be more in keeping with a dialogue rather than strictly an academic article, which is part of our point about including the voices of those who are not normally included in such academic work.

2. Chicana (or Chicano) is a term that Damiana uses to self-identify as a person of Spanish and indigenous descent on her father's side. It is often used as a term to signify political affiliations to Mexican-American social movements but, of course, the act of self-defining is always fraught with concerns (for an excellent examination of the complexity of self-identification as a Chicana researcher, see Villenas 1996). However, Damiana finds this term to be more applicable to her ethnicity than other terms. Each person finds her own terms depending on her circumstances.

3. The application of the term "nation" to Native American communities is historical in that it is based on various treaties that Native groups held with the U.S. government, signifying a complicated set of relationships in which Native people have a varying degree of sovereignty from the U.S. government. This is something that is constantly negotiated and renegotiated, as is how this sovereignty within the United States could be translated to sovereignty in a global context (Uran 2005; Wunder 1996).

4. This media arts program began as a program only for Native girls, which is why it is named Ogichidaakweg, or "Sisters in Leadership," but it now serves both genders equally (http://in-progress.viewbook.com/portfolio/news).

5. Gilligan, Lyons, and Hamner's (1990) focus on girls was in itself a break from previous studies based on Kohlberg's (1958) study on moral development, studies that focused on the moral judgments of males (Turiel 2008).

6. Téa's father is of Hispanic origin; therefore, she comes from multiple backgrounds. In an interview, Deanna and Téa address how she will have to decide how to live in both the Anishinaabe world of her mother and the Hispanic world of her father, a world that is also outside the reservation (personal communication, February 8, 2008). Deanna refers to Téa as Hispanic, which is a term that is often associated with the U.S. Government Census Bureau because it was the official government designation, but it is also a term that many women have chosen to describe their ethnicity and that of their children (Delgado Bernal et al. 2006).

7. Deanna and Téa live in the Bois Forte reservation, which their community calls the "Bois Forte nation" to express the way they view their sovereignty and their community affiliation. The people in the Bois Forte nation are Anishinaabe, which are a people related to but different from the Ojibwe nation.

8. In this research, Damiana collected a variety of data: fieldnotes on observations of programs; interviews with youth, facilitators, directors, and parents; curriculum guides, both published and unpublished; written work produced by youth; organizational websites; and unedited and edited youth video productions. Damiana also conducted follow-up interviews with Téa and Deanna when they happened to be at In Progress when Damiana's research team was collecting data. The larger research team, of which Damiana is a part, conducted research in three other youth media arts organizations across the United States, all in a similar manner (see Halverson and Gibbons 2010).

9. It should also be noted that Téa was not Damiana's only case study. She also took video and audio footage of other youth throughout the process. She chose Téa for this chapter, not because she was unusual but rather because she was indicative of the process and the youth work as a whole. But on a personal note, Damiana also had been welcomed by Téa and her family during her time in Téa's community, and because of this Damiana, Téa, and Deanna felt very comfortable with one another. Extending the opportunity to write this chapter to Téa and Deanna was an easy decision, given how much time Damiana had spent with this particular family, both during the workshop and in subsequent interviews, and they knew that they would be able to work well together.

10. Most of the youth produced video and digital photography work that was about their community and their place within it. Some of them did this through satire, such as a horror movie spoof, but most of the youth produced documentary videos, such as one about Native language dying out in their community or another about skateboarding on the reservation. The goals of this program were for youth to learn to honor their community through digital media production, and the youth took this mission seriously as they produced their videos and photography.

References

Bing-Canar, Jennifer, and Mary Zerkel. 1998. Reading the Media and Myself: Experiences in Critical Media Literacy with Young Arab-American Women. *Signs.* 23(3): 735–743.

Bird, S. Elizabeth. 2003. Imagining Indians: Negotiating Identity in a Media World. In *The Audience in Everyday Life: Living in a Media World,* 86–117. New York: Taylor & Francis Books, Inc.

Buckanaga, Ron, and Kristine Sorensen. 2007. *Through the Eagle's Eye: Innovative Approaches to Teaching Media Arts.* St. Paul, MN: In Progress.

Buckingham, David. 2006. *Media Education: Literacy, Learning, and Contemporary Culture.* Cambridge, UK: Polity Press.

Burn, Andrew. 2001. Making Your Mark: Digital Inscription, Animation, and a New Visual Semiotic. *Education, Communication, and Information* 2: 155–179.

———. 2009. *Making New Media: Creative Production and Digital Literacies.* New York: Peter Lang.

Burn, Andrew, and David Parker. 2003. *Analysing Media Texts.* London; New York: Continuum.

Chan, Chitat. 2006. Youth Voice? Whose Voice? Young People and Youth Media Practice in Hong Kong. *McGill Journal of Education* 41: 215–225.

Delgado Bernal, Dolores, C. Alejandra Elenes, Francisca E. Godinez, and Sofia Villenas, eds. 2006. *Chicana/Latina Education in Everyday Life.* Albany, NY: SUNY Press.

Fine, Michelle. 1994 . Working the Hyphens: Reinventing the Self and Other in Qualitative Research. In *Handbook of Qualitative Research,* eds. N. Denzin and Y. Lincoln, 70–82. Newbury Park, CA: Sage.

Fisherkeller, JoEllen. 2002. *Growing Up with Television: Everyday Learning Among Young Adolescents.* Philadelphia, PA: Temple University Press.

Fleetwood, Natalie R. 2005. Authenticating Practices: Producing Realness, Performing Youth. In *Youthscapes: The Popular, the National, the Global,* eds. S. Maira and E. Soep. Philadelphia, PA: University of Pennsylvania Press.

Gilligan, Carol, Nona P. Lyons, and Trudy J. Hamner. 1990. *Making Connections: The Relational Worlds of Adolescent Girls at Emma Willard School.* Cambridge, MA: Harvard University Press.

Goodman, Steve. 2003. *Teaching Youth Media: A Critical Guide to Literacy, Video Production, & Social Change.* New York: Teachers College Press.

Hall, Stuart. 1996. New Ethnicities. In *Critical Dialogues in Cultural Studies*, eds. K.H. Chen and D. Morley, 442–451. London: Routledge.

Halverson, Erica R. 2010. Film as Identity Exploration: A Multimodal Analysis of Youth-Produced Films. *Teachers College Record* 112(9): 2352–2378.

Halverson, Erica R., and Damiana Gibbons. 2010. "Key Moments" as Pedagogical Windows into the Digital Video Production Process. *Journal of Computing in Teacher Education* 26(2): 69–74.

Halverson, Erica, Rebecca Lowenhaupt, Damiana Gibbons, and Michelle Bass. 2008. Conceptualizing Identity in Youth Media Arts Organizations: A Comparative Case Study. *eLearning.* 6(1): 23-42.

Hull, Glynda A. and Mark E. Nelson. 2005. Locating the Semiotic Power of Multimodality. *Written Communication* 22: 224–261.

Hull, Glynda A., Mark E. Nelson, and Jeeva Roche-Smith. 2008. Challenges of Multimedia Self-Presentation: Taking, and Mistaking, the Show on the Road. *Written Communication* 25: 415–440.

In Progress homepage. Ogichidaakweg Program. In Progress. http://ipwithinus.blogspot.com/.

Jenkins, Henry, Katie Clinton, Ravi Purushotma, Alice Robison, and Margaret Weigel. 2006. *Confronting the Challenges of Participatory Culture: Media Education for the 21st Century.* Building the Field of Digital Media and Learning. MacArthur Foundation. Occasional Paper. http://digitallearning.macfound.org

Leuthold, Steven. 1997. Native American Documentary: An Emerging Genre? *Film Criticism* 22: 74–90.

———. 1998. *Indigenous Aesthetics: Native Art, Media, and Identity.* Austin: University of Texas Press.

———. 2001. Rhetorical Dimensions of Native American Documentary. *Wicazo Sa Review* 16: 55–73.

López, Antonio. 2008. Circling the Cross: Bridging Native America, Education, and Digital Media. In *Learning Race and Ethnicity: Youth and Digital Media,* ed. A. Everett, 109–128. Cambridge, MA: MIT Press.

Markstrom, Carol A., and Alejandro Iborra. 2003. Adolescent Identity Formation and Rites of Passage: The Navajo Kinaaldá Ceremony for Girls. *Journal of Research on Adolescence* 13: 399–425.

Mayer, Vicki. 2000. Capturing Cultural Identity/Creating Community: A Grassroots Video Project in San Antonio, Texas. *International Journal of Cultural Studies* 3(57): 57–76.

McCartney, Catherine E., Kate M. Steffens, Christine M. Imbra, and P.J. Ford Slack. 1992. Moral Development: Interviews with Young Ojibwa Women. *Initiatives* 55: 11–21.

Siebert, Monika. 2006. *Atanarjuat* and the Ideological Work of Contemporary Indigenous Filmmaking. *Public Culture* 18: 531–550.

Singer, Beverly R. 2005. The Making of *Who We Are*, Now Showing at the NMAI Lelawi Theater. *American Indian Quarterly* 29: 466–477.

Sirin, Selcuk R., and Michelle Fine. 2007. Hyphenated Selves: Muslim American Youth Negotiating

Identities on the Fault Lines of Global Conflict. *Applied Developmental Science* 11 151–163.

Soep, Elisabeth. 2006. Beyond Literacy and Voice in Youth Media Production. *McGill Journal of Education* 41: 197–214.

Stein, Pippa. 2007. *Multimodal Pedagogies in Diverse Classrooms: Representation, Rights, and Resources.* New York: Routledge.

Turiel, Elliot. 2008. Thought about Actions in Social Domains: Morality, Social Conventions, and Social Interactions. *Cognitive Developmen.* 23(1): 136–154.

Tyner, Kathleen. 1998. *Literacy in a Digital World: Teaching and Learning in the Age of Information.* Mahwah, NJ: Lawrence Erlbaum.

Uran, Chad. 2005. From Internalized Oppression to Internalized Sovereignty: Ojibwemowin Performance and Political Consciousness. *Studies in American Indian Literatures* 17(1): 42–61.

Villenas, Sofia. 1996. The Colonizer/Colonized Chicana Ethnographer: Identity, Marginalization, and Co-optation in the Field. *Harvard Educational Review* 66(4): 711–731.

Weaver, Hilary N. 2001. Indigenous Identity: What Is It, and Who Really Has It? *American Indian Quarterly* 25: 240–255.

Wunder, John R. 1996. *Native American Sovereignty.* New York: Routledge.

Zaal, Mayida, Tahani Salah, and Michelle Fine. 2007. The Weight of the Hyphen: Freedom, Fusion, and Responsibility Embodied by Young Muslim-American Women During a Time of Surveillance. *Applied Developmental Science* 11: 164–177.

10

Transnational Childhoods and Youth Media: Seeing with and Learning from One Immigrant Child's Visual Narrative

Wendy Luttrell, with Jennifer Dorsey, Carla Shalaby, and Julia Hayden

Introduction

"Your family is always there for you more than anybody else. Family is the one who takes care of you when you was growing up...."

Angeline, quoted above, migrated to the United States from Kenya at the age of seven.[1] She is part of a large, extended family with "lots of cousins...some are 'back home'" (in Kenya), some live in Massachusetts, others are in Texas, Missouri, Georgia, or Canada. "Like, they're all spread out." Reflecting on her transnational family circle, she says she is glad "because then I have more culture in me.... Some parts of my family are, like, Kenyan culture and American culture. So, I have two cultures. I'm black American, so, mostly Kenyan though."

Like the other participants in this youth media project, Children Framing Childhoods, Angeline took pictures of her family, school, and community life that emphasize her participation in and insights about larger social structures, processes, and ideologies—including poverty, gender, the global migration of people, and the American Dream. Such large-scale processes are not often understood

from the perspective of children as social actors (Orellana 2009; Thorne 2002), yet this was the goal of the project on which this chapter is based.[2]

Angeline was one of thirty-four children aged ten–twelve who took part in this media project. Their use of photography—the images they took and the explanations they provided—served as a means of entry into their social and emotional worlds and complex self-identifications. In addition to extensive participant observation in their public elementary school, data include 1,350 photographs collected over four years and sixty-five hours of videotaped interview data in which the children discuss the meanings of their own and each other's pictures. While the camera is just one among many tools, we contend that photography is an especially useful medium through which young people make visible their social worlds and express matters of the heart.

Our project is situated within an increasingly popular research practice that gives kids cameras as a means of inquiry. However, we take a different perspective on children or youth photography than the one taken by many photographers who are engaged in projects with young people. For example, Jim Hubbard, renowned professional photographer and founder of the Shooting Back project, explains that "unless there is a competent and ongoing tutorial element, most children will not produce images that truly depict the vast array of elements a community is comprised of.... Without ample guidance, the kids will take pictures of cars/hubcaps, hood ornaments, flowers, trees, grass, cats, dogs, and each other" (2007, 7). We did not encourage the children to produce a particular kind of image. Instead we believe there is merit in projects that seek to understand and preserve the meaning of these "ordinary" pictures to the children, on their own terms. Our approach is to assume that the meanings behind these images can be extraordinary, if we listen carefully and systematically as children help us see the world and themselves as they do.

That said, we do not believe that understanding transnational childhoods "through children's eyes" or capturing children's "voices" is a straightforward or simple task. We join others who challenge a notion of "voice" that assumes children speak as one, or with a singular voice (Arnot and Reay 2007; Luttrell and Chalfen 2010; Piper and Frankham 2007; Thomson 2009; Yates 2008).[3] We find that gender, race, ethnicity, class, and immigrant status influence the photographs children take, and what children say about those pictures. Also, there are shifts in how children discuss their photos depending on the context and audience—what is said to the interviewer may differ from what is said in peer groups or to teachers. We also find that there is no single theoretical framework with which to understand the "complex life" of the images children make.[4] We start from the premise that there are multiple layers of meaning in any single photograph and that children make deliberate choices to represent themselves and others, sometimes in an

effort to "speak back" to dominant or stereotypical images of themselves (Luttrell 2003).[5]

Through our analysis of children's use of photography, we wish to add nuance to the discourse about "immigrant" children within our field whose lives have mostly been examined in terms of two central questions: (1) How is Immigrant Group X adapting to school? (Lee 2005; Olsen 1997; Suárez-Orozco and Suárez-Orozco 2001); or (2) How do we explain the academic over- or underachievement of Immigrant Group Y, particularly as compared to other "minority" groups? (Coll and Marks 2009; Ngo and Lee 2007; Suárez-Orozco and Suárez-Orozco 2001). These are crucial questions, but they are not the only questions. In this chapter we focus on one particular immigrant child—Angeline—and the questions *she* raises about her transnational childhood.[6] Of the many themes that Angeline identifies, we wish to feature one—the social and emotional worlds of carework.[7] We have selected this theme for two reasons: first, because the relationship between care and learning is neglected in contemporary educational discourse, especially in this era of high-stakes testing and accountability; and yet, it is Angeline's participation in and awareness of carework that etches her identity, self-regard, and social consciousness. Second, by examining the ways in which Angeline reads signs of care across several contexts—family, school, community—we are better able to understand her transnational experience.

Background

Wendy Luttrell first visited the school—a kindergarten through sixth grade urban, public elementary school in Worcester, Massachusetts—in the fall of 2003. Discussions with the principal about her most pressing concerns resulted in several initiatives, including one that would evolve into Children Framing Childhoods, which would attempt to better integrate increasing numbers of immigrant students and families into school culture. The school serves immigrant families from a range of nations, including, to name a few, Albania, Iran, Kenya, Puerto Rico, and Vietnam. Of the 370 students enrolled, 92% are eligible for free school lunch; 37% are white, 10% are black, 18% are Asian, and 35% are Hispanic.[8] Luttrell saw this as an opportunity to investigate the lived experiences of transnational childhoods, and to consider the experiences and cultural knowledge of immigrant children as a rich resource for learning rather than as a deficit.

Using traditional ethnographic methods, Luttrell also designed a multilayered, reflexive approach, combining "photovoice" strategies and photo-elicitation interviews (PEI; see Luttrell 2010 for a full description of the research process).[9] Other researchers have noted that photos can introduce content and topics that might otherwise be overlooked or poorly understood from an adult viewpoint, and can trigger new information, memories, and meanings for the in-

terviewees (Clark 1999; Clark-Ibanez 2004; Collier 1967; Harper 2002; Orellana 1999; Rasmussen 1999; Schwartz 1989). Moreover, because there are no ready-made devices for interpreting children's photography, it was important to provide multiple opportunities for the children to *instruct* us about their photos' meanings.

Each child was given a disposable analogue camera with twenty-seven exposures. For many, this was their first camera. In the words of one student, "Having a camera is a big responsibility." The children had four days to photograph their school, family, and community worlds. In grade five, the children were told to "imagine you have a cousin your age that is moving to Worcester and coming to your school. Take pictures of the school, your family, and community that will help him or her know what to expect."[10] When participants went on to the sixth grade, they were free to take photos without specific prompting. After the photos were developed, each child discussed her or his photos with Luttrell or a research assistant.[11]

During these interviews, each child was asked to select five photos for public viewing and to be discussed with the other participating children.[12] Luttrell and her research assistants then led focus-group interviews where the children discussed what they noticed in each other's photographs. At the end of each school year, the children collaboratively curated an exhibition of their photographs to be shown at their school and at the Harvard Graduate School of Education. All interviews and group sessions were audio- and videotaped and transcribed.

In each context we worked inductively—the interview questions were open-ended. As the children spoke about the people, places, and things they had photographed, we paid attention to how they negotiated their social placements. We listened for their own categories and how they marked social and cultural differences. Individual children's interactions with various interviewers and audiences—their own multicultural peers, the predominantly white, female graduate students in their twenties and early thirties, and Wendy Luttrell, a white, middle-aged professor—provided additional insight into the children's identity work, including how they asserted their expertise, played with power, and were cued into authority and status.[13]

Our analysis of the children's collection of photographs—their "albums," so to speak, weds visual with narrative analysis as a means to understand a child's self, identity, and social consciousness (Daiute 2000; Daiute and Nelson 1997).[14] Each child took photographs that—in addition to commemorating occasions, relationships, and achievements—showed moments "when what is visible about [the child] attests to social matters about which [she/he] is proud" (Goffman 1979, 10) and through which a range of insights and emotions about childhood contexts can be appreciated. Writing about the convention of "private pictures" such as

these, Erving Goffman suggests that their "special properties" include the ability to "make palpable to the senses what might otherwise remain buried and tacit in the structure of social life" (10). With this in mind, it is difficult for us to write about our project, which is photo- and video-based without the benefit of the visual images to convey themes that are "hard to write about but easy to picture" (22). Social relationships and power dynamics are expressed through what Goffman calls shared "idioms of posture, position, and glances" that express how people "wordlessly choreograph [themselves] relative to others in social situations" (21).[15] It is the choreography of carework and how Angeline is positioned and positions herself and others that we wish to draw attention to in this chapter. We hope our analysis will accomplish two goals: (1) complicate the analysis of images produced in youth media projects; and (2) generate a need-to-know-more stance toward immigrant children and their individual experiences of transnationalism.

The Choreography of Carework

"Helping Each Other": Carework as *Collective*

A tacit structure of social life that Angeline's album makes visible is carework. Her photographs feature pictures of people in varied settings where she is cared for and where she cares for others. As if to echo the African proverb, "it takes a village to raise a child," Angeline emphasizes that care is work, and that caring is a *collective* endeavor. She uses her photographs to talk about care-giving and care-receiving as a two-way project—one that is co-constructed between children, and between adults and children.[16]

Angeline takes numerous pictures of her classroom, a setting in which children [she says "people"] "work hard," "help each other," and "cooperate." One of the classroom photographs is meant to show "people coming together. If somebody doesn't have a book, you just don't leave them. You help each other out." Interestingly, most of her photographs of classroom settings are taken of children in small groups with no adult or teacher present.

Angeline also takes pictures of her female friends because "they help you, they're always there for you." Of her special friend, Thea, she says,

> I walk to school with her. She lives about one house away from my house. She's a real good friend to me. She's there for me; whenever I need her she's there for me, encouraging. Like, I wasn't going to try out for basketball because I was nervous or something but she encouraged me to do it and I did do it.

"Nice" and "Kind": The Feeling Rules of Carework

In fifth grade, ten-year-old Angeline hands her camera over to her teacher because she wants a picture of herself with "Sue, the lunch lady." The two appear in the foreground, posing in a maternal-like embrace; both smile directly into the camera. Sue, a white woman with short auburn hair and chestnut eyes, wraps both arms affectionately around Angeline. Sue's bent head rests atop Angeline's tight cornrows. Angeline stands erect, her full forehead, deep brown eyes, and brown dimpled cheeks close to Sue's chest. The background is dark and grainy; a line of light reflects off the large, stainless steel refrigerator unit that flanks the wall of the cafeteria, and a bright, yellow, industrial mop bucket can be seen by the door. Of the photograph, Angeline says,

> That's Sue the lunch lady, she's really nice. I like her because she's very nice... she is really kind. I help her a lot with her work.... If we didn't have her we would be starving, *starving* [her emphasis] and we won't be able to learn. *Why?* How can we learn without no breakfast, no lunch, how can we learn like that? Our stomachs will be going "Give us some food!"

Angeline pays tribute to Sue's carework and perceives Sue's arguably low-wage service job with high esteem. Through hyperbole and changing the register of her voice to virtually "sing her praises," Angeline stresses the vital, if unrecognized, role of carework in the daily life of the school and in children's learning. In exchange, Angeline helps Sue clean the cafeteria tables.

How do we interpret the wordless choreography of gender, race, and class that is captured in this photograph? And what imagined audience(s) do Angeline and Sue have in mind as they pose for the camera? The embodiment of maternalism is inescapable, and Angeline draws our attention to Sue's caring, kindness, and nurturance.[17]

A gendered choreography of carework stands out in Angeline's images at school. She photographs a universe of smiling girls (friends) and women (her fifth-grade teacher, Sue the lunch lady, and the principal), whom she praises for their encouragement of the emotional and social development of children.

When we compare how Angeline photographs and speaks about her white, female, fifth-grade teacher and her white, male, sixth-grade teacher, the pattern is striking. Her female teacher is pictured smiling broadly, bending down to face level inside a ring of children's desks. Angeline says she took the picture "because my teacher helps me learn new things, and if I don't know what to do, she explains it to me and helps me understand it and I appreciate her very much." Her talk of the female teacher reflects the teacher's emotional form of labor and tending to the feelings of students—where the goal of the learning seems to be both to understand the material and to feel confident in one's ability to learn new things. By

contrast, her male teacher is pictured standing upright and apart from the children and their desks, looking directly into the camera without a smile. Of this photograph she says, "He pushes us to do our work. And, I'm really glad he pushes us, 'cause then he will get us into college." Her talk of the male teacher is rooted in an economic and social mobility discourse of education in which the goal of learning is to get into college. Both photographs depict the hard work of dedicated educators, but the emotional labor and "feeling rules" of teaching young children are more clearly reflected by the female teacher.

This choreography of care is mirrored in the different ways in which Angeline speaks of the role of her parents. Like so many children in the project, Angeline went to great lengths to photograph her parents.[18] In Angeline's case, it was 6:00 a.m. when she took her parents' picture.

> My dad had just woken up. He had to take my mom into work, he's so grumpy when he wakes up. He looks kind of mad, he doesn't have a smile. Okay, this is my mom. She was going to work, that's why she has her work clothes and her jacket.

Angeline narrates her photograph in terms of her parents' work schedules, featuring her mother's double shift.[19] Her mom, who is a certified nursing assistant in a nursing home, "goes to work 7a.m. to 11p.m., on Saturdays 7a.m. to 3p.m. Most of the time she goes at 7a.m. to 11p.m. and my Dad goes at 3a.m. to 11a.m."

The gender dynamics pictured in this photograph are hard to describe in words. Angeline's mom supports her husband's presence, both literally, by gripping his wrist and putting her arm around his waist as they both stand erect in front of the front door, and symbolically, by satisfying her daughter's request for his representation in spite of the early hour and his related "grumpy" mood. It is not that her father is uninvolved in her care, but his is of a different sort, captured by his refusal to smile (despite Angeline's instruction to do so, as she tells the interviewer). Her mother, on the other hand, manages a smile in spite of a set of quite challenging circumstances: the very early hour, the need to leave for the first of two work shifts, her daughter's request for a photograph at a relatively inconvenient time, and her husband's grumpiness. It is the woman, again, who meets her emotional work responsibilities, "managing" her own feelings (Hochschild 1983) to address the feelings of her daughter. Angeline describes her parents in the following way:

> I love my mom, she encourages me a lot. Like, for cooking. She encourages me for all the things I want to do. I love my mom. Like, mostly my dad encourages me to do math and stuff, like for MCAS [the Massachusetts Comprehensive Assessment of Skills] and he gives me good advice because he's very good at math. Sometimes I get awards in math so he is very good at [being] encouraging of that. And my mom is encouraging my cooking and my basketball team and all that stuff.

Angeline undoubtedly feels loved and cared for by both parents; still, she offers a gendered account of their carework—her mother encourages "all the things I want to do,"[20] while her father encourages "math" and her ability to perform on the high-stakes test.[21]

Angeline marks her own part in the gendered division of carework at home when explaining why she has taken a picture of the kitchen.

> Cooking, cleaning up the house. This is where I wash the dishes, this is the stove. I like cooking a lot. That's where I do my chores, most of the time on the weekends, that's what I do.

Angeline says her mom has been teaching her to cook, but "sometimes when my mom goes to work and she has to leave early, and she doesn't have time to cook, then if it's the weekend and I'm not going to school and I need something to eat, then I ask my dad if he can cook for me and then he cooks. He's a good cook, *for a man*" [her emphasis as she smiles at the interviewer].

Angeline was not the only child to make visible the gendered nature of care in households. Looking across all of the children's photographs provides ample evidence of the all-too-familiar gendered division of love and care labor, presented most frequently by "moms-in-kitchen" photographs that celebrate and honor mothers' primacy in "feeding the family" (DeVault 1991).[22] Moreover, we found that there was a difference in how boys and girls placed themselves in this calculus of maternal carework. Gender asymmetries were brought to the surface as girls took photographs that proudly displayed the objects and tools of their domestic chores (e.g., laundry, dishes, vacuum cleaner), often commenting on the need to help mothers who come home exhausted from their jobs. By contrast, boys took more photographs of (video) games, sports equipment, and outdoor play spaces. From the children's own accounts, parents' low-wage work routines seemed to shape the girls' and boys' lives differently, offering the boys more leisure time at home, as has been documented by other researchers (Dodson and Dickert 2004). In the children's photographs and testimonies of admiration for their (oftentimes single) mothers and the carework that they do, we found that boys described being *cared for* by women (mothers, aunts, grandmothers), whereas girls described *caring with* (and thus identifying with) a lineage of female family figures.

Growing and learning in this gendered context of care, how does Angeline make sense of her own identities and responsibilities as a young woman?

"A Hardworking Girl"

We have no direct way of knowing how Angeline understands the choreography of care—but we do know that her own identity is tied up in being a "helpful" and

"hardworking" girl whose training of the heart and preparation for the future takes place across family-school-community and national contexts.

It is her discussion of two self-portraits—one taken at home by her mother and one taken at school by her best friend—that provides us a glimpse into the complexities of her self-identification and raises provocative questions about how Angeline reads her world. In the first photograph Angeline sits on the living room sofa behind a small tray table. Her head is bent in concentration, her eyes intent on her paperwork with pencil in hand:

> Oh, that was me when I was doing my homework. Because I said what I do after school is I do homework sometimes. I read. I play. So I told my mom to take a picture of me doing my homework.

> *So what did you want to show? Why is this picture important to you?*

> Because I need homework in my life. Because even though some people don't really like it—I don't really like it that much, homework. But even if you don't like it you're going to need it in your life.

> *Why?*

> Because you're going to need math in your life. If you don't learn math when you're little then you're going to be really poor, you're going to have no money. Because you're going to be cheated...of a lot of things. They're going to be like, "Give me one hundred dollars and I'll give you one cent." And you're going to be like "OK" because they're going to think that one cent is worth more than one hundred dollars [*laughs*].

> *So it's important to learn math so you don't get cheated?*

> Yes. And don't I look beautiful?

Angeline sees herself as "beautiful," epitomizing her feminine self-regard. She needs homework in her life, but especially math, to protect herself. Throughout her interviews Angeline associates "math" with school achievement, going to college, but most important, with basic survival. She reiterates this message when she takes a picture of her "hardworking classroom."

> I took it in math because you know what I said about we need math in your life? You can't be anything; you won't know what to do with your life without math. Because obviously if you pick to be something you can still be cheated of money.

What does Angeline's allusion to poverty and being "cheated of a lot of things" have to do with her life experience or her parents' experience in Kenya and their migration to the United States? How might her associations about math be related to her previous post-colonial British schooling in Kenya? These are the need-to-know-more moments that are opened by Angeline's engagement in the project that beg for more information.

This theme of a hardworking girl is carried forward in the other photograph where she strikes the exact same pose:

My friend took it to show that I'm a hardworking girl.

Why is that important to show?

Because I want to learn, I want to get into college, I want to make my life really—you know, I don't want to have any problems with my life. I want to learn a lot so my life can be exactly like how I want it to be and go to college.

How do you want your life to be?

I want to live maybe in a big house or a mansion, have two cars—one of them should be a sports car and one of them should be a big car which is good for winter, a sports car maybe for summer. And I want to be a fashion designer or a doctor, mostly a doctor. And I want to have a family and I want to make my life interesting [*gesticulates outward with hands and smiles*].

As Angeline speaks, she shifts between two voice registers. One voice addresses her concerns about money, poverty, problems, and being cheated. Another voice addresses the American dream of abundance, luxury, and glamour. These are parallel scripts into which she has been initiated and through which she is articulating a social consciousness about money, power, and powerlessness. Still, there is another voice about the meaning of being a hardworking girl to which we now turn.

"I'm Really Appreciative": The Transnational Flow of Gratitude

As Angeline's opening quote asserts, "Your family is always there for you more than anybody else. Family is the one who takes care of you when you was growing up...." This care, however, should not be taken for granted. "Not everybody—kids can be born with their family but their parents don't want them. So, the kids don't even know that much about their parents."

So you took a picture of your parents and you wanted to show...

To show that I admire my parents, I love them because they born me into this world, with the help of God [*smiles*], yeah.

Throughout Angeline's interviews she communicates the significance of basic necessities and everyday rituals of care and survival.[23] Looking at a photograph she took of her apartment house, Angeline says, "Because my house means a lot to me, that's where I live. If I didn't live in a house I would be homeless, that's why I'm really appreciative [*stumbles over this word, and gesticulates to her heart*] that I have a house."

Angeline takes nothing for granted, often going out of her way to emphasize her gratitude. Angeline's photo of her carefully organized and full closet is a case in point. A viewer might guess that she is demonstrating an orientation toward American abundance and consumerism (Schor 2004), and Angeline does say that she enjoys shopping and "dressing good." But she also discusses her closet and her clothes as a means of maintaining ties with the important people she has left behind or lost through the act of giving and receiving.

> All my clothes mean a lot to me because if, when people buy them for me. Like, the ones I buy for myself and my grandparents buy for me are very special.... 'Cause my grandparents live all the way in Africa where I am from, so it's really special because that's something I can remember about them and when I wear them and look down at it I remember them. I picture them in my eye [*gestures putting her hands to her face*].

Presenting people, objects of value, and settings that she has captured in her photographs through a framework of *gratitude* is integral to Angeline's self and identity-work in the context of a transnational childhood. Angeline's narratives of gratitude for all of the things that others have provided—food (Sue, the lunch lady), clothing (her closet and family members), shelter (if she didn't have a house she would be homeless), and life itself (her parents, for having brought her into this world)—speak to an ethic of care that rises out of gratitude and mutual obligation (rather than entitlement), which orients Angeline's understanding of herself in relation to the world around her.

Angeline takes two photographs of a poem she wrote about her extended family at school that "traveled" home to be displayed in her bedroom—a fitting metaphor for the emotional realm of her transnational childhood. She says she photographed the poem "because that's my poem about my family, you'll see it [again] in one of these pictures." Coming upon the close-up shot of the poem, she says with great excitement in her voice, "Oh that's my poetry that I hanged up in my bedroom!" and without prompting reads it aloud to the interviewer.

> *My Family*
> When I need them, they are there for me
> When I'm lonely, they come to the rescue
> When I'm cold, they make me warm
> When my heart is broken, they put it back together
> Some are sensitive, some are not
> But I will always love them no matter what they are
> Because we are one big loving family
> by: Angeline

Angeline explains why she took the photo:

I didn't have time to take a picture of my *whole* family and I couldn't find a picture of my family so I just took a picture of this describing my family. [*emphasis hers*]

So you mean your whole family, not just your mom and dad?

My *whole* family. [*gesticulating widely, emphasis hers*]

Angeline uses the poem to communicate the emotional "here" and "thereness" of her transnational circle of care and to commemorate those she has lost and longs for.

The photograph of her poem leads her to reminisce about family members, including her favorite cousin who lives in Kenya with her grandmother:

> ...because my uncle and his father died, so when he was little he thought that my mom was his mom and my dad was his dad. And he thought that I was kind of his sister. And now he knows that his parents are dead but he's okay with that, but he's still closest in our family so he's kind of my brother.... He's my favorite, favorite—even though I love all of my cousins, he was my favorite one, he means a lot to me. He's, like, there's something special about him.

Angeline describes how she maintains contact with her special cousin—through photographs that her grandmother sends and talking to him regularly on the phone (with her mother's phone card). "Someday I might go back there to visit." In this way, Angeline's "album" features the practices, relationships, and sentiments that link her with her home country.

"He's Not Doing a Bad Thing": Navigating the Gaze

Angeline skillfully navigates the camera and the interview exchanges to protect her own and her family's public image. She is self-assured yet cautious about her self-presentation, consistently acknowledging the video camera as though it is a third party in the room. For example, Angeline takes a photo of a local health center to "show how people help each other get well. Like how they treat you very nice over here [in the United States]." As she describes the context of her photograph, she catches herself and wards off the possibility that her father will be viewed negatively:

> Like, sometimes if my parents, they need to get some medicine...I go with them...I took that when my dad was going there. He was getting medicine there. I don't know why. I don't know; *but he's not doing a bad thing* (she emphasizes these words and looks directly into the eyes of the interviewer and then to the video camera).

What social meanings does Angeline perceive her imagined audience will attach to her family—as Africans, as immigrants, as doing something "bad"? Angeline's efforts to manage her family's image in the face of viewers (teachers?

researchers? a judging public?) who might view them otherwise is part of a larger pattern we found across the children's albums. As immigrant children move between family and school, they must contend with an ideal of "family" reflected in cultural representations and institutional expectations that may not match their own. In this project, the children used their photographs to communicate their attachments and to extol the virtues of their parents' (predominantly mothers') carework. Behind their "ordinary" pictures lies an extraordinary choreography of carework that is part of the fabric of their lives.

Conclusions and Implications

We have argued that Angeline's album valorizes collective care-giving and care-receiving, while also shedding light on its gendered organization—a social process in both families and schools that underwrites inequality but is not the focus of mainstream social science research or public policy. At a time when basic resources and services are increasingly withdrawn from schools and post-welfare, neoliberal social policies fail to recognize and reward care-giving as a public good rather than a private affair, we think that Angeline's portrayal of collective carework (at home, in school, and in the community) is of civic significance. It is vital that concerned adults learn more from children and young people about this hidden and under-valued domain of everyday life, including how their self-regard and personal identities are bound up in this world of care. In doing so, we may discover that Angeline and her peers are ahead of social scientists and educational policy analysts who have long ignored the centrality of this affective domain in achieving social justice (Lynch et al. 2009).

We have also argued for a more full and complicated analysis of images produced in youth media projects. Collaborative youth media projects need to engage researchers, educators, and children themselves in a need-to-know-more stance about the images that are made and the hidden dimensions of social structure and cultural meanings that are conveyed. We take seriously the power of visual media in research with young people not because they necessarily show us something we haven't seen before, but because they show us something we are likely seeing through different lenses.

Finally, educators and social scientists need the help of young people like Angeline to refocus our lens to better align with how they make sense of their own transnational childhoods. Learning more about how children read signs of care will enable us to understand transnational experience as more than the flow of people, money, goods, and ideas, but also of *sentiments*.

Notes

1. All names are pseudonyms.

2. For more information about the project, including selected photographs, see www.wendy-luttrell.com.

3. See Pat Thomson (2009: 4–6) for her discussion and critique of "voice" research and its tendency to universalize children and youth experience. She reviews five different kinds of voice to which researchers have paid attention and suggests there may be more: authoritative, critical, therapeutic, consumer, and pedagogic. She also breaks down two different types of approaches to visual research—those in which researchers use visual methods *on* children (where children are framed as the subjects of inquiry) and those that use visual methods *with* children and youth as partners in inquiry.

4. See Catherine Lutz and Jane Collins (1993) for their discussion about the "complex life" of images in terms of their production, circulation, and interpretation.

5. Luttrell first took this approach in her image-based ethnographic study of how low-income, mostly African American pregnant girls experience "teenage pregnancy"—a phenomenon and stigmatizing label they were keenly aware of and navigated within the multiple contexts of family, school, and community (Luttrell 2003).

6. See Robert Smith (2006) and Michael Buroway et al. (2000) for discussions of transnational life and global ethnography.

7. We draw from an extensive feminist literature that has emerged since the 1980s about carework and inequality. Feminist scholars have sought to redefine the meaning and status of *care* as work like any other form of labor that uses complex skills, requires time and effort, is demanding, and should be valued as such. Scholars have also identified carework skills (e.g., tending to emotions and managing the feelings of others) that are required in service jobs, especially those jobs populated by women who are understood to be "naturally" suited for such work. Carework blurs the boundaries between what we consider the "private" world of emotions and the public sphere (Hochschild 1983).

8. These are the labels and percentages provided by the school; they do not publish records of immigrant status of the children. Students are eligible for Free and Reduced Lunch in schools if their family income is at or below 185 percent of the Federal poverty line. In the United States the percentage of students in a school receiving Free and Reduced Lunch is an indicator of the socioeconomic status of a school.

9. See Marisol Clark-Ibanez (2004) for a discussion of PEI approaches. Photovoice research stresses participant-produced photographs that are specifically intended for an audience of people with power. Photographs are used to stimulate community/civic discussion about what changes are needed or demands need to be made. For examples, see Brinton M. Lykes (2001); Caroline Wang (1999); Wang and Mary Ann Burris (1997); Wang, Burris, and Xiang Yue Ping (1996).

10. We brainstormed together with the children to arrive at additional prompts, for example, "Take pictures of places inside and outside of school where you feel comfortable. What do you do after school and on the weekends?"

11. The following open-ended questions guided the conversation: "Tell me about this photo. What's going on here? Why did you take it? What does it tell about your life and what is important to you?" At the end of each interview, children were asked if there were any photographs the child wished she or he could have taken but didn't or couldn't.

12. They were told that these five photographs would also be shared with their teachers, and with teachers-in-training at the Harvard Graduate School of Education.

13. A multicultural team of graduate students took part in the data analysis.

14. Data that constitutes an "album" includes the child's fifth-grade and sixth-grade photographs; the individual interviews about the meaning of the photographs; the child's response to an ed-

ited videotape of her/himself talking about her/his five favorite photographs in which the child could and did make changes, including Angeline; and the exit interview. See Riessman (2008) for a comprehensive discussion of visual narrative analysis.

15. Those idioms include relative size, the feminine touch, function ranking, the (nuclear) family, and rituals of subordination (Goffman 1979).

16. We are drawing on scholars who have written about carework from the perspective of children, including Barrie Thorne (2001), who writes about how children read signs of care across lines of social class, race, and gender, and across cultural divides and child-rearing philosophies; Arlie R. Hochschild (2003), about children as eavesdroppers and what they learn from parental negotiations about their care; and Mary Romero (2001), about what children learn from being taken by their mothers to their jobs.

17. Images of maternalism are historically and culturally situated, and carry multiple meanings and assumptions. For example, during the first wave of immigration at the turn of the 20th century, a politics of maternalism (sometimes called "social motherhood") was based on a conviction that white women reformers should function in a motherly role toward the poor and promote a middle-class morality. As several scholars have noted, these politics were riddled with "race anxiety" directed toward immigrant populations.

18. Children who were unable to photograph a parent or another important family member for a wide array of reasons (the demands of shift work, divorce, separation, incarceration, deportation, illness, or death) found creative ways to document them in their albums.

19. This pattern of narrating family photographs in terms of parents' work schedules was found across the children's albums.

20. Note that Angeline uses the same words to describe her female friend Thea.

21. Interestingly, Angeline associates math with the men in her life—her father and his encouragement of math, an uncle who is studying to be a doctor whom she helps with his math homework; her sixth-grade teacher who pushes her, especially in math; and even in her math classroom photograph, which is the only classroom image that includes a male student.

22. Across all the children's photographs, food and kitchen spaces were associated with female caregivers—mothers, aunts, grandmothers.

23. It would be interesting to consider the multiple models of child-rearing that Angeline may be reflecting through her album. Robert LeVine et al. have written about cultural models of child-rearing as having three parts: moral direction, a pragmatic design and a set of conventional scripts for action—a "cultural software package driving parental behavior" (1996, 248). Among the Gusii culture in Africa, they identified a "pediatric model" of child-rearing that stresses "survival, health and physical growth" in the face of high fertility and harsh life conditions compared to the American, middle-class "pedagogic model" of child-rearing that stresses preparing children for educational interactions. Whereas the main goal of mothering for the Gusii is *protection* of the infant or child against illness and danger, the main goal of mothering for the American middle-class is *education* through promoting "active engagement and social exchange."

References

Arnot, Madeleine, and Diane Reay. 2007. A Sociology of Pedagogic Voice: Power, Inequality, and Pupil Consultation. *Discourse Studies in the Cultural Politics of Education* 28(3): 311–325.

Buroway, Michael, Joseph A. Blum, George Sheba, and Gille Zsuzsa. 2000. *Global Ethnography: Forces, Connections, and Imaginations in a Postmodern World*. Berkeley and Los Angeles: University of California Press.

Clark, Cindy Dell. 1999. The Autodriven Interview: A Photographic Viewfinder into Children's Experiences. *Visual Sociology* 14: 39–50.

Clark-Ibanez, Marisol. 2004. Framing the Social World with Photo-Elicitation Interviews. *The American Behavioral Scientist* 47(12): 1507–1527.

Coll, Cynthia Garcia, and Amy Kerivan Marks. 2009. *Immigrant Stories: Ethnicity and Academics in Middle Childhood.* London: Oxford University Press.

Collier, John. 1967. *Visual Anthropology: Photography as a Research Method.* New York: Holt, Rinehart and Winston.

Daiute, Colette. 2000. The Rights of Children, the Rights of Nations: Developmental Theory and the Politics of Children's Rights. *Journal of Social Issues* 64(4): 701–723.

Daiute, Colette, and Katherine Nelson. 1997. Making Sense of the Sense-Making Function of Narrative Evaluation. *Journal of Narrative and Life History* 7: 207–215.

DeVault, Marjorie L. 1991. *Feeding the Family: The Social Organization of Caring as Gendered Work.* Chicago: University of Chicago Press.

Dodson, Lisa, and Jillian Dickert. 2004. Girls' Family Labor in Low Income Households: A Decade of Qualitative Research. *Journal of Marriage and Family* 66(2): 318–332.

Goffman, Erving. 1979. *Gender Advertisements.* New York: Harper and Row.

Harper, Douglas. 2002. Talking About Pictures: A Case for Photo Elicitation. *Visual Studies* 17(1): 13–26.

Hochschild, Arlie R. 1983. *The Managed Heart: Commercialization of Human Feeling.* Berkeley: University of California Press.

———. 2003. *The Commercialization of Intimate Life: Notes from Home and Work.* Berkeley: University of California Press.

Hubbard, James. 2007. *Shooting Back: Photographic Empowerment and Participatory Photography.* http://www.culturalagents.org/int/programs/pdf/Hubbard%20-%20Shooting%20Back.pdf.

Lee, Stacey J. 2005. *Up Against Whiteness: Race, School, and Immigrant Youth.* New York: Teachers College Press.

LeVine, Robert A., Suzanne Dixon, Sarah LeVine, Amy Richman, P. Herbert Leiderman, Constance H. Keefer, and T. Berry Brazelton. 1996. *Child Care and Culture: Lessons from Africa.* New York: Cambridge University Press.

Luttrell, Wendy. 2003. *Pregnant Bodies, Fertile Minds: Gender, Race and the Schooling of Pregnant Teens.* New York and London: Routledge Press.

———. 2010. Circles of Seeing and Hearing: Analyzing Children's Visual Narratives. *Visual Studies,* Special Issue: *Visual Research Methods and Issues of Voice.*

Luttrell, Wendy, and Richard Chalfen. 2010. Hearing Voices: An Introduction to Dilemmas in Visual Research. *Visual Studies,* Special Issue: *Visual Research Methods and Issues of Voice.*

———. 2010. 'A Camera is a Big Responsibility:' A Lens for Analyzing Children's Visual Voices. In *Visual Studies,* Vol. 25: 224–237.

———. 2010. Lifting Up Voices of Participatory Visual Research: Guest Editor Introduction. In *Visual Studies,* Vol. 25, No. 3: 197–200.

Lutz, Catherine A., and Jane Collins. 1993. *Reading National Geographic.* Chicago: University of Chicago Press.

Lykes, Brinton M. 2001. Creative Arts and Photography in Participatory Action Research in Guatemala. In *Handbook of Action Research: Participative Inquiry and Practice,* ed. P. Reason and H. Bradbury. London and Thousand Oaks, CA: Sage Publications.

Lynch, Kathleen. 2007. Love Labour as a Distinct and Non-Commodifiable Form of Care Labour. *Sociological Review* 54(3): 550–570.

Lynch, Kathleen, John Baker, and Maureen Lyon, with Sara Cantillon, Judy Walsh, Maggie Feeley, Niall Hanlon, and Maeve O'Brien. 2009. *Affective Equality: Love, Care, and Injustice.* New York: Palgrave Macmillan.

Ngo, Bic, and Stacey J. Lee. 2007. Complicating the Image of Model Minority Success: A Review of Southeast Asian American Education. *Review of Educational Research* 77(4): 415–453.

Olsen, Laurie. 1997. *Made in America: Immigrant Students in Our Public Schools.* New York: The New Press.

Orellana, Marjorie Falstich. 1999. Space and Place in an Urban Landscape: Learning from Children's Views of Their Social World. *Visual Sociology* 14: 73–89.

———. 2009. *Translating Childhoods: Immigrant Youth, Language and Culture.* New Brunswick, NJ: Rutgers University Press.

Piper, Heather, and Jo Frankham. 2007. Seeing Voices and Hearing Pictures: Image as Discourse and the Framing of Image-Based Research. *Discourse: Studies in the Cultural Politics of Education* 28(3): 373–387.

Rasmussen, Kim. 1999. Employing Photography and Photos in Research on Childhood. *Dansk Sociology* 10(1): 63–78.

Riessman, Catherine Kohler. 2008. *Narrative Methods for the Human Sciences.* London and Los Angeles: Sage Publications.

Romero, Mary. 2001. Unraveling Privilege: Workers' Children and the Hidden Costs of Paid Childcare. *Chicago-Kent Law Review* 76: 1651–1672.

Schor, Juliet B. 2004. *Born to Buy: The Commercialized Child and the New Consumer Culture.* New York: Scribner.

Schwartz, Dona. 1989. Visual Ethnography: Using Photography in Qualitative Research. *Qualitative Sociology* 12(2): 119–153.

Smith, Robert. 2006. *Mexican New York: Transnational Lives of New Immigrants.* Berkeley and Los Angeles: University of California Press.

Suárez-Orozco, Carola, and Marcelo Suárez-Orozco. 2001. *Children of Immigration.* Cambridge, MA: Harvard University Press.

Thomson, Patricia, ed. 2009. *Doing Visual Research with Children and Young People.* London and New York: Routledge.

Thorne, Barrie. 2001. Pick Up Time at Oakdale Elementary School: Work and Family from the Vantage Points of Children. In *Working Families: The Transformation of the American Home,* ed. R. Hertz and N. Marshall. Berkeley: University of California Press.

———. 2002. Editorial: From Silence to Voice: Bring Children More Fully into Knowledge. *Childhood* 9(3): 251–255.

Wang, Caroline. 1999. Photovoice: A Participatory Action Research Strategy Applied to Women's Health. *Journal of Women's Health* 8(2): 185–192.

Wang, Caroline, and Mary Ann Burris. 1997. Photovoice: Concept, Methodology, and Use for Participatory Needs Assessment. *Health Education & Behavior* 24(3): 369–387.

Wang, Caroline, Mary Ann Burris, and Xiang Yue Ping. 1996. Chinese Village Women as Visual Anthropologists: A Participatory Approach to Reaching Policymakers. *Social Science and Medicine* 42: 1391–1400.

Yates, Lynn. 2008. Visual Methods and the Issue of Voice. Paper presented at Radcliffe Advanced Seminar, "Emergent Seeing and Knowing: Mapping Practices of Participatory Visual Methods," Cambridge, MA, November 13–15.

Part Three

Cross-Cultural Youth Media Comparisons

and Collaborations

11

Interests in Motion: The Film Medium Through the Eyes and Lenses of Young Scandinavian Filmmakers

Fredrik Lindstrand, Lisbeth Frølunde, Øystein Gilje, and Lisa Öhman-Gullberg

Introduction

This chapter contributes to the general theme of the book by examining youth media from a Scandinavian perspective. Our primary interest here is to look at how the film medium as a knowledge domain, or a field of practice, is represented through the discourses of young Scandinavian filmmakers. We asked fifty-five young filmmakers (aged sixteen–twenty-one) to submit a film they had participated in making and describe a scene in the film that they felt was satisfying. They were also asked to explain *what* they felt was satisfying in the scene. The analyses in this chapter are applied to the twenty-nine written accounts that eventually were submitted and are focused on how the filmmakers talk about and represent aspects of the film medium in relation to their own filmmaking practices. We argue that their selections—and what they point out as successful in their own film scenes—are based on certain assumptions about how the film medium works (or should work) and what can be regarded as marks of quality within the different aspects of filmmaking they focus on. Since the analyzed statements are the filmmakers' ways of dealing with prompts from the researchers, we need to be careful about what claims we make. The filmmakers' accounts can be seen in terms of what they interpret as aspects that are acknowledged or recognized as correct ways of relating to values in film within the specific framing constituted by the project.

Our analysis uses a theoretical approach to communication and meaning-making that is based on a social semiotic perspective (Hodge and Kress 1988; Kress 2003, 2009; Kress and van Leeuwen 2006; van Leeuwen 2005). The concept of *interest* referred to in the chapter title is central to this approach, as it is assumed to guide the filmmaker's selections in the process of filmmaking. Interest emphasizes the centrality of social aspects—including issues of identity—in the meaning-making process.

The results presented in this chapter stem from the research project Making a Filmmaker, which focused on how young filmmakers in the Scandinavian countries of Norway, Sweden, and Denmark make learning paths—as they guide their own learning, given their interests and intentions—and find various resources for filmmaking in different contexts. The project relates to a growing field of studies of youth and digital media production, both from a British context (Buckingham, Grahame, and Sefton-Green 1995; Buckingham, Harvey, and Sefton-Green 1999; Buckingham 2007; Buckingham and Sefton-Green 1994; Buckingham and Willett 2009; Burn 2007; Burn and Durran 2007; Burn and Parker 2001; Sefton-Green 1998) and from traditions that grew out of digital storytelling in California (Hull 2003; Hull and Nelson 2005; Nelson 2006). We also draw on Scandinavian research on digital media production and moving images (Drotner 1999, 2001, 2003; Erstad, de Lange, and Gilje 2007; Erstad and Gilje 2008; Frølunde 2009; Frølunde et al. 2009; Lindstrand 2006; Öhman-Gullberg 2008).

For a more comprehensive presentation of the project, methods employed and methodological considerations, see Lisbeth Frølunde et al. (2009); Øystein Gilje (2009); and Gilje et al. (2010).

Scandinavian Contexts for Youth Filmmaking

The Scandinavian view on children and youth has traditionally been characterised by an acknowledgement of certain positive values related to childhood and adolescence (cf. Dahlberg, Moss, and Pence 1999; James and Prout 1990). As a consequence, children's aesthetic practices have been ascribed intrinsic values and are, therefore, supported in various ways at different levels of society. With the emergence of video technology in the 1980s, the field of moving images was recognised as a new domain for youth creativity. As a response, local media centres and national film festivals were established. While still being important for young Scandinavian filmmakers today, the availability of digital technologies inspired the development of an additional governmental resource in the form of a social web site (see www.dvoted.net) where young filmmakers can distribute their own films. Dvoted.net was launched in 2006 as a joint Nordic project, funded by the governments of Denmark, Finland, Iceland, Norway, and Sweden.

In Scandinavia, formal contexts provide important places for students to learn film-making, use DV-cameras and train in digital editing. Due to the age of our informants (sixteen to twenty-one), many have had opportunities to take the vocationally oriented subjects of media and communication, which include hands-on film production. During the last eight to ten years, the media and communication have become popular subjects at upper secondary schools in Sweden, Norway, and Denmark. In various ways these subjects offer 'space' and time for elaborative productions within a wide range of genres. Many of our informants participate in (or have taken part in) these courses.

Moreover, the Scandinavian countries have different traditions for non-formal contexts related to film production, such as after-school programs and film festivals. In Norway, local workshops started up in the mid 1990s (Erstad and Gilje 2008). In Sweden most media workshops are organized by municipalities. The local film councils/regions provide media pedagogical workshops, including collaborations with schools and the organization of media workshops during school holidays. The Danish Station Next differs: it has a goal of making films with professionals and employs mostly film professionals as course instructors. Most of our Danish informants are part of the Station Next program. In addition, film festivals are important channels for young Scandinavian filmmakers to show films and to meet with peers and professionals in the film industry. Sweden, Denmark, and Norway all have local and national film festivals where young people submit several hundred films each year. Our informants can be divided roughly into thirds in relation to these non-formal learning contexts: those who do not participate, those who participate on a regular basis, and those who participate in film workshops occasionally.

Informal contexts relate to participation that falls outside of school and is characterized as interest driven and may be self-taught or take place in communities of interest. The development of diverse sites for young filmmakers structures this informal context and in some cases also the process, since many sites, such as dvoted.net, offer structure or formality, with deadlines and commitment to membership required. The findings in our research indicate that young filmmakers show their films on You-Tube, dvoted.net, and have their own Web sites where they publish their films and information about themselves as young filmmakers. These informal contexts are used either as complements or alternatives to the other forms of contexts described above. Some of the filmmakers use the Web as a channel for disseminating films made within a more formally oriented educational setting, while others use social Web sites as their primary resource in their quest to learn and develop as filmmakers.

A Theoretical Framework for Analysing the Filmmakers' Statements

Our analyses in this chapter are primarily directed toward the filmmakers' accounts of the aspects they felt satisfied with in the film scenes they selected for us. The analyses are based on a social semiotic perspective that emphasizes that all texts construe three forms

of meaning simultaneously: (1) they represent some aspect of the world (ideational metafunction); (2) they represent and construct relations between the agents in communication (the interpersonal metafunction); and (3) they are constructed as coherent texts (the textual metafunction) (Kress 2003; Kress et al. 2001; van Leeuwen 2005). In terms of film, the ideational aspect is related to discourse. A choice has been made of what to tell the story about, what to depict, and so on. The interpersonal aspect has to do with how the audience is positioned in relation to the film. Are we observing at a distance or are we in the centre of events? Whose point of view is offered to us? And so on. The textual aspect has to do with the diegetic construction of the narrative world of the film (cf. Metz 1974/1991, 97ff). How tightly is the diegetic world constructed, and to what degree are we able to view the whole film text as an ongoing representation? Rick Iedema (2001, 197) contributes to the definition of textual meaning by suggesting a question: "How is it put together as a semiotic construct?" In our analyses we apply the notion of metafunctions as a way of clarifying *how* the filmmakers approach the different aspects of the film medium they bring into their discourses.

Three Scandinavian Filmmakers

We will now introduce three young filmmakers, their films, selected film scenes, and their reflections about quality in relation to these scenes. These films and filmmakers are representative of the larger material in three aspects: (1) the type of film, or an approach to the film medium that the films suggest; (2) the type of production context; and (3) the discourse about film and film quality that can be discerned in the comments regarding the filmmakers' principles that have guided the selection of the particular scenes.

Even though the focus in our analyses is directed toward the filmmakers' written accounts of particular film scenes, we present the scenes visually in order to give the reader a sense of the films and perhaps provide some further clues in relation to the themes highlighted—by the authors, and by the informants themselves.

Worst Enemy (Verste Fiende)

The animated film *Worst Enemy* was made in 2008 by the eighteen-year-old male Norwegian filmmaker Andreas. In his written account, he explains that the film was made for the Norwegian Amandus Festival in 2008, where it won a prize.

The film is approximately two minutes and forty seconds long and can be described as an animated poetic story. In terms of its design it is visually close to the aesthetics of modern graphic novels. It also bears a certain visual resemblance to the Japanese manga genre. The film tells the story of a young man who is fighting against his addiction to heroin, even though the addiction theme is not obvious from the start. Instead, the pieces fall into place step by step as more and more clues are given. Below is a visual representation of the selected scene from the start of the film, lasting forty-four seconds.

Figure 1: *Worst Enemy*, introducing an existential theme

1. Music (cello) begins to play and continues in one long note throughout the shot. Fade in. Close-up of a grass plant. A drop of water slides down one of the blades of grass.

2a. The music rises in pitch, but is still played in one continuous note. A pond is seen from above. The drop of water falls down with a dripping sound into the pond, creating rings on the water.

2b. The title appears in the pond and increases in size: Verste Fiende (*Worst Enemy*). From this point onward through the scene the music slowly becomes more complex as other instruments are added and notes overlap.

3. Long shot of a man sitting in profile against a tree. Voice-over: "Everybody…"
A butterfly flies across the image, from left to right. Voice-over: "…has an enemy".

4. Long shot from above, filmed in a tilting motion beginning in the pond/lake and gradually revealing the shore, grass, and finally showing the young man by the tree. Voice-over: "Sometimes it can be a person".

5. Long shot from upfront. Voice-over: "Sometimes…"
A flock of crows flies across the image from right to left, with a croaking sound. Voice-over: "…it can be a part of yourself".

6. Close-up of the young man. The camera slowly zooms in on his face, ending with an extreme close-up of his eye. The music ends in a minor chord and fades out. A light bulb sparks a couple of times in his pupil. The spark is accompanied by an electrical buzzing sound.

The extreme close-up dissolves into the first shot of the next scene.

In the following scenes we are brought into a darker and more violent urban environment, as we witness an encounter between the main character and a dark, mysterious person who tells him, "You know I always will be here, like a shadow hanging over you". The young man replies that he will never "go back to that life". The encounter between the two gradually becomes more violent as the mysterious person hits the young man with a stick and then continues to kick him as he is lying on the ground. The description of events between the two men is cross-cut with short glimpses of other things that take place in the first, more scenic, setting. We see hands removing a rock, hands picking up a plastic bag, the young man looking at a syringe in the plastic bag, hands preparing the syringe. The mysterious character concludes, "You sold your soul when you took heroin for the first time". The young man responds by reaching for the stick and hitting back. He defeats his opponent and the film ends in what can be termed a state of equilibrium as it returns to the place where it started (cf. Alexander 1993). The young man throws the plastic bag with the syringe into the water. The film ends with a written quote from Danish existential philosopher Søren Kierkegaard: "It is easier to look to the left and to the right than inside oneself."

In his account of why he selected the opening scene, Andreas makes a statement about achievement at a general level, as he explains that

> I like the beginning, because it feels like I managed to do it well (where he sits by the tree). In a way it can summarize the entire film by what is said and the transition to the next scene is symbolic and nice. In addition I was pleased by the way the few animations gave life to the images in a simple way. In summary, [there are] many details that I am satisfied with in addition to the music.

This type of statement is recurrent in the larger data, both in relation to the entire scene at a general level and in relation to various aspects in the process. Common to them is that they primarily refer to aspects regarding the filmmaking process, rather than the filmic content. In this particular case, the filmmaker is content with the fact that he *did* it well. However, he then specifies what he is satisfied with, and thus shifts focus from the process toward the film itself.

He begins at a general level by stating that the scene summarizes the whole film. Since it refers to the story and the narrative meaning, the statement can be said to deal with ideational aspects of the film. At the same time it also refers to textual meaning in the sense that it deals with the way different parts and aspects of the film are connected as a text. Another textual aspect is highlighted as he underlines that this is done in the mode of spoken language, in the voice-over. From a multimodal point of view we could say that he specifies the role of the particular mode of speech in relation to the other modes ap-

plied in the scene and in relation to a specific type of information (cf. Kress 2009). Spoken language is here presented as the primary resource for construing narrative meaning.

In the following part of his statement, he points to the transition to the next scene, which is "symbolic and nice". Again, the filmmaker refers both to ideational and textual aspects, ideational in the sense that he (1) highlights the symbolic function of the transition and (2) "the symbolic" necessarily must refer *to* something, i.e., some aspect of the diegetic world. The transition is central here and refers to the textual aspects of the film, since it is part of the "machinery" of moving image texts. Similar to the previous statement, we can also say something about the use of mode, by looking at how the transition becomes symbolic in the film. As we can see in the visual description of the scene above, the camera zooms in to an extreme close-up of the main character's eye. A light bulb sparks a couple of times in his pupil before the image dissolves into the first shot of the next scene (where the encounter in the urban environment is introduced). The spark of the light bulb brings the two represented environments and moments in time together. The symbolic, then, is here achieved by a combination of three modes: image, animation, and sound.

This focus on symbolic meaning-making through the interplay of different modes can be connected further to the next statement about being pleased with the way a few animations give life to the images in a simple way. Each shot contains only a few small, animated details, whereas most things seen in the images—including the main character in most parts of this scene—are frozen. His statement relates to the textual aspects of the film, in the way that it brings attention to *how* the film is made to work the way it does, with a particular focus on the affordances of the mode of animation.

The filmmaker also refers specifically to the music. Music is a mode and as such it can be approached in relation to any or all of the three metafunctions, for example by adding certain atmosphere to the film (ideational metafunction), as it does in this case; and creating coherence and continuity between various parts or signal the beginning or the end (textual metafunction). According to van Leeuwen (2005, 122), music can also work as a communicative act (i.e., interpersonally), as it can signal how we should engage with the film through the organization of rhythm, melody, and so on. However, there are no obvious references to interpersonal aspects—in relation to music or any other mode—in his written account.

Alone Child (Ene barn)

Alone Child was directed by Anne, a young Danish woman. She introduces the film by explaining that it was the result of her first serious film project at Station

Next. Apart from directing, she also came up with the original idea. The assignment was to make a short film with a time limit of three minutes. In addition, the crew was only allowed to use one location and two actors. The result is a two-minute, forty-second short "dedicated to the imagination of children". She was inspired by the fact that children are "able to make up and play with anything—whether or not there is anybody to play with or if the circumstances are boring". She continues:

> That is what the girl—who is at a boring party with her father—does. They find an empty guest room where she can be while her father finishes the conversation with his friends. The girl is left by herself with simple objects and has only her imagination as a playmate.

The selected sequence, which comprises the last two minutes of the film, begins when Alice is left by herself (see below).

Figure 2: "Alone Child" playing and imagining

1. The girl finds some paper and a pen. At the same time music—reminiscent of a music box—starts to play. She takes a sheet of paper and puts it on the floor.

2. She lies down on her belly. The lighting has changed, from cold and dull in the previous shot to a warm light.

3. Close-up of her hands as she starts to draw.

4. Close-up of her face.

5. Close-up of her hand as she draws a stalk, leaves, and flower.

6. Close-up of her face.

7. Alice suddenly sees a red balloon.

8. She walks to the balloon and takes it.

9. She turns around. A table has appeared with cake and a glass of pink lemonade with a straw.

10. Close-up as she looks at the cake.

11. Close-up of her hand as she takes some cream on a finger.

12. Close-up as she tastes the cream.

13. Shot in profile of girl blowing bubbles through the straw.

14. Medium shot of the room as soap bubbles start to fall down.

15. Medium shot of the girl as she jumps on the bed.

16. Low-medium shot of the father's body as he enters the room.

17. The girl jumps down from the bed.

18. Alice takes her father's hand and they leave the room together. The father asks who gave her the balloon.

End of scene.

Apart from thematic changes (related to the girl's activities), various modes are used in order to frame different parts of the film: lighting, colour, and music. The sequence highlighted by the filmmaker is framed by music. She explains:

> My favourite sequence in the film is where the music starts to play and Alice begins to draw while she lies with her belly against the floor. I feel that the atmosphere is coming through at this point, in the way you can hear the pencil against the paper and her breathing. The images are also incredibly beautiful here (they are all the way through really), as they really are focused on the drawing, the hands, and the pencil. That is just a special place in the film to me. It is the first time we come close to the girl and notice her childish playfulness, and this is also where her imagination begins to take off.

Looking at how her written account highlights the diegetic world itself and the aspects that are represented (i.e., "childish playfulness", "imagination"), her focus can be described as directed toward the ideational aspects of the film. In describing the scene she also brings attention to things seen (i.e., "the hand and the pencil") and heard (i.e., "the pencil against the paper and her breathing").

Anne also touches upon the textual level of the scene in the way she connects the ideational aspects she is satisfied with to the way various modes are engaged in order to achieve this. The focus on various modes and their function in the films is a recurring theme among several of the filmmakers in our study.

The interpersonal level is also apparent in her story, but at a meta-level, in her own presentation. An example of this can be seen in the statement that "it is the first time we come close to the girl…". The "we" here implies a meeting between an audience and the film and thus suggests a strong consideration of an audience in her way of approaching her film.

Dirty Fingers (Skitne fingre)

The film *Dirty Fingers* was made outside school by a group of young Norwegian enthusiasts who call themselves "Ragnarock Film AS" ("Ragnarock Film Inc"). The film team consisted of five persons, apart from the actors. According to our informant, the film was not made for any specific reason, "except we wanted to experiment with fiction film and do something we thought could be fun". In his written text he explains that he does not think of it as the best film he has participated in making, but that it certainly influenced the filmmakers in a good way and prepared them for future tasks. He concludes that this is the film he is most satisfied with "in relation to the level of our gang."

The film *Dirty Fingers* can be described as a tragic and violent comedy. It tells the story of a rather strange young man who lives with his hard-drinking mother in a remote part of Norway. He goes for a jog in the scenic landscape and stops on top of a steep hill to rest and take his asthma medication. While stretching his legs, he hap-

pens to notice that he is able to set a big rock in motion by pushing it. After a few attempts, and with much effort, he manages to push it down the hill. After a few seconds he hears a scream from lower on the hill and runs down to find a dead woman next to the rock. He panics and visits a drunken-looking farmer type who lives nearby and asks for his help. They try different ways of making the death of the woman look like an accident, but without any luck. Instead they decide to bury her. The young man begins to dig a grave for her, but is approached by a jogging classmate. The farmer apparently sees the classmate as a threat and kills him. This is where the selected scene, which is approximately one minute long, begins (see below).

Figure 3: *Dirty Fingers*, black humour and moral dilemmas

1. Long shot of the young man as he is dragging the body of his dead classmate. An old lady walks into the image from the left, leaning on a walker. She stops and looks in the direction of the young man.

2. Close-up of the lady.

3a. Blurry long shot of the young man, seen from the lady's point of view.

3b. The image sharpens. The young man is still dragging the body. He looks up toward the camera and reacts by dropping the body.

4. Reaction shot in close-up of the old lady. She looks frightened and hurries out of frame to the left.

5. Low shot of the old lady's legs and her walker as she starts to run across a field.

6. The farmer is sitting on a rock with the rifle in his hand. He reacts to the lady's motion (out of frame) by jumping down and hurrying out of frame to the right.

7. The old lady is seen from behind as she runs across the field. A rifle shot blows up some grass and mud on her right side. She throws away the walker and starts to run faster.

8. The farmer begins to reload while keeping his focus on the lady.

9. The lady keeps running across the field, now seen from the opposite direction.

10. The farmer continues to reload.

11. The old lady seen from the farmer's point of view.

12. The farmer fires his rifle again.

13. Filmed from the side, we see how the lady is hit in the back and hurled upward and right.

14. Shot filmed from yet another angle. The lady lands in the wet grass and slides towards the camera.

15. The farmer rolls the lady into a shallow grave and then begins to wipe his hands on his shirt.

16. Reaction shot of the young man. He says to the farmer, "What the hell have we done?"

17. Shot of the farmer with the young man sitting in the background. The farmer continues to wipe his hands on his shirt and says, "Damn old bitch. Better not be any more damn people coming now."

18. Brief reaction shot of the young man.

19a. Same composition as shot 17 above. The young man rises in agony and walks up to the farmer with the shovel raised.

19b. The young man hits the farmer's head with the shovel.

20. Brief shot of the shovel hitting the farmer.

21a. The farmer falls to the ground.

21b. The young man looks at the farmer for a few seconds. End of scene

After burying all of the bodies in shallow graves, the young man returns home. A news broadcast reports that an escaped prisoner has been captured and that he admits to the killing of a woman—the same woman that the young man found beside the rock. However, the police are puzzled since they cannot find her body. Teams are searching the area with dogs. End of story.

The idea behind the scene is rather simple and can be described as a moral story in itself. While covering the tracks of a murder that was committed in order to cover the tracks of the accidental killing of a young woman, the two men are observed by an old lady. One of the men reacts by killing the lady with his rifle. The other man is frustrated by what he has done and the way he talks about it—as if they may have to kill even more people. He reacts by hitting him with the shovel, causing yet another death. He kills to stop the killings.

The young filmmaker presents this scene as being "without doubt" the "best scene in the film". He explains that it is an

> incredibly comic scene that has kept on amusing the audience. We used sharp shotgun shots, but in a way that appears to be far more dangerous than it really was. Especially the editing is good here and creates a tension and expectation. This was also the first time we used a stuntman.

As in the other films we have presented in this chapter, the filmmaker's reflections are directed toward several types of meaning in relation to the scene. In this case, however, the primary focus is either directed toward the textual level of the scene or toward aspects that have more to do with the production process than with the scene itself.

In terms of the latter, the young man presents two facts: that they used sharp ammunition and that they used a stuntman for the first time in the filming of the scene. In this way, experiences during the making of the film contribute to the personal meaning of the filmmakers. This is something we see in the descriptions by other filmmakers, too. However, the statement about the use of sharp ammunition in this particular case is further elaborated in a way that relates both to the textual and ideational aspects of the film. The filmmaker explains that it *appears* to be far more dangerous than it really was, which refers to a textual aspect in that something has been made to appear in a certain way in the film, as a part of the diegetic construction. Stressed differently, he also says that it appears to be *dangerous,* which relates to the ideational in the sense that some aspect of the world is represented in a certain way. We speculate that this danger is part of their experiment and excitement, or something that he and the group "thought could be fun".

Perhaps more obviously referring to the textual dimension of the scene is his statement about editing—that it is good and that it creates a tension and expectation. Apart from saying that the editing works well in the scene, the statement also

points at qualities that can be attained by means of good editing: to create tension and expectation. Editing and aspects related to editing are picked up by many of the filmmakers in the study.

This filmmaker also says something that can be categorized as a general valuation of the scene in terms of successfulness in production: that it is "incredibly comic". We can see this claim as a statement about a general achievement of certain goals. Statements about achievement can also be read between the lines as he lets us know that the group has been successful in making the use of sharp ammunition seem more dangerous than it really was, in the way the editing efficiently produces tension and expectation, and in the general statement that the scene is incredibly comic. We will return to the theme of achievement below, as it is recurring in several of the filmmakers' reflections about their films.

Last, but not least, the audience is also apparent in his reflections as he states that the scene has "kept on amusing the audience". The notion of an audience is thereby represented as a part of how he thinks about the film medium.

Discussion

The three examples presented in this chapter were selected as representative of the different approaches to film and to the film medium found in the larger data material of the project, consisting of written accounts by twenty-nine filmmakers. As films, they differ in terms of orientation, ranging from a serious and personally oriented animated film on drug addiction, to a film told from a distant, third-person perspective on childhood innocence, to a black, moral story or comic tale using caricatures. They also show different ways of experimenting with the medium, focusing on different values. *Dirty Fingers* can be characterized by the use of trick filming and editing of shots—with use of comic exaggeration through sophisticated editing of many shots to show action and reaction. In *Alone Child*, the girl Alice's childish and lively imagination is shown as magic play, enforced through the use of lighting, colour, sound, and music. In *Worst Enemy*, the light-bulb image and sound shows the viewer and "gives life" to the main character's thinking. The rest of the films can be said to either touch upon similar themes or be distinguished by similar ways of approaching the medium.

Related to the different ways of experimenting with the medium is also the issue of production contexts and production values. The practice of filmmaking is framed differently within the various contexts presented in this chapter, with *Alone Child* and the context provided by Station Next at one end and *Dirty Fingers* and similar productions created outside any formal context at the other. However, while being different from each other in many ways, they are both distinguished by high degrees of collaboration. Social dynamics work as a driving

force in both production contexts but in somewhat opposite directions in relation to choice of themes, the medium, and its means of expression. *Worst Enemy* presents yet another position in this respect, as computer animation enables a more private form of filmmaking.

In terms of themes that are dealt with in the films, the international reader may wonder if they correspond to any aspect of everyday life for young Scandinavians. Even though some aspects could be seen as related to different forms of "local" issues (drug use in the big cities, the caricature of the farmer type, the emphasis on childhood imagination that somewhat corresponds to what we presented as a Scandinavian approach to children's creativity, etc.), we would rather suggest that the films indicate a connectedness across borders that open up for influences from all around the world.

As for the aspects highlighted by the young filmmakers in their written accounts, they do not only say something about what they were satisfied with in their own films, but also give an indication of their way of framing the film medium and the practice of film production as a knowledge domain, especially in relation to us as researchers. Our intention in applying the analytical notion of *metafunctions* to the filmmakers' descriptions was to highlight how their emphasis is directed toward different aspects of the nature of the film medium. They not only frame the film medium as a knowledge domain by pointing out the various elements that constitute the machinery of the medium and the skills related to successful handling of these elements, but also by referring to how different ways of handling these elements construe different kinds of meaning in film. In other words, form and content both contribute to the production of meaning.

The social semiotic and multimodal approach to moving images presented in this chapter contributes, along with analytical tools for tracking how filmmakers (or producers of representations in any other medium) use semiotic resources in order to construe meaning. According to this view, meaning is always actively made in every utterance and is always related to the meaning-maker's interests during production. Following this line of thought, the films presented in this chapter are all loaded with personal meaning. Each of the films can be seen as a positioning of the filmmakers in relation to some aspect of the world around them.

References

Alexander, John. 1993. *Televersions. Narrative Structures in Television,* 2nd ed. Surrey: InterMediaPublications.

Bordwell, David, and Kristin Thompson. 1993. *Film Art: An Introduction,* 4th ed. New York: McGraw-Hill.

Buckingham, David. 2007. Media Education Goes Digital: An Introduction. *Learning, Media and Technology* 32 (2): 111–119.

Buckingham, David, Jenny Grahame, and Julian Sefton-Green. 1995. *Making Media—Practical Production in Media Education.* London: The English and Media Centre.

Buckingham, David, Issy Harvey, and Julian Sefton-Green. 1999. The Difference Is Digital? Digital Technology and Student Media Production. *Convergence* 5 (4): 10–20.

Buckingham, David, and Julian Sefton-Green. 1994. *Cultural Studies Goes to School—Reading and Teaching Popular Media.* London: Taylor & Francis.

Buckingham, David, and Rebekha Willett, eds. 2009. *Camcorder Cultures: Media Technology and Everyday Creativity.* Basingstoke, UK: Palgrave Macmillan.

Burn, Andrew. 2007. The Place of Digital Video in the Curriculum. In *The Sage Handbook of E-Learning Research*, ed. Richard Andrews and Caroline Haythornthwaite. London: Sage.

Burn, Andrew, and James Durran. 2007. *Media Literacy in Schools—Practice, Production and Progression.* London: Sage.

Burn, Andrew, and David Parker. 2001. *Analysing Media Texts.* London and New York: Continuum.

Dahlberg, Gunilla, Peter Moss, and Alan Pence. 1999. *Beyond Quality in Early Childhood Education and Care: Postmodern Perspectives.* London: Falmer Press.

Drotner, Kirsten. 1999. *Unge, Medier og Modernitet—Pejlinger i et Forandreligt Landskab.* Valby, Denmark: Borgen/Medier.

———. 2001. *Medier for Fremtiden.* Copenhagen: Høst & Søn.

———. 2003. *At Skabe Sig-Selv: Ungdom, Æstetik, Pædagogik*, 2nd ed. Copenhagen: Gyldendal.

Erstad, Ola; Thomas de Lange, and Øystein Gilje. 2007. "Re-Defining Media Learning—Multiliteracies and Digital Production in Norwegian Media Education". *Learning, Media and Technology* 32 (2): 183–198.

Erstad, Ola, and Øystein Gilje. 2008. "Regaining Impact—Media Education and Media Literacy in a Norwegian Context". *Nordicom Review* 29 (2): 219–230.

Frølunde, Lisbeth. 2009. *Animated Symbols: A Study of How Young People Design Animated Films and Transform Meanings.* Ph.D. thesis, the Danish School of Education, University of Aarhus, Copenhagen.

Frølunde, Lisbeth, Øystein Gilje, Fredrik Lindstrand, and Lisa Öhman-Gullberg. 2009. Methodologies for Tracking Learning Paths: Designing the Online Research Study Making a Filmmaker. In *Mediekultur* (special issue on mediated learning/learning media) 46. SMID (Danish Association of Media Researchers). Available at www.mediekultur.dk.

Gilje, Øystein. 2009. Making a Filmmaker. Project Report for the Norwegian Medietilsynet (the Norwegian media council). Available for download at www.multimodalfilmmaking.tk.

Gilje, Øystein; Lisbeth Frølunde, Fredrik Lindstrand, and Lisa Öhman-Gullberg. 2010. Mapping Filmmaking Across Contexts. Portraits of Four Young Filmmakers in Scandinavia. In *Media literacy education: Nordic perspectives,* edited by Kotilainen, Sirkku, and Sol-Britt Arnolds-Granlund.(SUPPLY PAGE NUMBERS) Gothenburg: Nordicom & the Finnish Society on Media Education. Available for download at www.multimodalfilmmaking.tk.

Hodge, Robert, and Gunther Kress. 1988. *Social Semiotics.* Ithaca, NY: Cornell University Press.

Hull, Glynda. 2003. At Last: Youth Culture and Digital Media: New Literacies for New Times. *Research in the Teaching of English* 38 (2): 229–233.

Hull, Glynda, and Mark Evan Nelson. 2005. Locating the Semiotic Power of Multimodality. *Written Communication* 22 (2): 224–261.

Iedema, Rick. 2001. Analysing Film and Television: A Social Semiotic Account of *Hospital: An Unhealthy Business.* In *Handbook of Visual Analysis,* edited by Thea van Leeuwen and Carey Jewitt. 183–204. London: Sage.

James, Allison, and Alan Prout, eds. 1990. *Constructing and Reconstructing Childhood: Contemporary Issues and the Sociological Study of Childhood.* London: Falmer.

Kearney, Mary Celeste. 2006. *Girls Make Media.* New York and London: Routledge.

Kress, Gunther. 2003. *Literacy in the New Media Age.* London: Routledge.

———. 2009. *Multimodality: A Social Semiotic Approach to Contemporary Communication.* London: Routledge.

Kress, Gunther, Carey Jewitt, Jon Ogborn, and Charalampos Tsatsarelis. 2001. *Multimodal Teaching and Learning: The Rhetorics of the Science Classroom.* London and New York: Continuum.

Kress, Gunther, and Theo van Leeuwen. 2006. *Reading Images. The Grammar of Visual Design,* 2nd ed. London: Routledge.

Lindstrand, Fredrik. 2006. *Att Göra Skillnad. Representation, Identitet och Lärande i Ungdomars Arbete och Berättande Med Film* [Making difference: Representation, Identity and Learning in Teenagers' Work and Communication with Film]. Ph.D. thesis. Stockholm: HLS Förlag.

Metz, Christian. 1974/1991. *Film Language.* Chicago: University of Chicago Press.

Nelson, Mark Evan. 2006. Mode, Meaning and Synaesthesia in Multimedia L2 Writing. *Language, Learning and Technology* 10 (2): 56–76.

Öhman-Gullberg, Lisa. 2008. *Laddade Bilder—Representation och Meningsskapande I Unga Tjejers Filmberättande* [Loaded pictures—Representation and meaning making in females filmmaking]. Ph.D. Thesis. Stockholm: Stockholm University.

Sefton-Green, Julian, ed. 1998. *Digital Diversions—Youth Culture in the Age of Multimedia.* London: Routledge.

van Leeuwen, Theo. 2005. *Introducing Social Semiotics.* London: Routledge.

www.dvoted.net— Nordic Social Website and Online Resource for Young Filmmakers, which closed as of January 10th, 2011.

www.station-next.dk— Danish Film School for Teenagers and Young Adults..

www.youtube.com—Social Web site for distribution of moving images.

www.multimodalfilmmaking.tk—Web site with links to a number of texts by the chapter authors.

12

Center or Margin? The Place of Media Play in Children's Leisure: Case Studies from Sweden and Australia

Karen Orr Vered

While nobody would question the appropriateness of crayons, paints, books, and music in a children's recreation center, the provision of electronic media and children's access to digital playthings in after-school care settings is not a simple matter. Having undertaken a trip to Sweden to see how children were being supported to use media in play and recreation, I found that media had fallen from favor and adults were having difficulty maintaining access and replacing equipment, while children made the most of what remained. Drawing for comparison on earlier research in Australia, this chapter tries to make sense of the unexpected circumstances by looking at the larger discursive context in which children's recreation and leisure are defined and legitimated. Marketing narratives for consumer electronics, concerns about child health, and notions of appropriate modes for media consumption all influence children's access to media in after-school care settings.

Comparative Research: Making Sense of the Unexpected

In 2001 I began reporting research findings from an Australian study of children's media use in after-school care (Vered, 2001, 2006, 2008). At international conferences, my exchanges with Scandinavian colleagues left me with the impression that Scandinavian children had generous access to media in a variety of public contexts outside of homes and classrooms.[1] Meetings with Swedish colleagues in 2005 en-

couraged my view that Swedish after-school care services, in particular, were places where children were allowed to play freely with media and, more importantly, were encouraged to create media. My interest in a comparison between children's media play cultures in Australian after-school care services and the Swedish equivalent, *fritids* and *öppen fritidsverksamhet* (after-school leisure-time centers), was supported by other factors as well.

Sweden and Australia share a play-centric philosophy with respect to recreational childcare for children ages five to twelve. There was little indication in the literature that Sweden had adopted the view that has been growing in strength across the United States and United Kingdom to place the burden of educational remediation and enrichment on after-school care services.[2] Australian Out of School Hours Care services (including before- and after-school care and vacation care for school holidays) were initiated and endure to assist parents to remain in the workforce by providing children with safe and enjoyable leisure-time activities after school. In Sweden, *fritids* are similarly described with the dual functions of enabling parents to "combine parenthood and work" and ensuring that children have "high quality pedagogical activity to contribute to providing children with favorable conditions for growing up" (*Skolverket* 2007).[3] The priority for play culture in *fritids* was persistent in 2007 when I visited, while play had clearly come under threat and scrutiny elsewhere, especially in the United States as a result of the "No Child Left Behind" policy.[4] Scandinavian households are media rich by international standards, and consequently I expected to find a relatively positive attitude toward media integration and media use in general. I was eager to see what children were doing with media in these intermediary spaces and had hoped to find models for development or trial in Australia. In 2007 I undertook research in Sweden, where I visited *fritids* and *öppen fritidsverksamhet* to explore children's media cultures.[5]

To my surprise, the media play and use cultures in *fritids* and *öppen fritidsverksamhet* were more limited and circumscribed than I had anticipated, and there was little evidence that creative recreational media use was being encouraged. The place of media in *fritids* was marginal in terms of space and in relation to other play and creative activity. Children's access to media technologies, where available, was also limited to one session per week. The location of media technology was often peripheral to the other activities on offer. Rather than *fritids* services supporting and encouraging rich media play cultures, I found that the collaborative, creative and playful media cultures generated by children's activities were not being extended or supported by the structural contexts and management practices within care services.

My observations were further confirmed by staff when they said that they were having difficulty negotiating with superiors to fund equipment purchases,

even where they seemed to have well-developed plans for creative media projects. There were remnants from previous times when media play seems to have been more central to the play culture, but accounts by staff of these earlier, media-rich times were delivered with unease and lack of assuredness. Staff readily attributed the limitations on media access and play to parental request for less media play and more outdoor play. Despite a lack of support from external structures and adult agendas and actions designed to diminish media play, children's endemic media play cultures were surviving in the cracks and crannies.

How to make sense of the circumstances I encountered was challenging and not immediately obvious. While overt policy statements about the value of play and providing a broad range of recreational activities are meant to guide the design and provision of after-school care services and programs, pressure to shape services also comes from other, less-enduring discourses. Decisions about media provision, access, and activities in children's recreational settings are informed by discourses that intersect with notions of childhood, childcare, and supervision but which demonstrate little understanding of children's media practices and cultures. Children's media use is often demonized and pathologized as media are singled out and blamed for a range of unwanted social situations and circumstances. A common response in such climates is to discourage media use by children and youth in the realms that have specific responsibility for children: schools and leisure centers.

In the present social climate, the specter of rising rates of childhood obesity is readily brought into service in the ongoing battle to de-legitimate media play among children's leisure-time activities. The discourse of health and wellbeing marks media in two ways: media play is falsely characterized as sedentary, and media narratives are said to orient children toward unhealthy consumerism. Here there is no distinction between a *media text* and a *play activity that involves media*. They are seen as equally bad. The richness of interpretation and appreciation that children bring to a media text through play is not accounted for. The public and social dimensions of media use are likewise ignored.

What children actually do with media is less familiar to us than what marketing tells us we should do with media. Marketing campaigns and advertisements for hardware and software instruct us on how to use media and show us what it looks like to play a video game or surf the web (O'Grady 2010). Children's actual media practices and use patterns, however, are less familiar than the popular fictions of marketing that influence attitudes and policy on children's access to media and, in particular, the degree of autonomy children are granted for various activities. Discourses of leisure and work, which align with the places of home and school, also influence the development of policy for children's recreation and care. In an effort to understand the circumstances I encountered, this chapter considers how com-

peting discourses shape the provision and use of media in children's after-school care services and programs.

Why Media Play Matters

In *Teaching Youth Media* (2003), Steve Goodman clearly observes that

> the failure of schools and after-school programs to address the media as the predominant language of youth today, or to recognize the social and cultural contexts in which students live, has resulted in a profound disconnect. It's a disconnect that occurs between the experiences that most students have during their time in school and those they have during their time outside of school. (p. 2)

Goodman emphatically argues that educators and others who care about and for children and youth must "develop a deeper and nuanced understanding of the forces that shape their lives—our media and consumer culture" so that schools and after-school programs might help young people develop the abilities to "analyze, evaluate, and produce print, aural, and visual forms of communication;" in short, to develop "critical literacy" (p. 3).

More important for the younger cohort of five to twelve year olds involved in after-school care, the UNESCO's *Youth Media Survey 2001* reports that "there is very little evidence internationally of systematic or extensive media education provision for younger children (under the age of 11)" (Domaille and Buckingham 2001, 9). I would add that there is even less evidence of media production activity for this age group. More recently, according to the Australian Communication and Media Authority (2009), most children report learning about online safety and etiquette at school, well after they have become experienced online agents through use at home.[6] So, online experience and online safety "instruction" are asynchronous. Children become familiar and competent with media through recreational use outside of formal instruction or supervision by adults. They learn independently and with one another through recreational, participant, and consumer activities that are available in a media-rich culture. When recreational and entertainment media are excluded from after-school care services and programs, their absence seems unnatural, their omission planned. It is precisely because these media are the playthings of our time that they ought to be part of the everyday environment of recreational care. If after-school care services are meant to provide relevant play and leisure experiences for children, surely media play is legitimate play.

There is a growing concern among educationalists that classrooms are becoming evermore distinct from the rest of life, because classrooms are media-free zones where mobile phones are prohibited, Internet sites are blocked and games are unheard of. While some children's home lives may be media rich, the digital divide

has not been bridged. Many children do not have rich electronic home lives. Nor is there generic integration of media across the curriculum in primary schooling. After-school care services, without ties to curricular agendas, can provide recreational and entertainment media and are uniquely situated between home and classroom. They often have most of the media from both domains. Under these circumstances, children's media use is qualitatively different from the ways in which the same media are used in family homes and classrooms (Vered 2008). As intermediary spaces, after-school care services can help mend "the disconnect" that Goodman (2003) identifies in children's everyday experiences. More importantly, the contribution that after-school care can make to a child's growing media competency may be less aligned with critical literacy but more oriented toward developing creativity and expressivity.

Quality Media Play in After-school Care Settings

In Australia, after-school care (and its morning equivalent) provides an intermediary space between home and classroom, especially when services are situated on school grounds, as is the most common case. Although after-school care shares features of both home and school, it is neither. It is a third space in children's lives and one that mediates between the other two. The unique character of after-school care is reflected in the ways that children use media in this third space. Even though services have the same media as most households and classrooms, the ways in which children use media are different from both home and classroom use.

Children's media use in after-school care is:

- Restricted and limited due to resource pressures

- Social & collaborative due to the public and social environment

- Leisurely and playful because children direct their own activity

- Creative because children self-select activities and pursue them at a leisurely pace

- Public by design

- Peer-regulated by default as a result of scarce resources and high demand

Thus, children's media use in after-school care is related to but different from home and classroom use. The combination of these features makes children's media play in these public, recreational environments often of higher quality than their media play can be at home and more creative than their media use may be in classrooms. At home, children most often play video games alone. At after-school

care, the limitations of scarce resources push children to pursue activities and play in pairs and groups. They play video games in pairs with galleries of observers cheering, gasping, and chattering commentary and advice. The play space is effectively expanded beyond the screen as a social activity extended geographically. Children sometimes collaborate over video games in a serial fashion and thereby extend the play experience in time (Vered 2008, 82–85). Both playing in groups and playing with several players in a serial fashion are ways of playing that children have developed to accommodate the given constraints. Place, space and play cultures contour the activities and routines of media play in Out of School Hours Care (OSHC) (Vered 2006) and often reject the scripted play of marketing narratives.

Media play in after-school care engages children with one another in activities that are often pursued, much to the dissatisfaction of adults, independently at home. The popularity of media play in these group settings generates time limits on individual turns, in contrast to what occurs in family homes where children face less competition for resources and are less closely monitored. At home, children have longer periods of independent "time on machine." In Australian after-school care services, where children were given control over the playback of videos and DVDs, children often used the DVD player like a karaoke machine to play and replay favorite songs and sing along, performing dance routines and watching actively rather than "passively" (Vered 2008, 118). Television was the least popular medium, and use of the computer lab was a popular favorite across age groups and genders. The features of children's media play that most bother adults—individual use for great lengths of time—are simply not possible in after-school care, and the use patterns that are possible (collaborative, social, public) seem to turn on its head the set of prejudices that adults have about children's media play cultures.

Among the Australian services studied, only one of the six sustained a long-term media production program. Under the banner of "Movie Magic," children and staff produced a feature movie in about a year's time (see Vered 2008, chapter 8). The children generated the story idea and helped staff produce the script. Children mainly participated as actors in the movies, but some technical positions in camera and sound were undertaken by children. Children's responsibility for production roles increased each year as experienced technicians returned. The program approached moviemaking from a fan's perspective and capitalized on the children's consumer practices, knowledge and experience. The marketing-consumer nexus was used as an entry point to production, and the program aimed to produce a mini-Hollywood movie, replete with an opening-night gala event that drew hundreds to the Town Hall. Such sustained, organized, group production activity, however, was an exception among the after-school care services in Australia, but one that offers an instructive example.

Children's Media Play in *Fritids*

My trip to Sweden was conducted in September when children were still enjoying outdoor play before the winter weather set in. Visiting three cities—Malmö, Stockholm, and Halmstad—I attended four *fritids* and one *fritidsverksamhet* (service for youth) where I observed the children and spoke with them and the staff in most cases.[7] Given the similarities between the Australian and Swedish services, I was surprised by the limited institutional support for media use but pleased to see children making the most of media at the margins of play culture.

In Malmö the after-school care services were divided into three groups: two for children aged six to nine and a third for older children. Of the two groups for younger children, one had a single computer in the main indoor room, which was equipped with Audacity, Freemind, Movie Maker, Photfiltre, and Photostory software. I learned that children had previously worked with staff on producing photo essays and movies, but these activities were no longer pursued. The other group did not have an equivalent set-up but was expecting to acquire one soon. Media provision for this group amounted to one desktop computer with Internet access, housed in a small storage room. A variety of approved sites were bookmarked, including YouTube and a range of free gaming sites. Children were allowed fifteen-minute turns with a partner but not alone. The door was closed, but staff could see in through a glass pane. There were no "rules" posted or other instructions; the children were granted considerable autonomy during their turn, albeit with a partner.

I first sat with a pair of eight-year-old boys as they undertook a YouTube session, surfing for clips and genres. They sought Jackie Chan and Bruce Lee, excerpts from *The Simpsons*, music videos by rapper 50 Cent. "Extreme sports" was a search term, and "babies" was another, which provided a genre of comedic shorts that they enjoyed. The appeal of the baby videos reminded me of the *Baby Burlesque* short films from the early 1930s in which Shirley Temple starred. The comedy is based on the ironic inversion of babies performing adult actions. A Wilkinson shaving blade advertisement was a particular favorite with the boys.[8] The short animated narrative involves the stereotype of a jealous husband whose wife has a baby and subsequently neglects the man as she turns her affection to the infant. The man realizes that the baby's soft skin is the attraction for his wife, and he decides that he can win back her affection with the right shaving blade (a Wilkinson blade). The baby notices that the mother's attention has turned to the father, and he takes revenge on the father ninja-style, flying and kicking and karate chopping the adult into submission. The animation style is reminiscent of *Ally McBeal*'s (1997–2002) dancing baby, which became an Internet meme. The video combines two genres that the boys enjoyed: kung-fu and babies. Alternating turns

choosing the clip to view, the Wilkinson baby came up in their game of YouTube call and response after a kung-fu clip. Another favorite was "Hahaha," a home video of a giggling baby, which made them laugh hysterically.[9]

Multitasking, as they surfed for YouTube clips they also played back tunes from their mobile phones. About five minutes into their session the conversation about mobile phones gained momentum; they decided to download tunes from the Web to their phones. They attempted to transfer music via Bluetooth from the computer to a phone but were not successful. They spent another five minutes trying to negotiate the connection between computer and phone. They told me they knew how to do this at home and were disappointed that they could not achieve their goal.

Aiming to exploit as much technological potential as possible, the boys were attempting a task beyond the capabilities of the system. It seems the necessary Bluetooth dongle was missing, but the boys did not suspect that hardware might be the missing link. After five minutes on this activity, they returned to surfing, and they laughed, pointed and commented on the clips they were sharing with each other and with me. Although they wanted to do more, their play ultimately became a clip screening mash-up session. When their fifteen minutes were up, they happily moved on and two girls entered the computer cubby.

The girls came in on cue and engaged in roughly the same activities. They played a few online games and looked for clips from *The Simpsons*. Although they began, like the boys, with a system of taking turns showing each other a clip, they soon decided to look for clips that they both enjoyed. They shared an interest in *High School Musical 2* and were keen to find what they called the "real" *High School Musical 2* clips. Through a combination of Swedish, English and Spanish, I asked how they could tell a "real" clip from the rest. The girls (eight years old) supplied three criteria for authenticity: displaying the Disney logo or watermark, presence of the recognizable actors, and high-resolution video. These criteria demonstrate the girls' sophisticated knowledge of industrial business practices (watermarks), aesthetic hierarchy (high resolution), and YouTube's potpourri of "quality."[10] Their fluency with issues of genre was revealed when I asked them what they liked about the movie. They talked about the love story or romance, and they punctuated their remarks with a performance of mock kissing followed by giggles. Once they found the "real" clips they sang along. The re-mix and replay are similar to the video playback practices of Australian children who were given similar autonomy in video playback control.

The intimate setting of the computer's situation in a small alcove room meant that no more than two children at a time could use the computer. The karaoke utility that the girls discovered in YouTube clips could have provided an activity for several children, and a physically active one at that, had the computer been in a

more open and public arena. The paired-use rule resulted in same-sex/gender pairs, which also has consequences for the type of activity pursued. The girls' rejection of the alternation system and preference for a shared interest search strategy rings bells about gendered behavior, but that line of inquiry was not pursued due to time limitations.

Staff here said they had plans to acquire a new computer and equip it with Photoshop and other software to facilitate multi-step photo projects starting with digital still photography and moving through effects and editing to create photo essays, exhibitions, Web sites and other publications. The children frequently went on a short excursion to a nearby park to play on the climbing equipment, and the staff member thought that taking photographs in an off-site location would be appealing to the children and provide a starting point for a larger digital photo project. Here the staff had a clearly articulated ambition for media production, and given the appeal of music videos and karaoke to the children, they would have been keen to participate in production that would bring together music and image.

This school also ran a center for older children up to eighteen years of age, *fritidsverksamhet*, which operated in a facility that was also a youth centre in the later hours of the day and on weekends. Unlike the facility that the younger children used, this space had little trace of being a school. Among the pool table, foosball table, and canteen area was a widescreen TV mounted high on a wall, and several sofas formed a square from which the screen could be seen. Coffee tables had lit candles, and overall the ambiance was "lounge." At the edge of the lounge space, in a corridor adjoining this with the kitchen, was a PlayStation console opposite two groovy '70s-era automobile bucket seats. This gaming area was set up for competition between two players, given that the seating allowed for little else. Having seen that the girls were interested in video games, the service director purchased a few games with what he called "girls' taste" in mind. These were music quiz and karaoke games. Two girls would play while others watched and waited to play the winner in round-robin fashion.

Further to the periphery of the central action, atop a bench overlooking the kitchen, were two Internet-ready computers, but they did not have any production software loaded. The machines were there for accessing online games, tracking sport teams and scores, and other information retrieval. They were not equipped for any production activities. The computer provision stood in stark contrast to the elaborate arts and crafts production area, which was a dedicated and well-provisioned room. For both age groups the provision of hardware and software is better described as a gesture than a commitment. Sustained digital media production was not possible with such little investment. One could argue that

only the consumer side of the media equation was supported, with most access designed to position the user as an audience member due to lack of equipment.

There is, however, another way to view the consumer's participation in the clip culture that characterizes YouTube. The children's strategy of selecting clips and thereby creating flow is a mash-up technique prominent, if not dominant among practices that mark new media systems as having less distinction between production and consumption modes, and producer and consumer roles (Ulricchio 2009). The bricolage process required by YouTube signals emergent media production practices that are codified but not yet institutionalized. Even at the margins of media and in the crevices of children's leisure spaces, we can identify creativity in children's media practices.

At one site in Stockholm I was able to observe the children on the day they had access to the school's computer lab. At this school, children did not have access to computers in their classroom activities until sixth grade, when they began to use computers for research, writing, and some art making. During *fritids* on a Thursday, the children in the computer lab were in second and third grades and keen on computers. The day I observed, twenty-five children were in the lab, most participating in the virtual world, Club Penguin (www.clubpenguin.com).

Founded in 2005 as an ad-free virtual world for children to play games and interact, Club Penguin's success gained the attention of Disney and became part of the Disney family in 2007 (http://www.clubpenguin.com/company/about.htm). Today Club Penguin is an award-winning, virtual community inhabited by penguin characters and their pet "puffles." The site has an Entertainment Software Rating Board (ESRB) rating of E (Everyone, U.S.), and there is a moderator present during game play.[11] A player name and password allows one to play, but paid membership ($US 5.95/month) provides access to additional "members only" activities and privileges. The day I observed, only one child was a member, and the rest enjoyed the free access and activities.

The site offers a blog, comic strips, opportunity to upload fan art and photos of your Club Penguin soft toys, images to download and color in, wallpapers, screen savers, and the Penguin Poll (a survey tool), among other features. Game play, perhaps the most appealing aspect of the site, takes place on the iceberg where penguins congregate. Across a range of locations (sporting stadium, shopping, entertainment district, beach, dock, ski village, cove, mine, forest, and member igloos) a variety of activities and mini-games can be pursued. As penguin icons move around the terrain, other penguins might communicate in text bubbles, asking others to participate in a sled race or start a snowball fight.

In the lab, computers were arranged in the standard rows, and children sat side by side, each facing their own screen but all playing in Club Penguin. Eager to play with each other, they used the proximity of oral communication to overcome

the dispersed virtual presence. They yelled across the room to one another, "Where are you? Which world are you in?" With this question the child may be asking where in the game world the other player is, and once identified, their penguins can "play together" in a snowball fight or sled race. The question might, however, be asking which game server the friend is on. If the children are logged on to different servers, their penguins will not appear in the same game space. This can be remedied by logging off and on again to the nominated server. The point is that children strive to co-locate themselves in the virtual world while playing with each other in the computer lab. Since the computer lab is set up in rows, they cannot readily see the screen of their friend to monitor which server they log on to and where the penguins go. In their rush to log on, they did not bother to set a rendezvous server. To simultaneously play in the physical and virtual worlds requires supplemental communication and exchange. One child walked across the room to a friend and said, "I've sent you a message."

A favorite activity was virtual vandalism—rearranging the furniture in someone else's igloo. They played games, "bought" stuff for their penguins, read the penguin press, visited one another, and sent messages.[12] The English-language elements of the game aligned well with the bilingual school's curriculum, but more generally the virtual world offers familiarity with standard format, function, and operations associated with complex graphical interfaces common to many sites. The virtual world of Club Penguin defies the physical boundaries that distinguish home, classroom and *fritids* because it can be played anywhere, but children still engage the co-presence of their friends in physical proximity.

Another site I visited in Stockholm was a parent-managed school, what they call a "private" school, where 43 percent of the children attended *fritids*. Staff and the school principal had very positive attitudes toward media production but were battling parental disfavor; parents said they preferred *fritids* to provide more physical play and less media use. The school had recently retained a new principal and computer lab supervisor. The location of *fritids* had changed, and they no longer had daily access to computers. While staff reported that there had been a vibrant media production culture in the past, recent changes had resulted in a hiatus. When previously *fritids* had daily access to the computer lab, each day a different age-graded group would have two hours' access. Staff proudly told me how they had (in the past) maintained a digital portfolio of each child's creative works (paintings, drawings, origami, and so forth) so that upon graduation each child received a CD compilation to remember his/her *fritids* experiences. Also in the past, staff published a magazine about *fritids* and children made movies and CDs, although staff did the editing. They described a rich and varied media production culture with considerable support for children's digital media creativity. I was as-

tonished to see that very little remained. How easy is it to cease delivery of a popular activity, and how much pressure must be applied to make that decision?

Among the staff, a young male musician was keen to see the children make a film from script to final cut. In our conversations over three visits I tried to support his intentions because, given the circumstances and parental disposition, they were under threat. Perhaps because there was little media play at the time I observed, we had long and reflective conversations about children and media. Seeing that girls rarely played the video games, they had established "girls-only" days to encourage girls to play games, but they still limited game access because they feared it would be too popular. Staff did not think that a large group of children watching a couple of kids play a game was a good idea.

A strikingly similar view was expressed in the Australian study, where the service with the most well-developed media production program (Movie Magic) provided the least support for digital games and computer use. And, like the service in Australia, this one showed movies on Fridays, and the screenings would gather thirty to forty children to reverently watch a DVD. Such a screening practice, where movies are shown on select days and children sit in audience formation, replicates dominant patterns of film exhibition and marketing—the way one would behave in a theatre setting.

Here it was fairly easy to see how dominant marketing narratives and standardized media consumption patterns influenced the rules that adults set for children's media use. The large audience assembled to co-view a movie in reverent repose replicates the exhibition and consumption practices of theatrical release and was acceptable to adult sensibilities. On the other hand, a large group of children co-playing a video game is not the image that has been marketed for video game play, and this was discouraged. While adults support group viewing of a movie, a similarly large group of children playing with a video game is discouraged. This suggests that adult concepts of what constitutes children's media play are not based in knowledge of children's practices but are instead reflective of other ideologies, like those that marketing campaigns exploit when selling hardware and software for domestic use.[13]

Marketing, Media, and Mythology

It is safe to say that the majority of people who set policy for after-school care services have not been part of the core market for games and are not avid readers of gaming magazines. On the other hand, they would be familiar with mainstream advertising for games and hardware and with the popular and public discourse on gaming that circulates via news reports and representations of gaming in film and TV. The masculine bias of mainstream marketing of Xbox displays a culture of competition rather than collaboration, action rather than contemplation. The

absence of players in these ads does not support a view of the positive features of children's collaborative video game play that I have identified in children's recreational media cultures. After-school care providers do not see a likeness of themselves or their charges in advertising's rare representation of players. Digital games are not positively associated with school or after-school care. Despite the high quality of children's digital game-playing activity when it is undertaken in public, mixed-gender, mixed-age cohorts, this play culture is not well known and almost constitutes "secret children's knowledge."

Mainstream media advertisements for Microsoft (Xbox) and Sony (PlayStation) hardware tend not to feature players. Their demographic is the solid gaming constituency of males eighteen to thirty years old. A Google search (in September 2009) for "Xbox ads" revealed a series of ads aired in different national markets. Each ad featured a leisure activity like skateboarding, jumping rope, a multi-participant water balloon fight, or similar activities. Game consoles, game play, and players were either entirely absent or only appeared in the last shot as punctuation to a narrative about active fun. These ads relied upon images and feelings associated with physical activity, outdoor fun, and youthfulness to sell hardware for indoor recreation. They were aligned with a soft version of extreme sports. This recalls an earlier generation of Xbox marketing that featured competitive sports because sports games were central to the console's broad appeal upon release.[14]

With respect to the sale of game software, as graphic representation becomes more filmic, advertisements that feature in-game play are able to exploit an aesthetic continuity across film, game, and TV. Irrespective of whether the ad appears on broadcast TV, cable, satellite, or online, the medium is consumed as video, and in-game play now looks like movies and TV. In hardware and software advertisements, players are featured marginally, if at all. Instead of real players we have the idea of players, and that idea is a masculine one.

When gaming platforms moved from the arcade to the household, single-player games became increasingly common. We are now several generations down the line from the earliest consoles, but the image of the single player still holds an iconic status, despite the development of new technologies that afford a vast array of group play/use configurations. Unlike Sony and Microsoft, Nintendo has been keen to expand its market beyond the core male, eighteen- to thirty-year-old demographic. They make the most games for children, and the multiplayer input capabilities of the Nintendo64 platform were heavily promoted with its 1996 release. Nintendo's newer platforms, such as the personal-sized Dual Screen (DS) and the multi-function input Wii, are being actively marketed to female consumers. A Google search for "Nintendo DS ads" (in September 2009) yielded the following selection:

- Nicole Kidman & her Nintendo DS Lite advert

- Olivia Newton-John's Nintendo DS ad

- Rhythm Heaven Nintendo DSi commercial featuring Beyoncé

- Girls Aloud Nintendo DS advert

These ads feature popular celebrity women, some of them moving toward the "mature" end of the hot-chic continuum. In the Girls Aloud ad, the five women are playing together on their individual DS devices, grouped closely to one another on a plush sofa. In another advert Olivia Newton-John shares her DS with a young female assistant as they sit closely together riding in a limousine. Even such personal technology is featured as a social gaming platform or prompt for social interaction. The message in these campaigns is that the screen is more fun when shared with friends.

Most of the Wii commercials foreground localized group play and promote a party-like play culture where "friends come around and join in the fun." The wholesome fun of human co-presence has displaced the distributed-virtual-social nature of online communities and the imagined isolated player. One Wii Sport commercial features Australian pop singer Delta Goodrem and her current fiancé, former boy-band singer Brian McFadden, playing a game of Wii tennis. (There is a pun included here for Goodrem fans because she was previously romantically involved with pro-tennis player Mark Philippoussis.) Players are central to Nintendo's marketing campaigns, even for the "personal technologies" of Game Boy and DS. Although these devices are miniature and mobile, they feature multiplayer capabilities, with the newest models being "wi-fi ready" and earlier models connecting with one another through a link cable. Both systems allow for simultaneous multiplayer gaming.

Unlike the PlayStation and Xbox campaigns that sublimate the technology, the product, and the player(s) by substituting a sentiment, Nintendo advertisements feature the people that they want to become players. Nintendo ads seek to provide a reflection of the consumer—see yourself here; buy our product—they seem to say. But the market expansion project that seeks to develop a wider consumer base among women and across generations is relatively new.

The link between marketing campaigns and policy/programming development in after-school care is not a direct one, but the most accessible narratives that describe and characterize games and players leave behind a particular image. This image does not represent the type of practice that readily develops among play groups in after-school care settings when media are made available and children are granted autonomy in their play. The localized social world of play depicted in

the Nintendo Wii advertisements is more akin to what actually transpires in after-school care when children have access to video games and computers.

In both Australia and Sweden the commercial narratives about how to use media (how to play a game) or how to consume media (how to watch a film) appear to be the most accessible for adults. Adults want children to watch a film as a quietly assembled audience (individuals seated in a group), because that's how movies are watched in the theatre. They do not want children to play video games because they believe that these are played by single players, because that's what the marketing has told us until recently. The large group assembly for a movie screening is acceptable, but a large group playing a game is not. A movie must have an audience; watching alone is forbidden. A game should not have a gallery, presumably because game play is understood as a manual, not mental, activity; only those holding the controls are truly playing.

These dominant and culturally sanctioned media use patterns have developed from commercial imperatives. Digital games are distributed according to an economic model of publishing. Single player games sell more units. The economics of theatrical film exhibition, by contrast, rests with the theatre owner who rents the film and in whose interest it is to screen the film to a large audience. On the one hand, the dominant paradigm can help develop media production cultures like Movie Magic or the *fritids'* Electronic Newsletter. On the other hand, failing to allow children to play in ways unscripted by marketing narratives prevents us from discovering the creativity and diversity in children's media play when they are given autonomy. Forcing children to watch movies in theatrical style prohibits them from using the DVD as a karaoke machine or soundtrack for their dance routines.

The concern over rising rates of childhood obesity is also marshaled in the battle against the appropriateness and legitimacy of media in children's play. Although I did not *see* any fat children in Sweden, the idea of fat children was everywhere. The ambition to include more physical activity in the *fritids* agenda has resulted in a view that media play is not and cannot be physical. This view, however, is contrary to what I have documented of Australian children's media play, where children often use media content as background for their physical activities of dancing, performing, and role playing in quite elaborate run-and-chase games (Vered 2008, 77–82). Rather than using media to stimulate physical play, media play has been deemed to be mutually exclusive with physical activity. Practices like sequestering computers in broom closets establish physical limitations that preclude children from choreographing physical play with media use. The clip culture and karaoke practices of the Swedish children might have led to more physical and larger group play around music video had Internet access been available in a more open environment. One can easily imagine a group of children forming their own

band to perform for the production of a video clip that eventually becomes part of the YouTube archive. Perhaps the evolutionary developments of the Wii will be accompanied by a revolutionary change in attitudes toward children's media play as marketing makes clear the physical dimensions of media play with the new device.

A clear view of children's media play cultures is not possible through the prism of discourse on childhood obesity coupled with marketing mythologies. Adults need to recognize the collaborative and supportive friendship groups that group video game play generates rather than worrying about calorie conservation among the children watching while only two control screen action. Adults do not see children dancing to a movie's theme song; instead they see children replaying the same scene and hear them making noise instead of watching the DVD.

Parents have used the imaginary fat children to argue for less media access in *fritids*. They claim that children are spending too much time with media and need more exercise. Following this logic, they ask that *fritids* restrict media access and activities. While the goal is to reduce their child's total time in media play, parents may be unaware that media play in *fritids* can be of a higher quality than the same activity undertaken at home. By requesting that media access be restricted at *fritids,* parents achieve an overall reduction in media play without having to take on the responsibility of enforcement. The result, however, is a reduction in the variety of media play in *fritids* without consideration for the quality of that play experience.

This latest assault on children's media use is not without precedent. Today's claim that our children are fat because they spend too much time in the virtual garden is similar to earlier arguments that proffered a substitution theory. The suggestion is that healthy, aerobic play has been replaced by unhealthy, sedentary recreation enabled by digital devices. While it would be foolish to argue that the digital revolution has not changed our everyday living, it is equally imprudent to dismiss the complexity that characterizes our use of media, new and old. It is particularly disappointing to see the way that children's media use in after-school care settings is being restricted, and in some cases eliminated, when we still have not recognized the unique and diverse ways in which children play with media when they are made available in places and spaces beyond the scenes and settings imagined by the narratives of planned obsolescence, single player, sell more hardware, consumer marketing and scripted consumption.

Notes

1. Among the conferences at which I presented my research in progress were: *Summit 2000: Children, Youth & Media*, Toronto, 2000; *Young People & the Media: International Forum of Research,* UNESCO & Australian Broadcasting Authority, Sydney, 2000; *3rd World Congress of*

the International Toy Research Assn., London, 2002; *International Ratings Conference*, Office of Film and Literature Classification, Sydney, 2003; *Digital Generations Conference*, London, 2004; *4th World Congress of International Toy Researchers Assn.*, Spain, 2005.

2. For trends in the United States, see "Out of School Time: Leveraging Higher Education for Quality," The After-School Corporation, 2010.

3. *Skolverket* is the National Agency for Education. An explanation of the Swedish Education System in English is available on its Web site: http://www.skolverket.se/sb/d/190; and more detailed information on childcare for school-age children: http://www.skolverket.se/sb/d/2652. The Steering Documents outline the balance of responsibilities between national and local authorities: http://www.skolverket.se/sb/d/493.

4. Since returning from my field trip to Sweden I have located a *Skolverket* report (2007) indicating a push for improvements in the articulation between *fritids* and "the curriculum for the compulsory school system...in relation to national objectives and requirements" ("Descriptive data on pre-school activities, school-age childcare, schools and adult education in Sweden 2006," *Swedish National Agency for Education Report no. 283*, p. 13). This report may not have been released at the time of my visit because school and *fritids* staff/management did not express awareness, concern or interest in a call for better integration and articulation with curricular goals. Moreover, an articulation between curriculum and leisure does not necessarily mean more structured learning in leisure time. In Sweden it may well mean greater integration of leisure and play culture in classrooms. The move to integrate *fritids* staff into primary school classrooms suggests a belief in "play as a learning mode." The report is available as a pdf from the *Skolverket* site under "Publications," http://www.skolverket.se/sb/d/355.

5. The field trip was made possible by a fellowship from the Swedish Royal Academy of Letters, History & Antiquities (*Kungl. Vitterhets Historie och Antikvitets Akademien*) in association with the Australian Academy of the Humanities. See www.vitterhetsakad.se and www.humanities.org.au.

6. ACMA is the statutory authority of the Australian federal government responsible for broadcasting, Internet, radio, and telecommunications policies: www.acma.gov.au.

7. Although I do not speak Swedish, enough children spoke English that I was able to communicate directly in many instances and in other cases through a willing child interpreter or staff member.

8. Accessed via YouTube on 8/19/09: http://www.youtube.com/ watch?v=siJhUjyIz00&NR=1.

9. Accessed via YouTube on 8/19/09: http://www.youtube.com/ watch?v=5P6UU6m3cqk. In their Introduction to *The YouTube Reader* (2009:11), Snickars and Vonderau refer to the popularity of this particular clip, noting that its 83 million views far exceeds attendance for the most popular theatrically released films.

10. On YouTube and discourses of quality, see Eggo Müller's essay "Where Quality Matters: Discourses on the Art of Making a YouTube Video," in *The YouTube Reader*.

11. A non-governmental, industry self-regulation body, Entertainment Software Rating Board, www.esrb.org, assigns ratings to digital games.

12. I have corresponded with Club Penguin about when changes were implemented as a result of the August 2007 merger with Disney, but I have not received answers to all of my questions about the commercial dimensions of the site. In September 2007, I did not notice the "Toys" feature, and the children said they could decorate their igloos with furniture without a membership. Today a membership is required to furnish an igloo.

13. I am aware that some cynics might think screening a movie in theatrical style is merely a way to occupy a large number of children for 97 minutes. Childcare staff would never admit to deploying the "electronic babysitter," and I don't think they have such managerial intentions.
14. I am grateful to Martin Manning for his insights on game marketing.

References

Descriptive Data on Pre-school Activities, School-age Childcare, Schools and Adult Education in Sweden 2006 (Report 283). 2007. Stockholm: *Skolverket* (Swedish National Agency for Education).

Domaille, Kate and David Buckingham. 2001. Where Are We Going and How Can We Get There? General findings from the UNESCO Youth Media Education Survey 2001. Accessed via http://www.european-mediaculture.org

Goodman, Steven. 2003. *Teaching Youth Media: A Critical Guide to Literacy, Video Production, and Social Change*. NY: Teachers College Press.

Müller, Eggo. 2009. Where Quality Matters: Discourses on the Art of Making a YouTube Video. In *The YouTube Reader*, edited by Snickars and Vonderau, 126–139. Stockholm: National Library of Sweden.

National Testing, League Tables and School Performance Accountability. 2008. Victoria: Australian Education Union.

O'Grady, David. 2010. Beyond the Button: New Video Game Interfaces and the Implications for Embodiment, Performance, and Play. Conference paper presented at Society for Cinema and Media Studies, March.

Snickars, Pelle and Patrick Vonderau. 2009. Introduction. In *The YouTube Reader*, edited by Snickars and Vonderau, 9–21. Stockholm: National Library of Sweden.

Ulricchio, William. 2009. The Future of a Medium Once Known as Television. In *The YouTube Reader*, ed. Snickars and Vonderau, 24–39. Stockholm: National Library of Sweden.

Vered, Karen Orr. 2001. Intermediary Space and Media Competency: Children's Media Play in Out of School Hours Care. *Simile: Studies in Media and Information Literacy Education* 1 (2) (May). [http://www.utpjournals.com/ jour.ihtml?lp=simile/issue2/vered1.html.]

———. Children and Media in Out of School Hours Care 2006. South Australia: Department of Education and Children's Services. [http://www.decs.sa.gov.au/oshc/pages/services/media.]

———. *Children and Media Outside the Home: Playing and Learning in After-School Care*. 2008. London: Palgrave.

Web Sites

Australian Communication and Media Authority: www.acma.gov.au

Club Penguin: www.clubpenguin.com

Department of Education and Children's Services, South Australia: www.decs.sa.gov.au

Entertainment Software Rating Board: www.esrb.org

Skolverket (National Agency for Education): http://www.skolverket.se/sb/d/190

Swedish Royal Academy of Letters, History & Antiquities [*Kungl. Vitterhets Historie och Antikvitets Akademien*]: http://www.vitterhetsakad.se/home.html

YouTube: www.youtube.com

13

All the World's an Album:

Youth Media as Strategic Embedding

Elisabeth Soep

Introduction

It was January 2009, and this wasn't the story we thought we'd be telling. Barack Obama had won the U.S. presidential election just a few months before, and January was the month he'd be inaugurated. It was a historic moment, not just because Obama would be the first Black U.S. president, but also because of the crucial role young voters and digital culture had played in his election. Youth Radio,[1] the Oakland, California-based, youth-driven production company where I work, had big plans for how the newsroom would cover this landmark event. We envisioned several stories for National Public Radio (NPR), one of our regular outlets, which served a weekly audience of more than 26 million people. Plus we were launching a digital strategy that would leverage our relaunched Web site, built on an open-source system designed to enable youth contributors from anywhere to upload and engage with original content. The plan was to dedicate significant newsroom resources to coverage of the inauguration and the Obama presidency starting the first of the year. And then we heard about Oscar Grant.

A couple hours past midnight on New Year's Eve, Oscar Grant was on a Bay Area Rapid Transit (BART) train at the Fruitvale station in Oakland when transit officers ordered several people off the train and onto the platform. A fight had allegedly broken out, though exactly what took place that led transit police to gather up passengers—and how they decided which passengers—was unclear. In any case, Grant, a twenty-two-year-old Black man and new father, was among

those detained. At one point during the police procedure, a twenty-seven-year-old White officer named Johannes Mehserle forced Grant to the ground chest-down, restraining his arms behind his back. Witnesses recall hearing Grant pleading with the officer not to "tase" him—meaning, shoot him with a stun gun, which transit police are authorized to use under certain conditions to gain control over disorderly detainees. The officer did not tase Grant. Mehserle pulled out his pistol and shot him at close range in the back.

"Check this out," then nineteen-year-old reporter, Denise Tejada, said when we were all back in the newsroom after the holiday break. She hit play on a video recording[2] of Grant's killing she'd found on the Internet. Online coverage suggested the officer might have accidentally grabbed his pistol and fired, thinking he had his taser in his hand. Or maybe he hadn't meant to pull the trigger. We played the chilling footage over and over again. A stun gun feels nothing like a real gun, someone said, and besides, police officers are trained to holster them on opposite sides of the body. Why was Grant being tased at all, even if you did buy that logic? someone else asked. He appeared cooperative. We wondered what to make of the officer's expression and body language the moment after he'd pulled the trigger, when it looked like what he'd just done was registering.

We were not examining an official record of Oscar Grant's killing. That morning, we—alongside thousands of others with an Internet connection and interest in the story—were viewing a recording of the incident another passenger had produced via cell phone. Police officers tried to confiscate digital memory cards before riders who'd recorded the incident got back onto the train after the shooting. Investigators assigned to the case later used the footage to examine the incident from various angles. Almost immediately, passenger-generated videos spread on the Internet and via mainstream media like wildfire. Protesters who took to the streets of Oakland to express their fury over what had happened to Grant invoked the footage to back their claims of wrongdoing. Prosecutors later used the riders' amateur videos as material evidence when they eventually made the historic decision to try Mehserle for murder. "The tapes, the tapes, the tapes," one prosecutor observing the case told the *San Francisco Chronicle* once court hearings began. "That's the crux of the case."

Double Youth Media

Oscar Grant's case, and its co-production and coverage by youth media-makers, is striking in its stakes and intensity, especially for Youth Radio. The BART station where the killing took place was just a few miles from the organization's headquarters in downtown Oakland, and the story was a lightning rod for issues the newsroom had a long history of reporting on: urban violence and its place in the public imaginary, police brutality, and racial profiling.[3] There was an expression at the

time, "Driving While Black," which captured the sentiment of people of color who'd been pulled over or detained by police again and again, solely on the basis of race (the phrase played on the criminal classification of "Driving While Intoxicated"). The idea was that just being Black was enough to render a person suspect in the eyes of law enforcement. Hostilities were especially acute in Oakland, where community members painfully remembered the group of renegade police known as "The Riders" who earlier in the 2000s regularly brutalized drug suspects and then falsified reports, only to be cleared of all criminal charges.

With that social context as backdrop, the dimension of the Oscar Grant story I want to focus on here, which is more and more common in Youth Radio's coverage and youth media content overall, is the key role played by everyday digital recordings. The story is a case of "double youth media" in that youth-generated content is both a *character* in the scene described, and an *outcome* of the telling. I use the word *character* here deliberately, because the everyday content acts in and on the scene. It's not just a relic or neutral record. It's not included in the storytelling merely to add texture or a vérité quality. In this case and others, the immediate media generated as the event unfolds fundamentally changes what takes place in real time, as well as what happens after the fact for those involved, their communities, and their various local, national, and global publics.

In the rest of this chapter I trace the features and implications of double youth media for those working in and theorizing the intersection of youth and digital culture. To do so, I draw on the Oscar Grant coverage and another Youth Radio series in which Youth Radio presented its investigation of widespread hazing and abuse of young sailors at a U.S. Navy unit in the Persian Gulf country of Bahrain from 2004 to 2006. I'm using double youth media to refer to digital content young people develop that embeds recordings collected in the course of everyday life into media narratives designed to deliver a message to targeted audiences. The found media is captured using cell phones, Flip cameras, iPods, and other mobile devices more and more of us don't leave home without. These found media are repurposed by Youth Radio (and other youth media) creators to make a larger point. This embedding process is fundamental to today's digital media literacy. Moreover, learning to embed skillfully requires support, practice, and access to those with expertise, and I don't just mean technical mastery of the steps involved (e.g., cutting and pasting embed code for a video posted on YouTube onto a blog post). It is a mistake, then, to assume that young people, simply by virtue of their gaining access to the means of recording, will know how to produce content with meaning and impact.

Double youth media transforms content originally generated for instrumental reasons—to witness, to gather evidence, to remember, to humiliate, to play—by connecting that material to larger histories and collective calls for engagement and

action. Through their media productions, young people connected images of Oscar Grant held down on the floor of that subway platform with other powerful scenes, including past incidents of police brutality, and new creations the community made to express anger and solidarity over the event: for example, posters and Facebook status updates announcing "I Am Oscar Grant" or "We Are All Oscar Grant." That's a refrain picked up in the aftermath of Grant's shooting, which came to symbolize something larger than this one death, to speak to widespread institutionalized betrayals and brutalities. By transforming found media content in this way, youth producers do more than create individual stories. They form and reform a dynamic collective album of disparate images and captured moments that define shared cultural troubles and turning points in a public way, connecting isolated incidents to wider interests and movements for change.

If all the world's an album, then all the youth are merely documentarians, entering and exiting but never really leaving public stages. A searchable digital archive keeps their lines (and gestures, and movements) permanently available to audiences. And so it's never been more important for young people, especially those who've been marginalized from digital privilege, to contribute not just with everyday raw records but also with strategic and deliberate coverage of the issues and events that are shaping their lives. Drawing on one final series—Youth Radio's coverage of the war in Gaza (2008–2009)—the chapter closes with a discussion of credibility as a theme that carries especial urgency in an era of double youth media. But first, some context on Youth Radio and my research.

Youth Radio

Founded in 1992 by reporter Ellin O'Leary with San Francisco Bay Area high school students Deverol Ross, Chano Soccarras, Ayoka Medlock, Noah Nelson, and Jacinda Abcarian, Youth Radio is a youth-driven production company and journalism training program where young people aged fourteen to twenty-four make and distribute original media across formats and use and develop emerging technologies. Young people come to Youth Radio primarily from the nation's economically abandoned public school districts, in which students are often organized into separate academic tracks (remedial, "regular," honors, and advanced placement), and where Black and Brown youth are disproportionately disciplined and relegated to the poorest schools. At Youth Radio (headquartered in downtown Oakland, California), beginning with students' very first class, they work together to carry out a single, demanding, shared task—producing a weekly live radio show, *Youth in Control*, plus all the digital media products (e.g., photos, video, blog posts) that give radio an online presence. In addition to the Oakland headquarters, Youth Radio has bureaus in Los Angeles, Washington, D.C., and Atlanta, as well as partnerships with other youth groups around the country: in a

coal-mining community in Eastern Kentucky, a gentrifying Chicago neighborhood, a Native American reservation in Arizona, and a juvenile detention facility just outside Oakland. Youth Radio's coverage is transnational, with stories in recent years coming from Afghanistan,[4] Iraq,[5] Ireland,[6] Israel,[7] Palestine,[8] India,[9] South Africa,[10] Ghana,[11] and other locations throughout the world.

Recruited by program graduates, students working at Youth Radio's Oakland program begin with introductory transmedia classes and advance through specialized courses and eventually paid positions as media-makers, engineers, and peer educators. There are no academic requirements to join—although applicants do need to fill out some basic information and participate in an interview. Recruitment decisions are guided by efforts to fill a class of twenty, four times per year, which is balanced in terms of gender and geography, diverse in terms of race, and composed primarily of low-income youths and young people of color. All programs are free. Students receive individualized education and career counseling, and, in 2007, the organization began offering high school and community college credit and brought on board a licensed social worker who offers one-on-one therapy and leads agency-wide health initiatives.

Youth Radio reporters, commentators, and producers deliver content on deadline to commercial, public, and community-supported radio stations as well as the *San Francisco Chronicle*, the *Huffington Post*, *Current TV*, iTunes, and the Internet's varied social media sites. Through a combination of intensive training, deadline-driven production, and one-time workshops and presentations, the organization reaches more than 1,200 people per year. The newsroom files regularly—approximately three broadcast stories per month plus digital content—to public broadcasting shows including NPR's *All Things Considered* and *Morning Edition* and American Public Media's *Marketplace*. Youth Radio has been honored with George Foster Peabody, Alfred I. DuPont, Edward R. Murrow, Robert F. Kennedy, Investigative Reporters and Editors, and Gracie Allen awards. These are honors normally bestowed to newsrooms staffed by journalism veterans at the nation's top public and commercial media outlets. Youth Radio is undoubtedly unusual in the recognition it's received from professional journalists and in its collaboration with mass media outlets. And yet the organization's core values and strategy of leveraging media production to promote youth development and justice are not uncommon at all, as evident not least through the other chapters in this volume. In this sense, lessons from Youth Radio hold relevance for any place where young people find, frame, articulate, and spread stories they feel a pressing need to tell. Implications help in our efforts to understand any site where adults and young people convene to work on high-stakes creative projects with the goal of generating some kind of public awareness, impact, or influence.

Like the focus of this chapter, my role at Youth Radio has its own double quality. I've got a two-part title, Senior Producer and Research Director, to which I apply two-tracked training that combines journalism and media production with a Ph.D. in education and an academic focus on cultural studies and ethnography of communication. How that translates in practice is, on the one hand, that I collaborate with young people to produce media content. We work within a model I characterize elsewhere as "collegial pedagogy" (Chavez and Soep 2005, Soep and Chavez 2010), wherein young people and adults jointly create original work for outside audiences that are expansive and beyond the makers' control. Though deeply indebted to critical pedagogy (Freire 1970; Darder, Baltodano, and Torres 2003), apprenticeship models, and the framework of learning as participation in communities of practice (Chaiklin and Lave 1996; Lave and Wenger 1991), collegial pedagogy is distinctive in that neither party—youth or adults—could carry out the work as well (if at all) without the other.

Within Youth Radio, collegial pedagogy leverages young people's access, networks, nuanced analyses, and a sensibility for new ways to tell stories. The adults bring years of experience and connections to powerful others who can deliver the stories to massive audiences, and scaffold opportunities for young people's advancement through formal channels of higher education and employment. As senior producer, I work daily with young people in this dynamic, producing stories for the organization's varied outlets, collaborating on coming up with ideas and pitching, recording, mixing, and delivering content via broadcast and digital channels. The most interesting and challenging production projects within Youth Radio unsettle expectations about who possesses what forms of expertise and leave room for necessary but sometimes difficult questioning of whose story is, in the end, being produced and told.

On the other hand, building on more than sixteen years of study on youth discourse and collaborative media/arts production, as Research Director I investigate our own work and related projects across the United States, with a focus on implications for learning, literacy, and ethnography (Soep 2006, 2007; Soep, Mayeno Saavedra, and Kurwa 2008). Ethnographers call their signature method "thick description." Through detailed accounts of everyday cultural practices, they interpret how the people they study make meaning in their lives, so the researchers can, in Geertz's (1973, 24) words, "converse" with their subjects. While profoundly informed by ethnographic traditions, in carrying out the research reported in this chapter and my other writing on Youth Radio, I've sought a way to articulate my "thick *participation*" in my study site (Spittler 2001, emphasis added). I converse with the young people and adults who populate this site not only for the purposes of research. I don't need a qualitative research methodology as a vocabulary for those conversations. We work together. I depend on them to meet deadlines and

deliver high-quality work. They depend on me for the same. Though our relationships transcend those of researcher-researched, we have found qualitative methods good to think with, as Claude Lévi-Strauss might say, as we generate new knowledge about youth media practice and theory.

In emphasizing our reciprocity, I do not want to imply simple equality in position, status, or influence between young people and adults, perhaps especially when our disparities in age and experience are interlaced with differences in race (I'm White; most Youth Radio students are young people of color) and access to social and cultural capital. Whether we are assigning stories, editing copy, or voice coaching in the studio, as youth media makers and scholars we are always navigating uneven relationships, emotions, and unfinished histories that mark the processes and products of our joint productions.

My double role is, therefore, not always comfortable, and certainly there are things I can't (or don't want to) see because I am "in" the work and not standing outside. But, drawing from traditions of community-based participatory research and participant action research (Minkler and Wallerstein 2003; Morrell 2004; Torre and Fine 2006), it is my view that there are also special affordances that come with this unorthodox research position. Perhaps most relevant here is a capacity to watch what happens to individual media projects long before and after they manifest as public products, and to participate with young people in navigating how the story behind the story unfolds.

The Tapes, the Tapes, the Tapes

Youth Radio's coverage of Oscar Grant's killing ran the gamut from online posts, audio slideshows, videos, and interviews with key players (including Grant family attorney and longtime civil rights lawyer John Burris), to first-person commentaries for NPR, to live discussions on iTunes with local artists who were responding to the case through music and hip-hop organizing. Of particular interest for Youth Radio, of course, was talking to the young people at the BART station that night who'd had the presence of mind to record the shooting using their personal equipment. Denise Tejada, the first Youth Radio reporter to bring Grant's story to our newsroom, had seen a local TV spot featuring Karina Vargas, a teenager who'd supplied footage to the case. Denise tracked her down via MySpace, confirming that she'd found the right person because Karina was wearing the same patterned shirt in her profile photo as she had on the news. Denise sent Karina a message via MySpace, saying she was covering the aftermath of the shooting for Youth Radio and requesting an interview. With Youth Radio's online editor, Noah Nelson, and video producer, Nathan Hadden, Denise produced a short-form video[12] with Karina, taking her back to the Fruitvale BART station for the first time since the night of the shooting.

"I feel a little nervous and I don't know why," Karina says, looking at the camera while standing outside the BART station at dusk. The video cuts between a headshot of Karina describing and reflecting on the events of the night, and footage of the shooting. "This is where I peeked my head out," she says once she's inside the BART station, remembering that the young men who'd been pulled from the train were lining up "against that wall over there." At one point that night, Karina says, there were so many people and so much going on, she got scared, hopped back on the train, and turned off her camera. But when it started getting loud again, she turned the camera back on and stepped onto the platform, walking closer and closer to the scene. "I'm standing ten feet away," she says, using the present tense to describe what happened that night as she approached. She remembered Grant's words to the officers: he told them please not to shoot him, please go easy on him. "I keep recording and they throw him on his belly," Karina continues to narrate. "Another officer puts his knee on his neck, and another officer stands directly on top of him...and he's laying flat on his belly." At that moment, Karina's voice-over abruptly cuts off. You hear the firing of the gun and see the mayhem that follows, with voices calling out in the background, "They just shot him! They just shot him! Get on the train!"

Karina says that night changed her life, especially on an emotional level. "I think about the shooting all the time." She gets stopped in stores by people who recognize her from her television appearance, and she's asked again and again to comment on the case and what she saw. Through her on-the-fly documentary work, Karina has become a recognizable public witness, and an official one inside the court system. Her footage was used in the Oscar Grant hearing, and at the time that Youth Radio was producing its video, Karina was getting ready to testify. "It's a hard thing for me, and even though I know I'm telling the truth, it's hard because I know the officer will be sitting there as I testify, just looking at me," she tells Denise. "It's a scary thing. There are people mad at me for turning in that video, people that thank me for turning in that video, and at the same time I'm sad for that family that lost a son, that lost a father.... They could sentence the officer, but in the end, the officer also has a newborn daughter. In the end, two little girls lost their fathers."

Those are the final words of the video Denise Tejada produced for Youth Radio. What stands out about the process of making the video is the extent to which its production started before Youth Radio even knew there was a story, and extended well beyond the moment the segment was posted online. The primary visual material featured in the video had been generated not for broadcast, but out of Karina's instinct that she'd better record the intensifying events transpiring at the BART station that night. If pre-production is typically a phase during which media makers plan their projects, make contacts, and carry out necessary research, here Karina herself had already initiated a period of pre–pre-production, generat-

ing the content that would comprise the bulk of Youth Radio's story before the production process had officially begun. Denise's work, in this sense, was as much about curating and effectively contextualizing another young person's media content as it was about generating her own.

Likewise, if post-production is the period when media makers typically edit together their source materials and ready the piece for delivery and dissemination, here Karina launched a high-stakes post–post-production phase of her own video product, which she'd never intended to create in the first place. Her story would have material impact on the lives of those directly involved in the violence she captured, and on her own life. (For example, she talked to Youth Radio about ways in which she might want to continue making media now that she'd had this experience.) For Denise, as well, there was a period of post–post-production, during which she and colleagues would circulate this and other Oscar Grant stories that over time accumulated into a body of work occupying nine pages of headlines linking to coverage of this "beat" on Youth Radio's Web site. Through comment sections on digital outlets ranging from YouTube to National Public Radio, audiences continued dialogue that would forever live alongside the original stories, evidence of an ongoing conversation.

In this sense, Karina's video started as a record of events unfolding before her eyes, the outcome still unknown. Through her own distribution of the video, and through the work of Youth Radio's newsroom and other news agencies, as well as Oakland residents and young people from around the country and across the world, the footage was elevated to a public symbol, a call for justice and reform.

All that being said, even with a story with this kind of urgency, it's not always easy to get it out to the audiences you want to reach. Youth Radio produced a different Oscar Grant segment[13] around this time that intercut between interviews with two key figures—Oakland Mayor Ron Dellums and prominent Bay Area rapper Too $hort—with images from the shooting and street protests, running music underneath. One of the organization's producers pitched the piece to a highly regarded hip hop Web site, making the case for its relevance to issues and themes that are prominent within hip hop lyrics and communities. This same Youth Radio producer, who also makes music and performs outside the organization, had recently art-directed a music video featuring gorgeous women out at a club, in a sultry bath, and so on. The Oscar Grant pitch got no response, but that same week, the producer's music video ran on the site. This young producer knew more than his older, more seasoned colleagues in the newsroom about how to get content published on a premium Web site that held significant value for the organization's commitment to reaching young audiences with excellent, relevant content. That's one feature of collegial pedagogy at work—evidence of a youth-led inquiry. And yet that knowledge wasn't enough to place the newsroom's story on the site.

Perhaps there's nothing particularly surprising about that outcome. It's a given that content needs to match an outlet's core interest and vibe. Maybe there was something too earnest or "newsy" about the Oscar Grant pitch to the site. However, this coda to Youth Radio's coverage highlights the importance of creating conditions for young people to see everyday media production—shooting from the hip using cell phones and other personal recording devices—as where their work *starts*, rather than ends. Karina Vargas and the other young people who bore digital witness to the BART station killing performed a crucial social function, a dimension of citizenship we have come to expect: when things go bad in a public space, someone will record and post it. And yet it was only by transforming those raw documents into double youth media stories and bodies of work—a collectively curated virtual album, if you will—that Denise Tejada and other producers within Youth Radio, across Oakland, and around the country, amplified Oscar Grant's story by embedding it within larger discussions related to violence, inequality, and fundamental human rights.

Navy Abuse

It was May 2009, and this was, once again, not the story we thought we'd be telling. Youth Radio reporter Rachel Krantz had been covering the California Supreme Court's decision to uphold Proposition 8, a same-sex marriage ban that voters approved on the same day they elected Barack Obama president of the United States. Rachel was on the scene with recording equipment, speaking with members of the public about their thoughts on the court's decision. That was her assignment, with the idea that she'd pull together a short video to post on Youth Radio's Web site.

In the course of her interviews, Rachel met twenty-three-year-old Joseph Christopher Rocha, who was there as part of a group advocating for marriage equality. He got talking to Rachel and mentioned that he was a veteran of the U.S. Navy, in which he'd enlisted on his eighteenth birthday. Having finished her official assignment to cover the Prop 8 decision, Rachel sent this email to her editors:

Hey guys, I just want to email this now so I don't forget to bring it up tomorrow. So one of the guys I videotaped—the gay Iraq veteran, emailed me back for this piece. He has really interesting stories to tell and is very eloquent—his best friend killed herself he says because of don't ask don't tell and he had an experience of abuse in his brigade because of it. I think this is a really important issue, especially since it gets kind of buried and people forget it was an Obama campaign promise that has now been altered on his website. I can do a regular story, but I can see this being a really strong interview/feature, possibly for npr. Let me know what you think.

Sincerely,
Rachel

It was a busy time in the newsroom, and Rachel had to fight for attention to this story amidst all the other deadlines and assignments reporters and producers were fielding. She'd been seriously moved by Joseph's account, and her news sense told her it could be a big story. She was right.

First Rachel did a studio interview with Joseph. She focused this time not on Proposition 8, but on what he went through while deployed as a teenager as part of a Navy canine unit in Bahrain, and the implications for U.S. policies regarding gays in the military. She worked with producer Brett Myers to edit that interview into a segment on Youth Radio's Web site, which ran under the headline, "The High Cost of Don't Ask Don't Tell." ("Don't Ask Don't Tell" is the name of the highly controversial U.S. military policy enacted under President William Clinton banning openly gay Americans from military service.) In Joseph's story, he describes the abuse he encountered over two years inside the Navy unit once he declined to have sex with prostitutes, which he says routinely took place on base. That was enough, he told Rachel, to convince his fellow sailors that he was gay. Soon he was being rolled through the base hog-tied to a chair and left in a dog kennel spread with feces. Joseph goes on to describe the most "disgusting, degrading" part of the abuse, when the unit's leadership ordered Joseph to simulate oral sex on a fellow sailor on videotape, as part of a supposed training exercise for members of the unit. "Having my military leadership on videotape, mind you, telling me that I needed to be more believable, act more queer, have a higher pitched voice, be more feminine and make the sounds and gestures more realistic, I didn't think I had a choice."

As with the Oscar Grant story, media production is already a part of the story before the reporting begins. None of the sailors we spoke with in the course of the project could say what happened to the videos in question. And yet those recordings somehow provided crucial evidence of the credibility of their accounts, even though they never leaked to us or to the public. (Sailors speculate that the tapes were destroyed.)

The Navy routinely uses videotaped exercises—they're called training "evolutions"—to prepare sailors for scenarios they might face while deployed. The Chief Petty Officer at the canine unit used this media framework to carry out Joseph's humiliation, orchestrating a fictional scene where another sailor would barge into a room with his attack dog, interrupting two young enlisted men having sex (that was the scenario being simulated). There was also a second training video sailors described to Youth Radio. In that one, a female member of the unit was reportedly ordered to role-play as the lover of another female sailor, who was handcuffed to a bed and appeared naked under the sheets. One of the women involved in this simulation was the unit's second in command. After the Navy finally investigated allegations of hazing and abuse within the unit, she learned that she was likely to

be blamed for what happened there, while its Chief had already been transferred and promoted. The day after getting that news from one of her commanders—she was told she was being removed from her position at the kennel and would be held on the base for further investigation—this young woman took her own life.

When Rachel's interview with Joseph ran on Youth Radio's Web site, it was picked up by a prominent gay culture site. After that, Joseph says he was inundated by friend requests on Facebook, from readers he'd never met. It was at that point that he had to make a crucial decision. Did he want to maintain his personal identity and social life on Facebook? Or was he prepared to surrender that space as a site of friendship and leisure, and turn it into a public platform, claiming (or accepting) a role as public figure calling for accountability for what he and unit mates suffered, and for the harm inflicted by Don't Ask Don't Tell? He decided it was worth it for him to take on that new role, and proceeded to accept every friend request. Once again, digital technology is pivotal as both a register and engine of the story's developing impact.

At that point, Joseph came to Youth Radio to support our further reporting on the Navy's investigation into abuse in his canine unit. He especially wanted to know why the Chief wasn't punished, despite ample evidence that he had tolerated and in many cases instigated the wrongdoing. Joseph brought with him a list of contacts for Rachel and her production team (which for this story included producers Charlie Foster and me, and Youth Radio's founder and chief content officer, Ellin O'Leary). And he delivered a several-inches-thick file of documents his fellow sailor had obtained through a Freedom of Information Act request to find out anything he could about the investigation. Throughout those documents, the videotapes of abuse figured prominently, including testimony from sailors in the unit saying they were ordered to view them as part of their supposed training.

Before Youth Radio could publish the story, we needed bullet-proof verification of every reported fact, including what we'd heard from several sources inside the unit about the chief's promotion to the position of senior chief at the most prestigious canine post in the U.S. Navy. This was not information the Navy's public affairs officials would initially disclose. It was during an interview with another member of the unit that Rachel gleaned a crucial piece of information. This female sailor, who described sexual harassment within the unit, mentioned a social networking Web site for service members and veterans of the Navy. She said the chief had a profile there, which we later retrieved. Though evidence on that site wasn't enough on its own to nail this crucial bit of fact-checking for the story, it gave Youth Radio a key piece of information Rachel could leverage in her subsequent interviews with Navy officials and thus turned out to be a turning point in her reporting.

When you take a step back from this story together with Youth Radio's coverage of Oscar Grant, the role played by social networking sites—MySpace, Facebook, the niche military site—is striking, as tools for research and reporting that moved the stories forward. It's another dimension of double youth media—one that took on particular poignancy in Youth Radio's coverage of the suicide within the canine unit. Among the last things the young woman had done before taking her own life was update her MySpace page with an entry that remained long after her death. It read: "Tired of being blamed for other people's mistakes. Carry on smartly now."

After breaking the Navy abuse story on our own site and on the front page of the *Huffington Post*, Youth Radio produced a nine-minute audio version of the story,[14] working closely with an editorial team at National Public Radio's *All Things Considered*. The NPR host introduced the story like this:

> Picture a young man, duct taped to a chair, left in a kennel with dogs barking and feces all around. Later he is forced to simulate sex acts on videotape. He is not a prisoner. He's a U.S. sailor, Joseph Christopher Rocha.

That's an introduction Youth Radio helped compose with our NPR editors, and the framing was intentional, though also careful. We'd been struck all along by parallels between the events at Rocha's Bahrain canine unit between 2004 and 2006 and the torture that took place not long before then at the Abu Ghraib prison. In that now-iconic place, detainees were also tied up, humiliated, and forced to simulate sex acts, with U.S. military personnel documenting all of it using digital cameras. These resonances notwithstanding, we were wary of creating false connections between the two events that erased important distinctions related to the nature, context, and targets of abuse, and its role in the larger wars being carried out in Afghanistan and Iraq.

The relationship between the canine unit and Abu Ghraib came through in the story's comments sections as well. On the *Huffington Post*, for example, one commenter wrote: "Abu Ghraib was disgusting; this is beyond sick, it is the behavior of psychopaths," and another wondered what further evidence would come to light: "who knows what kind of Abu Ghraib type sexual abuse occurred to Iraqi civilians by our soldiers and Blackwater employees knowing they could do so and get away with their inhumane behavior." As I have argued throughout this chapter, digital conversations inspired by double youth media stories become part of the stories themselves. Those conversations help transform the "found" media content featured within those stories—the footage of Oscar Grant, the videotaped sexual simulations—from their original purposes and contexts into embedded images that both reveal and change history—and I mean that for better or worse. The same digital functionality that enables users to find, spread, and remix images

of Oscar Grant's shooting or abuses carried out by and against U.S. military personnel overseas enables them to pervert those images into instruments of mockery and hate.

In the case of the Navy abuse story, however, the unit members' willingness to tell what they saw and experienced, and Youth Radio's reporting on those events, led a member of the U.S. Joint Chiefs of Staff to call for a review of the outcomes of the investigation into abuses in Bahrain. On the basis of that review, the unit's chief petty officer was forced out of his elite position and out of the U.S. Navy. Further investigation into how high the corruption went up the chain of command is still underway.

Digital Youthscapes

As we've seen in the two production processes I've examined in this chapter, even young people's spontaneous and personal daily media engagements don't happen in isolation, but are embedded in local, national, and global forces (Maira and Soep 2005). One young woman's instinct to turn her camera back on when it got loud again on the subway platform; a young man's choice to take on a public persona via Facebook and re-open a profoundly painful part of his past; a woman's decision, when directed to participate in a sexualized simulation on videotape, that she had to follow that order; a youth reporter's conversation while shooting interviews for one story that got her started on an entirely different kind of assignment: these are captured moments within young people's digitized lives that changed their own trajectories and others', not always in ways they may have expected.

Youth Radio producers have leveraged these everyday, captured moments again and again, particularly as consumer recording equipment and content-sharing platforms have become increasingly available. The pre-existence of youth-generated media can be especially important in the case of stories unfolding far away. When Israel launched its attack on Gaza in 2008–2009, for example, mainstream media outlets in the United States and elsewhere struggled to find first-person, eyewitness accounts as well as broadcast-quality tape from the region, with phone lines and any other form of electronic connection so unreliable. Through one of its graduates who'd done work in that region, Youth Radio reached out via Skype, email, recorded phone calls, and social networking sites to a handful of young Palestinians. Inside the war zone, they were using every resource at their disposal to capture what they saw, heard, and felt. They were telling the story as they were living the story, using digital tools to fulfill the role of witness they defined for themselves, often filing photographs, video footage, and blog posts from their locked-down living-rooms. Typical is the following excerpt from the diary Safa Joudeh maintained throughout the attacks, which Youth Radio helped package for an entry on the massively trafficked website, the *Huffington Post*:

December 27th, 2008 *It was just before noon when I heard the first explosion. I rushed to my window and barely did I get there and look out when I was pushed back by the force and air-pressure from another explosion. What followed seems pretty much surreal. Outside my home, which is close to the two largest universities in Gaza, a missile fell on a large group of young men. We've all been warned not to stand in groups as it makes for an easy target, but they were waiting for buses to take them home. Seven were killed, four college students and three young men. The three young men were our neighbors. Nothing could stop my 14-year-old brother from rushing out to see the bodies of his friends lying in the street. He hasn't spoken a word since. As I'm writing this I can hear their funeral procession go by outside. They were best friends, spent all their time together when they were alive. They died together and now they are sharing the same funeral together. Never had we imagined anything like this. It all happened so fast but the amount of death and destruction is inconceivable, even to me. I've been watching TV seeing images that you probably can't see in the US.*

It's at precisely a moment like this that bystander accounts are crucial and not easy to access, that brings into relief the importance of learning to embed far-flung media records inside larger narratives reaching mass audiences. The work goes beyond curation—by now a widely recognized digital literacy skill. Yes, young people need to learn to find, collect, arrange, and display existing content alongside their own original stories. But what's underneath this activity is something deeper—the work of embedding. That's what it takes to connect individual media records into sustained stories designed to make a point, to have an impact, to capture a moment in time and connect it to a message that raises awareness and calls for change.

"Capture" is an interesting word in the context of this discussion. It conveys the act of creating a permanent recording, which can make all the difference in stories such as these, when concrete evidence is needed to legitimate troubling claims: that a young man was murdered at the BART station on New Year's Eve night, that sailors were abused while deployed with the U.S. military, that innocent Palestinian civilians' lives, schools, and homes were destroyed by war. And credibility is, for double youth media stories, the heart of the matter. I don't mean that in the way credibility is usually taken up in youth media studies, through analysis of young people's uneven abilities to assess the credibility of information they encounter online (Flanagin and Metzger 2008). As producers of media with lives at stake, credibility is what they need to *earn*, if their work is to matter in the ways they want and need it to. "There has been surprisingly little attention" in studies of digital media and learning, says Ellen Seiter (2008, 27), "to substantive content in digital pedagogy." She urges researchers and practitioners, particularly those caught up in all the excitement about technology's potential to invigorate learning, to recognize the difference between weak versions of digital literacy, like knowing how to operate equipment, and potent versions of digital literacy, wherein young people are not just users but programmers and makers. "The recognition of these distinctions among forms of digital literacy," says Seiter (2008, 37), "determines the convertibility of digital skills into social prestige or earning

capacity." It is also what determines the convertibility of found media into sustained, targeted bodies of work young people collectively create when they take on substantive issues that matter to them and their varied social worlds.

But capture also means holding in place, confiscation. And so it is not enough to train young people to operate digital media tools through which they can record what they see and know. To be fully enfranchised as citizens in a digitized, mediated world that never stands still, they need systematic and equitably distributed opportunities to learn how to make their media move, how to refuse its confiscation (literal and figurative), and how to embed it inside larger narratives for others to make again. New media technologies make meaning, after all, "not only by building new text through absorption and transformation of other texts," say Anna Everett and John T. Caldwell (2003, 7, emphasis added) but also "by *embedding* the entirety of text (analog and digital) seamlessly within the new."

Notes

1. http://www.youthradio.org/
2. http://www.youtube.com/watch?v=ZKKQ-gzc_Yw
3. http://www.youthradio.org/news/dna-black-experience
4. http://www.npr.org/templates/story/story.php?storyId=1784263
5. http://www.npr.org/templates/story/story.php?storyId=5025325
6. http://www.huffingtonpost.com/youth-radio-youth-media-international/youth-voices-from-ireland_b_160178.html
7. http://www.youthradio.org/oldsite/international/060804_notsafe.shtml
8. http://www.youthradio.org/news/gaza-city-diary-safa-joudeh-full-audio
9. http://www.youthradio.org/news/an-indian-wedding
10. http://marketplace.publicradio.org/display/web/2005/12/15/their_own_set_of_wheels/
11. http://www.youthradio.org/news/the-turf-the-village-0
12. http://www.youthradio.org/news/oscar-grant-eyewitness-karina-vargas-video
13. http://www.youthradio.org/news/exclusive-dellums-and-too-short
14. http://www.npr.org/templates/story/story.php?storyId=113121445

References

Chaiklin, Seth and Jean Lave. 1996. *Understanding Practice: Perspectives on Activity and Context.* Cambridge: Cambridge University Press.

Chávez, Vivian and Elisabeth Soep. 2005. Youth Radio and the Pedagogy of Collegiality. *Harvard Educational Review* 75(4): 409–434.

Darder, Antonia, Marta Baltodano, and Rodolfo Torres. 2003. *The Critical Pedagogy Reader.* New York: RoutledgeFalmer.

Everett, Anna and John Caldwell. 2003. *New Media: Theories and Practices of Digitextuality.* New York: Routledge.

Flanagin, Andrew and Miriam Metzger. 2008. Digital Media and Youth: Unparalleled Opportunity and Unprecedented Responsibility. In *Digital Media, Youth, and Credibility,* edited by Miriam Metzger and Andrew Flanagin. Cambridge: MIT Press.

Fleetwood, Nicole. 2010. *Troubling Vision: Performance, Visuality, and Blackness*. Chicago: University of Chicago Press.

Freire, Paulo. 1970. *Pedagogy of the Oppressed*. New York: Continuum.

Geertz, Clifford. 1973. *The Interpretation of Cultures*. New York: Basic Books.

Lave, Jean and Etienne Wenger. 1991. *Situated Learning: Legitimate Peripheral Participation*. Cambridge: Cambridge University Press.

Maira, Sunaina and Elisabeth Soep, eds. 2005. *Youthscapes: The Popular, the National, the Global*. Philadelphia: University of Pennsylvania Press.

Minkler, Meredith and Nina Wallerstein. 2003. *Community-Based Participatory Research for Health*. San Francisco: Jossey-Bass.

Morrell, Ernest. 2004. *Becoming Critical Researchers: Literacy and Empowerment for Urban Youth*. New York: Peter Lang.

Seiter, Ellen. 2008. Practicing at Home: Computers, Pianos, and Cultural Capital. In *Digital Youth, Innovation, and the Unexpected*, edited by T. McPherson, 27–52. Cambridge: MIT Press.

Soep, Elisabeth. 2006. Beyond Literacy and Voice in Youth Media Production. *McGill Journal of Education* 41(3): 197–213.

———. 2007. Working the Crowd: Youth Media Interactivity. In *Handbook of Literacy Research: Visual, Communicative and Performative Arts*, edited by S.B. Heath and D. Lap, 271–278. Mahwah, NJ: Lawrence Erlbaum.

Soep, Elisabeth, Belia Mayeno Saavedra, and Nishat Kurwa. 2008. Social Justice Youth Media. In *Handbook of Social Justice Education*, edited by William Ayers, Therese Quinn, and David Stovall, 477–484. Mahwah, NJ: Lawrence Erlbaum.

Soep, Elisabeth and Vivian Chávez. 2010. *Drop That Knowledge: Youth Radio Stories*. Berkeley: University of California Press.

Spittler, Gerd. 2001. Teilnehmende Beobachtung als Dichte Teilnahme. *Zeitschrift für Ethnologie*, 126: 1–25.

Torre, Maria and Michelle Fine. 2006. Researching and Resisting: Democratic Policy Research by and for Youth. In *Beyond Resistance! Youth Activism and Community Change*, edited by Shawn Ginwright, Pedro. Noguera, and Julio. Cammarota, 269–286. New York: Routledge.

14

Cosmopolitan Imaginings of Self and Other: Youth and Social Networking in a Global World[1]

Amy Stornaiuolo, Glynda A. Hull, and Urvashi Sahni

Aditi[2] dreams of becoming a computer professional; Nathan, gifted at drawing and mathematics, wants to be an architect; Lillith imagines herself a doctor in the future; and Nadra aspires to be a teacher. One is the child of a vegetable vendor in India; another is growing up in a small South African farming village; the third calls home a neighborhood in an American inner city; the last is the child of immigrant parents in a Norwegian suburb. These young people, though diverse in their social, cultural, and material milieux, have in common the coming of age in a global world (cf. Hull, Zacher, and Hiebert 2009). In addition, they are relationally linked via their participation in an Internet-enabled social network, itself an exemplar of the radical connectivity of our digital era, where "cultural flows" of ideas, artifacts, texts, and images become our resources for meaning making and "self-imagining" across national, cultural, textual, and linguistic borders (Appadurai 1996, 4).

Communicating with each other online, experimenting there with representations of self and engaging the self-representations of others, addressing audiences both local and global by means of multiple symbol systems, media, and modes—young people today, like Aditi and her friends, stand on the frontlines of intercul-

tural learning, navigating and negotiating digitally mediated relationships and understandings. In this chapter we explore their developing capacities to imagine and communicate with interlocutors who inhabit life worlds very different from their own, yet are similarly positioned on the precipice of adulthood, linked through like-minded aspirations, challenges, and desires. To frame our discussion of youth's online activities and their import, we turn to recent theorizing about "cosmopolitanism," an ancient idea newly conceived as a philosophical and educational response to a world that is at once inescapably interdependent and insistently divided (Hansen 2010; Papastephanou 2005; Rizvi 2009). Animating our gleanings from this theoretical literature with empirical data drawn from observations, interviews, digital products, and online tracings, we hope to reveal how burgeoning cosmopolitanism looks on the ground in the digitally mediated conversational realities of global youth.

Cosmopolitan Habits of Mind

The signature trope of cosmopolitanism is dialogue, for it is by means of dialogue, according to Kwame Appiah (2006), that tolerance and respect for "legitimate difference" can develop (xv). Cosmopolitanism asks us to enact identities as global citizens whose responsibilities extend beyond the local to include larger arenas of concern, and to construct new spaces for the practice of dialogue, where our human obligations can transcend traditional ties of kith and kind. In our global world, awash in great shifts, challenges, and opportunities—these brought about variously by political and economic strife and realignment, environmental concerns and crises, unprecedented migration, and new communication technologies and patterns of interaction—cosmopolitanism holds out hope that seemingly unbridgeable differences need not divide us.

Our task as cosmopolitan citizens is thus to develop the skills and dispositions needed to mediate encounters with lifeworlds that differ radically from our own. Such mediation goes beyond merely being alert to difference, though such perception is key. For David Hansen (2010), in fact, the process necessitates the development of the self, as we improve and nurture our own "intellectual, moral, political, and aesthetic being" and simultaneously grow ever more responsive "to the demands of justice toward others" (8). Our interest has been to document interactional moments that seem to supply the building blocks of such growth and transformation. With Nikos Papastergiadis (2007), we examine cosmopolitanism "through the prism of small gestures made in specific places" (146), believing that "to grasp the dynamic of cultural cosmopolitanism we may need not only to consider the big shifts and wide networks of global change, but also to ponder how little commonality is now necessary before people can find a connection with others" (144–45).

For most people, but surely for youth, media now are inextricably implicated in the ethical and moral processes of understanding ourselves in relation to others and the world. Drawing on cosmopolitanism to theorize mass and personal media as a moral public space, Roger Silverstone (2007) in fact argued that the quintessential characteristic of media in our global and digital world is its potential to link us one to another across geographic, social, and historical spaces. Images of strangers, mediated by television, computers, cell phones, radio, and the like, largely constitute our understanding of others in the world, and absent shared physical spaces, they do so within the realm of the imagination and the symbolic. Via our symbolic engagements, Silverstone reminds us, we must "recognize not just the stranger as other, but the other in oneself" (14), cultivating "hospitable" readings of images of difference. How such habits of mind might develop among youth, in particular the forms they take in the course of online exchanges and interactions, is our major research interest.

It is well known, of course, that many young people now regularly take advantage of the affordances of digital tools and networks to author, interpret, and exchange creative materials, engage in identity work and play, and sustain social interaction (boyd and Ellison 2007; Ito et al. 2008). Social media, it is often said, afford participatory engagements (Jenkins et al. 2009). Like other chroniclers of youth's appropriation of new media, especially in non-school contexts, we acknowledge the power of their "symbolic creativity" (Willis 1990) and their agentive use of social media to support their interactions with peers. It also seems clear, however, that the participatory culture surrounding new media will not necessarily facilitate cosmopolitan habits of mind, tolerance across difference, or engagement with a larger public good. Recent early studies have revealed, in fact, that participation on social networking sites largely mirrors the social segregation that occurs off-site (Hargittai and Hinnant 2008) and that their most prominent use is to connect users to groups of existing friends, not distant or foreign others (boyd and Ellison 2007).

The growth of participatory cultures begs the question, too, of unequal access to digital tools and related social practices, still notable within the United States and most definitely outside it (Prinsloo and Walton 2008; Warschauer 2003). Rather than centering our work on the documentation of the spontaneous media practices of "digital youth," we have attempted to develop tools and provide technological access for populations who are often shut out from the media revolution, and simultaneously to develop curricula and participant structures that position youth to develop cosmopolitan habits of mind in relation to their uses of social media. The project of cosmopolitanism, as we and others have argued, is at heart an educative endeavor (Hansen 2010; Hull and Stornaiuolo 2010).

Site Development, Data Collection, and Data Analysis

Launched in 2008, the Kidnet project has three components: (1) the development of offline extra-school or school-based programs in several countries, where youth participate in arts-based, literacy-rich activities such as digital storytelling; (2) the creation of a private social network, Space2Cre8,[3] where youth communicate with each other and share their digital artifacts; and (3) research on the evolution of this network, especially its intersection with identity formation and cultural knowledge development, and the roles that various forms of communication—language, image, music, video, and multimodal combinations thereof—play in these processes.

In each country teachers and researchers have collaborated with each other and a central research team to develop curricula on issues related to media representation, communication with distant audiences, and local concerns and personal interests. However, each site has developed differently in response to local norms and needs, national contexts, and institutional opportunities. The South African and Indian programs, for example, operated in relation to school, taking place twice a week within the school day but outside the formal curriculum. In South Africa, the thirty-eight eighth-grade participants had never used computers previously, and most were unacquainted with the Internet. In India, the fifteen high school participants, all girls who worked in the mornings to support their families and then attended an "afternoon school," similarly learned about computers from the ground up in the course of this project. In Norway, a once-a-week meeting of twenty-nine eighth-graders was situated within the school day and conformed to local curricular demands, while in the United States, the twice-weekly meetings of fifteen middle school students were held after school, since an accountability-driven school-day curriculum left little room for arts-based activities. At all sites, youth needed to learn to communicate on Space2Cre8, addressing heretofore unknown interlocutors.

Space2Cre8, like Facebook and other social networking sites, allows participants to articulate lists of friends, make wall and blog postings, send private messages, chat, post videos, form groups, and see recent site activities. However, Space2Cre8 differs in several respects, including being shaped architecturally, functionally, and aesthetically by the needs and desires of its members, and has undergone four major design phases to date. It differs as well by being a private site that is open just to members of our designated programs; by including a data collection mechanism for research purposes, and, in fostering friendship networks that privilege online-only relationships. Further, in contrast to most social networking sites where place is implicit, on Space2Cre8 national identities are represented overtly and frequently.

For the research reported in this chapter, we used a mixed-methods approach to data collection and analysis, including the automatic gathering of both quanti-

tative and qualitative data via the tracking system embedded within the network. We also collected observational field notes, audio and video recordings of classes and activities, periodic semi-structured interviews, and participants' creative artifacts. At each site a team versant in local customs and languages carried out data collection and translations, assisted by visiting researchers during yearly or biannual visits. Juxtaposing a variety of records of online and offline participation, we were able in this project—in contrast to much research on social networking—to combine the affordances of informatic and ethnographic approaches.[4] It was possible, for example, to peruse records of chat among youth over time, to contextualize their interactions in terms of frequency, volume, and function in comparison to the network as a whole, and also to query those youth about their authorial intentions, as well as to trace how echoes of online exchanges reverberated in offline activities and creative products.

In this chapter we ask: (1) What kinds of cosmopolitan practice emerged in association with the network? (2) What capacities to imagine and communicate with distant interlocutors did youth display in their online interactions and creative artifacts? (3) What semiotic practices indexed these capacities? That is, what literate forms did cosmopolitan gestures take? To address these questions we combined open-ended and focused thematic codings (Dyson and Genishi 2005) of field notes, interviews, and chats, using the qualitative analysis program Atlas TI. In addition, as part of addressing question 2, in order to understand how digital stories conveyed meaning through different sign systems and combinations of systems, we brought to bear a semiotic lens (Hull and Nelson 2005), unpacking how modalities such as image, voice, and words functioned in relation to each other.

Everyday Cosmopolitanism: Representing Self to Others

"Hello peeps!"—"Cool pic!"—"Luv your background!"—"My name is [Dalton], and I live in [Kaap] Western Cape South Africa." So it was that young people from several countries ventured forth, making their initial attempts to communicate with each other on the Space2Cre8 social network. Such efforts represented one kind of nascent cosmopolitan practice, an "everyday" cosmopolitanism that was evident in workaday interactions. That is, youth routinely connected with each other in three interactional contexts: the everyday design of their online persona, most often constructed via profile pages; the often intermittent broadcasting of greetings and other phatic "shout outs"; and the more sustained everyday interactions that built on discovered commonalities via dialogic network features such as chat and private messages.

By virtue of belonging to an online international community, youth were positioned to communicate with others whom they had not—and almost certainly would not—meet face to face. Not only did youth need to connect with unfamiliar

others, they had to do so with adolescents from widely divergent cultural and linguistic backgrounds, lifeworlds that were composed of daily rhythms unfamiliar to the majority of participants and that consequently required significant imaginative leaps of understanding. In both of these ways, then, the social network presented youth with challenges to imagining an audience for their engagements on the network, requiring them to bring interpretive and predictive communicative capacities to bear in building and sustaining relationships with unfamiliar interlocutors.

While certainly the act of imagining unknown, unpredictable, or shifting audiences is a regular feature of digitally enabled online communication (cf. Warschauer and Grimes 2007), most of the online composing youth perform on social networks is geared toward familiar others as the primary audience, usually friends, friends of friends, or members of shared affinity groups (boyd and Ellison 2007). In contrast, this international community asked adolescents to muster the courage and creativity to forge connections with strangers through the sharing of often self-revelatory digital artifacts, with this unfamiliar audience as an important focus for their creative work and network engagements. We found that in response to this communicative challenge, youth on Space2Cre8 regularly attempted to take those imagined others into account in their online composing practices.

Participants spent considerable time pondering how others might perceive their work, what they might need to explain to their audiences, what they could assume was shared, and what might be effective rhetorically in their new media compositions—all composing behaviors that teachers value but which are not often present in youth's school writing (cf. Coker and Lewis 2008). In their writing on and for the network, youth regularly and often explicitly shaped their compositions with the needs of their potential audiences in mind, including scripting and revising digital artifacts that might be understood multimodally by speakers of multiple languages (e.g., adding subtitles, choosing music to convey a mood, or repeating images for clarity). Through these imaginings of others, we found that participants developed budding cosmopolitan dispositions in their everyday encounters on the social network as they reached out, seeking commonality across difference in small moments of intercultural exchange. We next consider these forms of everyday cosmopolitan interactions in more detail.

A primary representational means through which youth communicated with one another was the design of an online persona via an individual profile page. In designing an emerging and evolving online identity on the network (cf. Buckingham 2008), youth spent significant energy crafting multimodal self-representations that they imagined would resonate with their online peers. These kinds of online self-representations have been examined by scholars as evidence of youth's performative and improvisational compositions of self as they manage impressions of others (cf. Goffman 1959) and convey information about their tastes and identities

(e.g., boyd 2008; Liu 2008; Dowdall 2009). However, youth's profile designs on Space2Cre8, including their choices of profile pictures and background images, were created to manage impressions of unknown global peers in addition to their co-present classmates, a carefully considered identity performance that youth took seriously as they envisioned themselves in relation to these imagined others. Indeed, all youth spent time considering how to design the look of their individual profile pages, with some participants making great efforts to coordinate their profile pictures with harmonizing background colors, while others spent considerable time choosing background images that reflected interests in light of what they imagined their peers to care about, using these profile designs as a communicative overture to the larger community about their interests and character traits. These reflexive practices were nurtured through the educational emphasis in the Kidnet classes, as teachers regularly directed youth toward considering the profile designs of themselves and others through carefully timed questions. For example, Reggie, a twelve-year-old boy at a U.S. site, considered a bloody Scarface image for his background image. When his teacher inquired how Reggie had chosen the image on his screen, Reggie pondered aloud whether it might be "too violent" to depict on the network and ultimately decided to choose an image of a car to represent himself. These online self-representations via profiles suggest the routine, everyday imagining of others that youth engaged in, serving as one form of communicative outreach to others who might share their interests or backgrounds.

Youth also communicated with one another via messages that could be characterized as phatic, broadcasted, or fleeting as they searched for common ground. These messages, left in inboxes, on profile walls, or in comments on digital artifacts, included short and often complimentary notes ("cool pic!" or "luv your background") as youth searched for ways to make connections with one another, leveraging their peers' taste preferences (Liu 2008) as an opening conversational gambit. Often these messages were simply shout outs to others that were read and appreciated but not necessarily responded to, as when Nelson, a thirteen-year-old boy from Oakland, California, posted the status update, "hello world." Sometimes, though, these moments of small communicative outreach allowed youth to begin building spaces for dialogue, as they searched for common ground and practiced becoming respectful and generous interlocutors. One example of a short-lived communicative encounter that suggested hospitable interpretive stances between participants occurred as a thirteen-year-old boy from South Africa and a thirteen-year-old girl in Norway conversed through the network's blogging feature. A native Afrikaans speaker, Dalton wrote his first-ever blog: "Hello, my name is [Dalton] and I live in [Kaap] Western Cape South Africa. I like animales very much like lions, buffol, and so on. I love or nature very much and birds and mammels."[5] Writing in English in order to communicate with his peers in Norway, India, and

the United States, Dalton sought a means to connect with others through his announcement of his interests. Lillith, a girl whose family had immigrated to Norway, commented on Dalton's blog: "Hi. I like animals but not like lions. I like more the type cats, birds and rabbits. I think your nature is way different from Norways nature ☺." In this reply, Lillith searched for common ground with Dalton, looking for points of connection and variation between their interests and between their countries' geographies. In this small moment of cross-cultural communication, in which two adolescents from very different lifeworlds worked at negotiating linguistic, cultural, geographic, and ideological differences, they both attempted to communicate respectfully and generously, imagining their audiences at the same time as they imagined their audiences imagining them.

This capacity to become a hospitable (Silverstone 2007) interlocutor, ever more crucial as a 21st-century literacy, involves taking into account both what we may share and what we may not when we communicate with online audiences who are sometimes known but are more often projected. Lillith and Dalton had not yet become acquainted online, and both made overtures to their imagined potential audiences. Despite his unfamiliarity with the genre of blogs, Dalton wrote about one of his greatest passions—animals found in South Africa—in a message designed to introduce himself to potential new friends. In addition to giving his name, hometown, and personal interest, he communicated to his global audience using English instead of his native Afrikaans, hoping to start a conversation with an audience he assumed would be more familiar with English. Lillith, too, tried to imagine who Dalton might be, someone whose "nature is way different" than her own (hers populated with animals like cats, birds, and rabbits rather than lions) but who could perhaps find a bond over a love of animals nonetheless. In order to seek this connection to Dalton, Lillith (who primarily spoke Kurdish and Norwegian) communicated in her third language of English and added a tooth-filled smiley emoticon that served to emphasize her understatement about the likely differences between South African and Norwegian topography. It is this search for commonality and places of connection across linguistic, cultural, and geographic differences—a search that requires an imaginative capacity for composing to and with potential audiences—that constitutes the kind of new media literacy youth will need in order to negotiate the rapidly shifting communicative landscape afforded by social media. We submit that this new media literacy can be fostered through small but potentially significant moments of reaching out—what we are calling everyday cosmopolitanism (Hull, Stornaiuolo, and Sahni 2010; cf. Corpus Ong 2009).

These micro-moments of connection, in which youth attempted to find common ground, were pivotal for creating a sense of belonging to a common space, an important precursor, we would argue, to developing a sense of belonging to a broader human community. Over time, youth felt connected to and more responsi-

ble for one another, even though most of their interactions were of these abbreviated varieties, often with long intervals between responses as youth combated different time zones, intermittent Internet access, and conflicting school schedules. Notwithstanding these challenges, youth came to feel connected to others in the network, as Reggie evidenced when he commented on a new user's wall: "okay i see that you dont have any friends so i will send u a friend request." This kind of concern for one another manifested itself across the network in gestures such as Reggie's reaching out, his extension of a friend request inviting a new person into the network and connecting her to the community culture. Such instances of participatory agency were important in helping youth see themselves as civic actors with obligations to others, including obligations to listen to one another.

While most of the routine encounters on the network were of these phatic, fleeting, or broadcasting varieties, occasionally youth sustained a conversation with others across an extended period of time or across sensitive topics, building on smaller interactional moments. Often, youth took advantage of the more private and dialogic functions of the network, like private messaging and chat, to carry out these conversations. In particular, chat was very popular, and while most of the users were not online at the same time, youth still used chat asynchronously, leaving messages that the other user would find later when they signed on. When users were online at the same time, often those who had Internet access at home and could chat at late hours with kids in different time zones, these chats typically began around imagined points of commonality, such as time, weather, or geography, but then progressed to more elaborated dialogues about topics of import. For example, Nelson, a prolific chatter who often initiated conversations on Space2Cre8 with users he did not know, chatted with thirteen-year-old Meryem from Norway over the course of several weeks and 244 turns. He confided in her: "You know i cant believe that you are talking 2 me. People ignore me at school. They always pick on me." Nelson and Meryem discussed popularity in school and the pain and difficulty of not being accepted. Many of these conversations began around topics that youth assumed others might share knowledge about, which is how Nelson struck up an extended conversation with another girl from Norway, searching for common ground with fourteen-year-old Olina:

Olina	do u like music?
Nelson	yea, do u?
Olina	Yes I love music
Nelson	wat kind?
Olina	Al. I like almost everyting
Olina	what about u?
Nelson	me, too
Olina	cool:D

Nelson	i am an all-around person
Nelson	we have a lot in common
Olina	Cool
Nelson	yes, very kool!
Nelson	i mean..great..:D

In a chat that spanned 234 turns, Nelson and Olina searched for elements of their lives that they might share, discovering in the process that neither was romantically attached to anyone, both were serious and mature for their ages, and both liked diverse musical styles and genres. They found that they "have a lot in common," something that is "cool" and that both thought could lead to more of a relationship in the future, despite the variety of differences that separated them.

Over time, we believe that everyday cosmopolitan gestures, including abbreviated, transitory, or delayed communicative forays, can lead to more sustained interactions, helping youth negotiate the inevitable missteps and subsequent retracings and repairs that occur. As youth communicated multimodally, interacting across languages and through images and sound, inevitably they bumped up against beliefs and practices that were unfamiliar. However, learning to negotiate such rough or awkward moments is, we believe, core to developing a cosmopolitan disposition and communicative repertoire. As their chat continued, Olina and Nelson hit such a speed bump in their developing relationship as he became suspicious of her ready acceptance of him and his increasingly romantic overtures:

Olina	U are so cool:D
Nelson	is this some kind of joke?
Olina	no
Nelson	r u like a dude, who is just posing as a 14 year old girl?
Olina	No:O
Olina	I'm a girl
Olina	why do u think that?
Nelson	i9 dont know?
Nelson	i saw it happen on this TV show
Olina	Ok… But I'm a girl. read my profile…
Olina	don't u belive me?
Nelson	yea
Nelson	if i c your picture, i'll trust even more:D
Olina	Ok.. I can try to fix a picture tomorrow or something
Nelson	nice..yea

Without the presence of a picture on her profile wall, Nelson had his doubts that Olina was who she said she was. He questioned Olina's sincerity and worried about her interest in him as someone who is "so cool" in part because he was not

perceived that way by his schoolmates and also because he and his classmates were attuned to potential online risks. But through the multimodal communication of the network, with easy availability of pictures and videos, youth were able to negotiate these emergent understandings and sometimes bumpy relations with one another across more-sustained dialogues. Olina did, in fact, upload a picture of herself, and they did continue their conversations without further apparent misunderstanding.

With scaffolding and support, we have found that routine communicative exchanges can help foster youth's sense of themselves in relation to others, as people with responsibilities toward others, even across challenging encounters. These everyday moments of connection, built up over time and across modes, including across profile designs, fleeting moments of reaching out, and more-sustained dialogues, helped youth imagine themselves in relation to others, practice hospitable communicative moves, and see themselves as part of a larger community, with its attendant responsibilities and obligations.

Intercultural Triggers: Space2Cre8 Community as Global Audience[5]

In addition to everyday cosmopolitan practice, we observed instances of expansive and dramatic connection across difference. Often triggered by especially provocative multimodal artifacts such as particular digital stories, these moments of exchange and contact positioned young people to engage imaginatively and hospitably with the lifeworlds of others, shifting their senses of self, their perceptions of others, and their understandings of local and global contexts. Rather than momentary, fleeting, broadcasted, or dyadic, these moments were far-reaching and sustained, frequently involving youth across sites in larger numbers, on and off the network, and often across time. Such "intercultural triggers" (Hull, Stornaiuolo, and Sahni 2010) generated a flurry of activity on and off the network, typically catching us by surprise as youthful responses emerged from the conjunction of their interests, the activity or participant structure at play, and the communicative power of a multimodal artifact. In addition, they often provided a sense of cohesion within and across sites and led to lengthy intra-site discussions and activities, resulting in noticeable and immediate shifts in attitudes and actions. Young people often made large leaps forward in their cosmopolitan understandings, becoming for the moment hospitable, considerate, and respectful communicators able to recognize, to borrow Silverstone's (2007) phrasing, the other in themselves.

Dramatic moments of cosmopolitan understanding often developed in relation to multimodal artifacts that served to connect youth to one another in ways many participants found meaningful. While youth regularly enjoyed one another's films and digital stories, occasionally a multimodal artifact captured many participants' attention and served as an intercultural trigger for communication across

sites and across time. One particular instance of such a trigger illustrated a surprising reversal of what Silverstone (2007) termed "polarities of interpretation," the customary pattern and directionality of representations of others through media. That is, for a long time, people in the West have been able to assume their dominance as interpreters of others, but in Silverstone's imagined "mediapolis," where the use of media achieves a moral dimension, such roles are likely to be questioned and reversed. So it was in the case of a digital story by an Indian girl that had a major impact on network participants, on audience and author, both on and offline, through its unexpected and unpredictable circulatory power and influence. This brief movie by sixteen-year-old Bakhti depicted the formidable challenges of her young life, and it provoked mirror stories and transnational, transcultural, and trans-semiotic exchanges.

Here are Bakhti's words as she narrated them in English,[6] offered in concert with the images that she selected for her digital story:

> Hello I am [Bakhti] from India. I live in a small house with my family. I have 3 sisters and a brother. I am eldest of them all. My younger sister [Chanda] like to play with her clay toys. Elder sister [Trisha] is a brilliant cook. Although we don't have a proper kitchen and a stove [Trisha] still manages to provide us a fair meal. [Gita] and me work as domestic help in several houses. One of the house I work for is a Sherma family. They are very nice people. Their daughter [Radha] is my good friend. My dad is an alcoholic and spends all his money on alcohol and never support the family neither financially nor emotionally. All this time [Prayas] school has been a haven. Our teachers never let us miss our late mother. All my friends at [Prayas] are like my sisters. We laugh together and cry together. My journey in search of a home ends here.

In this narrative, Bakhti told the story of the actors in her social worlds of home, work, and school: her resilient siblings, kind employer, deceased mother, alcoholic father, and beloved friends and teachers. What made her digital story all the more poignant and semantically full was the layering and expansion of meaning made possible through the juxtaposition and orchestration of multiple modes (cf. Hull and Nelson 2005)—that is, the propositional content of her simple yet powerful story, the accompanying vivid images that located her story in a particular locale and moment, and Bakhti's optimistic tone of voice and narrative evaluation, which suggests a strength of character and a serenity of self that contradicted her youthfulness and her constrained circumstances. Multimodal compositions can obtain considerable power via such an expansion of meaning that occurs when the semantic content of one channel simultaneously contrasts and complements that of another, resulting in a more powerful understanding and aesthetic experience than any one of these modes might convey alone or merely indexically (cf. Hull and Nelson 2005; Lemke 1998).

Youth from the different sites who have viewed Bakhti's story, whether discovering it on their own or as part of a presentation by their teachers, often seemed powerfully influenced. One of the most affecting images from the story featured a small child squatting on an uneven brick floor, utensils spread on a tarp nearby, and tending a black cooking pot set on a makeshift brick fire pit in front of her (see Figure 1).

Figure 1: Cooking Pot Image from Bakhti's Digital Story

The image is suspended onscreen for ten seconds, the longest of any picture in the story. Youth in South Africa and the United States noted the communicative power of the image, which depicted an admitted lack of a "proper kitchen," paired with Bakhti's praise for her young sister as a "brilliant cook." Rather than lamenting or hiding their circumstances, Bakhti straightforwardly revealed them, and in so doing, she took the opportunity to emphasize her sister's skill, made all the more impressive in light of the siblings' poverty. Her message, represented multimodally and drawing its power from the multiplicative relation of word, image, and voice, was communicated memorably to viewers of the story, embodying hopefulness and strength in the face of adversity on the part of children for whom such resilience and maturity would not customarily be expected or required.

In South Africa youth viewed Bakhti's movie as part of a montage of several digital stories, featuring the work of young people from several sites. When asked later in interviews what they remembered and enjoyed from this presentation, over two-thirds of the children referenced Bakhti's movie, the majority of them mentioning "the girl with no kitchen," even though there were a number of other striking and memorable digital stories screened that day. Charlotte, a South African girl who lived with her grandmother in a farming community, sharing a one-room house with no heat, explained that she had not considered that others could be worse off than she was, as she compared Bakhti's living situation to her own. Bakhti's story thus inspired youth in South Africa and the United States to reconsider poverty in relation to themselves and their own social and economic worlds. The story not only provoked emotional responses and prompted changes in the

attitudes of those who watched it but also inspired creative action on the part of some youth, who shifted their understandings of their own digital stories and decided to create mirror stories. In South Africa, youth developed stories that echoed Bakhti's, exploring deeply felt experiences, such as car accidents and the death of a parent. One youth in Oakland, Shanae, immediately upon watching the movie, exclaimed, "I want to change my [digital] story." That is, she wanted to make a story about her own life instead of the story she had been working on, which was about her dream life. She reflected, "We got more opportunities than they do. We don't have to go to work." This sparked a conversation about hardship and how youth like Bakhti "had to take such responsibility from such a young age." Thus, discussions about poverty grew from the viewing of the movie, opening new dialogic spaces for discussing difficult issues and shifting youth's self-understandings as a result.

While not all digital artifacts circulated with the agency of Bakhti's or triggered new intercultural exchanges and understandings, certain powerful multimodal artifacts functioned as intercultural triggers that captured the attention of youth and inspired new narratives of self (cf. Stevenson 2003). These included material artifacts like greeting cards sent via visiting teachers or digitally, as well as collaborative group movies exchanged across the network. Such moments of connection with others who are both quite different from and similar to oneself can accumulate to help youth develop hospitable reading practices as they imagine points of commonality, seeking not just "ways to tolerate differences between them but also ways to learn from one another" (Hansen 2010, 4). Youth learned from one another not only via small moments of exchange, whereby they built up awareness of and attention toward others in their multimodal composing and interpretive practices, but also via these larger communicative overtures that jolted participants into understanding other youthful lifeworlds as both similar to and different from their own. Through instances of cosmopolitan connection, youth felt increasingly tied to one another, understanding themselves to be part of a larger community and seeing themselves as social actors with moral obligations toward others.

A Cosmopolitanism Continuum

In this chapter, we have explored the communicative practices and 21st-century literacies that emerged when youth were positioned to develop and enact cosmopolitan stances toward their local contexts and diverse and distant others. That positioning included a global online social network that privileged multimodal, arts-based expression, collaboration, and communication, in tandem with a local offline curriculum and set of participant structures that privileged youthful reflexivity about meaning-making practices in relation to others, particularly youth's

obligations toward others as communicators in a digital and global world. Together, these forms of interaction, association, and meaning-making helped young participants to imagine and enact morally and ethically alert selves—that is, "to be responsive to the demands of justice toward others and of the desire for self-improvement" (Hansen 2010, 8). These practices of understanding oneself in relation to others and the world at large, particularly as those practices involved digitally enabled multimodal artifacts, happened in fits and starts, sometimes by way of small, everyday moments of connection and at others via dramatic intercultural triggers. Both kinds of cosmopolitan connections—whether everyday or dramatic—constitute an orientation toward others that Jonathan Corpus Ong (2009) characterizes as a continuum, whereby "we weave in and out of being open and closed to difference—in the rhythm of daily life" (463). This weaving in and out of openness and closedness is characteristic of the participatory patterns we observed in the project, as youth worked to represent themselves to others, to communicate with unfamiliar interlocutors across vast differences and distances, and to imagine themselves as the kind of people who communicated with and bore responsibilities toward others. And we would argue that such an orientation toward others is a crucial one, necessary for living in a global world at our particular historical moment and working with the newly available social media that links us one to another.

We designed Space2Cre8 as a vehicle for international linkages of diverse and distant others, for youth like Aditi, Nathan, Lillith, and Nadra who imagine their possible futures and ideally begin to imagine them in relation to the world more broadly. Observing their attempts to participate via this network taught us, first, how significant was the challenge we had presented them. Conversing and connecting in a digital environment with unknown others requires skill, courage, and imagination. Participants must envision how to represent themselves as worthy interlocutors, desirable potential friends, and young people with things of interest to say to a global community, making myriad choices about mode, language, aesthetics, and design. For their part, teachers (who are often absent in accounts of youth media production) must scaffold this choice-making and moderate complex offline conversations about culture, identity, and communication in local and global contexts (cf. Hull and Stornaiuolo 2010). As youth encounter media created by others that challenge their familiar ways of interpreting and understanding the world in such pedagogical contexts, this juxtaposition can foster, we are hopeful, youth's imaginative capacities as hospitable interlocutors. More hopefully still, the process of developing cosmopolitan habits of mind can be nurtured by educators who are willing to assist youth to participate actively and to "dwell educationally in the world" (Hansen 2010, 24).

Notes

1. We gratefully acknowledge the support given the larger project from which this paper grew: Lauren Jones Young and the Spencer Foundation; the UC Links project of the University of California; the Graduate School of Education at UC Berkeley; and the Steinhardt School of Culture, Education, and Human Development at New York University. Special thanks are due P. David Pearson and Mike Wood, whose considerable early assistance and belief in the work made all that followed possible. We also acknowledge the members of the research, development, and teaching team of the Kidnet project: Sangeeta Anand, Patricia Baker, Anand Chitravanshi, Ola Erstad, Anna Floch, Adrienne Herd, Suenel Holloway, Garth Jones, Gary Jones, Nora Kenney, Knut Lundby, Dave Malinowski, Stacy Marple, Mark Nelson, John Scott, Kenneth Silseth, Xolani Tembu, Kristin Beate Vasbø, Rian Whittle, and Duncan Winter. We thank Daniele E. C. Fogel for sharing her resources on cosmopolitanism and David Hansen for his comments on an earlier version of this paper. Finally, we thank JoEllen Fisherkeller and Michael Moore for supporting the publication of this chapter. For a more detailed account of the research summarized in this paper that focuses particularly on the Indian site of the Kidnet project, see Hull, Stornaiuolo, and Sahni (2010).

2. All names are pseudonyms.

3. See www.space2cre8.com for more information about the project and a demonstration site for the social network itself.

4. To date, in research on social networking, descriptive and correlational studies have dominated, detailing features and uses of social networking sites in relation to user demographics (Ahn 2010), and including large-scale quantitative analyses as well as small-scale qualitative and ethnographic accounts. Research on social networking is still very young, as are the phenomena studied, and presents a range of methodological challenges that result in understandings that are quite partial. Computer science-driven informatics reveal content and behavioral patterns gleaned from users' traces, but such findings are usually limited to what can be inferred from an a priori set of categories imposed by the networks' tagging systems (Burgess and Green 2009). Ethnographic and qualitative studies of communities of users and individuals add a nuanced sense of the lived experience of users, but generally sacrifice knowledge of actual online communications, as well as the documentation of larger-scale patterns of participation. Research conducted from a cultural and media studies perspective helpfully tracks the use of specific Web sites over time, with researchers themselves sometimes becoming contributing members to the online communities. Such work can inform us in a nuanced way about online practices but typically does not articulate the relationship between online and offline experience.

5. All quoted material is rendered here exactly as it was posted online (brackets indicate substituted text for pseudonyms). Young people's postings often included conventions similar to those seen in texting and IM practices, and sometimes they contained errors in grammar and spelling, including mistakes that arose from practicing English on the site as a second or third language.

6. This section is elaborated on in more detail in Hull, Stornaiuolo, and Sahni (2010). Bakhti had the choice of writing and narrating her story in Hindi or in English; for this, her first digital story for the Kidnet project, she chose English in order to more easily communicate with youth elsewhere. We haven't in this article discussed the role of English on Space2Cre8, which is a multi-lingual network that currently supports the use of Hindi, Afrikaans, and Norwegian in addition to English. Youth from India, South Africa, and Norway chose to write in English most of the time, viewing the network as a language-learning opportunity, as did their teachers,

teachers, while some youth in the United States lamented the dominance of English on the network yet did not engage actively in learning the other languages themselves.

References

Ahn, June. 2010. *The Effect of Social Network Sites on Adolescents' Social and Academic Development: Contemporary Issues and Research.* Unpublished Ph.D. dissertation filed at the University of Southern California, Los Angeles, CA.

Appadurai, Arjun. 1996. *Modernity at Large: Cultural Dimensions of Globalization.* Minneapolis: University of Minnesota Press.

Appiah, Kwame A. 2006. *Cosmopolitanism: Ethics in a World of Strangers.* New York: W.W. Norton.

Bakhtin, M.M. 1986. *Speech Genres and Other Late Essays,* edited by C. Emerson and M. Holquist, trans. V.W. McGee. Austin: University of Texas Press.

boyd, danah. 2008. Why Youth ♥ Social Network Sites: The Role of Networked Publics in Teenage Social Life. In *Youth, Identity, and Digital Media,* edited by David Buckingham. Cambridge, MA: MIT Press.

boyd, danah, and Nicole B. Ellison. 2007. Social Network Sites: Definition, History, and Scholarship. *Journal of Computer-Mediated Communication* 13(2007): 210–230.

Buckingham, David. 2008. Introducing Identity. In *Youth, Identity, and Digital Media,* ed. David Buckingham. Cambridge, MA: MIT Press.

Burgess, Jean, and Joshua Green. 2009. *YouTube: Online Video and Participatory Culture.* Cambridge, UK: Polity Press.

Coker, David, and William E. Lewis. 2008. Beyond Writing Next: A Discussion of Writing Research and Instructional Uncertainty. *Harvard Educational Review* 78 (1): 231–251.

Corpus Ong, Jonathan. 2009. The Cosmopolitan Continuum: Locating Cosmopolitanism in Cultural and Media Studies. *Media, Culture & Society* 31(3): 449–466.

Dowdall, Clare. 2009. Impressions, Improvisations and Compositions: Reframing Children's Text Production in Social Network Sites. *Literacy* 43 (2): 91–99.

Dyson, Anne Haas, and Celia Genishi. 2005. *On the Case: Approaches to Language and Literacy Research.* New York: Teachers College Press.

Goffman, Erving. 1959. *The Presentation of Self in Everyday Life.* New York: Doubleday.

Hansen, David T. 2010. Cosmopolitanism and Education: A View from the Ground. *Teachers College Record* 112(1): 1–30.

Hargittai, Eszter, and A. Hinnant. 2008. Digital Inequality: Differences in Young Adults' Use of the Internet. *Communication Research* 35 (5): 602–621.

Hull, Glynda A., and Mark Evan Nelson. 2005. Locating the Semiotic Power of Multimodality. *Written Communication* 22(2): 224–261.

Hull, Glynda A., and Amy Stornaiuolo. 2010. Literate Arts in a Global World: Reframing Social Networking as Cosmopolitan Practice. *Journal of Adolescent & Adult Literacy* 54 (2): 84–96.

Hull, Glynda A., Amy Stornaiuolo, and Urvashi Sahni. 2010. Cultural Citizenship and Cosmopolitan Practice: Global Youth Communicate Online. *English Education* 42 (4): 331–367.

Hull, Glynda A., Jessica Zacher, and Liesel Hiebert. 2009. Youth, Risk, and Equity in a Global World. *Review of Research in Education* 33: 117–159.

Ito, Mizuko, Heather Horst, Matteo Bittanti, danah boyd, Becky Herr-Stephenson, Patricia G. Lange, C.J. Pascoe, and Laura Robinson. 2008. Living and Learning with New Media: Summary of Findings from the Digital Youth Project." In *The John D. and Catherine T. MacArthur Foundation Reports on Digital Media and Learning.* Chicago: MacArthur Foundation.

Jenkins, Henry, Katie Clinton, Ravi Purushotma, Alice J. Robison, and Margaret Weigel. 2009.

Confronting the Challenge of Participatory Culture: Media Education for the 21st Century. In *Occasional Papers on Digital Media and Learning*: Chicago: MacArthur Foundation.

Lemke, Jay. 1998. Metamedia Literacy: Transforming Meanings and Media. In *Handbook of Literacy and Technology: Transformations in a Post-Typographic World*, edited by David Reinking, Michael C McKenna, Linda Labbo and Ronald D. Kieffer, 283–302. Mahwah, NJ: Lawrence Erlbaum.

Liu, Hugo. 2008. Social Network Profiles as Taste Performances. *Journal of Computer-Mediated Communication* 13: 252–275.

Papastephanou, Marianna. 2005. Globalization, Globalism and Cosmopolitanism as an Educational Ideal. *Educational Philosophy and Theory* 37 (4): 533–551.

Papastergiadis, Nikos. 2007. Glimpses of Cosmopolitanism in the Hospitality of Art. *European Journal of Social Theory* 10 (1): 139–152.

Prinsloo, Mastin, and Marion Walton. 2008. Situated Responses to the Digital Literacies of Electronic Communication in Marginal School Settings. In *Yearbook 2008: African Media, African Children*, ed. N. Pecora, E. Osei-Hwere and U. Carlsson. Göteborg: Nordicom.

Rizvi, Fazal. 2009. Toward Cosmopolitan Learning. *Discourse: Studies in the Cultural Politics of Education* 30 (3): 253–268.

Silverstone, Roger. 2007. *Media and Morality: On the Rise of the Mediapolis*. Cambridge, UK: Polity.

Stevenson, Nick. 2003. Cultural Citizenship in the "Cultural" Society: A Cosmopolitan Approach. *Citizenship Studies* 7(3): 331–338.

Warschauer, Mark. 2003. *Technology and Social Inclusion: Rethinking the Digital Divide*. Cambridge, MA: MIT Press.

Warschauer, Mark, and Douglas Grimes. 2007. Audience, Authorship, and Artifact: The Emergent Semiotics of Web 2.0. *Annual Review of Applied Linguistics* 27: 1–23.

Willis, Paul. 1990. *Common Culture: Symbolic Work at Play in the Everyday Culture of the Young*. Boulder, CO: Westview Press.

Part Four

Proposals, Recommendations,

and Suggestions for the Future

Facilitating the Social Reality Challenge with Youth Filmmakers

Peter Lemish

Introduction

Narrative filmmaking involves a dual social reality challenge: (a) to understand, and then (b) to re-present social phenomena and issues in film. This part of film-making is an essential, dynamic, non-linear, interactive process that is intermittently reflective, investigatory, and creative. Undoubtedly an intense and complex process, this is all the more so for young filmmakers producing their initial productions as well as for film educators who facilitate and assess this process. As such, the preparation of the film has the potential to develop deep, even critical, understandings of social life and thus contribute in significant ways to students' capabilities as filmmakers as well as their participation as responsible participants in civic life.

The aim of this chapter is to propose and exemplify practices that can be employed: first, by young filmmakers in engaging the challenge of understanding and re-presenting social life—henceforth the Challenge—(Lemish [A], in preparation); and second, in facilitating as well as assessing the fruits of their engagement as integrated in the film text. Accordingly, the chapter's initial discussion presents four practices, along with key points for film educator facilitation of the Challenge process. Selected assessments of film productions by Israeli high school film students demonstrate varying outcomes of Challenge engagement. The chapter concludes with a discussion of issues and contributions to young filmmakers through the use of these practices in filmmaking and in civic life.

The Social Reality Challenge

The premise advanced in this chapter is that a youth-made film is evidence of the producers' filmmaking capabilities and qualities of engagement with the Challenge. Success in the latter involves developing *verstehen*—deep, reflexive, and substantive understandings of social life, in our case of the film's topic, as embedded in commonsense everyday social life (Bernstein 1976; Heller 1984; Outhwaite 1975; Sarbin & Kituse 1994; Schutz 1962) and then employing these understandings in constructing the re-presentation of social reality in their film. Thus, producing a film requires that the filmmakers probe, understand, be critical, as well as offer interpretations and alternative views of self and social life. The practices proposed in this chapter can enable them to maximize this opportunity.

This chapter's focus on the Challenge is undertaken for the following reasons. First, I submit that successful engagement in the Challenge enhances the quality of the filmmaking process and the film. Second, attaining *verstehen* is necessary for communicating understandable meanings to a film's anonymous audience. Third, the film product presents demonstrable evidence of the quality of Challenge engagement. Fourth, the four proposed practices can be used to assess the quality of the filmmakers' inquiry, reflection, and learning.

Reflexive social epistemology and Challenge engagement are among the essences of filmmaking (Cavell 1971/1979; Diken & Laustsen 2007; Lemish [A], in preparation; Yates 2006). In this process, filmmakers draw upon a wealth of resources and experiences from their own life-world, media resources, and general social understanding as they engage in a systematic process of producing the film. Indeed, all of these understandings, experiences, and capabilities are involved throughout the collaborative nature of the production process, which includes proposing and selecting the film's topic, investigating and analyzing the topic, integrating social understandings into the script and framing decisions, constructing the storyboard, selecting and directing actors, editing, and even final market-framing of the film to different audiences in presenting the film to critics and/or examiners.

This process also involves a number of dilemmas. First, while filmmakers may be interested in problematizing *normalized* thought patterns and norms, we can ask: Is this possible, given their own socialization? This raises another question: How do we develop an original or personal statement if our thinking is highly mediated, socialized, and contextualized? Second, how do we communicate with an audience that has not undergone this complex process (Collins 1997; Diken & Laustsen 2007; Heller 1984; Mannheim 1924/1952)? Third, there is the epistemological dilemma of representation: How do we invest meanings in symbols, the plot, characters, and so forth that are true to our vision while engaging in the communicative act? While a full discussion of these dilemmas is beyond the scope

and aims of this chapter (see Lemish [A] in preparation), the thesis advanced here is that the four practices shared below assist filmmakers in dealing substantively with these dilemmas, and, therefore, they should be among the key practices learned by youth filmmakers, assisted by a Challenge-oriented film educator.

Practices for Engaging the Challenge

Engaging the Challenge is, essentially, a social phenomenological endeavor that integrates ontological reflection, epistemological inquiry, moral judgment, and advancing knowledge-into-action. Paulo Freire encapsulated this process in the concept of *praxis*, defined as actions undertaken through critical understanding and moral judgment (Au 2007; Freire 1974; Gadotti 1996; Lemish 1997; Lemish & Schlote 2009). As a social educator working with youth and adults, Freire developed praxis as a practical, reflective approach in which *verstehen* develops into knowledge-into-action. Freire explained his rationale for praxis as follows:

> Humans...are beings of praxis [that is] of action and of reflection. [They] find themselves marked by the results of their own actions in their relations with the world, and through action in it. By acting they transform; by transforming they create a reality which conditions their manner of acting. (Freire 1982, 102)

Hence, praxis is a perfect fit for engaging the Challenge in filmmaking because it (1) requires reflection as opposed to normalized responses to events in social life— an aim shared by many filmmakers; (2) problematizes social reality; (3) develops *verstehen*; (4) emphasizes the moral and ethical dimensions; and (5) advances actions undertaken through understanding and moral judgment.

The Freirean approach includes four key practices that are directly related to the Challenge engagement and by extension to filmmaking. Prior to profiling each practice, one important caveat is needed: praxis is a dynamic, often cyclical process. Hence, a holistic approach is advised, one that allows for the interplay of these practices. Therefore, we seek collective evidence of engagement with all four of these practices. How such a holistic approach can also be applied as a qualitative assessment approach is demonstrated later in this exposition of the praxis approach.

Problematizing

Problematizing initiates the praxis process when we become curious, inquire, examine, and reflect on particular phenomena present in social reality. An alternative way of describing problematizing is that praxis can involve perceiving and focusing on phenomena that other persons gloss over, often as a result of normalization and socialization. Thus, the immediate consequence of problematizing is

that one does not act "automatically," as expected; rather, re-acting is delayed as the next set of praxis practices are advanced.

Similarly, the filmmaking process is initiated most often by deliberating about options and ultimately selecting the film's topic or story. Filmmakers' deliberations and ultimate selections are declarations of intent to engage a topic/issue/story. Such engagement can involve reflection about their own personal knowledge, experiences, opinions, and values (Diken & Laustsen 2007; Sarbin & Kituse 1994; Schutz 1962) along with inquiry into various aspects and issues related to phenomena *in situ* and beyond.

Therefore, the *first key point* in assisting young filmmakers to engage the Challenge can occur when film educators engage them in dialogue about such questions as: Why do these issues, problems, topics, stories interest them? What is their initial "reading" of these phenomena? What personal and other resources are available to understand the topic? Deliberations and dialogue about such questions produce initial explanations that problematize, that is, demonstrate questioning and initial inquiry about the topics, problems, issues, or stories included in the proposed film.

Verstehen

Attaining a deep, critical understanding of phenomena enables praxis practitioners to contextualize and "locate" the topic and other related factors in historical and contemporary patterns of social life. Achieving *verstehen* enables one to understand and explain why the situation is not natural but constructed, the underlying interests driving the construction of social life, how it evolved, as well as past, present, and possible future consequences. Thus, *verstehen* is achieved when we understand the underlying structures that created and sustain social phenomena, problems, and conflicts, such as power relations, organizational structures and strategies, ideological interests, and hegemonic mechanisms.

A direct way to understand the intent, practice, and potential outcomes of *verstehen* is the Documentary Method proposed by Karl Mannheim (Mannheim, 1924/1952; as well as Bohnsack 2008; and Garfinkel 1967). Mannheim argued that *verstehen* develops when an inquirer approaches a social phenomenon as a document or representative artifact of deeper social processes produced in social life, according to rules, values, understandings, and ideologies. Such deep understanding—what Mannheim refers to as Documentary Knowledge—can be distinguished from two superficial types of understanding: (1) Objective Knowledge, a limited understanding that relates only to the present nature of phenomena, such that it describes, simply, who is involved, what, how, where, and when phenomena happened; (2) Subjective Knowledge, which also relates only to the here-and-now

and answers—partially—the question of *why* a social event happens by presenting participants' opinions, rationales, and explanations.

In contrast, Documentary Knowledge enables praxis practitioners to provide a deeper explanation of why and how social forces—past as well as present—produce the immediate social phenomena that are the subject of inquiry. If Documentary Knowledge is achieved, then we expect filmmakers to employ understandings and the epistemological grammar—including rules, language forms, ideologies, driving actions, rationales, artifacts, and so on—achieved in documentary inquiry in the film.

Thus, the *second key point* for film educator intervention may evolve over a number of meetings as they guide young filmmakers in a mini-research process that involves, initially, gathering data via interviews, participant observation, media resources and archives, historical analyses and commentaries, and so forth. The analysis of these materials may involve active film educator facilitation given the complexity and historical roots of social reality. If engaged in successfully, the products of this process are the three forms of knowledge defined by Mannheim.

In terms of assessing quality, we should be able to see quite clearly the difference between thin and thick understandings of the social phenomena re-presented in the film. Indeed, as the evidence presented below suggests, the difference can be quite dramatic. Furthermore, a successful Challenge engagement can be an important social learning experience whose import extends well beyond knowledge of the particular topic investigated or film produced.

Moral Reflection and Judgment

In proposing inclusion of systematic moral reflection and judgment, filmmakers are offered an opportunity to develop their stance in regard to the social situation under consideration. Thus, the *third key point* of film educator intervention involves asking young filmmakers to reflect on questions such as: Is this situation humane, just, and fair? Who is able to participate in social life, and are there different forms of participation; for example, in oppressor-oppressed, rich-poor relationships, or initiator-reactor scenarios? Are participants' human rights violated? Does this topic or form of representation relate to issues of gender, race, ethnicity, class, and so forth? What moral alternatives can be posed by different characters? What do you think should happen to rectify the situation?

This questioning enables the filmmakers to clarify and develop their posing of the moral dimension as well as their own and possible alternative stances.

Knowledge-into-Action

Freire's approach to praxis invites practitioners to shift their involvement from being curious and reflective to becoming conscious agents whose reactions are in-

formed by this process (Bayne 2007) and, in the case of filmmakers, whose re-presentation of social life in the film will be informed by the praxis process. At this point, with the topic or story of the film having been problematized, understood through Mannheim's multiple types of knowledge, and considered for moral implications, filmmakers are well prepared to advance production tasks. Indeed, in all likelihood the processes of praxis and production preparation have been developing simultaneously, in a dialectical, integrated manner. This is the intent of the practice Freire referred to as knowledge-into-action. What remains, then, as the *fourth key praxis point*, is for film educators to assist young filmmakers to rise above the nitty-gritty of production activities to recall the *verstehen*, stances, and vision they developed in the praxis process.

Assessing/Researching Challenge Engagement

While praxis practices have been adopted by educators, activists, and academics, among others, worldwide—as an approach whose aims include advancing empowerment and critical involvement in civic life (Au 2007; Gadotti 1996)—this study seems to be the first to extend Freire's approach to the Challenge engagement as an integral part of producing a film (Lemish [A] in preparation). However, the intent here is not prescriptive or programmatic. Rather, the remainder of this chapter aims to demonstrate how to answer two interrelated questions: What qualities of successful engagement in the Challenge are evident in a film text? How can we assess the quality of such engagement (i.e., the process)?

The holistic approach proposed for assessing the quality of praxis-based engagement in the Challenge in the youth-made films led to constructing and refining the following four statements throughout the analysis and assessment of the films in the Israeli corpus:

THIN

1 = Limited evidence of praxis: Superficial, Objective Knowledge used in a largely descriptive narrative; limited problematizing and contextualizing of the topic; topic assumed to be normal, interesting local phenomenon, without a history; Subjective Knowledge used to present only one character's point of view; action without signs of *verstehen*, reflection on moral dimensions, or consequences of the event or issue.

2 = Some evidence of praxis: Topic assumed to be normal, local phenomenon but with more nuanced Objective Knowledge-ground narrative, and some history; presentation of at least two actors' Subjective Knowledge-perspectives; evidence of some consideration of action option/s, awareness of possible or actual consequences.

THICK

3 = Various signs of deeper praxis: Problematizing film's topic demonstrates awareness that it is a "document" or exemplar of related social phenomena in past and present; Documentary Knowledge employed places topic in historical context, integrating underlying forces and interests; selective use of Objective Knowledge and multiple Subjective Knowledge perspectives to reveal actors' thought processes, critiques, and identification of key issues, including reference to moral dimensions, action options, and consequences.

4 = Extensive evidence of deep praxis engagement: Very rich, multi-layered text integrating selective use of Objective Knowledge as historical and contextual grounding, and multiple Subjective perspectives. Documentary analysis reveals deeper social forces, broader ethical/moral issues raised by topic; action options involve dealing with consequences of actions taken as well as consideration of involvement in transformative social change.

Knowledge-into-action is employed in all four efforts; however, the quality of reflection, knowledge, and overall praxis-Challenge engagement are distinguishable. For example, we can determine when there is sole dependence on Objective and Subjective Knowledges as opposed to the selective use of these knowledge forms in presenting Documentary understanding of the social problem constructed in the film.

In summary, praxis can be employed when filmmakers—and citizens in everyday life—relate to and to communicate about social reality in a critical manner. Doing so enables them, first, to create/re-present social reality in a manner understandable by the audience. Second, praxis requires reflection, questioning, and critical engagement with filmmakers' own lived experiences and understandings of normalized social life. Engaging in such reflection and investigation can be particularly difficult for youth filmmakers if they have been educated through "closed socialization"; that is, closed in terms of ideologies, social values, and behaviors, or to specific ways of engaging in filmmaking (Lemish 2003). Yet the final film project in a high school or college film studies program is a unique space in which to engage filmmakers in all these challenges.

Research Methods

This chapter has emerged from a broader study of Israeli secondary school student film productions selected for participation in the 2008 Dimona Student Film Festival Competition, conducted by the Israel Ministry of Education (www.dimonafest.org) (Lemish [B], in preparation).

The films selected from the countrywide competition are, normally, the final projects of young filmmakers who have been studying in the three-year Film Stud-

ies and Mass Communication elective major in Israeli secondary schools. [N.B.: An overwhelming majority of these are public schools functioning in both the secular and religious sectors of the dominant Jewish society, along with a few secondary schools in the minority Palestinian sector.] The films are collaborative efforts by a team of three or four students who are responsible for all aspects of the film (i.e., selecting topic, writing script, producing, directing, filming, and editing). Film educators and other students in the program meet from time to time to review drafts, check the film's progress, and critique these efforts.

Films participating in the Dimona Film Festival are chosen initially by individual schools and then by the Festival Committee, which is composed of professional filmmakers, film educators, and Ministry representatives who ultimately select the winners. The overwhelming majority of the films in the festival competed in the fiction (34/65) and non-fiction (27/65) categories, along with very few advertisements and animations (4/65).

The research process involved multiple viewings and analyses through qualitative research procedures (Lindloff and Taylor 2002) of the 65 films available on the festival Web site (85% of the 77 entries). The wider study aimed to analyze the nature and quality of this cohort of youth-made films in regard to genre, geographical location (center versus periphery), topic, and, in particular, manifestations of living amidst intractable domestic and international conflict in script structure and Challenge engagement.

Findings

In terms of the holistic assessment, well over half (38 of 65) of the total corpus were judged to present Thick film texts; that is, there was solid evidence of Challenge engagement (Praxis 3 and 4), though only six films were judged to have substantial engagement (Praxis 4). This significant finding indicates that well over half of the young filmmakers engaged the Challenge and found ways to integrate their understandings and reflections in their films.

Probing beyond this overall finding, an interesting difference was found in genre comparison. Whereas the non-fiction films can be distinguished by the topics addressed as well as by the quality of Challenge engagement, the analysis produced five sub-genres of fiction films, each of which had varying degrees of praxis-oriented Challenge engagement, and employed various knowledge-into-action techniques for employing Challenge-related understandings. Accordingly, evidence of these findings is presented via genre distinction.

Non-Fiction

Though there was nearly a 40/60 split of Thin versus Thick engagement in the non-fiction film texts, respectfully, Praxis 2 and Praxis 3 (indicating varying de-

grees of "some" engagement) were actually the dominant modes. However, for this initial presentation of praxis-based analysis, I share the full spectrum of Challenge engagement in the films via the two leading topical interests of these young film-makers—presenting social problems and documentary portraits.

Presenting Social Problems

The Hummus We Share is prototypical for this corpus and research, as it is an ex-cellent example of significant engagement (Praxis 4) and use of the Documentary Method to present a social problem. This film problematizes the Israeli-Palestinian conflict by focusing on one of its most outstanding contradictions: Whereas from both the Israeli and Palestinian macro-views they live amidst an intractable conflict between national cultures, the conflict does not necessarily exist at the micro-level of everyday inter-communal life. In this regard, the young filmmakers' rhetorical stance is clear: If we can live with one another in everyday life, why can't this be the case at the macro-national level? Ignored and glossed over by politicians, the media, as well as by many Jews who have daily contact with Arabs in all manner of everyday life, the filmmakers selected—as evidence to sup-port their stance—the case of Jewish Israelis who travel to a specific restaurant in a Palestinian city in the center of Israel to eat what patrons consider to be the best, most authentic hummus available (paste of garbanzo beans, ground sesame seeds, olive oil, and lemon served with pita, a Middle Eastern flatbread). Through inter-views interwoven in the text we learn about the rationales and balancing of feel-ings about the macro-conflict and the micro-role of hummus from Jewish-Israeli guests and Palestinian host-owners and restaurant workers. We also hear strong messages from interviewees about the importance and role of everyday interaction between individuals from the two communities. The alternative view presented by Jewish-Israeli non-patron opponents of frequenting businesses in the Palestinian sector is "supported," ironically, with a wink by the filmmakers, by quoting these interviewees' [mistaken] idea that hummus is actually a Jewish dish. In summary, this film is not only an outstanding example of success in Challenge engagement. It is also unusual by Israeli standards, as the filmmakers doubt and criticize some of the most important messages of socialization to which they have been exposed in their formal schooling and informal cultural education.

The Entire Length of the Way (Praxis 1) is a magazine report that presents the season of the reigning national high school champion women's cross-country team. As the film presents selected events leading up to the next national champi-onship, we meet five unique student-runners: three Jewish immigrants from dif-ferent countries, an Israeli-born Bedouin [semi-nomadic Muslims who live primarily in southern Israel and Jordan], and an Israeli-born Jew. All five teen women study at a live-away rural school in southern Israel, in the current war-

zone. This vibrant mix of people, the school's location, gender issues, and the status of women in sports all have significant but untapped potential for the film's exploration of an array of social issues. For example, one undeveloped subtext is representation of the equality among team members. However, rather than problematize by contrasting this apparent achievement with the unfulfilled promise of equality in Israeli society, we are presented with an a-contextual, acultural, ahistorical, unproblematic Objective Knowledge-driven narrative of the team's dramatic failure to repeat its championship success.

Between Sambousek and Bourekas (Praxis 2) presents claims by two actors and the children of George Ovadia [the filmmaker known for creating the *Bourekas* genre of films considered by many cultural critics to be demeaning of Jewish-Israelis of Middle Eastern origins; *Bourekas* films refer to an iconic Mediterranean-style pastry] that their father was abused and abandoned by the Israeli film community and later died a bitter man. Three key Challenge-related critiques of the film can be offered. First, the film fails to cite or include interviews with film historians and/or film critics that present "the other side's" critique of the genre and non-familial rendering of the debate about the historical legacy of Mr. Ovadia and the genre. Second, no reference is made to the larger context or the iconic and symbolic roles of the *Bourekas* film in the European–Middle Eastern culture schism in Jewish domestic and cultural affairs in Israel. Third, neither Ovadia's children nor the filmmakers offer options for recognizing the filmmaker-father's achievements. Thus, like *The Hummus We Share*, this film is prototypical; however, in this case it is prototypical of the unrealized potential to engage in praxis-oriented critique and intervention to confront an important social-cultural issue exemplified by Ovadia's reputation and the *Bourekas* genre.

Finally, the following films are examples of unfulfilled Challenge engagement (Praxis 3) in presenting social problems: *My Lord* problematizes life in Jerusalem's gay community through portrayals of two GLBT entertainers. However, the film pays scant attention to the historical context and current battles of the culture war waged between gay and ultra-religious (and other anti-gay) communities in Jerusalem, Israel, and globally. *Living amidst Fear* problematizes waves of violent attacks on elderly persons in Haifa by presenting a victim and a police officer who call for the courts to render harsher punishments for convicted offenders. This film requires presenting more Documentary Knowledge and contextualization, including the history and nature of the problem in Haifa, other Israeli cities, and other countries; identification of contributing factors, including the Israeli-Palestinian conflict; social consequences beyond victims and perpetrators; and other ways in which cities in and beyond Israel are confronting these problems.

When Theatre Meets the Periphery presents an attempted solution to a social problem (only presented tangentially), namely, the gaping schism—in all social,

cultural, economic, and political domains—between the periphery and the country's urban center. The film presents documentary evidence of the efforts and views of the local organizer and six members of a Tel Aviv theatre company during their temporary residence in the rural southern town of Dimona, as they develop a theatre project with local residents. The film neither places the project in the context of the aforementioned schisms nor assesses the consequences and impact, locally and beyond, of this social change effort.

Documentary Portraits

The following synopses present a spectrum of Challenge engagement by young Israeli filmmakers presenting documentary portraits.

In the Stage Lights presents Or, who recounts her ongoing struggles with poverty, musical studies, and her debut public performance as a jazz singer. As an exemplar of Praxis 1, this film employs only Objective and Subjective Knowledge in presenting this straightforward, factual reconstruction of Or's life and views. In doing so, the filmmakers fail to "problematize" Or's journey and thus do not maximize the potential to present her story as an example of young persons who live with and confront the consequences of poverty or the failures of educational and social welfare systems, which are also related to Israel's ethnic-cultural schism.

In recounting the impressive accomplishments of Galiya, a thirty-year-old Down syndrome adult, *Queen Galiya* only employs Objective and Subjective Knowledge, with comments about her accomplishments by her mother, teachers, and co-workers (and therefore is Praxis 2). A documentary accounting of Galiya's social life would explain how all these persons and other supportive institutions and social policies supported Galiya. Without this perspective, the viewer is left with the false impression that Galiya's significant achievements are solely of her own making.

In *Story of a Leg* (Praxis 3), the praxis process is a main narrative vector in Gabi's recounting of his pre- and post-illness life: living with a diseased leg; deliberations about amputation; the rationale employed in deciding to take this drastic action; and positive outcomes and changes in his post-amputation life. While it is true that we only hear Gabi's voice in this largely Objective-Subjective account, the praxis-structured narrative moves the film into the Thick range. Adding the voices of significant others as well as medical and psychological professionals would have strengthened the film significantly.

Fajah Neighborhood is a second Thick praxis prototype, with extensive evidence of significant Challenge engagement (Praxis 4). Here the complex problem addressed is how to survive and advance change in government-neglected neighborhoods. The filmmakers make it clear that Fajah is an example of hundreds of such Israeli neighborhoods, and Kfir, a Fajah activist and musician, is one

among many residents who struggle daily to save themselves and advance change. In a manner diametrically opposed to the "natural" approach of accepting the living conditions in Fajah, Kfir's efforts as a youth worker as well as his hip-hop–style songs—themselves exemplars of praxis—problematize, expose, and critique life in Fajah and government abandonment. Kfir honors others who are struggling as well as the spirit of the hip-hop art form as he and his youthful partners perform their music before the community, with the aim of entertaining, advancing audience members' problematizing of their lives, and cajoling them to act.

Fiction

The findings of the analysis of the fiction films in the student corpus offered a number of additional insights into understanding how reflective engagement with the Social Reality Challenge can be involved in film production. As in the non-fiction films, the analysis of the corpus found a praxis-spectrum ranging from limited to strong engagement. Here, too, over half of the fiction texts (23 of 38) displayed evidence of Challenge engagement (Praxis 3–4). However, over one quarter demonstrated little involvement (Praxis 1; 10 of 38).

A second finding suggests an interesting phenomenon worthy of future research: Five sub-genres were identified in the fiction corpus: engagement in local Israeli context; engagement with "universal" context (i.e., engagement with what could be any [Western] social reality; i.e., films demonstrate familiarity, capacity, interest in portraying the universal or a non-interest in local); social marketing intended to transmit a moral-prescriptive message; film-centered texts in which the filmmakers' primary interest seems to be engaging in dialogue with film as an art form, with the social and topical of secondary importance (e.g., reproduction of film noir, science-fiction, slapstick comedy); and screen adaptation of literature.

Third, fiction provided filmmakers with creative opportunities to share their evolving understandings of social reality. The primary methods they employed included general script structure and the "script turn," character construction, highlighting affective and moral aspects of dealing with a social problem, and satire. Due to space constraints, only select exemplars of these methods can be shared here.

We begin with two interrelated ways in which the results of Challenge engagement were involved in script structure—direct problematizing of an aspect of social reality as the film's main subject and use of the praxis approach as a vector in the script.

Direct Problematizing of Social Reality

By employing names of biblical characters in the title—*Amnon and Tamar*—the filmmakers identify the social problem addressed. Indeed, one might suspect that

the script simply employs Objective Knowledge as a direct way to retell the story of Tamar's rape by Amnon, here during a romantic camping trip, along with the subjective views of Tamar and a police officer's inconclusive investigation of her complaint against Amnon. However, the final frames' quotes from research reports about the high incidence of rape in Israel and numerous inconclusive police investigations/prosecutions reveal that the filmmakers were guided by the Documentary Method when producing a film with the aim of presenting their critique of this important problem. Though assessed as Praxis 3, due to the limited sharing of deep *verstehen*, *Amnon and Tamar* demonstrates that Objective and Subjective Knowledges can be employed to frame Documentary understanding.

Praxis as a Script Vector

The praxis process was also found to be an excellent way to present the dramatic text. Indeed, *Noa at Sea* (Praxis 3) demonstrates use of both praxis and Documentary Knowledge as script vectors. Through a deftly crafted re-presentation of growing up as a young Jew in the 1960s, the filmmakers' not-so-subtle critique hits the soft under-belly of early adolescent socialization in Israel. In doing so, the filmmakers present a critical view of this period of adolescent transition from childhood to soon-to-be adult. Close relations among four friends are portrayed, with Noa's problematizing upcoming events in her life as the main narrative. Here, the characters offer different views—Subjective Knowledge—regarding Noa's upcoming Bat Mitzvah (a ceremonial Jewish rite of passage) and early teen beauty pressures. In doing so, we see the birth of naïveté, purity, friendship, and subtle yet healthy teen cynicism. The filmmakers advance praxis knowledge-into-action in the script as the characters attempt to live up to their views and friendship covenant not to participate in various rite-of-passage ceremonies. Collectively, these accounts reveal young adolescent naïveté and difficulties involved in holding onto their views in the face of strong parental and communal pressures. More subtly, the deep *verstehen* expressed as a subtext vector is the filmmakers' critique of social mechanisms that produce the compliant nature of many persons in Jewish-Israeli society.

Buka Mabuluka [nonsensical, surreal title] (Praxis 3) is a commentary on the vicissitudes of filmmaking as a young filmmaker. For our purposes, the script is one long, praxis-driven self-reflection revealing the young protagonist's inner world—sometimes real, at other times surrealistic. In praxis terms, the script structure is representative of the cyclical nature of the filmmaking process, in a seemingly endless process of confronting a new problem via actions just outside his reach with incessant, insufficient actions leading to further reflection-into-action. There are the challenges of trying to make the film with endless disappointments by friends who break their promises to help, deflecting parental pressure and plati-

tudes, escaping to spend time with his grandmother—who is the sole source of authentic support—and endless rowing a boat at sea—symbolic of adolescence and the nature of the filmmaking experience for these young filmmakers.

Character Construction

Fiction offers artists the opportunity to create characters that advance all manner of Subjective Knowledge-into-action. This enables the filmmaker to construct different praxis-patterns and opposing life-worlds as well as knowledge-into-action. For example, tension between the universalist and the Zionist [Jewish nationalist] life-worlds is a subtext that unfolds in *France* (Praxis 2) as three teen friends react to Dina's news that her family is moving to Paris. This film employs comedy to present critical commentaries on two highly inflammatory issues—emigration and not fulfilling mandatory conscription into the Israeli army. Here the fiction and comedic formats enabled the filmmakers to use the characters to present differing views (Subjective Knowledge). Each character proposed knowledge-into-action by indicating how they plan to act in the future—some proposed staying safely within the clear boundaries of Israeli society while others imagined transgressing boundaries—physically via emigration or intellectually by challenging normalized views.

Insider Perspective

Producing a fiction film that presents an insider perspective of a character requires that filmmakers engage deeply in social phenomenology; that is, create a script that presents the character's perspective of the inner and outer worlds, the personal and the social, as well as their intersection in "knowledge-into-action" into "further reflection" and "eventual further actions." The title, the story, and film structures of *To Cross the Lines* (Praxis 4) are evidence of the filmmakers' successful engagement in this process. The film's story presents the ugly and seemingly endless consequences for the lives of elderly Holocaust survivors, who have been "crossed," transgressed, and violated on numerous occasions by various governments, including Israel, and even by their neighbors. The protagonist's gut-wrenching words echo a world of abandonment, loneliness, isolation, and fears, as well as the need to tell her story through compulsive diary writing until the last chapter—the final *crossing over the lines*—by taking her own life. As her daughter reads the diary to her granddaughter sometime in the future, we learn about her Holocaust experiences and difficulties adjusting to life in Israel as well as the most recent violation, a vicious attack by thieves in her home that resulted in the symbolic breaking of her few remaining mementos of pre-Holocaust life. Certainly her desire to visit her family is positive, but we learn that this is an act of parting in anticipation of her decision to take her life, now that her story is told. Unfortunately this is an all-

too-familiar story, yet the filmmakers' praxis-driven engagement with a very diffi-cult challenge enabled them to integrate the inner and outer worlds in this cumu-lative tapestry of Holocaust survivors' last years.

Discussion

Input received just after completing the analysis of the research corpus—receipt of the professional jury's selection of prize-winning films—offers us a good jumping-off point for discussion of issues and implications of the preceding presentation. The comparison between the films selected and the Challenge-related analysis proved to be quite insightful: there was a strong correlation between the analysis and the fiction film winners (all five films awarded prizes were assessed as Praxis 3+ and 4) and just the opposite—a weak correlation between non-fiction films awarded prizes and our Social Reality Challenge assessments (three of four award-winning films were rated as Praxis 1 and 2). Thus, contrary to common sense, this suggests that the Challenge-related assessment and the praxis process may work very well for fiction, when filmmakers are relatively free to construct their own version of social reality. However, this may not be the case when they must de-velop a deep understanding of social reality and have limited degrees of freedom in re-presenting social life in the non-fiction film.

If the negative correlation were present in both genres, then the conclusion would be that my tools may be inadequate or that Challenge engagement is not an important criterion in judging films. Alternatively, I suggest considering the fol-lowing argument: Since there is such strong validity with the fiction films, then I suspect the key can be found in investigating the three non-fiction winners where there is disagreement between my proposals and the assessments of professional filmmakers and educators. Herein, I submit, lay two inter-linked explanations. First, each is a dramatic portrayal of heroic persons: the jazz singer, Galiya, with Down syndrome, and George Ovadia, the filmmaker. Second, these films employ extended use of drama in retelling the story, in a manner remarkably close to a fiction script. And here, I submit, is the key to one explanation: The filmmakers-educators are impressed by young filmmakers' use of the Hollywood *fiction* for-mula made famous by Syd Field (1979/2005): Tell a good story in dramatic fash-ion about a person engaged in a heroic struggle that is highly emotional in a well-made film, and you win a Hollywood contract to make your film. Or, in our case, you win a prize.

If so, then I can ask: To what degree do film educators value systematic reflec-tion, attaining *verstehen*, and linking the subject to larger social phenomena or causes? As indicated in my brief assessment of these three winning non-fiction films, each is an exemplar of the lack of praxis-engagement in the Challenge; and, in particular, none have even the slightest linkage to broader social process and

factors that assist us, the viewers, in understanding the underlying causes and forces involved in these actual issues and problems in contemporary Israeli social life. In my view, this is a missed opportunity by film educators to contribute to their students' capabilities as filmmakers, as commentator-interveners in civic life, and as citizen-agents involved in commonsense, everyday social life (Bayne 2007; Schutz 1962).

Accordingly, the second explanation relates not only to these award-winning, non-fiction films but also to nearly half of the films in the research corpus assessed to function at Praxis 1 and 2 in terms of engagement with the Social Reality Challenge: namely, film educators could benefit, pedagogically, from in-depth discussion of the kinds of practices presented and examined in this chapter and future work in progress (Lemish [A, B] in preparation).

In this spirit, I conclude by indicating how the four practices and key filmmaker–film educator interactions offer numerous opportunities for Challenge-oriented cinematic and social learning.

Problematizing advances doubt and questioning, not only in initial selection of the film's topic or social situation, but throughout the praxis and film production process. In this sense, the entire film production process is an evolving dialogue among creative persons that is paradigmatic for being a praxis-practitioner in everyday civic life.

Verstehen processes, too, are cinematic and civic practices with the potential to develop filmmakers' understandings of deep processes and mechanisms involved in creation and control of social problems and situations. In developing *verstehen* through the praxis process and Documentary Method, the students produce various forms of knowledge, and the educator can guide them in critique as well as integration of these different forms of knowledge in the film script. In addition, achieving *verstehen* through developing Documentary Knowledge also provides the students with a grounded, more realistic view of accomplishing able and meaningful social change.

Moral reflection is perhaps the most delicate of the film educator's tasks in facilitating young filmmakers' Challenge engagement, yet in my experience youth and young adults have a keen desire to engage in discussion of important moral dimensions of social issues. Furthermore, raising moral questions rekindles the problematizing character of the praxis process and engages filmmakers in one of the most interesting aspects of filmmaking—enabling viewers to be exposed to a variety of ideas and opinions not often encountered in their daily lives.

Knowledge-into-action can be the jewel in the crown of serious engagement in the Social Reality Challenge via the praxis approach. In seeking to employ this practice, young filmmakers have an opportunity to integrate the achievements of the praxis process in the script as well as in instructions to actors and film editors.

In non-fiction, this practice will challenge them to advance a truth-seeking representation of social phenomena...and, in the case of fiction, to engage in a playful but meaningful exercise in putting knowledge and vision into action and testing the consequences in their characters' lives.

In summary, engaging the Social Reality Challenge in all manner of narrative texts through the praxis process provides filmmakers with an opportunity to produce a quality film, or other media product, and to develop important practices for responsible participation in civic life.

Acknowledgments

The author is extremely grateful for the important feedback and support received during the preparation of this chapter from Dafna Lemish and this book's editor, JoEllen Fisherkeller, and wishes to thank Dorit Balin, Chief Inspector of Cinema and Mass Communication Studies, Israel Ministry of Education, for inviting me to study the Dimona Film Festival.

References

Au, Wayne. 2007. Epistemology of the Oppressed: The Dialectic of Paulo Freire's Theory of Knowledge. *Journal for Critical Education Policy Studies* 5(2). http://www.jceps.com/?pageID=article&articleID=100. (Downloaded July 15, 2009.)

Bayne, Tim. 2007. The Phenomenology of Agency. *Philosophy Compass* 3(1): 182–202.

Bernstein, Richard. 1976. *The Restructuring of Social and Political Theory*. New York: Harcourt Brace Jovanovich.

Bohnsack, Rolf. 2008. The Interpretation of Pictures and the Documentary Method. *Forum: Qualitative Social Research* 9(3): Article 26. http://www.qualitative-research.net/index.php/fqs/article/view/1171/2592. (Downloaded October 2, 2009.)

Cavell, Stanley. 1971/1979. *The World Viewed: Reflections of the Ontology of Film*. Cambridge, MA: Harvard University Press.

Collins, Finn. 1997. *Social Reality*. London: Routledge.

Diken, Bülent, and Carsten Bagge Laustsen. 2007. *Sociology Through the Projector*. Oxon, England: Routledge.

Field, Syd. 1979/2005. *The Foundations of Screenwriting*. New York: Random House.

Freire, Paulo. 1974. *Pedagogy of the Oppressed*. Trans. M. Ramos. New York: Seabury.

———. 1982. Extension or Communication (L. Bigwood and M. Marshall, Trans.). In *Education for Critical Consciousness* (pp. 93–164). New York: Continuum.

Gadotti, M. 1996. *Pedagogy of Praxis: A Dialectical Philosophy of Education*. Trans. J. Milton. Albany: SUNY Press.

Garfinkel, Harold. 1967. *Studies in Ethnomethodology*. Englewood Cliffs, NJ: Prentice-Hall.

Heller, Agnes. 1984. *Everyday Life*. London: Routledge.

Lemish, Peter. 1997. Exposing Indifference: Applying Films in Praxis Pedagogy with Teenagers in a Conflicted Society. *Radical Teacher* 50: 17–22.

———. 2003. Civic and Citizenship Education in Israel. *Cambridge Review of Education*. 33:1, 53–72.

———. (A: in preparation). *The Social Reality Challenge in Filmmaking*.

———. (B: in preparation). *Youth Filmmaking amidst Multiple Intractable Conflicts*.

Lemish, Peter and Elke Schlote. 2009. Media Portrayals of Youth Involvement in Social Change: The Roles of Agency, Praxis, and Conflict Resolution Processes in TV Programs. In *Youth Engaging with the World—Media, Communication, and Social Change,* 193–215, ed. T. Tufte and F. Enghel. Göteburg, Sweden: Nordicom.

Lindloff, Thomas and Bryan C. Taylor. 2002. *Qualitative Communication Research Methods.* Thousand Oaks, CA: Sage.

Mannheim, Karl. 1924/1952. On the Interpretation of Weltanschauung. *Karl Mannheim: Essays in the Sociology of Knowledge,* 33–83. London: Routledge & Kegan Paul.

Outhwaite, William. 1975. *Understanding Social Life—The Method Called Verstehen.* London: George Allen & Unwin.

Sarbin, Theodore and John Kituse. 1994. A Prologue to Constructing the Social. In *Constructing the Social.* Thousand Oaks, CA: Sage.

Schutz, Alfred. 1962. *Collected Papers.* Vol 1. Edited with introduction by Maurice Natanson. The Hague: Martinus Nijhoff.

Yates, Christopher. 2006. A Phenomenological Aesthetic of Cinematic Worlds. *Contemporary Aesthetics.* http://www.contempaesthetics.org/newvolume/ pages/article.php?articleID=394. (Downloaded October 15, 2009.)

16

Not Just Philosophizing: Producing Effective Youth Media and Communication Projects

Stuart R. Poyntz and Michael Hoechsmann

Introduction

Dramatic developments in communication technologies over the past two decades have enabled an outpouring of youth expression through a variety of media forms and genres. School-based and community media educators are increasingly recognizing the tremendous potential that new production technologies and distribution platforms offer for youth expression, empowerment, and development. In this chapter, we outline four pivotal questions that school and community-based media educators should take into consideration when planning and implementing media production projects. These questions make up a continuum of key issues embedded in the youth media production process—including vocationalism, youth voice, democratic participation, and pleasure—that are always already present in youth production projects whether they are explicitly addressed or not. Throughout, we draw on a cross-section of research but also rely on our own experience as community-based media educators to describe the elements and foci that are, in our view, central to developing effective youth media/communication projects. We acknowledge that the continuum of key questions in youth media production will play out differently across distinct contexts. As we engage this discussion, we do so carrying some trepidation about the revolutionary characteristics often attributed to the Read/Write world of the Web 2.0 (Lessig 2008). Given our experiences and observations, we wish to express a more limited view of what the new technologies have added to the equation. Thus, the arguments and in-

sights expressed in this chapter both predate and embrace the new Web 2.0 conditions.

Four Key Questions in Youth Media Production Contexts

1. Technical Skills Development and Vocational Training

Perhaps the most common question raised in relation to youth media production is: How can such projects help develop the technical skills and competencies young people need to function in a highly media-saturated world? This question is often something schools and community groups either actively embrace or keep at arm's length for fear of diluting purer intentions (see youth "voice" below as an example of what is often considered a more authentic goal). Where media projects embrace this issue, the idea of developing young people's technical skills is often justified as an aspect of vocational training within media education contexts. In this sense, a dialectic of "learning by doing" is taken up, but largely in functionalist terms. Learning how to work with editing equipment, light a scene, or record an interview doesn't guarantee that one is thinking critically about one's world; it is about developing strategies for job-readiness.

Preparing kids for job markets through media production has been attractive for many reasons. Perhaps most significantly, there is an assumption that schools and/or community-based programs can address and confront what is now called the digital divide by giving low-income and otherwise marginalized kids access to technologies and social networks they might otherwise not have. A vocational approach is thus a kind of equalizer in socio-economic circumstances and an enabler for those not succeeding in academic streams. British educators Ian Connell and Geoff Hurd (1989) extend this debate further and argue that media production-as-skills-development should be understood as a form of critical vocationalism (Goldfarb 2002). They suggest that for students who have less opportunity due to combined reasons of class, race, gender or assessed intelligence, skills development is a necessary step in gaining access to employment and the means of production. For kids who aren't succeeding in the mainstream school system, in other words, a technical orientation in production work provides something everyone needs: a way to survive.

This argument may express an important truth, but at the same time, the idea of targeting production classes and programs at less-well-off students has added an important class dimension to the way "production-work-as skills"-development has evolved more broadly. In fact, the long history of association between vocational training and students with poor academic records has cast a shadow over how skills development through media production has been understood to foster

youth agency. Indeed, a vocational association has often appeared to suggest that education in media production is a dumbed-down approach to learning how to imitate the styles and practices of the media industry itself.

In response to this, we note that this concern touches on sensitivities that arise whenever young people get their hands on media. Despite evidence to the contrary, the concern here is that this will only lead to copycat behaviour or perhaps mindless play with new toys. Indeed, learning any new media form always and necessarily involves some kind of imitation. This is how young people learn about technical equipment and the relationship between this equipment and the sedimented practices of visual, audio, or textual representation that are invoked whenever one engages in media production. Thus, learning how to write a magazine article, produce a video, or craft a digital media space involves a process of learning media conventions: how media languages have been used, how these languages relate to specific technical resources, and what expectations media producers and audiences have about the use of specific representational codes. In this sense, imitation isn't something to be avoided—it is a necessary and unavoidable step in learning how to produce cultural expressions in the first place. Michael learned this first-hand during his time at Young People's Press (YPP).

At YPP, the mandate revolved around youth expression and empowerment, so vocational training was never a primary objective in the program. Nonetheless, YPP was committed to publishing youth in major newspapers, and so it became a central concern to enable youth to participate by teaching them the codes and conventions of the various genres of news writing. During its most successful years, YPP often had big-city newspaper editors breathing down youth participants' necks. This was particularly true over the two years during which YPP ran a weekly, three-page section called "young street" in the Life section of the *Toronto Star*, Canada's largest circulation daily. To throw youth to the lions—the proofreaders and editors of the *Star*—without adequate training was a non-starter. Because of this, the YPP philosophy was that while youth brought stories and perspectives to the table, the facilitators' task was to help them quickly develop an appreciation for the genres and conventions of news writing and to assist them in crafting a publishable piece.

Beyond learning the specific codes of mainstream newspaper journalism, the other type of vocational training that took place at YPP was the sum of learning curves mounted, experiences gained, articles published, and portfolios built on the part of the participants. Over time, a significant number of YPP participants were admitted into journalism programs at a variety of universities, and some went on to other types of programs, jobs, or careers that involved journalistic writing. What this suggests is that while you can try to minimize vocationalism in media

production and community-based youth media programs, you can never eliminate it, because the participants will adopt it on their own.

Another key point in regard to the devaluing of vocationalism in media production is the evidence that suggests that when young people imitate other work—whether a music video, an advertisement, or a film genre—they rarely if ever simply reproduce what they see, read, or hear (Buckingham 2003a). Indeed, it is increasingly apparent that teenagers alter or rework the meaning of the texts or genre language they are working with. As many educators will attest, this process of reworking is often laden with a sense of parody or irony. Reports from classrooms and community-based practices suggest, in fact, that when youth imitate other media practices, they undertake a mode of dialogic communication (Bakhtin 1981) that leads to the production of new texts which contain evidence of the conventions and codes of representation they've learned, but also evidence of some repositioning or re-imagination of these codes.

If the foregoing discussion brings comfort to those who promote media production in relation to skills development, many youth, educators, and researchers argue that technical training still doesn't capture the full richness of learning possibilities available through creative work. Where skills development is part of fostering young people's agency, then, a fuller sense of what this agency might involve is ignored if we only imagine production practices in terms of instrumental ends dictated by economic circumstances and needs. Many would suggest, in fact, that broader questions emerge through youth media production that relate to issues of youth expression and voice, participation in public life and the role of pleasure and play in young people's media work. We thus turn to these issues in the next sections.

2. Creativity, Expression and Youth Voice

The second question to think about in relation to the way media production enables youth agency has been especially popular with school and community-based arts educators. At root, the issue here is: how does media production help to develop young people's voices and self-identities? How does it help young people to "find their voice," or, how can it aid in the development of "'silenced voices' by providing teenagers with the skills and access needed to express their stories" (Soep 2006, 198)? When expressed in this way, the implicit claim is that media production fosters youth agency by providing a means through which creative self-expression can be materialized and shared. This, in turn, is thought to provide the ground on which young people can come to understand themselves and, as importantly, manifest this self, or voice, to the world.

This idea emerges, to a great extent, from embedded assumptions in the West about creativity, what it means to be an artist, and what creativity means in relation to art practice. Since the earliest days of modern art, the artist has been envisioned as someone capable of manifesting a unique and distinct vision of the world. This vision in turn has been thought to be the objective articulation of a creative individual force emanating from inside the artist-genius. As such, creativity has often been interpreted as having a mysterious and even mythic quality. In a sense, creative voice has been cast as the conduit through which an authentic expression of the true nature and identity of the artist and his or her experience might reveal itself.

Where creative youth production is concerned, this notion has been appealing because youth composition in text, audio, or visual formats has been cast as a vital means through which students' real experiences and identities can reveal themselves. The degree to which this is true is of course a crucial question. Research does tell us that creative practices are a powerful means for students to explore their emotional investments in the media (Buckingham 2006). It also offers a space for young people to examine how these emotional investments relate to their identities. In addition, as Michael learned through his work at YPP, media production can inspire a remarkable confidence among young people. The "young street" experiment with the *Toronto Star*, for instance, opened the door to hundreds of youth from all walks of life to add their voice to public discourse on the issues of the day. Through this, youth who had never dreamed they could publish a piece of writing in a major Canadian newspaper did so and, as a result, developed the confidence that has allowed them to pursue a life of writing.

Beyond psychological benefits that help young people to find their voice, production work also fosters youth agency by nurturing those silenced voices that otherwise go unheard in contemporary culture. This has been especially important for young people of colour, women and working-class or queer youth. The challenges here, of course, are the vast differences that can exist between learners in terms of their production capacities, their desire for learning, and the quality of their stories. In a project with a social justice orientation like YPP, for instance, Michael discovered it often seemed that the young people with the best stories were also those with the least writing experience and sometimes the least motivation. In this sense, to develop a youth media project with the premise of giving youth a voice can often mean investing tremendous effort in the creative output of those who need the most help and motivation. Thus, if there is a vision of democratic practice at the heart of one's project, it is important to acknowledge that some youth will have fewer obstacles to overcome in order to participate, and it is to those with greater needs that the most attention should be given.

This said, we know that young people in general don't "participate equally in the making of culture in the everyday world or in public spheres" (Kelly 2006, 35). Because of this, the call to put cameras and computers into the hands of young people is compelling, not least because the benefits of such opportunities can be significant. In a study (Poyntz 2008) of a summer youth media program in Vancouver, Canada, for instance, Stuart found that the creation of such spaces is itself empowering for teenagers. A young female participant in Stuart's study noted as much, suggesting that such programs create opportunities for youth expression that are increasingly hard to find.

> Young people have such interesting stories to tell and such important things to discuss. [They] have so much potential to contribute to their communities by producing art and engaging in conversation.... Allowing people to have these conversations and articulate what they're thinking is so important.... [At the same time,] there needs to be more opportunities where youth can...talk to each other and adults in a really free, unrestricted, uncensored way. (quoted in Poyntz 2008, 230)

These spaces are increasingly rare, but, the student continued, they allow time for teenagers to "try to articulate things we're thinking and philosophizing about" (quoted in Poyntz 2008, 231). As such, media programs can operate as a youthscape, an environment shaped by social, political, and cultural forces, which simultaneously nurtures the perspectives and points of view of new creative voices.

While media production can foster and develop youth voice and agency, there are also good reasons to think that the celebration of voice is hardly trouble free. David Trend (1997) notes, for instance, that media producers who work with marginalized youth often overstate the benefits of such projects for young people. At root, the problem is that many community-based media producers hold to the modernist assumption that all self-expression is always liberating. But this assumption fails to acknowledge the way in which self-expression can itself be disempowering or force youth to face precarious ethical dilemmas.

In a study by Nicole Fleetwood (2005), for instance, the researcher spent time working with a racially diverse group of young women in a summer media production program in San Francisco, California. The video they were to produce was "decidedly about youth and was to be shot from youth's perspectives" (Fleetwood 2005, 155). In working on this project, however, Fleetwood discovered that when young people are invited to produce so-called authentic representations about their lives, the results can often reproduce the sensationalized and racialized stereotypes and identities that are used to categorize and isolate specific young people in contemporary culture. The problem with this is that the work then ends up reifying entrenched social inequalities, even if the youth media program intended to undermine these very inequities. In another study, Robert Huesca

(2009) shows that because youth often produce media about the problems and experiences that are closest to their lives, media work can lead to ethically challenging situations involving schools, families, and sometimes police, which youth are often ill-equipped to address.

Fleetwood's and Huesca's research points to some of the social, political, and ethical issues that can intervene whenever young people engage in creative work. The need to pay attention to these issues has led educators, youth, and others to look beyond questions of voice in thinking about how production practices foster youth agency. Inevitably, this has raised questions about the dialogic nature of production and the way in which creative practices relate to normative questions, including the relationship of production to young people's democratic habituation. In the next section, it is to these issues that our discussion turns.

3. Media Production, Dialogic Experiences, and the Making of Public Life

The third question about how media production can contribute to young people's agency asks: How can creative media work foster youths' democratic habits of mind to develop an analysis of power relations and the social conditions that shape kids' lives? At least in part the appeal of this question has to do with the fact that producing media seems to position young people dialogically in relation to the larger social world in which we live. Creative practices place youth in conversation with others and thus offer opportunities for young people to address the sedimented social discourses and cultural practices that shape their experiences. If this helps to nurture democratic habits, many would suggest it is the social nature of production itself that underlies this potential.

In practical terms, the social nature of media production is probably most apparent because group work dominates the way zines, videos, and other media are made in many youth programs. This is the case for two reasons. First, group work helps to leverage limited technical resources to give a greater number of kids access to the means of production. Second, group work tends to encourage attention to the process of production as much as to the final product. From the perspective of educators, the advantage is that this encourages youth to engage with others, to discuss why certain choices are being made and, quite possibly, what aesthetic and socio-political implications these choices have in relation to the audience or to youth's social positioning as gendered, raced, and class-bound subjects. Of course, these questions don't always arise unprompted. Most often they are the outcome of a process of analysis and questioning initiated by educators working with young people (Drotner 2008).

Beyond group work, Elisabeth Soep (2006) offers a somewhat different explanation for why creative practices situate youth in dialogic relations with others. Soep's study draws on data and experiences gathered over a decade of working

with youth media arts programs. Soep notes that what often goes unrecognized in thinking about media work is the way youth speak in "double-voiced discourse" throughout the production process. The notion of double-voiced discourse comes from the work of the Russian literary critic Mikhail Bakhtin (1981). What Bakhtin wanted to draw attention to was how the words of others "enter a speaker's utterance in a concealed form" (Soep 2006, 202). When we speak, Bakhtin argued, our own voices are formed in and through our inclusion of the voices of others. In this sense, our own voices are never quite our own; they are always mediated by multiple voices. Using this idea, Soep (2006) goes on to analyze a youth media program, showing the way young people inevitably "weave various voices into their own utterances, particularly as they prepare and assess their own creative projects." Youth are often unaware of this process; nonetheless, what one hears in their voices is a kind of "crowded talk," an intertextual form of speaking woven through a mixing together of one's own words with the words of others. Soep concludes from her analysis that production work is profoundly social, even if these social relationships and their effects on youth participants are not always addressed explicitly (see also Weber and Mitchell 2008). Of course, the work of developing production pedagogies that explicitly address the social and political concerns that arise through creative practices is complicated. Community-based media programs have shown some real success in leading this work. In fact, the idea that media production can contribute to young people's agency by fostering an analysis of power relations and the social conditions that shape kids' lives has been a dominant preoccupation in community media programs. There are various reasons for this.

In general, community-based media initiatives around the world are united in the belief that media can be localized. Radio and television, newspapers and magazines, or, now, digital communication networks can be appropriated by amateur producers to tell stories about the places and issues that shape our lives (Tufte and Enghel 2009). In the history of the community video movement in Canada and the United States, this has led to important visions about the ability of local media producers to challenge the power and authority of mainstream commercial and public broadcasters. By taking advantage of portable video and now digital media, the idea has been that students, artists, and social activists can "participate in the production of images that...shape their culture.... Through [this], the mystique of production [is] shattered" and video and other media are turned into a "vehicle[s] through which the social world [can] be...documented" and the public sphere remade (Berko, quoted in Burnett 1996, 292). Various models of media production have been offered over the years to encourage this work. In particular, the Educational Video Center in New York City—an organization profiled in Chapter 18 of this volume—has developed a powerful example of a democratically oriented

learning curriculum. If EVC is one example, however, other researchers have explored additional strategies for linking creative media work to issues of citizenship.

Michelle Stack (2008), for instance, focuses on youth–adult collaborations as the context for making videos that explore both the pleasurable aspects of media culture and those aspects that need to be critically analyzed and challenged. Stack's study reports on a unique university media education course she created in a mid-size Canadian city that brought together teenagers from a lower-middle-class high school and university students, most of whom were training to work as teachers, counselors, or child and youth care workers. Both the high school students and the university students engaged in media literacy discussions before working in small groups (with at least one teenager and one university student) to make videos that explored the role of media consumption and production in teens' lives. The students' backgrounds with media literacy no doubt influenced their approach (Stack 2008, 118–119). But Stack notes that the collaborative production process itself created an important opportunity for participating teens to situate their work in a public context.

On the one hand, collaborating with adults forced the youth to define what they mean by a "youth issue." Initially, the adult participants did this and listed concerns like "eating disorders, drugs, alcohol, and unprotected sex" (Stack 2008, 120). To the high school students, this list represented the "stuff [they hear about] all the time" in school (quoted in Stack 2008, 121). As such, these were not understood to be youth issues as much as schooling issues. In response, the youth proposed a different set of concerns, including the environment, the war in Iraq, and consumerism. What's interesting about the second list (and the videos that evolved from it) is not that it is necessarily more public or political than the first; rather, the point is that the collaborative working relationship created an opportunity for teenagers to define their understanding of the public issues that matter to them. Through this, they not only challenged stereotypes that suggest youth are largely apolitical today, they also began to articulate how politics fits in with their lives and their visions of the future.

On the other hand, production work itself allowed the youth to explore ways of knowing that moved beyond traditional versions of adult- (or teacher-) student relationships. Video-making (or other media production practices) typically does not involve information transfer or the kind of fact-based learning that still dominates in many schooling environments. Rather, it allows youth to engage in multiple ways of learning, "including the artistic and the aesthetic" (Stack 2008, 121). Stack found that because of this, teen participants in her study took seriously the power of video as an alternative knowledge source. The appeal of this source, in turn, led "the youth [to see] themselves as playing a vital role in...discovering and generating new knowledge...that would lead them and others to a better under-

standing of the issues they explore in their videos" (Stack 2008, 121). In this sense, the dynamism of media production itself opened up new opportunities for learning, a process that, in turn, led participating youth to take on roles as public actors capable of representing the issues that mattered in their lives.

In Stuart's (Poyntz 2008, 2009) study of a youth media program in Vancouver, Canada, he highlights another way youth media programs can contribute to young people's democratic habituation. Peer-to-peer mentoring has been a feature of informal, community-based youth media production programs since the 1970s. Surprisingly, however, there has been little written about how peer mentorship impacts mentors themselves. What we do know tends to be focused on psychological or vocational changes that result from mentoring experiences. But peer mentoring less-experienced media makers can also have a profoundly democratic influence on how youth see themselves and their social futures.

In Stuart's yearlong ethnography, he followed a group of teenagers hired to mentor less experienced video makers in a summer media institute. Summer Stories is designed to give low-income kids opportunities to become more actively engaged with contemporary media. Developing creative voices while fostering young people's sense of competency, belonging, and power are all parts of this process. So, too, is promoting media literacy, which is done in Summer Stories by nurturing youths' critical viewing and production habits. Alongside these broader objectives, the role of youth mentors in the program is to support, challenge, and guide novice participants over the course of each production cycle. Mentors are typically former students of the program, ranging from sixteen to twenty years of age. Symptomatic of the global influences shaping Vancouver today, the mentors also represent a cross-section of educational levels, socio-economic backgrounds and cultural and ethnic diversity.

Importantly for our purposes, what Stuart's study found is that peer mentoring is an important way in which youth begin to see themselves as social beings, as actors whose lives are bound up in a set of contestable relationships with the media environment in which they live. Mentoring demands that young people listen to other youth. It tends to draw attention to the way commercial media scripts insert themselves into the ideas and self-identities of all media producers, but especially those new to any media form. Identifying this process in turn can help mentors to understand their own social positioning and how they might respond to this through their work. In this sense, mentoring can foster youth's democratic habits of mind by nurturing a form of thinking and doing that is responsive to others, to the fact that we are all part of a shared world.

For many, media production fosters youth agency by helping youth to see themselves in light of the social, political, and cultural forces that shape and enable experience. The hope is that this will lead to a critical examination of our world

and how we act and engage with it now and in the future. The goal of nurturing critical perspectives on contemporary worlds has also been taken up by those interested in media production for less rational ends. Indeed, in the next section, it is to the whole question of pleasure that we turn our attention.

4. The Problem of Pleasure/Play and Critique

The problem of whether and how to address the thorny nexus that links together adolescence, pleasure, and popular culture has long been a challenge in media education. Where media production is concerned, the stakes have only seemed to rise as more young people have opportunities to produce their own work. In part this rise is because the easy pleasure young people often find in popular media culture has been cause for suspicion within educational discourses. Anything that easy to consume can't be good for you, many argue. Of course this sentiment has been around for some time, and if it is beginning to wane, pleasure itself—whether linked to media or not—remains a challenge for educators. This is so because pleasure immediately raises questions of the body and thus sexuality. It raises concerns about transgressive behaviour that pushes beyond the bounds of "proper decorum," raising issues about what is appropriate to address in institutionally mediated learning environments. "Schooling has traditionally been defined largely in instrumental terms. Along with the explicit goals of imparting knowledge, skills and information, the school has also been implicitly mandated to transmit the norms, language, styles, and values of the dominant culture" (Grace and Tobin 2002, 206). As a consequence, questions of pleasure can seem to open a messy and contestable can of worms, pushing many media literacy practitioners, researchers, and scholars to avoid this terrain altogether.

Perhaps because of this, some educators and theorists have been drawn to the challenging role of pleasure in youth media production and have asked: How is agency enabled and fostered when young people explore and leverage the relationship between pleasure and play in media culture and their own identities and possible social futures?

Of course, pleasure is almost always an aspect of youths' relationships with media. It is often what draws kids to certain media texts, and that has a deep bearing on how youth approach making media. Because of this, Kevin Leander and Amy Frank (2006) argue that to understand media production as a social practice "involves understanding how individuals relate to images aesthetically—as pleasing, stylish, 'cool,' beautiful, or tasteful" (185). In a sense, the aesthetic or the pleasurable is a kind of glue that binds together the affective relationships between media production and kids' personal, social, and cultural lives. For many media educators, this point is beyond doubt. In fact, in a very practical sense, for some time now we have known that the pleasures of creative work are a significant part

of the appeal of media production in education (Buckingham 2003a). But pleasure is more than just bait in production work. As evidenced in a study (de Block and Rydin 2006) examining the production and exchange of a series of videos made by refugee and migrant youth, for instance, certain forms of pleasure can also function as codes of belonging among diverse groups of youth.

In the European project, Children in Communication About Migration, for instance, six media clubs were set up for children aged ten to fourteen in six European countries (Germany, Greece, Italy, the Netherlands, Sweden and the United Kingdom). The clubs met weekly after school over a period of a year, producing videos and exchanging them over the Internet on themes ranging from education and peer relations to families and intercultural communication. Among the productions was a subset of rap videos. In examining these productions, Liesbeth de Block and Ingegerd Rydin (2006) note that the youth found pleasure working in this genre not only because they like rap "fashions, language, dance, graffiti, videos and [the] associated technology" (300). The pleasures found in these resources were also related to the way they functioned as codes of belonging that linked together "the feeling of social exclusion among immigrant boys from very diverse backgrounds" (de Block and Rydin 2006, 299–300). Pleasure was not only tied to personal appeal, in other words; rather, to know and love rap was a sign of social awareness, an indication of shared experience and respect that bound kids together who were otherwise separated by geography, language, cultural heritage, and history. Pleasure was not just bait in the production process, then; it was a kind of glue, binding together the social and political lives of disconnected immigrant youth.

In the context of global consumer cultures and the ongoing commodification of hip hop, it is of course possible to over-romanticize the relationship between rap and youths' meaningful social engagement. At the same time, de Block's and Rydin's work offers a sense of how the ludic dimension can play a role in fostering youth agency as media producers. Those of us who have spent time working with young people would concur. What media production enables, in fact, is a kind of affective engagement that is not always well captured when changes in kids' critical thinking is thought to be the primary objective of creative practices. Affective engagement is evident, however, in the glee and excitement kids demonstrate when they pick up a camera to shoot their neighbourhood for the first time, or when they corner an official for an interview on a testy matter. Experiencing this sense of excitement enables a felt sense of belonging to resonate among and between youth media producers. And it is this felt sense of belonging and connection that offers a grounding from which critical engagement with the world can begin.

This theme is taken up more explicitly in a study by Donna Grace and Joseph Tobin (2002), which looks at how children's agency might be furthered by allow-

ing elementary students to create videos according to their own tastes and interests, without the usual restrictions on content that is common with school projects. The intent behind the project was to assess how video production could help foster children's literacy practices in the context of a child-centred pedagogy that challenged typical classroom hierarchies between teachers and students.

For Grace and Tobin (2002), what this exercise served to demonstrate is that under these kinds of circumstances, video production can become a powerful means through which "students can play with the boundaries of language and ideology and enjoy transgressive collective pleasures" (196). They mean by this that video production allowed the students a sense of freedom to explore and parody the meanings and messages within popular culture, as well as to experiment and celebrate their own sense of joy at the physicality of being on camera, performing gestures, facial expressions, and sound effects. "Fueled by the desire to surprise, amuse, and entertain, the content of some of these videos was [of course] of questionable taste, including depictions of drool, burps, blood...violence, and occasional severed body parts" (Grace and Tobin 2002, 200). As Grace and Tobin note, however, we might also interpret this to mean that the videos reflected what Mikhail Bakhtin (1984) called the carnivalesque.

For Bakhtin, the carnivalesque describes instances where laughter, bodily pleasures, and bad taste are used as expressions of freedom, pleasure and desire. Bakhtin suggested that such expressions are important, especially among those with little social power. With few other resources, the bawdy and the body become sites of contestation, a way to challenge systems of order or figures of authority by those on the outside of power. In a similar vein, Grace and Tobin (2002) suggest that we see "the parodic, the fantastic and the horrific, the grotesque, and the forbidden" in the children's videos as an affront to the normal hierarchies and restrictions that govern students' lives in the classroom (201). The excessiveness and silliness of the children's videos is thus an expression of agency, a transgressive challenge to the learning environments where kids spend so much of their days. Of course, Grace and Tobin are aware that foregrounding pleasure in children's media production work can generate unwanted consequences, including harmful language, racial caricatures, and forms of cruelty that are inappropriate in any context. The challenge that their study raises, however, has to do with where media educators are to draw the line around the role of pleasure in production work.

In the past, a modernist assumption that media education necessarily involves rational, conceptual understanding demonstrated through distanced, critical analysis of texts has carried the day. What we are learning more and more, however, is that young people's relationships with media culture and media production are never only rational. Media relationships are always embodied and involved with questions of desire, pleasure and play. These dimensions filter through the

affective intensities we all feel toward certain media texts and production practices. This does not mean that we should excuse the morally and ideologically objectionable practices and representations that can come about when young people produce their own media. It means that "[a]ttempting to assess such work merely in terms of what it tells us about students' conceptual understanding is inevitably reductive" (Buckingham 2003b, 324). Pleasure fosters student interest and student understanding. It knits together our self-identities with our social, cultural, and political lives. As such, it cannot be ignored, but must be made susceptible to a kind of understanding, not only in terms of how it nurtures youth's social engagements, but also in the way it fosters youth identities and learning.

Conclusion

In this chapter, we have identified four questions that school and community-based media educators should take into consideration when planning and implementing media production projects. These form a continuum of key issues embedded in the youth media production process—including vocationalism, youth voice, democratic participation, and pleasure—that are always already present whether they are explicitly addressed or not. In our experience as community-based media educators, we have seen first-hand the value of foregrounding all four of these questions to develop a pedagogy that emphasizes skills development, seeks to give youth a space for personal and group expression, situates youth expression in a broader politics of public participation, and that takes seriously youth pleasure by, in turn, not taking itself too seriously. Working with youth in media production is not a straightforward process and—particularly in school settings—this may involve unlearning some of the institutional relationships associated with traditional models of teacher/student relationships. In community-based projects there is more room for innovation and play, and far less pressure from the various stakeholders that crowd the education system. Thus, we acknowledge that the continuum of key questions in youth media production will play out differently across distinct contexts.

As we engage this discussion—as stated earlier—we do so with some trepidation about the revolutionary characteristics often attributed to the Read/Write world of the Web 2.0 (Lessig 2008). This is not a criticism of Lessig's Read/Write description of the Web 2.0, but rather of the notion that new conditions have radically transformed the conditions and concerns of youth media production. Given our experiences and observations, we wish to express a more limited view of what the new technologies have added to the equation. Thus, the arguments and insights expressed in this chapter both predate and embrace the new Web 2.0 conditions. New technologies have provided an exponential impetus to youth me-

dia production and have guaranteed that youth media production projects—both in schools and community settings—will continue to grow. The key questions that make up the continuum of concerns we develop in this chapter, however, predate the new circumstances. Drawn from years of experience in youth media production contexts, these questions are central to a balanced approach to working with youth in the era of participatory media.

Biographical Note

While now researchers and teachers in universities, the authors bring to this discussion more than twenty years of experience initiating and implementing media production programs in schools and community-based settings. Stuart's work as the director of education at Vancouver's Pacific Cinémathèque has largely been focused on digital video production. As the director of education of Young People's Press, a non-profit news service for youth located in Toronto, Canada, Michael's work has largely been centered in print-based journalism.

References

Bakhtin, Mikhail. 1981. Discourse in the Novel. In *The Dialogic Imagination: Four Essays by M.M. Bakhtin*, edited by M. Holquist. Austin: University of Texas Press.

––––––. 1984. *Rabelais and His World*, trans. H. Iswolsky. Bloomington: Indiana University Press.

Buckingham, David. 1999. The Place of Production: Media Education and Youth Media Production in the UK. In *Children and Media: Image, Education, Participation*, edited by Cecilia von Feilitzen and Ulla Carlsson, 219–28. Göteborg: International Clearinghouse on Children and Violence on the Screen.

–––––. 2006. The Media Literacy of Children and Young People: A Review of the Research Literature. 1–71. London: Centre for the Study of Children, Youth, and Media, Institute of Education.

–––––. 2003a. *Media Education: Literacy, Learning and Contemporary Culture*. Cambridge: Polity.

–––––. 2003b. Media Education and the End of the Critical Consumer. *Harvard Educational Review* 73(3): 309–27.

Burnett, Ron. 1996. Video: The Politics of Culture and Community. In *Resolutions: Contemporary Video Practices*, edited by Michael Renov and Erika Suderburg, 283–301. Minneapolis, MN: University of Minnesota Press.

Connell, Ian, and Geoff Hurd. 1989. Cultural Education: A Revised Program. *Media Information Australia*, no. 53 (1989): 23–30.

de Block, Liesbeth, and Ingegerd Rydin. 2006. Digital Rapping in Media Productions: Intercultural Communication through Youth Culture. In *Digital Generations: Children, Young People, and New Media*, edited by David Buckingham and Rebekah Willett, 295–312. Mahwah, NJ: Lawrence Erlbaum Associates.

Drotner, Kirsten. 2008. Leisure Is Hard Work: Digital Practices and Future Competencies. In *Youth, Identity and Digital Media*, edited by David Buckingham, 167–84. Cambridge, MA: MIT Press.

Fleetwood, Nicole. 2005. Authenticating Practices: Producing Realness, Performing Youth. In *Youthscapes: The Popular, the National, the Global*, edited by Sunaina Maira and Elizabeth Soep, 155–72. Philadelphia: University of Pennsylvania Press.

Goldfarb, Brian. 2002. *Visual Pedagogy: Media Cultures in and Beyond the Classroom*. Durham, NC: Duke University Press.

Grace, Donna J., and Joseph Tobin. 2002. Pleasure, Creativity, and the Carnivalesque in Children's Video Production. In *The Arts in Children's Lives*, edited by L. Bresler and C.M. Thompson, 195–214. Dordrecht: Kluwer Academic Publishers.

Huesca, Robert. 2009. Ethical Challenges in U.S. Youth Radio Training Programs. In *Yearbook 2009: Youth Engaging with the World—Media, Communication and Social Change*, edited by Thomas Tufte and Florencia Enghel, 249–64. Göteborg, Sweden: International Clearinghouse on Children, Youth and Media.

Kelly, Deirdre M. 2006. Framework: Helping Youth Counter Their Misrepresentations in Media. *Canadian Journal of Education* 29(1): 27–48.

Leander, Kevin, and Amy Frank. 2006. The Aesthetic Production and Distribution of Image/Subjects among Online Youth. *E-Learning* 3(2): 185–206.

Lessig, Lawrence. 2008. *Remix: Making Art and Commerce Thrive in the Hybrid Economy*. New York: Penguin.

Poyntz, Stuart R. 2008. Producing Publics: An Ethnographic Study of Democratic Practice and Youth Media Production and Mentorship. Ph.D. Dissertation, University of British Columbia.

———. 2009. "On Behalf of a Shared World": Arendtian Politics in a Culture of Youth Media Production. *Review of Education, Pedagogy and Cultural Studies* 31(4): 365–86.

Soep, Elisabeth. 2006. Beyond Literacy and Voice in Youth Media Education. *McGill Journal of Education* 41(3): 197–213.

Stack, Michelle. 2008. Spectacle and Symbolic Subversion: Canadian Youth–Adult Video Collaborations on War and Commodification. *Journal of Children and Media* 2(2): 114–28.

Trend, David. 1997. *Cultural Democracy: Politics, Media, New Technology*. Albany: State University of New York Press.

Tufte, Thomas, and Florencia Enghel. 2009. Youth Engaging with Media and Communication: Different, Unequal and Disconnected? In *Yearbook 2009: Youth Engaging with the World—Media, Communication and Social Change*, edited by Thomas Tufte and Florencia Enghel, 11–18. Göteborg: International Clearinghouse on Children, Youth and Media.

Weber, Sandra, and Claudia Mitchell. 2008. Imaging, Keyboarding, and Posting Identities: Young People and New Media Technologies. In *Youth, Identity, and Digital Media*, edited by David Buckingham, 25–48. Cambridge, MA: MIT Press.

Willett, Rebekah. 2008. Consumer Citizens Online: Structure, Agency, and Gender in Online Participation. In *Youth, Identity, and Digital Media*, edited by David Buckingham, 49–69. Cambridge, MA: MIT Press.

17

Practicing Sustainable Youth Media[1]

Antonio López

Introduction

Communication, culture, and society have always been intrinsically ecological—that is, they do not stand outside the stream of life of which they are part. Furthermore, because these human processes dominate the interests of other species, they can be said to have a tangible impact on systems of which they are part—in many cases, profoundly degrading them. The semiosphere and the biosphere...are entwined. When we act on the world in a planned way, we operate symbolically: We cut, dig, gouge, hack, build, enclose, and otherwise shape the environment in ways that reflect cultural norms, myths, archetypes, and ideologies. Such action is intrinsic to being in the world; it is also communicative. Conversely, all communication is biospheric in its action. From the molecular exchanges of sensory organs and the passage of electromagnetic fields to the vast industrially based infrastructures that support communication industries, communication and culture are material forces.

Tom Jagtenberg and David McKie
Eco-Impacts and the Greening of Postmodernity

David Orr argues that all education is environmental education, whether or not it acknowledges its underlying ecological bias (Orr 1994, 12).[2] In this same vein I see all media as ecologically pedagogical, even more powerful than formal education. In a study of the correlation between consumption in the United States and advertising, Robert J. Brulle and Lindsay E. Young point out that $971 in ad dollars were spent per capita in the United States in 2005, and that from the period between 1900 and 2000, there was a direct correlation between advertising dollars and increased consumption (Brulle and Young 2007, 527). When it comes to specific environmental messages, according to the National Environmental Educa-

tion & Training Foundation's study of environmental literacy in America, as of 2001 63% of people got their information about the environment from television (Coyle 2005, 15). Not only is our mainstream media model coeval with the system of advertising and consumption, it clearly parallels the increasing destruction of our biosphere. Nonetheless, the idea of passive media consumption is one-dimensional and old school. Today's youth simultaneously produce, consume, and network with media, engaging a far more complex environment in which messages about consumption and ecology are circulating. However, even if youth were ignoring consumption messages, as media makers they are likely unaware of how their media tools impact the environment. The CO_2 emissions produced by our communications system roughly equals those produced by the aviation industry, and the toxicity of our disposable electronic gadgets is increasingly unjust due to the externalization of their material production, extraction, and disposal processes (see Lewis and Boyce 2009; Greenpeace 2010; Leonard 2007).

This situation requires a shift from mere media consumption to green media citizenship: "Economic citizenship predicated on limitless media growth diminishes potentially egalitarian and sustainable production, consumption, and participation, because it omits the impact on climate change of media technology and uptake.... Green citizenship looks centuries ahead, refusing to discount the health and value of future generations as it opposes elemental risks created by capitalist growth in the present. This necessitates an eco-ethical orientation toward the media" (Maxwell and Miller 2009, 19–20). Media education can address participation in what Roger Silverstone calls the "mediapolis," our collective space of civic and democratic participation within the realm of globally mediated technology. He argues citizenship skills require "the kinds of judgment and reflexivity which underpin the idea of literacy at every level in the mediapolis: a critical understanding of media and mediation as a global practice with significant consequences for the way we all live" (Silverstone 2007, 182). Silverstone and other media ethicists are justified in their calls for media literacy as a mitigating factor for diminished democratic participation and its ecological consequences, but what form would it take, especially when considering sustainability as a key aspect of global media citizenship?

By implication, cultural citizenship calls for improving public discourse through a kind of information proficiency advocated for by so-called "protectionists"—media educators who focus on analyzing media texts as a way of promoting critical literacy and a better-informed citizenry. But Kathleen Tyner cautions, "Protectionist approaches of this type, especially in regard to television critical viewing, argue that media education could blunt the effects of media and popular culture through structured critical thinking exercises with children about the constructed nature of media. These views are at loggerheads with traditional literacy

theories that envision literacy as a pathway to social capital, independent thinking, and pleasure" (Tyner 2010, 4). David Buckingham argues that media literacy is the outcome of media usage, but media education is what shapes practice. He calls for an approach that is not just about technology and information, but media as *cultural forms*:

> Media education…is both a critical and a creative enterprise. It provides young people with the critical resources they need to interpret, to understand and (if necessary) to challenge the media that permeate their lives; and yet it also offers them the ability to produce their own media, to become active participants in media culture rather than mere consumers. It therefore involves the rigorous analysis of media texts, in terms of the visual and verbal 'languages' they employ and the representations of the world they make available; the study of the companies and institutions that produce media, and how they seek to reach their target audiences; and the creative production of media in a range of genres and formats (Buckingham 2007, 145).

Buckingham's approach is a starting point for youth media that incorporates the skills necessary for green cultural citizenship.

One of the primary tasks is to develop technological literacy, not just in the sense of how a machine works, but the broader issue of technology's role in society as a cultural form. As one of the premier historians of technology, Thomas P. Hughes, argues, "Environmentalists educate the public about endangered species, the decrease in biological diversity, and the loss of sustaining habitat. On the other hand, persons informing the public about technological change and the state of the ecotechnological environment, especially the human-built part of it, are few in number. To participate, the public needs to become technically and aesthetically literate, as well as being morally concerned about the role of humans as creators" (Hughes 2004, 170). The great technology critic Lewis Mumford put it this way:

> "If we are to prevent megatechnics from further controlling and deforming every aspect of human culture, we shall be able to do so only with the aid of a radically different model derived directly—not from machines, but from living organisms and organic complexes (ecosystems). What can be known about only through the process of living—and so is part of the experience of even the humblest of organisms—must be added to all the other aspects that can be observed, abstracted, measured" (Mumford 1970, 395).

The core of this technological literacy would be to identify the difference between mechanistic and organic uses of media.

Briefly, mechanism, like Mumford's megatechnics, is a worldview that emerged from the Industrial and Scientific Revolution and is characterized by a Cartesian subjectivity that objectifies the natural world. Historian and ecofeminist scholar Carolyn Merchant summarizes the differences as such: "In the organic world, order meant the function of each part within the larger whole as determined by its nature,

while power was diffused from the top downward through the social or cosmic hier-
archies. In the mechanical world, order was redefined to mean the predictable be-
havior of each part within a rationally determined system of laws, while power
derived from active and immediate intervention in a secularized world. Order and
power together constituted control. Rational control over nature, society, and the
self was achieved by redefining reality itself through the new machine metaphor"
(Merchant 1989/1980, 192–193). Scholars inspiring the so-called media ecology
discipline stress that the *machine form* derives first from an ontological framework,
what Jacques Ellul (1964) calls *technique*, and Lewis Mumford (1967) refers to as
the *megamachine*. As an ordering principle, mechanism permeates all aspects of soci-
ety, from economics to media systems to education, and is at the root of our ecologi-
cal crisis. Its pervasiveness is so deep-rooted that we often fail to see it.

Consequently, even the best-intentioned media education can unconsciously
carry with it a larger pedagogical project that lacks an ecological dimension. For ex-
ample, issues of concern defined in the above Buckingham quotation make no men-
tion of sustainability, yet "companies and institutions that produce media" are very
much at the center of whether or not the mediapolis will effectively grapple with the
primary challenge of current and future generations: climate change. Such a silence is
so natural that we fail to see how absent it is from any meaningful discussion of me-
dia and education. In all fairness to Buckingham and the rest of us who are products
of social science, cultural and media studies, and by extension the field of media edu-
cation, we have yet to make the turn that feminist, queer, and postcolonial studies
have made in our fields of inquiry. Tom Jagtenberg and David McKie contend:

> Communication and cultural studies in their egalitarian modes parallel science's utopian
> and visionary aspirations.... Both participate in a common Western 20th-century intellec-
> tual journey and are still rounding similar corners: the linguistic turn where everything
> seemed to hang on language; the feminist sweep that transformed contents, methods, and
> paradigms; the self-reflexive curve where everyone had to demonstrate awareness of their
> own practices; and the postmodern bend where everything had to be relativized and de-
> centered. In traveling such paths, communication and cultural studies have done more
> work than science, yet both need to stay true to their respective projects' emancipatory
> roots, to come to terms with the environment and its ecological imperatives as the fourth
> dimension of social space. (Jagtenberg and McKie 1997, 220)

John Barry argues that there are four central assertions necessary for greening social
theory that are also applicable to media education. They are "a rejection of the sepa-
ration of 'humanity' and 'environment'; a stress on the biological embodiedness and
ecological embeddedness of humans; viewing social-environmental relations as not
only important in human society, but also constitutive of human society; and a claim
that social-environment relations are of moral concern" (Barry 1999, 216). The final
point was already made: the state of our biosphere requires immediate action from

all sectors of society, media educators in particular. But the first three arguments, though obvious if you study ecology, are not intuitive to subjects of modernity. As a result, the growing academic field of environmental communication is addressing the manner in which culture determines what is "environmental" and what is not.[3] Media studies is well versed in the tactics by which media construct identity and ideology (such as issues around race, gender, and sexuality), but often neglects nature as part of the analysis. Julia B. Corbett points out:

> "nature," and in a different way "environment," are complicated cultural concepts, not just words. Nevertheless, they *communicate*. The words and how we use them interpret and define what exists beyond humans. This is nature, that is not. This is an environmental issue, but this is not. The definitions and meanings to a certain extent influence our behaviors and practices and our communication about it…. That is not to say, however, that nature or environment or whatever we want to call it is one big social construction and doesn't really exist out there independent of us and our definition of it. The physical, nonhuman world does exist; ecosystems and their inhabitants would unfold and continue just fine without humans. *Social construction*—the definitions and meanings we come to accept through our social interaction—is just one component. Other components are the historical and cultural contexts in which we live and the unique sets of individual experience we carry with us. (Corbett 2006, 6)

There is no reason why media education should not address our ability to see ourselves (or not) as embedded in (and as part of) the environment, and the relationship between social systems and the earth. This is the task ahead.

Making the Turn Toward Organic Media Education

For an epistemological framework to connect youth media and ecology, there's an account from the first contact between Spanish conquistadors and the Hopi that illuminates divergent ways of seeing and living in the world. As the story goes, in 1540 when the Hopi, in what is now northern Arizona, encountered the cross-bearing Castilians, they interpreted the crucifix from a defamiliarized perspective. In its grid they saw a form of linear thinking that represented skilled engineering and manipulation of the material realm, but they recognized the Spaniards' Cartesian perspective as unbalanced because it lacked one key element: a circle. By contrast the medicine wheel, a common emblem among North American tribes, has an encircled cross, which represents a holistic map of the cosmos. Embedded within the circle, the cross comes to represent the four directions, with its cyclical nature indicated by the motion of the seasons. It is also a good visualization of ecology's primary assertion: Everything is connected to everything else (with the caveat that not all things are connected equally). In my view the cross without a circle metaphorically represents an unbalanced mind that emphasizes left-brained thinking, which is abstract, linear, scientific, and rational.[4] An organic, circular

view of the world is pattern oriented, and is distinguished by music, art, and spatial thinking, all characteristic of how the right-brain processes nerve stimulation. As the Hopi recognized, both are necessary, hence the cross-embedded circle symbolically models an organic perspective, because without holistic minds, we cannot conceive sustainable patterns of life. Youth media, if done according to a balanced methodology, can help achieve a healthy interaction with the world that will correct what the Hopi call *koyaanisqatsi*—life out of balance.

Youth media can make an ecological turn by combining media education (as defined by Buckingham) with ecoliteracy. Such a shift means transitioning from a mechanistic to an organic framework. First, we need to see how mechanistic media and education are analogous. For example, the linear information model conceived by Shannon-Weaver (sender-channel-noise-receiver) parallels the transmission and conduit concept of teaching: the professional teacher (rational subject) sends coded information through lectures (channel) where students (presumably rational subjects) listen (adding noise through distraction or inability to clearly understand lecturer's transmission) and receive the information in order to decode it, only later to regurgitate the ruminants into an exam. An alternative and organic way of thinking about media and education includes *ritual* (Carey 2009), which emphasizes the social character of knowledge within a specific context. Additionally, the changing view of media consumption as *agency* and *practice* (Couldry 2006) parallels the idea of student-centered learning promoted by sustainable education (Sterling 2004). Finally, these approaches are in line with best practices advocated by proponents of *multiliteracies* (Tyner 2010). If ecoliteracy and media education share a common approach, it would be to stress dialogue, learning by doing, and convergence culture practices described by Henry Jenkins (2006), such as collective intelligence, participatory culture, affective economics, and transmedia storytelling. Underlying the difference between mechanistic and organic approaches is a conception of intelligence that transitions from the view of the brain as a programmable machine to one in which the mind is conceived of as a garden. The former can be injected with information; the latter requires cultivation.

Sustainable education theorist Stephen Sterling (2004) argues for a model of transformative education that combines two approaches: education *for* sustainability, which refers to the content of education, and education *as* sustainability, which is about education's form. This parallels Buckingham's concept of media education. Both mirror my efforts to develop a holistic model that combines critical engagement of media systems, media making, and principles of ecoliteracy called "mediacology."[5] I like to think of this method as a kind of *(re)mediation*. The original use of the term *remediation* denotes the repair of damaged ecosystems. *Mediation* is the manner in which the world is interpreted by means other than direct observation. *(Re)mediation* is the repair of our damaged relationship with broader ecosystems (as

described by Barry in his call for green social theory), and also the repurposing of useful communication models for sustainability advocated by the emerging field of environmental communication. "*Re*" signifies that humans are always in the process of recycling/composting/repurposing the symbolic world.

In the same way that deep ecology is transformative as opposed to reform-oriented, *deep* mediacology is a holistic approach that combines mindful inquiry of media with an organic media-making approach.[6] In other words, deep mediacology eschews the separation between form and content in media education, and considers youth media to be both about learners critically engaging media forms in relationship with their place in the world, but also about becoming active and holistic creators of media. In sum,

- Deep mediacology is media education *for* sustainability through the disarticulation of the mechanistic paradigm through mindful inquiry and critical engagement.

- Deep mediacology is media education *as* sustainability through the (re)articulation/(re)creation of an organic paradigm through media making.

The goal is to encourage learners to mindfully engage media in relationship to environmental themes and concerns, and to become organic practitioners that embody sustainable behavior.

Learning from Pattern

The anti-technology polemics of some ecologists is as problematic as the absence of environmental themes in the practice of media education. Ultimately such dichotomies don't offer us a way to recognize that there are actually a number of ecologically oriented behaviors in media usage that can serve as a bridge to sustainability. Still, making the transition will entail professional discord. As Kuhn famously pointed out, scientific paradigm shifts lead to tremendous disorder. For example, in describing the conflict between traditional and new media, media ethicist Deni Elliot points out, "One hallmark of paradigm shift...is that a significant number of relevant parties realize that old assumptions for content and process in the social institution under examination no longer hold. Yet, even as the new paradigm is clashing with the old, practitioners in the field need to keep functioning. The 'pre-paradigm' period—the time in which new understandings and conventions are in development—is notable for its lack of consensus" (Elliot 2009, 28). In terms of an ecoliterate youth media, we are definitely in a "pre-paradigmatic" stage, yet we need to "keep functioning" in our field. What follows, then, is an effort to establish some orientation points that can help guide the work toward an ecological orientation.

Table 1: Transmissive Versus Transformative Media Literacy

Transmissive Media Literacy Education for Change	Transformative Media Literacy Education for Change
Message outcome ("smoking is bad")	Construction of meaning (tobacco ads are part of a larger system)
Text as object of study	Text as hermeneutical exploration
Deconstruction	Reconstruction
Behavioral change (drinking, smoking less, consuming more consciously)	Students find new and interesting interpretations and uses of media
One size fits all: standard deconstruction model and assumptions about nature of information as objects, media as a syringe	Student's context just as important: culture, psychology, spiritual, emotional, environmental context
Autonomous learners	Collective intelligence
Expert paradigm: teacher knows best	Local ownership
First order change	First and second order change
Product oriented (outcomes, rubrics)	Process oriented: production is as important as textual analysis
Problem solving: what does this media example mean?	Problem-reframing: how did this media example come into existence?
Rigid (ideological, i.e., critical theory)	Dynamic (culture studies), responsive
Factual skills: replicating deconstruction skills	Understanding relationship between media and environment

A primary difficulty for bringing ecoliteracy into the fold is its converse framework (see Table 1). Neoliberal education systems are generally more concerned with product than process, and as most working teachers know, standardized curriculum these days is all about outcomes and measurable rubrics. No doubt these are important, but one of the harder things to accept about ecological approaches to education is that it is actually difficult to quantify "sustainable behavior" because it is like creating a new language—we do it collectively and it emerges as we create it. However, in broad strokes, a policy developed by Education for a Sustainable Future outlines some key competencies. Such ecoliterate practitioners will have:

- a deep understanding of complex environmental, economic, and social systems;

- recognition of the importance of the interconnectedness of these systems in a sustainable world;

- respect for diversity of points of view and interpretation of complex issues from cultural, racial, religious, ethnic, regional and intergenerational perspectives. (Byrne 2000, 49)

In terms of achieving these goals, physicist and systems theorist Fritjof Capra warns, "Because living systems are nonlinear and rooted in patterns of relationships, understanding the principles of ecology requires a new way of seeing the world and of thinking—in terms of relationships, connectedness, and context—that goes against the grain of traditional Western science and education" (Capra 2005, 20). Despite these obstacles, though, he offers a model for ecoliteracy that can guide curriculum design.

"Contextual" and "systemic" ways of thinking, Capra argues, consist of several perceptual shifts: "from the parts to the whole"; "from objects to relationships"; "from objective knowledge to contextual knowledge"; "from quantity to quality"; "from structure to process"; and "from contents to patterns" (Capra 2005, 20–21). Clearly these challenge reductionist approaches to media education that focus exclusively on oppositional readings of media content (because such literacy approaches assume a mechanical view of intelligence). Capra's ecoliteracy approach is founded on process, which complements media education's prerogative to explore the cultural form of media. From this perspective, there are a number of new media practices that are indeed ecological in scope. For instance, concerning network technology, Manuel Castells's primary take-home message is about their pedagogical nature: "The networking of production, the differentiation of consumption, the decentering of power and the individualization of experience are reflected, amplified and codified by the fragmentation of meaning in the broken mirror of the electronic hypertext, where the only shared meaning is the meaning of sharing the network" (quoted in Rantanen 2005, 144). As such, many new media users are already shifting into the perceptual model advocated by Capra because, unlike the standard notion of passive media consumers, their media engagement is characterized by relationships, contextual knowledge, quality, process, patterns and the whole (see Table 2).[7]

Table 2: Transmissive Versus Transformative Media Structures

Industrial Media	Networked Media
Broadcast: one-to-many	Flow: many-to-many
Selling/propaganda	Stories
Push	Pull
Intellectual property/copyright	Open source/creative common
Information object/thing	Relationship/event/intertextuality/remix
Consumerism	Affective economics
Expert paradigm	Collective Intelligence
Limited channels	Transmedia storytelling
Hierarchal culture	Participatory culture

With youth migrating to social networks and engaged in new media practices described by Jenkins's (2006) convergence culture model, our contemporary me-

dia education environment is epistemologically different from the system most of us were educated in. The image of single-tower broadcasting to the general public represents the old communication model ("one-to-many"), while a web of filaments (a very natural metaphor) represents the new paradigm ("many-to-many"). Lawrence Lessig (2008) refers to the old system as based on "Read/Only" (RO) media, which is commodified information controlled by a strict regime of copyright and "tokens" such as books, DVDs, or CDs. Such a culture is predicated on a hierarchal model of mass markets, production and consumption. The new paradigm, an emerging networked culture based on the "social Web" (Web 2.0) embodies different attitudes and skills, what Lessig calls "Read/Write" (RW), a culture that reads and writes in vernacular media. These new practices involve user-generated media made by "prosumers" that remix, collaborate, and operate in hybrid community spaces that are a mix of sharing and commercial economies. Accordingly, Capra (2004) argues that because online networks are openly interconnected, they behave like self-organized living systems. In this regard, one of the keys for moving our society into a sustainable direction is to reorganize institutions (education and business especially) toward the model of living organizations.[8] In youth media it means highlighting the connection between new media uses and sustainable forms of social organization. In essence, the distinction between RO and RW cultural practices is the difference between "closed" and "open" systems. Likewise, ecological solutions correspond with how we conceptualize the role of media-making, culture, and communication. Ecological media education has to utilize new models of production, many of which can be found in RW culture as opposed to RO.

Practicing Deep Mediacology

Practice is something that we do to improve skills, but it is also a process of experimentation and play. Practice in the sense of the latter meaning is the underlying attitude of what follows.

One of the prime directives of sustainability is to look at design as a foundation for redirecting our energies into an ecological paradigm. In terms of media education, I have referred to this as *media permaculture* (see López 2008), which applies an organic model of agriculture to media (this is not so strange if you consider how several media-related words come from farming, such as *culture*, *broadcast* [of seeds], and *field* [in Italian "field" is used for "signal"]). Vandana Shiva (1993) compares unsustainable cultural attitudes to a monoculture of the mind, the antidote being biocultural diversity derived from the "soil of culture" (see Shiva 2008). In regard to media education, I have argued that mainstream media literacy is about the products of design (i.e., deconstructing media texts), whereas media permaculture requires that we look at the design of media instead (how

these texts come to be). But this latter approach means that we still remain within the media logic of the text (i.e., the commercial and attention-grabbing prerogative of commercial media). It doesn't offer us a path outside the media system's thinking process, nor away from the conventional theories used to explain it. Likewise, focusing exclusively on texts disregards the various media "traditions" that audiences engage in. For example, Lucila Vargas's study of transnational Latina teens revealed that they are media "polyglots" with "polyphonic selves" who navigated upward of four different popular culture traditions: white/Anglo hegemonic, black, Latino/a, and global Spanish language (Vargas 2009, 206–207). This is further complicated by the intertextual nature of media, which requires not just deconstruction skills but also genre literacy that helps explain how texts find their cultural niches (see Gray 2006). Such a multifarious media environment mirrors the complexity an ecological outlook seeks to address.

For ecologically oriented youth media to be effective it needs an alternative framework for inquiry and response. For this we can turn to ecological designers who apply an integrated approach to design, function, and nature to endeavors as diverse as gardening, architecture, community planning, and education. These principles are mutually dependent because nature is itself integrative. Andres R. Edwards, whose book *The Sustainability Revolution* surveys the major approaches to sustainability, highlights the Ecological Design Institute's (EDI) five core concepts for ecological design: "1) Solutions grow from place; 2) Ecological accounting informs design; 3) Design with nature; 4) Everyone is a designer; and 5) Make nature visible" (2005, 102). As we'll see, these core principles can be incorporated into ecologically designed youth media programs. They enable us to move into a new paradigm without being handcuffed by old patterns of thought that reinforce outdated thinking about media practice.

I'd like to suggest that there is a kind of transformative media education that aligns EDI's design concepts with Buckingham's four categories of inquiry for media education: representation, language, production, and audience (Buckingham 2007, 155–156). As discussed earlier, nature is eerily absent from media education discourse. We absolutely must "make nature visible" (EDI point five) and, when it is represented, study closely those depictions. Making nature visible could also be done by highlighting those convergence culture practices that leverage sustainable behavior. Along these lines, the language of both media and nature can be compared and investigated, as is the case with the work of environmental communication research.

The perceptual patterns described by Capra are an example of ecological design (EDI point three). Where do they intersect with media and communication? Production can "grow from place" (EDI point one). This is possible in terms of the learner's orientation as an individual, connected being, and embedded organism in the world. Any media that she studies or creates will come from somewhere, so it will be key to

identify the various points of reference she is working within, including community, landscape, and lifeworld. Moreover, as a mediamaker, she is a designer (EDI point four). This last point also highlights the learner's role as audience. As a practitioner and designer she is part of a network of users and creators, and as a consumer is a target of prevailing messages about consumption, which are of ecological consequence. As a consumer and producer, she can make an *ecological accounting* of her work (EDI point two), whether it is in terms of the consumption of electronic gadgets and nonrenewable resources, use of open or closed software and media platforms, the intended effect of her storytelling, or the general role her media usage plays in the scheme of sustainability.

These guidelines, of course, are general and need to be customized and contextualized according to a particular environment. In my own work I have attempted to develop some tactics to integrate these ideas. What follows represents some concrete examples of how deep mediacology can be utilized to promote these values.

Organic World Bridger

Like good youth media programs, ecoliteracy is also student-led. A hybrid of Walter Benjamin's notion of "author as producer" and Antonio Gramsci's "organic intellectual," within the deep mediacology framework the learner is an "Organic World Bridger"—a kind of media permaculture designer/author as producer. "World Bridger" is derived from the Q'chua word *chakaruna*, "bridge person," someone who straddles different paradigms. Organic World Bridgers are fluid mixers of worlds; they are like DJs who can cut and paste and invent new culture (see Fig. 2). The Organic World Bridger is a bit of an artist. She is part of a creative matrix in order to (re)create her world, as opposed to just (re)producing it. As a facilitator, I am also modeling the role of the Organic World Bridger.

Media Wheel and Mixer

Figure 1. Media Wheel Mandala

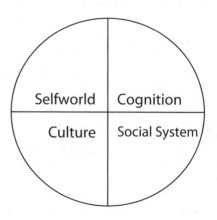

Organic World Bridgers should be fluent in different communications techniques—oral, written, visual, sensual. The media wheel mandala[9] is a visual representation of interrelationships between different fields (Fig. 1) of life experience. Mandalas exist across cultures serving different purposes, but they all have in common a circular/cyclical design. Based on a medicine wheel, the media wheel mandala is a meant to be a kind of "systems mandala." Like a standard medicine wheel, the media mandala is divided into four quadrants.

Now, imagine a DJ mixer set-up: two turntables, a microphone, and a mixer (Fig. 2). Each turntable has a disk representing the two worldviews I have described: mechanistic and organic. Usually a mixer has a "fader" which allows the DJ to mix back and forth between sound sources. When it is directly in the middle, both sound sources are mixed at 50 percent each. The DJ moves the slider left or right depending on how she wants to balance the sound's output. In the case of this particular mixer, depending on the balance between monoculture and organic states, different levels of reality appear or disappear in the four quadrants. For example, if the fader is set to the extreme of monoculture in the upper right quadrant of the media wheel mandala ("cognition"), you get the belief that a mind is a programmable machine. If you move the fader to the maximum of organic culture, then you get the view of a mind as a garden.

Figure 2. Paradigm Mixer

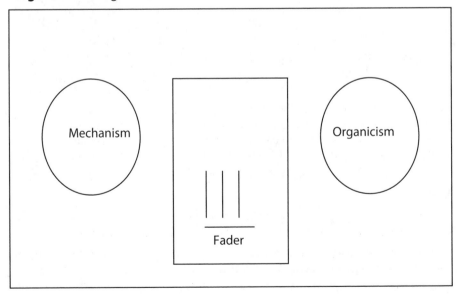

Transformative Media Literacy

A common example of a media literacy curriculum is a CD-ROM/DVD based on a theme ("Health and the Media," "Tobacco and Media," etc.). These CD-ROM/DVDs usually have sections with a series of lessons based on media samples (print ads, TV commercials, film clips). The lessons are generally didactic, depending largely on a teacher leading students through a series of questions and suggested answers. For example, a print ad for cigarettes will be shown to students with a linear series of questions that can lead to only one conclusion: that commercial tobacco ads are manipulative and smoking is bad for you. While these conclusions are certainly true, they don't probe deeper into the context and environment that produced these ads or how they relate to the reader's lifeworld. A deeper exploration would include an understanding of the conflict between the sacred and monocultural uses of tobacco, and the inquirer would have a more profound understanding of her own cultural and personal history related to tobacco (Native American youth involved with traditional ceremonies, for example, will have a different cultural context than suburban youth). CD-ROM/DVDs have the tendency to be closed systems. These curricula usually don't have a production or collaborative component. These kinds of curricula, in my view, do not incorporate many of the goals of ecoliteracy, nor do they connect explicitly with ecological themes.

Likewise, if media education is to synchronize with ecoliteracy, it must incorporate a transformative model of communication. Specific processes include dialogue (Isaacs 1999; Vella 2002), nonviolent communication (Rosenberg 2003), Theory U (Scharmer 2007), and collaborative learning characterized by convergence cultural practices (Jenkins 2006). Critical engagement (as opposed to "thinking") and mindfulness are essential components (Brookfield 1987).

I use a style of media literacy that is centered on dialogue about media messages, which gives learners an opportunity to explore and to contextualize global media frames/forms with local knowledge and experience. I then work to facilitate creating responses to these "media environments" through do-it-yourself media production. As a practitioner of "slow media" (see López 2010), this usually means making media for "internal" or local audiences, but also can be shared for networking purposes on the Web.

Theory U

A technique that facilitates the learner to move the fader through different perceptual modes is a method based on C. Otto Scharmer's Theory U (2007). This is a process that he developed at MIT as part of his study of institutional change and transformational leadership. With youth media, the potential outcome of this process is to empower the Organic World Bridger toward becoming a kind of real-

ity DJ. Ideally she uses these skills as an applied DIY practitioner, philosopher, and activist who can consciously navigate worlds.

A workshop can be structured along the design principles of Theory U. Ideally a program will have as an outcome a collaborative service-leadership project for peer education designed by the host organization, individual participants or development team. In Theory U there are four steps that help organizations, communities, or any groups engaged in collective action to develop a vision. It is called "Theory U" because the process is represented by a "U" shape: We descend from a problem on the upper left side down to the bottom of the U to get beneath its causes, then rise up the right side with a solution. Calling it "developing a capacity to see," Scharmer lists the following steps:

1. Crystallize intention;

2. Move into context;

3. Suspend judgment and connect to wonder;

4. Dialogue: enter into a space of seeing together. (2007, 142)

"Seeing" in this sense means "seeing our seeing," that is, learning to understand and detect patterns in our own perception of a problem. In my youth media projects, normally in our first session, I show some TV ads to generate a discussion about communication strategies. This kind of dialogue is meant to break the ice and to activate student thinking about communication design. We move deeper into deconstruction techniques until participants get a good handle on how ads are designed and how intention is manifested in a media production. Afterward, we start playing with the video camera, learning how to frame shots, use microphones, and work with light. In terms of Scharmer's model, by looking at media texts first, I start with step two, "move into context." It may be that I'm working in the wrong order, but my reason comes from the need to have some theory to explain the process, which is a reflection of how I learned media literacy. Arts-oriented educators argue for more student-led learning at the beginning. You can mix and match what works best for your environment; I'm still experimenting.

Once students feel comfortable with the equipment we start to design an "internal communication"—some kind of message for a local community audience. The "magic" formula is:

• What is your channel of communication (video, print, Web, radio, etc.)?

• What do you want to say?

• Why do you want to say it?

- Who is your audience?

- How are you going to say it?

As simple as this is, you'd be surprised how rarely these questions are incorporated into many media-making workshops, in particular those designed around new media tools. The tendency is to share an enthusiasm with a particular media-making tool, but rarely ask the pertinent question at the beginning: Why communicate in the first place? We assume that people have something to say, but what is the point of communication tools when the content of that communication is secondary? It's like asking beginning art students to draw something without reference to reality.

The first step of the magic formula is usually decided beforehand by the workshop organizers, but occasionally students can choose. The second two steps determine what message we want to communicate. This is where intention really comes in. We are setting the goal of our project, the kind of outcome we'd like to see. My only guideline is that it has to be specific. It can't be general, like "pollution is bad," but must be about a particular topic that focuses on a problem, such as why people don't recycle. The fourth step is to decide what kind of audience would be the target of the message. This is also where we set the context: In what community (or communities) are these media being shared?

Returning to Scharmer's model, we come to the hard part—suspending judgment and connecting to wonder (the bottom of the U in stage three). This is where learners have to collectively script a story, creating something solely from their imagination. This process is always the scariest, because usually we start with writer's block. Then, inevitably, the transformative "ah-ha" moment comes and a spark lights the group's imagination. Suddenly ideas and energy explode and the students are rapidly jotting down and storyboarding ideas. By the time we start shooting, which represents the dialogue phase (stage four), the process becomes play: everyone is seeing together, clicking, having fun, and energized. The final product culminates in a screening with the host community, which is always an inspiring experience that continues the dialogue process. A final wrap-up allows the group to see together how these different phases unfolded. The debriefing can also be used to connect the media-making process with sustainable cultural practice.

Workshop outcomes should be designed around building awareness of the four integral quadrants (as described in the Media Wheel Mandala):

- Self—one's inner-world connection to the outer environment.

- Cognition and body—one's learning and cognitive style and cultivation of an ecological self.

- Culture—the strengths and weaknesses of one's source culture/s; the evolving of new cultural practices through collaborative and artistic practice.

- Social system—one's ability to deconstruct hegemonic messages and the power structure.

For my Theory U discussion I used the example of video making because it is the most common form of youth media, but there are many other tools that can be used. Each of the following can be cultivated depending on your particular environment and project goals.

- Mapmaking/environmental documentation (using media to document learner's landscape of experience).

- Disarticulation of corporate frames of nature through semiotics and media deconstruction.

- Orienteering with the Media Wheel Mandala (situating media in a learner's lifeworld).

- Media making/storytelling (harnessing diverse media tools like photography and art to become empowered communicators in the learner's home community).

- Autoethnographies (journaling or Webcam monologues for self-reflection).

- Convergence media practices (collaborative media-making for the Web).

Curriculum content themes can cover a variety of topics. For ecologically themed work, these can include corporate representations of nature in ads; developing green cultural citizenship; evaluating the ecological claims of store products; deconstructing environmental news and government framing of environmental issues; car ads and the matrix of the oil economy; food—fast food, nutrition, soda and sugar ads, etc.; bottled water; health and the environment; greenwashing; environment and social justice; specific environmental conflicts in the community; global environmental problems like climate change; and alternative media and artist responses to environmental issues.

Conclusion

Robert Cox suggests that environmental communication is a "crisis discipline," meaning that our current predicament calls for urgent action and normative ecological ethics (Cox 2009, 20–29). This urgency comes somewhat into conflict with the best practices of media education, which eschew didactic pedagogy. It is

my hope that a form of media education that is in keeping with the design principles of ecoliteracy can resolve this tension. To reiterate, ecological youth media is less about mechanics and more about gardening. As ecoeducator Satish Kumar puts it, "The word education comes from the Latin term, *educare*, which implies that a teacher draws out what is best in you. All of us have intellect, emotions, artistry, imagination and spirit. Educators should address all of these aspects and bring out each person's unique genius, rather than seeing students as empty pots to be filled up with external information. Like a gardener helps and encourages the plant to emerge from the seed, in the same way a teacher helps and encourages students to realize their potential" (Kumar 2010, 38). Sustainability can only grow and emerge from a culture whose soil has been cared for. Like good stewards of Earth, as media educators it is time for us to start planting and growing.

Notes

1. Acknowledgment: In my effort to evolve a theory of ecologically oriented youth media, it goes without saying that I could not have developed an integrative perspective without the direct experience of engaging youth of diverse cultures. In particular, the many years I spent working with Native American communities taught me an alternative epistemological framework that challenges standard media literacy and educational practices. What follows is an aggregate of the many incredible and important encounters I have had working in dozens of communities, and is a theory-in-progress based on those experiences.

2. Here I'm using ecology as a neutral term, not to mean "good" or "bad," but simply a paradigmatic way of engaging the world, be it mechanistic or organic.

3. See Alexander Wilson (1992); Laurence Coupe (2000); Greg Garrard (2004); William Cronon (1995); Robert Cox (2009); Anders Hansen (2010); Julia B. Corbett (2006); and Tema Milstein (2009). Also *Environmental Communication: A Journal of Nature and Culture* (http://www.tandf.co.uk/journals/titles/17524032.asp), and the Environmental Communications Network (http://www.esf.edu/ecn/default.htm).

4. See my book (López 2008) for a more detailed explanation of the difference between right- and left-brain thinking.

5. One of the challenges of articulating a new paradigm is working with language that carries old assumptions. So one of the difficulties of writing about and envisioning new practices is having to rearticulate and find new ways of expressing ideas that don't fit into current language use. Thus, you will find that throughout, this essay comments on language usage. For a very useful and thorough deconstruction of how language carries prejudices of the past, see C. A. Bowers (2008).

6. For "deep" we could also make analogs with "depth" from depth psychology, or "thick" from Clifford Geertz's "thick description."

7. For more on the impact of networks on culture see Clay Shirky (2008), Lawrence Lessig, (2008) and Yochai Benkler (2006).

8. For more about living organizations, see Joseph Jaworski and Betty Flowers (1996), C. Otto Scharmer (2007), Peter Senge et al. (2005), and Margaret Wheatley (2007).

9. Independently of me, Kathleen Tyner and the College of Communication, University of Texas at Austin, developed a "multiliteracy mandala" which is similar to my own concept of the Media Wheel Mandala. You can see more at http://win-dev.communication.utexas.edu/mandala/.

References

Barry, John. 1999. *Environment and Social Theory*. London; New York: Routledge.

Benkler, Yochai. 2006. *The Wealth of Networks: How Social Production Transforms Markets and Freedom*. New Haven, CT: Yale University Press.

Bowers, C.A. 2008. *Toward a Post-Industrial Consciousness: Understanding the Linguistic Basis of Ecologically Sustainable Educational Reforms*. Eugene, OR: EcoJustice Press, http://www.cabowers.net/ pdf/Book%20on%20language.pdf.

Brookfield, Stephen. 1987. *Developing Critical Thinkers: Challenging Adults to Explore Alternative Ways of Thinking and Acting*. San Francisco: Jossey-Bass.

Brulle, Robert J., and Young, Lindsay E. 2007. Advertising and Individual Consumption Levels 1900–2000. *Sociological Inquiry* 77 (4): 522–542.

Buckingham, David. 2007. *Beyond Technology: Children's Learning in the Age of Digital Culture*. Cambridge: Polity.

Byrne, Jack. 2000. From Policy to Practice: Creating Education for a Sustainable Future. In *Education for a Sustainable Future: A Paradigm of Hope for the 21st Century*, edited by Keith A. Wheeler, Anne Perraca Bijur, 35–72. New York : Kluwer Academic/Plenum Publishers.

Capra, Fritjof. 2004. *The Hidden Connections: Integrating the Biological, Cognitive, and Social Dimensions of Life into a Science of Sustainability*. New York: Anchor Books.

———. 2005. Speaking Nature's Language: Principles for Sustainability. In *Ecological Literacy: Educating our Children for a Sustainable World*, edited by Michael K. Stone and Zenobia Barlow, 18–29. San Francisco and Berkeley: Sierra Club Books.

Carey, James T. 2009. *Communication as Culture: Essays on Media and Society*. Rev. ed. London and New York: Routledge.

Corbett, Julia B. 2006. *Communicating Nature: How We Create and Understand Environmental Messages*. Washington, DC: Island Press.

Couldry, Nick. 2006. *Listening Beyond the Echoes: Media, Ethics, and Agency in an Uncertain World*. Boulder, CO: Paradigm Publishers.

Coupe, Laurence, ed. 2000. *The Green Studies Reader from Romanticism to Ecocriticism*. New York; London: Routledge.

Cox, Robert. 2009. *Environmental Communication and the Public Sphere*. 2nd ed. Thousand Oaks, CA: Sage Publications.

Coyle, Kevin. 2005. *Environmental Literacy in America*. Washington, DC: National Environmental Education & Training Foundation.

Cronon, William, ed. 1995. *Uncommon Ground: Toward Reinventing Nature*. New York: W.W. Norton & Co.

Edwards, Andres R. 2005. *The Sustainability Revolution: Portrait of a Paradigm Shift*. Gabriola, BC: New Society Publishers.

Elliot, Deni. 2009. Essential Shared Values and 21st Century Journalism. In *The Handbook of Mass Media Ethics*, ed. Lee Wilkins, Clifford G. Christians, 28–39. New York; London: Routledge.

Ellul, Jacques. 1964. *The Technological Society*. New York: Knopf.

Garrard, Greg. 2004. *Ecocriticism*. New York; London: Routledge.

Gray, Jonathan. 2006. *Watching with* The Simpsons*: Television, Parody, and Intertextuality*. New York; London: Routledge.

Greenpeace International. 2010. *Make IT Green—Cloud Computing and its Contribution to Climate Change*. Greenpeace, http://www.greenpeace.org/usa/press-center/reports4/make-it-green-cloud-computing (accessed April 14, 2010).

Hansen, Anders. 2010. *Environment, Media and Communication*. New York; London: Routledge.

Hughes, Thomas. 2004. *Human-Built World: How to Think About Technology and Culture*. Chicago: University of Chicago Press.

Isaacs, William. 1999. *Dialogue and the Art of Thinking Together: A Pioneering Approach to Communicating in Business and in Life*. New York: Currency.

Jagtenberg, Tom, and David McKie. 1997. *Eco-Impacts and the Greening of Postmodernity: New Maps for Communication Studies, Cultural Studies, and Sociology*. Thousand Oaks, CA: Sage Publications.

Jaworski, Joseph, and Betty S. Flowers. 1996. *Synchronicity: The Inner Path of Leadership*. San Francisco: Berrett-Koehler Publishers.

Jenkins, Henry. 2006. *Convergence Culture: Where Old and New Media Collide*. New York: New York University Press.

Kumar, Satish. 2010. *Earth Pilgrim: Conversations with Satish Kumar*. Devon, U.K.: Green Books.

Leonard, Annie. 2007. *Story of Stuff, Referenced and Annotated Script*. http://www.storyofstuff.com/resources.html (accessed August 12, 2009).

Lessig, Lawrence. 2008. *Remix: Making Art and Commerce Thrive in the Hybrid Economy*. New York: Penguin Press.

Lewis, Justin, and Tammy Boyce. 2009. Climate Change and the Media: The Scale of the Challenge. In *Climate Change and the Media (Global Crises and the Media)*, edited by Justin Lewis and Tammy Boyce, 3–16. New York: Peter Lang.

López, Antonio. 2008. *Mediacology: A Multicultural Approach to Media Literacy in the 21st Century*. New York: Peter Lang.

———. 2010. Defusing the Cannon/Canon: An Organic Media Approach to Environmental Communication. *Environmental Communication: A Journal of Nature and Culture* 4 (1): 99–108.

Maxwell, Richard, and Toby Miller. 2009. Talking Rubbish: Green Citizenship, Media and the Environment. In *Climate Change and the Media (Global Crises and the Media)*, ed. Justin Lewis and Tammy Boyce, 17–27. New York: Peter Lang.

Merchant, Carolyn. 1989/1980. *The Death of Nature: Women, Ecology, and the Scientific Revolution*. New York: Harper & Row.

Milstein, Tema. 2009. Environmental Communication Theories. In *Encyclopedia of Communication Theory*, edited by S. Littlejohn and K. Foss, 344–349. Thousand Oaks, CA: Sage.

Mumford, Lewis. 1967. *The Myth of the Machine: Technics and Human Development*. New York: Harcourt Brace Jovanovich.

———. 1970. *The Pentagon of Power*. New York: Harcourt Brace Jovanovich.

Orr, David W. 1994. *Earth in Mind: On Education, Environment, and the Human Prospect*. Washington, DC: Island Press.

Rantanen, Terhi. 2005. The Message Is the Medium: An Interview with Manuel Castells. *Global Media and Communication* 1 (2): 135–147.

Rosenberg, Marshall B. 2003. *Nonviolent Communication: A Language of Life*. Encinitas, CA: PuddleDancer Press.

Scharmer, Claus Otto. 2007. *Theory U: Leading from the Emerging Future*. Cambridge, MA: Society for Organizational Learning.

Senge, Peter M., Claus Otto Scharmer, Joseph Jaworski, and Betty Sue Flowers. 2005. *Presence: Exploring Profound Change in People, Organizations, and Society*. New York: Doubleday.

Shirky, Clay. 2008. *Here Comes Everybody: How Digital Networks Transform Our Ability to Gather and Cooperate*. New York: Penguin Press.

Shiva, Vandana. 2008. *Soil Not Oil: Environmental Justice in a Time of Climate Crisis*. Cambridge, MA: South End Press.

Shiva, Vandana, and Third World Network. 1993. *Monocultures of the Mind: Perspectives on Biodiversity and Biotechnology*. London; Penang, Malaysia: Zed Books; Third World Network.

Silverstone, Roger. 2007. *Media and Morality: On the Rise of the Mediapolis*. Cambridge: Polity Press.

Sterling, Stephen. 2004. *Sustainable Education: Re-Visioning Learning and Change*. Devon, U.K.: Green Books.

Tyner, Kathleen. 2010. Introduction: New Agendas for Media Literacy. In *Media Literacy: New Agendas in Communication*, edited by Kathleen Tyner, 1–7. New York; London: Routledge.

Vargas, Lucila. 2009. *Latina Teens, Migration, and Popular Culture*. New York: Peter Lang.

Vella, Jane Kathryn. 2002. *Learning to Listen, Learning to Teach: The Power of Dialogue in Educating Adults*. San Francisco, CA: Jossey-Bass.

Wheatley, Margaret J. 2007. *Finding our Way: Leadership for an Uncertain Time*. San Francisco: Berrett-Koehler Publishers.

Wilson, Alexander. 1992. *The Culture of Nature: North American Landscape from Disney to the Exxon Valdez*. Cambridge, MA: Blackwell.

"Mad Hard Fun":

Building a Microculture of Youth Media in

New York City Transfer Schools

Steven Goodman

Introduction

The roots of youth media in the United States can be traced to the fields of community media arts, progressive education, youth development, and media literacy. These programs, most of which serve youth of color and youth of poverty, are known for the high quality of the media products and the transformative *process* that the youth experience while producing them. Whether they teach video, radio, magazine, photography, and, more recently, new digital media production, the most well-developed models of this work over the past two decades have been situated institutionally in the out-of-school sector. Free from the institutional constraints that most schools impose—such as state-mandated standardized testing, class size and duration, surveillance and social control—these programs report student outcomes that schools struggle to achieve, including increased critical literacy skills and involvement in social justice and community improvement projects, stronger adult transition skills, and formation of new identities (Akom et al. 2008; Butler and Zaslow 2004; Goodman 2003; Grantmakers in Film and Electronic Media 2006, 3–5; Stuart Foundation 2006, 24).

However, these out-of-school youth media programs serve only a tiny fraction of students in the United States. In a recent field mapping report, nearly half of the youth media organizations surveyed provide training for only up to one hun-

dred youth per year (Tyner 2009, 13; see also chapter 1, this volume). This limited reach leaves out those young people who can most benefit from participating in this transformative work, particularly those struggling learners in large urban school districts who are disengaged and dropping out of high school at rates close to 50% (Bridgeland et al. 2006; Noguera 2009).

Even as the U.S. school system presents numerous structural and cultural impediments that are closing down options for integrating youth media programs in schools, the continued growth of small-school networks, and calls to "resize the school day and year" with expanded school-day programs designed for disengaged students, are creating new openings (New York City Department of Education 2006; TASC 2009). Strategies for aligning students' academic identities with the habits and demands of school in "academic microcultures" (Jackson 2003) present new ways to conceptualize how youth media can fit in these openings. For youth media's pedagogical practices to be effectively brought into scale in partnership with schools, research is needed to deepen our understanding of the culture that makes this work possible in out-of-school settings and how it can be adapted to and sustained in the social context of school.

Drawing on the hybridity theory of Homi Bhabha (1994), case studies of youth media programs (Hull et. al. 2006; White 2009) have described them as creating a "liminal" or "third space" for participants, located between home and school, combining elements of informal outside-of-school learning and formal in-school learning. Researchers have also applied the lens of learning and literacy development theories (Gee 2003; Halpern 2008; Lave and Wenger 1991; Tyner 1998) to conceptualize this practice, anchored to the process of media production, as situated, apprenticeship, and cognitive apprenticeship learning.

In this chapter I will examine the case of the Educational Video Center's (EVC) professional development initiative, which is working to integrate elements of this third space, apprenticeship model of youth media in two New York City schools serving over-age, under-credited students. Weaving together learning and identity theory, class observations, and interviews with school principals, teachers, students, and EVC's media education coaches,[1] we will examine:

- Student and teacher change through the introduction of youth media practices and culture, with a focus on student critical literacy, sense of agency, and identity development;
- The possibilities and institutional constraints on building a sustainable microculture of youth media within schools.

School Partners

Arriving at the address, it isn't apparent that there is a school operating inside at all. It is a church. Climbing the narrow winding stairs to the second floor above the church, the school principal, Sylvia Jones,[2] greets us with a warm smile.

Opened in the fall of 2009, the High School for Scholars (HSS) is designed to serve over-age eighth-graders at least sixteen years old, are two or more years behind in middle school, and are not yet ready to enter high school. Students typically enter high school in the United States at age fourteen. HSS has 83 students, 98% of whom come from families at or below the poverty line as measured by those who qualify for free lunches (interview with Principal Sylvia Jones, 4/22/10).

Twice a week, a group of eight students stays after school until 6 p.m. to work on their video documentary. Arguing about whether teen drinking or teen pregnancy was the more important problem to make their documentary about, they decided on teen sex. They began their project in December 2009 by surveying their fellow students and interviewing school social workers, security guards, people in the neighborhood, and public health experts. In May 2010, they screened their finished documentary for the full school.

Traveling the subway line almost an hour in the other direction, we make our way to the Community High School (CHS). Opened in the fall of 2008, it serves 150 over-age and under-credited students sixteen to twenty years old. The average student entering the school reads at a sixth-grade level. Eighty-five percent of the students come from homes with incomes below the poverty level (interview with Principal Linda Norman, 1/21/10).

The CHS principal's boundless energy and enthusiasm is infectious. The school hallways are covered with samples of student writing and artwork. Several contain students' personal commitments to come to school regularly and on time.

On this day, the police from the local precinct are conducting a random security scan of the students. The Bloods gang is said to operate in the nearby housing projects, and there has been a recent shooting outside the school. Students know it's a scanning day when they see the police van parked outside the school, and 30–40% more students stay away (according to the principal) due to long waits outside in inclement weather or for fear their iPods and cell phones will be confiscated.

In the summer of 2009, students documented their trip to Philadelphia, where they helped other teens create a community garden. Now with cameras and microphones in hand, the students in social studies/government class are surveying residents in the school's neighborhood on the meaning of community service.

Both principals have made an institutional commitment to integrate student video production into their schools because they believe it will increase their stu-

dents' engagement in learning and build their 21^{st}-century literacy skills. Their commitment has included investments of teacher and staff time, video production and laptop editing equipment, space in the curriculum and class schedules, and intensive professional development both offsite and in-class provided by the Educational Video Center over the 2009–2010 academic year.

EVC, a nonprofit youth media organization based in New York City (www.evc.org), sought partnerships with these schools because of their shared pedagogical practices and values. According to EVC's "Institutional Fit" protocol (Culp and Tally 2009), EVC sought schools with teachers who had experience with cooperative and project-based learning, discussing student issues that may be sensitive or controversial, community-based research, youth development practices, and portfolio- (rather than standardized test-) based assessment.

Capacity building and program integration look somewhat different in each school. At HSS, social studies teacher Debra Johnson dedicates all her Friday classes to teaching students to create public service announcements. Two days per week she stays after school from 4 p.m. to 6 p.m. to facilitate a video class for 8 students, with the help of David Robinson, a technology specialist and graphic design artist.

At CHS, social studies teacher Carol Anderson teaches video documentary every day as part of her social studies/government class, and English teacher/literacy coach Susan Greene also teaches video in a government class and in an English class. Carol's class produced a documentary on community service, and Susan's class created a public service announcement on the importance of health checkups for teenagers. Three other teachers attended EVC's week-long professional development video workshop in July 2009.

Transfer Schools

Both schools were established as part of a city-wide initiative launched by New York City's Office of Multiple Pathways to Graduation (OMPG) to create Transfer Schools and GED programs (for students who have not earned a high school diploma and will take the General Educational Development Test, also known as the General Equivalency Diploma). This office was established in September 2005 to increase the graduation rates and expand connections to college and career opportunities for the approximately 138,000 teens and young adults in New York City between the ages of sixteen and twenty-one, both in and out of school, who are considered over-age and under-credited and have dropped out or have fallen behind and are significantly off track for graduation. As of the spring of 2010, the OMPG operated forty Transfer Schools.

According to the Department of Education reports, students graduate from Transfer High Schools at an average rate of 56%—compared with 19% if they

remain in comprehensive high schools. The attendance rate for students enrolled in Transfer Schools as of June 2005 was 78%, compared with a rate of 40% prior to Transfer School enrollment (NYC Department of Education 2006, 3–4). Even with these gains, principals and teachers describe a daily struggle for Transfer Schools to successfully engage and retain their students through graduation.

Most students were out of school for at least six months prior to enrolling in a Transfer School and developed internalized identities that labeled themselves as "the bad student," "slow reader," or "troublemaker." Even after they have renewed their commitment to school, health problems, court dates, and lack of stable homes often contribute to continued low attendance (interview with Susan Greene, February 24, 2010).

EVC's Model of Professional Development and Coaching

EVC provides teachers with multiple resources and pedagogical scaffolds so they can teach students to research, shoot, and edit documentary projects that explore critical issues in their lives. While learning to teach students to use digital cameras and editing systems may be the first and most visible challenge for teachers to master in EVC's curriculum, its larger professional development goal (also considered its "hidden curriculum") is to bring about more democratic, learner-centered social relations in the classroom and a greater sense of agency among the students. Developing a "pedagogy of collegiality," as Vivian Chavez and Elisabeth Soep (2005) call it, engages the teacher as a co-learner/facilitator/change agent engaged in her students' community and in solidarity with their most pressing concerns. Supporting teachers through the process of such change requires a process of sustained and multi-layered professional development, including curriculum guides, experiential workshops, and on-site coaching.

EVC coaches make explicit what such a pedagogy looks like through rubrics assessing classroom practice ensuring that all students contribute to discussions and decision making; use the community as a source of knowledge and information; connect personal experiences to social concerns; use multiple modes of literacy in their daily work; develop critical questions to guide their inquiry; revise their work and reflect on their learning; and use their video to inspire community dialogue and action.

These pedagogical beliefs and practices are described on EVC's Web site (www.evc.org) and in research about EVC (Goodman 2003). However, it is in EVC's week-long professional development media institute where teachers experience this educational philosophy for themselves as learners within the context of the documentary production process.

Each summer, teachers gather for institutes at EVC's facilities where they engage in activities drawn from EVC's "Youth Powered Video" curriculum, working

collaboratively to plan, research, and produce their own short video inquiry project. Each day they reflect on their experiences and discuss the facilitation strategies that the EVC staff developers have modeled and the techniques they would use with their own students with on-site coaching from EVC staff (Baudenbacher and Goodman 2006).

Following the institute, EVC provides each teacher with a coach with whom to meet on a weekly basis, in some cases twice a week, over the course of the school year. As opposed to one-shot professional development workshops, where experts talk to a room full of strangers, this approach is based on building an ongoing, trusting, and non-judgmental relationship between the teacher and coach, creating conditions in which teachers will be more likely to experiment, take risks, and broaden their repertoire (Knight 2009, 19). Coaching involves three interrelated stages: (1) a planning conversation; (2) a class observation where the coach gathers non-judgmental data; and (3) a debrief conversation in which the coach shares observations with the teacher and collaboratively develops new practices to be implemented (Knight 2007, 11).

The case studies of student video work in these two schools were conducted through field research and the collection of supporting documents. This research includes class observations; interviews and personal communication with students, teachers, and principals; and transcripts from videotaped events and interviews. Additional material was gathered from New York City Department of Education reports and school records.

Youth Media at HSS and CHS

Evidence collected from the early stages of EVC's work at HSS and CHS points to an emerging "microculture" of youth media in those schools. The concept of a microculture grows out of D. Bruce Jackson's observation that student academic failure is largely a problem of identity, and for many students, schools have become "identity conflict zones" (Jackson 2003, 582). Students who are treated as "slow learners" or "trouble makers" internalize and incorporate those labels as part of their academic identity and render schoolwork and the academic habits required for success in school incompatible with their sense of self (580). He calls for schools to practice an "identity sensitive education" and develop "academic microcultures"—social spaces of student agency and engagement that present an alternative to mainstream school culture, which struggling students explicitly reject. In these spaces (such as charter schools, alternative programs, and clubs), students align their self-identity with the educational project of schooling, including such essential activities as note taking, homework, and test taking.

A youth media microculture embraces a more expanded notion of learning beyond the limits of an academic identity. It foregrounds the concept of agency,

where youth and the media they create can contribute to increased democratic participation in the civic life of their community. It highlights the concept of border crossing, which negates the binary divisions that define traditional schooling: formal/informal learning, school/community, teacher/student, work/play, thought/action.

Building on Bhabha's theory of hybridity (1994), researchers White (2009) and Hull et al. (2006) have characterized this fluidity of social context and cross-border practice in out-of-school youth media organizations as a "third space." White described the third space at EVC as an "in-between" space between two or more discourses, "a geographical metaphor; a site of praxis where theory and practice meet...literally a place that is not a site of formal (school), or informal (not school), education... " (73).

Hull identifies three key "freedoms" that can be found in out-of-school, successful third space environments: freedom of students to choose the subjects of their digital stories using local knowledge and values, as well as popular culture references; freedom of movement, whereby youth can leave the building to a much greater extent than allowed in school; and freedom from school identities, providing the students with "an alternative site of identity construction" to form new selves as learners and creative media makers..." (2006, 33, 31).

The central challenge and paradox of EVC's effort to create a youth media microculture lies in maintaining the core border-crossing practices and freedoms that animate its third space model—defined by its difference from school—while serving students within the institutional culture of a "first space" school setting: in other words, creating a school experience that doesn't *feel* like school. In many ways, those elements of the documentary program that are most attractive for students—such as the social context of learning, the freedom to leave the school, and the ability to choose projects that are controversial—are precisely the elements that run against the grain of many school bureaucratic structures and disciplinary practices.

To construct a school-based microculture of youth media, EVC has implemented a capacity-building change strategy that is integrated, flexible, and long term. It is capacity building in its emphasis on professional development of pairs of teachers. It is integrated where classroom/pedagogical change is planned and implemented within the context of larger school/structural change. Principals, teachers, and EVC media educators all need to be at the table when goals are set, problems are addressed, and progress is assessed. It is flexible so that the ideal conditions of an out-of-school program are adapted to fit the on-the-ground needs, resources, and social context of each school. And it is based on a long-term approach that takes into account the developmental stages of the people and institutions involved.

The nascent development of such a youth media microculture can be seen in the level of student engagement—the way students and teachers talk about the work they have created, what they have learned in the process, and how they have changed as a result. It is also evident in the public celebrations, screenings, and discussions of their work, the ripple effect it is having in the larger community, and the future plans for sustaining the program. However, along with the possibilities, there are constraints to consider. We will now discuss students' developing capacities for engagement and critical literacy, agency, and new identity formation through their media work in the two schools.

Engagement and Critical Literacy

As social linguist James Paul Gee describes it, students "cannot learn deeply only by being told things outside the context of embodied actions. Yet at the same time, children must be motivated to engage in a good deal of practice if they are to master what is to be learned. However, if this practice is boring they will resist it" (2003, 68).

Video projects provide students with highly motivating opportunities to learn and practice language as contextualized embodied action. For example, as they worked on their documentary on teen sexual health, the students in the after-school HSS program practiced multiple modes of communication for research and expression. Each task had an authentic purpose and tangible outcome within their larger documentary project: to inspire action. They developed survey questions in order to generate new statistical information from their peers in school; composed email messages to persuade health experts to be interviewed on video; wrote questions and conducted interviews to gather information and stories from people on the street, a professor of family health, a school social worker, and a school safety agent—all in the hopes that they would yield answers that might change the attitudes and behavior of youth audiences when their video was screened in their school and community.

In both schools, attendance was markedly higher in the video classes on average than in the rest of the school. This is of particular importance for disengaged and struggling learners such as CHS students, only 53% of whom were passing their classes as of as of the second marking cycle, and HSS students who repeated at least two years of their middle school. The HSS after-school students had an average attendance rate of 94%, a full ten points higher than the school average (personal communication with David Robinson, May 17, 2010). According to the principal's records, Carol Anderson's social studies/government documentary class had the third-highest passing rate in CHS at 85%.

While increased student attendance is not the goal itself, it is the basic requirement for any subsequent rich learning and literacy development that takes

place. It is evidence of an active microculture where students are aligning their identity to the academic demands of school. A survey conducted by the CHS principal on this class resulted in positive responses to visual, spoken, and tactile learning: "I learned how to speak very well during interviews." "I learn better visually." "It's a great form of working together. Sharing ideas, and learning from one another." "...its hands on which I never had that before."

Engaging students in multi-modal media project-based work in school signifies a microculture shift where learning is situated (Lave and Wenger 1991) within an apprenticeship-like context, and the classroom takes the form of a workshop. In this environment, as Robert Halpern describes, organized activities are centered around a "production cycle that creates a frame for an expanding set of tasks and skills [which include] a conceptualization phase, design phase, production phase, feedback and revision and final production or performance" (2008, 25). In contrast to the school culture of binary testing that either rewards the right answers or punishes the wrong ones, the apprenticeship environment engages students in project work in which they "face open-ended problems and shifting variables...marked by real-world constraints" and that affords them "...plentiful opportunities for the trial and error, practice and experimentation that solidify emergent abilities" (2008, 23, 21).

In addition to the activities the project requires, the physical space of the workshop also shapes the apprenticeship's culture of learning and work. As media producers, the youth are surrounded by the tools of the trade: computer editing work stations, shelves of DVDs and tapes, edit plans, storyboards and notes tacked and taped to walls, closets containing cameras, audio, and light equipment. Symbolic artifacts lining the walls such as festival posters, awards, and photos of students in action connect the project at hand to the broader national and even international field of youth media producers and contribute to a culture of high standards, public recognition, and aspirations for the future.

Agency

Researchers have described how out-of-school youth media programs develop an increased sense of agency in the young participants (Hull et al. 2006; Akom et al. 2008; Anderson 2008). In these two school-based programs, students were able to develop a sense that they could act on their future by telling their stories and distributing new knowledge through their projects in three important ways.

First, in choosing their own topic for investigation, students develop agency as self-directed learners and civic journalists, turning questions or problems from their out-of-school life into valid subjects of study in school. In Susan Greene's CHS government class, students generated a substantial list of problems they felt the public needed to know about and discussed until they settled on the issues of

health checkups and AIDS awareness. The HSS students described their decision process: "We came out with the topic because there was an argument about teen pregnancy and teen drinking, so we concluded with teen sex.... Some of my friends are pregnant already and they are fifteen, sixteen or seventeen" (Final HSS screening interviews, May 7, 2010). The process of researching and reporting on their own lived experiences and rendering the stories of others in the community, shares common elements with Youth Participatory Action Research, which Akom et al. describe as a "methodology in which young people study their own social contexts to understand how to improve conditions...an approach that breaks down the barriers between the researcher and the researched, and values community members as equitable partners in the research enterprise" (Akom et al. 2008, 4–5).

In addition, students exercise agency as civic journalists when they cross borders and challenge power relations by questioning adult authorities who, outside their camera-mediated interaction, would have higher status over them (e.g., a police officer, principal, or professor). Students at HSS interviewed a social worker, a school safety agent, and a professor of public health. When asked what was his proudest moment in creating the video, one student responded, "Well, the interview I got at Columbia University.... It was great getting the opportunity to interview a doctor, a person that really knows about pregnancy and stuff" (Final HSS screening interview, May 7, 2010). Crossing borders can also provide students with opportunities to learn and work in solidarity with peers from other communities, as was the case when CHS students travelled to Philadelphia to document and assist inner-city youth in building a community garden there.

Second, they develop artistic agency, forging a vision of what their final documentary can be and taking creative and editorial action with their team members to make their vision a reality. This is an iterative process that can be enacted through dozens of choices, including the positioning of a camera on a shoot; the inclusion, elimination, and ordering of footage in editing; or the choice of a song over credits. Asking students to draw a storyboard or create an edit plan requires them to imagine what doesn't yet exist and trust in a process they haven't yet completed.

The freedom to project into the future and then follow the creative arc they have sketched out can be exhilarating but can also be frustrating and more than a little intimidating. As EVC media educator Deneen Reynolds-Knot reflected when her students complained to her, "Miss, this is mad hard":

> Think about how much we are asking the students to do. A whole lot: picking a topic, writing a storyboard, a script, to be creative, work in groups, find information and create knowledge. Think about how daunting it is, how stressful it is—even just for PSA project—when they haven't ever been asked to think in this way and do this kind of work before in school. (Interview with Deneen Reynolds-Knot, March 28, 2010)

Finally, students develop a moral agency harnessing their own individual sense of agency to the collective wellbeing of the community as they use screenings to provoke public dialogue and action on the problem they have identified. Philosopher Maxine Greene argues for developing a *praxis* of educational consequence that creates openings for students to find "spaces of action" outside the taken-for-granted givens, and "become 'challengers' ready for alternatives, alternatives that include caring and community" (1988, 49, 56).

The themes explored by students in both schools illustrate this sense of caring for the surrounding community. Through their documentaries they aim to persuade audiences that it is not only other people's problem, but *our* problem.

The CHS students dedicated their documentary on community service to the memory of a CHS student who was killed in a fight during the time in which they were making their video. At the end of their documentary, these words are heard: "Dedicated to Steven Smith." Then the picture fades to black, and a black-and-white close-up photo of him staring straight at the camera fades in, framed with his name and "R.I.P." This portrait was posted in the halls and classrooms of the school after his death, followed by the words in plain white font over black: "Stop the Violence!" then, "Get involved in your community!" and "Pass it forward!!"

Another example of students looking for alternatives and connecting their personal experience to the greater well-being of the community is an HSS student's public proposal to make a video about domestic violence. It is an example of students moving from a place of silence to feeling empowered to speak out, create knowledge, and take action. "The reason I brought it up is there is a lot of kids at a young age getting abused, which is pretty sad to see. It's a really important thing to know that you gotta take care of your kids. Not torture them (pause). Also— (pause) I think I was abused, too (pause). By my uncle. I think he was drunk. And I wanted to bring that up. Just to let other parents see what's going on with their kids. To take good care of it."

Moral agency is connected to a developed sense of empathy. As one HSS student described how working on her documentary changed her: "Some of my friends are pregnant already and they are fifteen, sixteen, or seventeen. And sometimes I think they are kinda a bad influence, but now I feel bad for them. Cause they are going through things that I'm not. They are paying for something they didn't want to do and that opened my eyes.... I'd have to go up to them and say, 'I'm sorry. I looked at you differently. The wrong way.'"

Identity Formation

Buckingham describes psychologist Erik Erikson's theory of adolescence "as a 'psychosocial moratorium,' a period of 'time out' in which young people can experiment with different potential identities" (Buckingham 2008, 3). While all teens

may take "time outs" to one degree or another, the stakes of such experimentation are especially high for the teenage students in Transfer Schools struggling to reconcile the "adult" problems they may face out of school (such as pregnancy, drug and alcohol abuse, violence, and depression), and peer group affiliations, with the academic habits and identities that success in school requires. Many students in both schools have formed academic identities of resistance to the school's mainstream culture and are in need of what Gee calls identity "repair work" (Gee 2003) and Jackson refers to as "identity scaffolding" (Jackson 2003).

EVC's effort to transform video classes into youth media microcultures that don't quite *feel* like school was, in part, an effort to erect such scaffolding by giving students opportunities to try on new identities as youth media producers. And although it's still early in the process, there is evidence that some students did form such identities because of the social context of their work and the public nature of their success, which was valued by their peers and by the school authorities.

As Jean Lave's situated cognitive theory describes it, "learning is not best judged by a change in mind (the traditional school measure), but by 'changing participation in changing practices.' Most important, learning is a change not just in practice, but in *identity*..." (as cited in Gee, 2003, pp. 189–90).

Shifts in identity were revealed perhaps most noticeably by remarks made by students from both schools at the premiere screenings of their documentaries. In both schools, strong messages were sent to the students about how important the screening of their video was. HSS held a "town hall meeting" for the full school to watch the video. After it was over, the students sat at the front of the room and answered questions from the audience. Students were asked to state their names and tell what they did on the project. The first to stand up said, "I'm Derrick. One of the producers of the movie. My role was to get as much information as possible about STDs [sexually transmitted diseases] that's been around, getting interviews, doing research, and trying to get interviews with the doctors that we showed in the movie." Each student followed by identifying him or herself as a "youth producer" with a specific role in the project, such as camera person or narrator.

At CHS, the premiere screening was an exclusive event with a full buffet of food and drink at the back of the classroom. The principal, assistant principal, EVC staff, and several teachers were in the audience. Prepared by the teacher Carol Anderson, shining black cardboard cutouts of film cameras and gold stars hung from fluorescent lights, and balloons were floating throughout the room.

At the end of the video, when a long montage sequence of group photos was displayed, one of the video students jumped out of her seat. Talking back to the screen at the front of the room she said, "That makes me so happy, it makes me wanna cry." More than identifying them as documentary video makers, the public visual representation of the group in the photo seemed to evoke in the students an

emotional, almost nostalgic identification and bonding. Their hard work and publicly lauded successful outcome reinforced this sense of identity, pride, and belonging.

Both principals observed instances of identity changes in their students. As Linda Norman described it, "One of our students—who was thrown out of his prior school because he had a gun—is now a different person because of video class. Instead of holding a gun, he is so excited to be holding a microphone. He has a voice. He's a different person now—and that's huge" (interview with Linda Norman, April 26, 2010).

Sylvia Jones also spoke of how her students had noticeably changed. "Ricardo was very reluctant to join activities. He was not focused, not taking things seriously.... The video brought out his confidence and also he felt more focused, a sense of accomplishment—I saw a different person now—the way he walks, the way he moves, the way he now feels connected" (interview with Sylvia Jones, April 22, 2010).

David Robinson described the change in another student, "Derrick was so shy. You know, he almost dropped out of middle school. He told me he wanted to learn to speak publicly and now he is doing it—speaking to his fellow students, even a professor at Columbia University" (Final HSS screening, May 7, 2010).

Institutional and Pedagogical Constraints and Possibilities

Keeping in mind the early stage of development, and that the schools themselves are newly established—HSS is in its first year and CHS is in its second—it is still important to discuss emerging opportunities for and constraints on the broader development of youth media microcultures in schools at the level of change in the institution, the teacher, and the student.

On the level of institution, it is worth saying that both principals have been heroic in their efforts to protect and lead their young schools in the face of great adversity on a daily basis. A small sample of such challenges would include ensuring that students have a place to eat their lunch, protecting them from SARS (severe acute respiratory syndrome) infection, finding a way to replace and protect new computers from another vandal attack, and helping students grieve over the death of a fellow student.

Even with all these challenges, the leadership of HSS and CHS made substantial investments through funding, equipment, professional development and teacher time for the 2010 school year and has made renewed commitments for 2011. New computers have been purchased for editing, more teachers will be attending EVC's summer institute, a dedicated student editing room may be created in the new HSS building, and schedules will make room for more teachers to incorporate video into their classes and after-school programs. The schools' contin-

ued commitment signals a recognition of the value of the media work and the need to ensure its sustainability through a long-term investment in teacher-facilitated, student-generated media making.

Even with these steps forward, there are challenges largely beyond the principal's control that weaken a microculture's positive impact. In the case of CHS, gang-related violence in the local neighborhood raised concerns for the physical safety and morale of the students and staff. Both schools faced a problem of staff stretched to capacity, with the most veteran and capable teachers chosen for the video program working with other subject area coaches and being pulled in numerous other directions as well. The graduation requirement for students to accumulate credits and pass standardized tests determined scheduling and other educational priorities. Leaving the building for community interviews remained a problem, particularly for the video classes held in fifty-five-minute periods during the school day. Limited space meant that teachers shared classrooms and were less likely to put permanent visual symbols on the walls to give them the look of an apprentice workshop.

On the level of teacher change, a constant refrain was how invigorating it was for them to learn to work in partnership with their students and to facilitate their self-expression. Reflecting on how he grew to be more of a facilitator of student voices, David Robinson said, "The major thing I learned was not to stifle a young person's vision or dream. And not to put so much adult thinking into their production…this was an opportunity for me to actually step back and let them do it. To be patient and let them explore their own gifts and that was the major thing for me…something I had to fight myself to do" (Final HSS Screening Interview, May 7, 2010).

These comments illustrate how teachers have grown beyond just teaching the creative storytelling and technical media skills of documentary production. Attending to the "hidden curriculum," they have succeeded in making the classroom a more social, collaborative, and participatory space.

"Mad Hard Fun"

On the level of student change, elements of an emerging youth media microculture, representing both their cognitive and social development, can be found in the comments HSS staff and students made after their premiere screening. David Robinson described his great pride in his students' ability to complete their project, to stick with it over time. "From the beginning [in December], when we were out in cold trying to get interviews and people were running away from them. And they were getting frustrated. 'Oh, no one wants to get interviewed.' To see them stick together and stick with it. And finish something they started was just a powerful thing for me to see. 'Cause everyone can start something. This core group

started and finished. That's what made me the most proud as a bigger brother, as an instructor, as a dad. I was happy."

The students all separately commented on the dual "hard/fun" nature of their work. One can interpret their use of "fun" as an expression of their pleasure in the social engagement with peers through the creative process of production, and the use of "hard" as an indication of how challenging it was for them, all in their own way taking risks, going out of their comfort zones, crossing borders, practicing, and getting good at performing new skills. Gee argues that this is when youth "are operating at the outer edge of their regime of competence…when learning is most exciting and rewarding" (Gee 2003, 70). So difficult to implement in schools, "mad hard fun" can be seen as a hallmark of a highly functioning youth media microculture.

Wendy: "It was pretty fun. I did the narrator part which was really hard. Cause I had to try to concentrate, read perfectly and smooth.... And I had to read 3 times for my part to choose which one was better....We did some editings. It was really hard, but we tried our best. And look what we did...."

Veridiana: "It was fun. Some of the producers might say it was boring because of the editing. But I thought it was fun." And she also said, "It was hard for me 'cause I'm a shy person and I don't like to talk to strangers."

Brian: "In this program I had fun, and mostly in classrooms I was just copying things and writing them down so I didn't have that much fun.... It was hard boring because of the edit. We have to like see the parts over and over again."

As Veridiana explained, "All of us had a time to bond and grow a bigger friendship. Me and Wendy, one of the other producers, we would always chit chat about different stuff about school and when we went to EVC, we would chit chat about how we were going to shoot the camera, how we were going to shoot the interview. How we are going to do this and how we are going to do that."

Veridiana's account gives us a compelling image of what a youth media microculture in school looks like. She and Wendy are forming new social relationships and identities as youth media producers, combining the pleasure of creating and learning together with the hard work, sustained rigor, and agentive process their documentary production demands. And they and their peers are eager for more such journeys.

Students in both schools in this case demonstrated that with sustained and committed support from their teachers, EVC coaches, and principals, they can in fact rewrite their educational autobiographies with narratives of action and possibility. Their growth and transformation shows the great promise of this work. However, there remain many challenges to building youth media microcultures in schools on a broad scale; a clear vision of the goal ahead must not be mistaken for the distance it takes to get there.

We owe it to our students, in the spirit of Raymond Williams's "long revolution" (1983), to challenge the false binaries and standardized institutional inevitabilities of our traditional school system, and insist on practical alternatives. Only then can we create more open structures and hybrid educational "spaces of action" that invite, inspire, and support students to cross borders and—with cameras in hand—make their own journeys along diverse paths of inquiry, creative storytelling, and community healing.

Notes

1. I would like to thank the principals, teachers, students, and EVC media educators whose generous time and assistance made this chapter possible.
2. The schools, principals, teachers, and students named in this chapter are pseudonymous.

References

Akom, A.A., J. Cammarota, and S. Ginwright. 2008. Youthtopias: Towards a New Paradigm of Critical Youth Studies. *Youth Media Reporter, The Professional Journal of the Youth Media Field*. New York: Academy for Educational Development (August 15).

Alberto, Aaron. 2008. Interview with Steven Goodman.

Anderson, Stephanie. 2008. Editing Lives: Developmental Consequences of Youth Engagement in the Educational Video Center. Paper presented at the Qualitative Inquiry conference, University of Illinois at Urbana-Champaign, May 14–17.

Baudenbacher, Gretchen and Steven Goodman. 2006. *Youth Powered Video: A Hands On Curriculum or Teaching Documentary*. New York: Educational Video Center.

Bhabha, Homi K. 1994. *The Location of Culture*. London: Routledge.

Bridgeland, John M., John J. DiIulio, Jr., and Karen Burke Morison. 2006. *The Silent Epidemic Perspectives of High School Dropouts*. A report by Civic Enterprises in association with Peter D. Hart Research Associates for the Bill & Melinda Gates Foundation. March.

Buckingham, David. 2008. Introducing Identity. *Youth, Identity, and Digital Media*. Edited by David Buckingham. The John D. and Catherine T. MacArthur Foundation Series on Digital Media and Learning. Cambridge, MA: MIT Press, 1–24.

Butler, Allison and Emilie Zaslow. 2004. *Voice, Self, & Community Through Video Production: An Evaluation of the Long-Term Impact of the Educational Video Center's Youth Documentary Programs*. New York: Educational Video Center, June. http://www.evc.org/tools/research-articles/voice-self-community-through-video-production#attachments

Chavez, Vivian and Elizabth Soep. 2005. Youth Radio and the Pedagogy of Collegiality. *Harvard Educational Review* 75(4): 409–434.

Culp, Katherine McMillan and William Tally. 2009. *Evaluation Instruments to Support the Scale Up of EVC's Documentary Workshop Summary Report*. Center for Children and Technology/EDC. August 1.

Final HSS Screening. 2010. Interview conducted by Jessica Cele. May 7.

Gee, James Paul. 2003. *What Video Games Have to Teach Us about Learning and Literacy*. New York: Palgrave Macmillan.

Goodman, Steven. 2003. *Teaching Youth Media: A Critical Guide to Literacy, Video Production and Social Change*. New York: Teachers College Press.

Grantmakers in Film and Electronic Media. 2006. Open Society Institute's Youth Media Program: Investing in Youth Media: A Guide for Grantmakers.

Greene, Susan. 2010. Interview by Steven Goodman. February 24.

Greene, Maxine. 1988. *The Dialectic of Freedom*. New York and London: Teachers College Press.

Halpern, Robert. 2008. *Means to Grow Up: Reinventing Apprenticeship as a Developmental Support in Adolescence*. New York and London: Routledge.

Hull, Glynda A., Nora L. Kenney, Stacy Marple, and Ali Forsman-Schneider. 2006. Many Versions of Masculine: An Exploration of Boys' Identity Formation through Digital Storytelling in an Afterschool Program. *Afterschool Matters* 6 (Spring).

Jackson, D. Bruce. 2003. Education Reform as if Student Agency Mattered: Academic Microcultures And Student Identity. *Phi Delta Kappan* (April), 84 (8): 579–585.

Jones, Sylvia. 2010. Interview by Steven Goodman. April 22.

Knight, Jim. 2007. *Coaching: A Partnership Approach to Improving Instruction*. Thousand Oaks, CA: Corwin Press.

Knight, Jim. 2009. Notes on Coaching. *National Staff Development Council* 30(1) (Winter): 18–22.

Lave, Jean and Etienne Wenger. 1991. *Situated Learning: Legitimate Peripheral Participation*. Cambridge and New York: Cambridge University Press.

New York City Department of Education Office of Multiple Pathways to Graduation. 2006. Summary Findings of Research and Development Work on Overage Under-Credited Youth in New York City. New York City Department of Education. October 25. http://schools.nyc.gov/NR/rdonlyres/B5EC6D1C-F88A-4610-8F0F-A14D63420115/0/FindingsofOMPG.pdf.

Noguera, Pedro. 2009. Commentary: Throwing Billions at Schools Won't Fix Them. CNN Politics.com, March 5. www.cnn.com/2009/POLITICS/03/05/ noguera.schools/index.html.

Norman, Linda. 2010. Interview by Steven Goodman. January 21.

———. 2010. Interview by Steven Goodman. April 26.

Reynolds-Knot, Deneen. 2010. Interview by Steven Goodman and Lindsay Fauntleroy. March 28.

Stuart Foundation. 2006. *I Exist. I Am Visible. I Matter*. San Francisco: Stuart Foundation.

TASC. 2009. ELT: Expanding and Enriching Learning Time for All. *A TASC Policy Brief*. August 18. http://www.tascorp.org/content/document/detail/2575/.

Tyner, Kathleen. 1998. *Literacy in a Digital World*, Mahwah, NJ: Lawrence Erlbaum Associates.

———. 2009. Mapping the Field: Results of the 2008 Survey of Youth Media Organizations in the United States. *Youth Media Reporter, The Professional Journal of the Youth Media Field*. New York: Academy for Educational Development.

White, M.L. 2009. Filming Ourselves: An Ethnographic Study Investigating the Pedagogical Process and Practice of Digital Video Production at Educational Video Center (NYC). Ph.D. diss., Middlesex University.

Williams, Raymond. 1983. *Towards 2000*. London: Chatto and Windus, .

19

Youth Media in School:

Insights from a Professional Development

Initiative in Media Arts and Media Literacy

Lisa Tripp

Introduction

In schools, young peoples' media production activities are largely structured by institutional and adult concerns and one facilitated by teachers who must justify the activities as contributing to—or at least as not detracting from—the accepted school curriculum. As a result, school-based media production often occurs in the context of "teaching technology" or using media as a "teaching aid to assist subject learning, or to develop more generalized qualities such as motivation and collaboration..." (Buckingham 2003, 179–180). In the process, many of the dynamic and progressive aspects of youth media—such as an emphasis on creative production, critical media analysis, and youth voice (Tyner and Mokund 2003; Goodman 2003)—are often downplayed or lost.

Despite such challenges, there is a robust tradition of media artists, activists, and educators attempting to bring youth media into the classroom. Some of the more successful efforts have been initiatives in which a media artist or youth media organization works directly with students and teachers in a classroom to help scaffold and support youth media production. This tradition represents an important and viable strategy for facilitating youth media in schools, but it also typically de-

pends on the continued involvement of the media artist or organization to be sustained.

This chapter addresses a different approach to bringing youth media into schools, one that focuses on teacher professional development. In what follows, I examine an initiative that trained Los Angeles Unified School District (LAUSD) middle school teachers to incorporate media arts and media literacy into diverse academic content areas. Drawing on an ethnographic study of the initiative, I identify problems and potential areas of possibility for using this model of professional development to bring youth media into public school contexts. I argue that media arts is a viable content area for promoting youth media in schools, and that professional development and curriculum reform efforts are essential to making school-based youth media experiences accessible to more young people. At the same time, I also recognize and address significant challenges and limitations associated with such efforts. Throughout, the discussion emphasizes insights and lessons learned that might benefit others working to promote youth media in school contexts.[1]

Professional Development in Media Arts and Media Literacy

During the 2005–2006 academic year, the University of Southern California Institute for Media Literacy (IML) and the Los Angeles Unified School District (LAUSD) Arts Education Branch (AEB) collaborated in delivering a professional development initiative through a grant from the Annenberg Foundation.[2] The initiative trained teachers from five Los Angeles middle schools (serving children ages eleven to fourteen) in media arts and media literacy. The participating middle schools[3] were academically "low performing" schools that served predominantly Latino[4] youth from poor households. Teams from each school included one Arts teacher and two teachers from other content areas (including Language Arts, Social Studies/History, and Science/Health). In one school, the teachers were also part of the school's Special Education academy, a program designed for students who were behind grade level academically (in some cases because of learning disabilities). The professional development initiative included a weeklong Summer Institute and several daylong, follow-up workshops; periodic meetings with "coaches" (experienced Arts teachers from nearby high schools); and classroom assistance from IML staff and researchers. The focus of the professional development was on teachers gaining firsthand experience with creating media arts projects; analyzing youth media and popular media texts; developing "standards-based" instructional units that incorporated youth-produced media; and scaffolding youth media production in the classroom.

As a group, the participating teachers were evenly balanced between men and women and were of diverse ethnic backgrounds, including several African Ameri-

can, Latino, and "White" teachers, as well as one Asian American teacher. They also represented diverse levels of teaching experience, including both new and highly experienced teachers. Schools applied to be a part of the initiative and were selected by staff from the IML and LAUSD based, in part, on an expressed interest in media arts, project-based learning, standards-based instruction, and collaborative teaching. Teachers did not, however, need to have prior experience or training in media arts, media literacy, or teaching with media. This resulted in a group of teachers with diverse levels of experience, skill, and comfort in these areas. A few of the teachers had some prior experience creating digital media projects, and two of the teachers had taught media production at school. Most of the teachers, however, had little or no prior experience with media production, and none of the teachers had received any formal training in media studies or media literacy education.

Professional development began with a weeklong Summer Institute that was co-facilitated by IML and LAUSD staff. The Institute introduced participants (including teachers, administrators, and coaches) to media production through a hands-on practicum in which, over the course of several days, participants created documentary videos and multimedia presentations. In the process, participants gained practice with media analysis through researching and evaluating media sources, discussing the meaning of media messages, and analyzing drafts of each other's work. Opportunities to learn and practice critical media analysis were also built into the week's seminar series. For example, a professor specializing in media studies screened an episode of a popular Disney Channel children's sitcom, *That's So Raven,* and an action film, *The Rundown,* and then led participants through a formal analysis and discussion of race and stereotyping in these two genres.[5]

The Summer Institute also introduced participants to the field of youth media. For example, youth media experts and practitioners[6] led training sessions throughout the week in which they screened and discussed a wide range of youth media examples. They also discussed principles of effective youth media pedagogy based on the Educational Video Center (EVC) approach to critical literacy, which focused on multiple literacies, continuous inquiry, and reflection (see Goodman 2003, and Educational Video Center 2006, for a more in-depth discussion of EVC pedagogy). In this way, youth media was presented as offering model curriculum and pedagogy for doing media production work with young people.

As part of the initiative, teachers were also expected to design and implement a curriculum unit that addressed Arts standards and content standards from their respective subject areas (e.g., Science, Math, and Language Arts), with a focus on helping young people develop skills in media production and analysis. In the United States, standards-based education has become increasingly widespread and is often associated with a controversial (but now politically dominant) school re-

form movement emphasizing testing and accountability. Although definitions vary, the movement generally emphasizes, among other things:

> *academic expectations for students* (the standards are often described as indicating 'what students should know and be able to do'), *alignment of the key elements of the educational system* to promote attainment of these expectations, [and] the use of *assessments of student achievement* to monitor performance.... (emphases in original). (Hamilton, Stecher, and Yuan 2008, 2)

It has become increasingly difficult for teachers in the U.S. context to justify or defend instructional activities that are not directly standards-based. The professional development initiative's emphasis on standards-based curriculum development should be viewed within this context. On the one hand, it was a necessary focus in order to legitimate media arts-related curriculum development efforts and make it feasible for teachers to devote class time to media production and analysis activities. On the other hand, the staff from the LAUSD AEB believed strongly in the potential for standards-based arts education to help foster quality instruction and student academic achievement.

Historically, arts education in the Los Angeles Unified School District has included four art forms: Visual Arts, Theatre, Music, and Dance. As a result, at the time of the initiative, there were no official district standards in media arts. To address this shortcoming, AEB staff identified standards within the four arts disciplines that were most relevant to media arts. These standards addressed both media analysis and production competencies, such as the following example standards suggest:

> Identify examples of how theatre, television, and film can influence or be influenced by politics and culture. (AEB Theater Standard 6.4.2)

> Use theatrical skills to present content or concepts in other subject areas, such as creating a video. (AEB Theater Standard 8.5.1)

> Use technology to create original works of art. (AEB Visual Art standard 6.2.6)

> Analyze the use of the elements of art and the principles of design as they relate to meaning in video, film, or electronic media. (AEB Visual Art Standard 8.1.3)

Teachers used these standards and began developing their units during the Summer Institute through daily work sessions facilitated by AEB staff. In these sessions, teachers were introduced to a modified version of Grant Wiggins and Jay McTighe's (2005) "backward design" model of curriculum development, which focuses on the big ideas, questions, and "enduring understandings" that students will retain after completing a course of instruction, as distinct from focusing

merely on the content knowledge of a given subject.[7] By the end of the Summer Institute, teachers had completed outlines of their unit plans. Over the course of the school year, they further developed their units during follow-up training workshops and on-site meetings with coaches and IML staff, and then implemented their units in the classroom. As shall be discussed in the next section, the initiative included a research agenda that involved documenting and examining the implementation of teachers' instructional units. This produced rich data about the potential—and the challenges—for using professional development in media arts to bring youth media into public school contexts.

Methods

The study of this professional development initiative incorporated mixed methods and included both program evaluation and ethnographic research components. Program evaluation sought to assess the quality and implementation of the initiative, and the outcomes for teachers, administrators, coaches, and students. Ethnographic research aimed to provide a rich, descriptive account of how teachers incorporated media arts, media literacy, and youth-produced media into instruction and how young people engaged in the activities. The research team was made up of three external program evaluators and three ethnographic researchers (including the author).[8] Program evaluators and ethnographers played different roles in the initiative but collaborated on designing the study, collecting and sharing data, and interpreting the findings.

The program evaluation component of the study used a variety of qualitative and quantitative methods, including pre-event and year-end surveys of participating teachers; classroom observation protocols; teacher and staff interviews; and student focus groups. The ethnographic research component of the study focused on participant observation in several classrooms at three of the school sites and home visits and interviews with students from one of the classrooms. Participant observation was documented through detailed field notes, and home visits and interviews were audio recorded and later transcribed. As participant observers, our research team visited schools routinely, concentrating on when teachers were attempting to incorporate media into instruction. In total, our team spent over 150 hours at the various school sites. Toward the end of the year, we selected students from one of the schools for further study and then conducted a series of home visits and interviews with students and their parents about their experiences with media and technology.[9] This chapter draws on these various data sources, focusing on teacher surveys and interviews, participant observation of classrooms, and student focus groups and interviews.

The ethnographic approach of the study was informed by the tradition of "action," "participatory," and "collaborative" ethnography (Barab and Squire 2004).

From this perspective, our goal was to study—and actively support—the integration of media arts and media literacy into the school curriculum, ideally in a way that fostered young peoples' creativity and meaningful engagement in the activities. Thus, when we visited classrooms, we not only observed and documented the activities, but also played the role of program assistants. For example, we often worked with teachers to help them plan lessons, and with young people to help them develop and create their media art projects. This position as collaborative ethnographers gave us unique opportunities for developing rapport with teachers and students, and rich access to classroom activities and conversations surrounding media. In the discussion and analysis that follow, I draw on a variety of these data sources, including both the program evaluation and ethnographic research components of the study.

Findings

The professional development initiative was a resource-intensive effort that would probably be difficult to replicate. Nevertheless, research findings offer insight into the possibilities—and likely areas of difficulty and challenge—in training teachers to facilitate youth media production in the classroom.[10] These findings, and related implications, are discussed and examined in the following sections.

Teachers succeeded at developing and implementing instructional units that incorporated media production, but made few advances in media analysis.

Over the course of the school year, each of the teachers implemented the instructional units they had developed through participation in the initiative.[11] In some cases, teachers developed and implemented more than one unit. In a Special Education class, for example, teachers developed a total of eight units over the course of the school year. Some examples of the units included the following:

- A Visual Arts teacher taught her students how to use PowerPoint as an artistic tool. Students wrote poems about aspects of their identities and combined them with photographic self-portraits.

- A Language Arts teacher worked with her students to create videos about issues important to the school community (such as school uniforms and drugs). Students used persuasive language to make their arguments, in accordance with Language Arts standards for their grade level.

- A Health Science teacher worked with his students to produce video Public Service Announcements about health, safety, and environmental issues.

- A Special Education team of teachers collaborated throughout the year to produce several media projects with their students, addressing content in Language Arts, Health, and Science. Their culminating project was a series of videotaped skits written by the students to inform others about the dangers of drug use and strategies for resisting peer pressure.

As these examples demonstrate, teachers used the curriculum development approach of the initiative to foster opportunities for youth-produced media in the classroom. This represented a significant achievement for teachers, particularly because they were relatively new to creating (and teaching) digital media. Teachers were, overall, very pleased with their participation in the initiative and the success of their instructional units. In surveys, focus groups, and interviews, they reported that their skill, interest, and confidence in teaching with media improved over the course of the initiative. Further, when teachers responded to a post-survey question about what, if anything, they gained from the professional development, their responses related to improved technological skills, the ability to teach media arts, and expanded beliefs or expectations about their students' potential (Beck, Groth, and Harris 2006).

Despite such evidence of success, there were also significant limitations in the ability of the instructional units to address the broader goals of incorporating media literacy, analysis, and reflection into instruction. For example, in general, teachers didn't view or discuss examples of media with their classes, and they didn't discuss or analyze the production choices that students made related to their own creative work. In this way, teachers' instructional units fell short of addressing media education goals that include theoretical reflection and analysis of media content and tools. As David Buckingham explains:

> We need to differentiate between educating through media and educating about media, or in other words, between the use of media as a teaching aid and the study of media in their own right. The primary aim of using media production here is to assist subject learning, or to develop more generalized qualities such as motivation and collaboration, rather than to promote a more conceptual awareness of the media themselves. This is perfectly valid, but it is not media education. (2003, 179–180)

This finding is understandable given that teachers had relatively little experience teaching with, or about, media before coming into the professional development initiative. For them, incorporating media production into the classroom required a great deal of effort and time, and often pushed them outside their comfort zones in terms of how to teach and manage a class project. Further, they frequently expressed being nervous about taking time away from the standard curriculum, and not wanting their students to fall behind academically as a result. Despite these challenges, however, teachers were persistent in their efforts to in-

corporate media production into instruction, specifically because they thought it would help student learning and motivation (Tripp and Herr-Stephenson 2009).

Teachers did not appear to hold the same sense of interest or hope in the potential of media analysis to engage their students. Instead, media analysis appeared to "fall off their radar" as a central component of the initiative. For example, in focus groups and interviews, teachers consistently talked about the importance and benefits of teaching students "media arts," "media production," and "technology," but barely (if at all) mentioned "media literacy" or "media analysis" in the conversation. In this way, teachers exhibited an attitude toward digital media that is common in U.S. schools, in which technology is treated in the instrumental terms Buckingham (2003) describes, as a method of teaching or teaching aid. While the professional development initiative included training in media analysis, this training was apparently insufficient to motivate or prepare teachers to facilitate media analysis in the classroom. As a result, with only a few exceptions,[12] teachers did not tend to see or frame production activities as opportunities for media analysis or media education.

Young people struggled to engage with the academic content of media production activities, yet found aspects of the process meaningful.

Young people in the study were generally positive about their experiences with teachers' media arts instructional units, and they valued the opportunity to create digital media for school assignments. In focus groups and interviews, they discussed how using digital technology and making media projects increased their engagement in the classroom and motivation to learn. Examples of student comments include:

> I thought it was cool that they taught it [media production] to us. It's more fun to learn it like that, than just reading the textbook.

> It's a funner way of learning because like when we learned it before, and he'd explain it, it was more like you didn't want to listen. But now you want to. And then [we're] doing it on the computer now, so it's interesting.

> Because like if they give you funner and easier ways to learn, you're gonna want to learn. Right? Than like having some boring lesson.

> It [media production] makes you go to the school. Because some people, without fun in the school, they just don't want to go. This encourages people to come to school more.

Teachers also reported that media production helped their students be more involved and engaged in class activities. To illustrate this point, one teacher explained:

Even one of my kids, who usually ditches class and everything, was leading his group and trying to show them where the different camera parts were and whatnot. And some of the kids, they've just been asking, "When are we going to film? When are we going to film?"

Despite such positive comments, classroom observations and interviews with students also bore out the fact that students generally found the more "academic" aspects of the assignments "hard" and "boring." Some even talked emphatically about how much they did not like these aspects of the projects. One student, for example, explained how she did not like conducting research on Wikipedia for one of her projects:

Student: I did not like that part. The Wikipedia, it was so boring, and since I had to type it like three times, because I lost it.

Interviewer: Why was it boring?

Student: Because I had to find research and I had to find pictures and match with the things, and then I didn't like it, and I didn't find no research about it.

Interviewer: You're making research sound like a bad word.

Student: It is. I don't like doing it.

Another student complained to us about script writing. The process was "too long," he explained, and "it took forever." Students' engagement in the media production process bore out these kinds of attitudes in practice. They often dragged their feet or avoided working on the assigned tasks at hand. One of the ethnographic researchers on the project wrote numerous field notes about working with small groups of students, helping them develop their project ideas over the course of various days, bit by bit (Herr-Stephenson 2008). By providing a high level of assistance, she was able to help keep the students on task, and they were able to finish their scripts and go on to create their projects. In many cases, however, without this kind of direct attention and scaffolding, students struggled to stay focused on the research and writing activities related to their projects.

Despite students' general frustration with many aspects of the media arts instructional units, they also valued the opportunity to learn media production skills. For many of the young people in the study, school was the primary place where they had access to digital media tools, including computers, digital cameras, and the Internet (Tripp and Herr-Stephenson 2009). In general, they were excited to use these tools and learn how to create media, even when they found the topics of the projects boring. As the school year progressed, they also had several opportunities to provide technical assistance to each other and to students in other classes. In one school, for example, students from a "Special Education" class helped students from a "Gifted and Talented" class learn to use PowerPoint to

create digital art projects. This represented somewhat of a role reversal, in which students who typically experienced being viewed as "less capable" got to demonstrate expertise and knowledge in a subject area that mattered to students. In this instance and others, young people expressed a great deal of pride in their accomplishments, particularly in having developed valuable technical skills. Examples of student comments include:

> [The software] doesn't do it by itself, we have to do it. But then it looks hard, but then when we do it, it starts getting easier. I am like, 'I know this!'

> I had fun, I didn't know what to do. So it was like at the same time tricky, but fun…. Now, I know how to do it, I'll do it anytime you need.

> Mostly I'm proud of myself 'cause none of my brothers have done that [made movies]. Some know how to use [computers]; some don't. Sometimes I teach 'em how to use it or sometimes I just teach my sister how to use the Internet, the computer, how to treat it.

Young people in the study also frequently talked about how having an audience for their work had been important to them personally. For example, one student explained how she had grown from sharing her media projects with others:

> The first time [I showed my work] was my 'I Poem' and I was so nervous 'cause I wrote how I felt about my family and my parents living apart…and I got shy. Now I'm pretty used to it to show my movies…. I just show my movies to my parents and my uncles and aunts, my brothers…. They thought it [my I Poem] was pretty cool. My mom, well she was crying…'cause she thought that I would never [be able] to write that before, the way that I feel. Now she read it; she was crying for how proud she was how I was making it.

The process of media production also fostered opportunities for young people to pursue activities and interests they found meaningful. For example, media production often included chances for students to be social, talk, and hang out while developing a project, shooting footage, or sitting side by side at their computers. In the process, they often laughed and bonded around funny moments of shooting footage or viewing each other's work. One student explained to us that what he liked about "being behind the camera" was "seeing [his friends] laugh and all that." Another student described media projects as her favorite class activity, explaining:

> Because I'm on the computer, and then my friends are there, and I'm like, "Oh, that's cool." And I'm like, "How'd you get it, how'd you get it?" And they showed me. It was, I don't know, I liked it.

In these ways, aspects of media production provided a welcome disruption to the dominant modes of being in school framed around individualistic "studying,"

"being serious," and "being quiet," and students understandably found these activities pleasurable.

As Buckingham has argued, media production in school "arises from a negotiation between the interests of the peer group" and what counts as legitimate by school standards (2003, 128). In the process, "students frequently walk a difficult line between 'following school rules' and 'playing to the gallery,' that is, to the peer audience" (136). As a result, student projects often reflect "hybrid or mutated genres" that incorporate references to school culture, popular media, and peer culture simultaneously.[13] These tendencies have been most pronounced in settings where students have relative freedom of choice in the kinds of projects they make, or in settings where students are creating media *about* popular media culture (Grace and Tobin 1998; Buckingham 1998). In our study, by contrast, students had relatively little choice in determining the topic or structure of their media projects. What's more, as discussed earlier, popular media culture was never an explicit focus of classroom-based media production activities. Nevertheless, students still often managed to work a "peer orientation" into their projects, and found pleasure in the process.

One example of this was a video produced by a group of boys that was based on the school's "Too Good for Drugs" curriculum. The video tells a tale of three boys who are tempted by smoking dope. Two of the boys decide to quit smoking, relaying the reasons they've learned in health class about why it's bad for them. They say things to each other like, "Did you know that smoking dope can kill your brain cells?" and "Thanks for stating the facts." The third boy, however, does not follow such warnings and becomes an avid dope smoker. A few years later, the first two boys have been accepted to college and are reading the newspaper when they open the page to find that their friend has "died from smoking dope." In this way, the video clearly delivers an unambiguous (although implausible) anti-marijuana message that is totally within the boundaries of school acceptability.

At the same time, while the boys worked on the video, they built in some moments of dialogue that tested the boundaries of school acceptability. Twice, one of the boys calls the other one "Mr. fatty fat, fat chick," a line lifted directly from a *South Park* video. In another instance, one of the boys refers to the other, saying, "Hey, loser." Lines such as these would have been unacceptable if uttered to one another in the classroom, but were allowed to pass in the video because they were an official part of the script. This was much to the delight of the boys, who saw these as some of their favorite parts of the video. Other parts of the video got laughs too, such as a moment of deadpan acting, witty line delivery, or the dramatic obituary in the newspaper that announced, "Dead Kid Found" (complete with picture). In these ways, the boys brought humor into the piece in a way they

thought their friends would enjoy—and the project reflected both "educational" and "entertainment" orientations.

As this discussion exemplifies, young people in the study found value in the social and playful aspects of media production—social aspects such as collaborating on a project, having an audience, and developing media skills valued by their peers and family members, and playful aspects such as hanging out and laughing with friends and pushing the boundaries of what is typically acceptable in school. These sources of pleasure derived, in many ways, from the extent to which young people valued digital media as a form of popular culture with tangible pleasures and meanings, and the extent to which they believed media production skills to be genuinely valuable and useful. That said, as discussed above, there were significant limitations to the extent to which the media production activities captured young peoples' interest. The activities were still, by and large, teacher-defined projects that addressed the school curriculum, and students remained, for the most part, disinterested in the aspects of the activities that focused on traditional school content, reading, and writing.

Conclusion: Insights and Implications

While the study discussed in this chapter focused on a single professional development initiative, the research findings raise issues and concerns relevant to the broader goal of bringing youth media into public school contexts. In what follows, I discuss findings, insights, and implications from the research that I believe are most relevant to this agenda.

A significant success of the professional development initiative was that teachers were able to use standards related to media arts to incorporate youth media production into the classroom and link production activities to a range of different content area standards. This suggests that media arts can in fact provide a viable curricular framework for helping make youth-produced media a legitimate "standards-based" activity in the classroom. This potential has been strengthened by recent efforts by the LAUSD Arts Education Branch to make Media Arts the fifth official Arts discipline in the district, and to develop standards in media arts.[14] According to Dain Olsen, who has been central to these efforts, a key goal of the standards is to encourage students' "imaginative capabilities, tolerance of ambiguity, resistance to closure, and divergent thinking" (personal communication, December 2009). At each grade level, the new standards address the following themes: (1) artistic perception; (2) creative expression; (3) historical and cultural context; (4) aesthetic valuing; and (5) connections, relationships, and applications. Within these different themes, specific standards encourage creative production, critical analysis, and reflection on a wide range of topics and issues, addressing both mainstream mass media as well as independent and community-based media.

(The LAUSD Draft Media Arts Standards for grade seven are provided in the appendix as an example.) In these ways, the media arts standards significantly extend and improve on the standards that teachers had access to at the time of this study, which were limited in number and perhaps overly general (e.g., "Use technology to create original works of art"). If adopted and supported by the district, the new standards will provide a fairly broad and robust framework for media education that could be used to help guide and facilitate—and perhaps legitimate—efforts to bring youth media into school contexts.

While media arts standards can provide a curricular framework for these kinds of efforts, teacher training and other supports are needed to help prepare teachers to do the work. As this study documented, teachers who received professional development were in fact able to facilitate and scaffold classroom-based media production. This represented a significant achievement for the participating teachers, many of whom were relatively new to creating (or teaching) digital media. Yet, as discussed earlier, teachers tended to treat media production activities in instrumental terms, as teaching aids and motivational tools. In the process, they missed critical opportunities to foreground media literacy skills, and also to connect school activities to young people's interests in popular culture and new media (Tripp and Herr-Stephenson 2009). As Jenkins and co-authors have argued, new media literacies reflect social skills and cultural competencies that should be seen as "ways of interacting within a larger community, and not simply an individualized skill to be used for personal expression" (2006, 20). While young people may find it useful and valuable to learn digital media production skills, these skills alone do not necessarily help youth examine media critically or participate in new media cultures more actively, ethically, and responsibly. Schools have an important role to play in helping make new media literacies broadly accessible to young people, yet to realize this potential teachers will need to develop new approaches to teaching with media. This suggests the need for teacher training that emphasizes new media literacy concepts, including practical models for incorporating media analysis and reflection into the media production process. Further, given that most teachers—at least in the U.S. context—have had very little exposure to media education, training is needed that is long term in nature, and that includes partnerships with experienced media educators who can model effective instructional practices.

This research raises cautions about using school-based media production activities as a strategy for improving the academic and textual literacy skills of low-achieving or educationally disadvantaged students. While the study showed that in the process of media production, students did in fact address content-area standards and practice reading and writing skills, it also showed that students required a lot of support from teachers, classroom assistants, and ethnographic researchers

to stay focused on and accomplish these tasks. This was possible in large part because of the unique conditions of the professional development initiative. In typical classrooms, providing this level of scaffolding and assistance to students is often impossible, and many students may not be able to benefit academically from putting a lot of time into media production. As Ellen Seiter (2005) and Mark Warschauer (2007) have argued, many efforts to incorporate technology into instruction are ill conceived and fail to facilitate student learning. This implies the need to treat hype about incorporating digital media into instruction with some skepticism. While there is great potential in bringing youth media into public school contexts, such efforts should involve careful planning, strong professional development (or other means of teacher preparation), and adequate classroom supports.

This research also raises cautions about the ability of classroom-based media production activities to genuinely address youth interests and concerns. Young people in the study played an active role in helping determine the direction and content of media projects, yet their ability to pursue their own interests with media was fundamentally limited by the teacher-driven nature of assignments and the framework of standards-based education. As a result, there were many parts of the production process that young people engaged with only half-heartedly, and in some cases actively resisted. This was particularly evident when young people worked on the research, reading, and writing activities related to their projects. In contrast, young people found media production engaging when they were able to incorporate some of their own interests into the process—interests such as socializing with friends, learning technical skills, referencing popular culture, and making each other laugh. These strategies helped make the activities more personally relevant to young people than they might have been otherwise. This suggests the need for professional development that emphasizes models of youth-centered pedagogy, particularly for helping young people develop project ideas that address issues and concerns that genuinely matter to them (for a useful model of such a pedagogy, see Educational Video Center 2006).

At the same time, however, this finding also points to the fundamental challenge of attempting a youth-centered pedagogy in the context of traditional schooling. When young people are able to pursue their own interests and motivations with media, they often use media for "hanging out" and socializing with friends, or for "messing around" and tinkering with media as they pursue interests such as looking around online, media production, and game play (Ito et al. 2010). Schools rarely allow for such open-ended, unstructured, or friendship-oriented activities with media, leading to a fundamental disconnect between the media practices that young people find the most meaningful, and those that are typically fostered at school. As Lisa Tripp and Rebecca Herr-Stephenson (2009) have ar-

gued, media production activities at school tend to emphasize "assignment-oriented" activities and school-sanctioned topics. While this kind of "adult-driven" media production can offer valuable learning opportunities for young people, it is also important to recognize young people's interests and motivations with media as meaningful in their own right, as well as valuable for social development and learning (Dyson 1997; Jenkins et al. 2006; Ito et al. 2010). Further, adult-driven genres of media production run the risk of reproducing the same types of challenges that young people experience with the standard curriculum. Young people who feel alienated and disenfranchised by the curriculum, for example, are likely to have similar feelings toward school-based media production that focuses on that curriculum. This suggests the importance of—and indeed the need for—media education to be approached as part of broader school change efforts, such as those aimed at developing a more "culturally relevant" or "learner centered" curriculum that young people may find more meaningful and motivating (Banks and Banks 2006; Gay 2000; Keengwe, Onchwari, and Onchwari 2009; Riel, Schwarz, and Hitt 2002). Without such efforts, incorporating youth media into instruction will be constrained by current institutional contexts and agendas that are often antithetical to the goals of youth voice, critical thinking, and creativity.

Appendix:
LAUSD Draft Media Arts Standards, Grade Seven

The LAUSD Arts Education Branch has proposed that Media Arts be a fifth Arts content discipline in LAUSD K–12 schools. Below are standards for grade seven, provided as an example of the architecture and content of the proposed discipline.

ARTISTIC PERCEPTION

1.1 Describe and test how elements can be effectively amplified, elaborated, abstracted, distorted, and exaggerated in media art works.

1.2 Analyze and describe how specific elements and principles contribute to expressive qualities in works of media art.

1.3 Explain how media tools and processes can affect an audience's sense of time and space.

1.4 Compare and contrast digital media with previous forms of media, e.g., analog, linear, traditional.

CREATIVE EXPRESSION

2.1 Create innovative media art works that communicate complex stories, ideas, or emotions.

2.2 Create a media art work that investigates an issue of importance in their lives and the lives of their communities.

2.3 Structure and design media art works for specific audiences and venues.

2.4 Purposefully refine media art works.

2.5 Incorporate live performance, improvisation, and/or spontaneity in media arts productions and processes.

HISTORICAL AND CULTURAL CONTEXT

3.1 Investigate and compare American mainstream mass media, community and distributed media.

3.2 Reflect on personal biases, assumptions, and perspectives in viewing a variety of media art works.

3.3 Investigate historical and contemporary media art works for stereotypes and biases, as well as underlying assumptions and intentions.

3.4 Explain how cultural and contextual factors influence the production, perception, or meaning of works of media arts.

AESTHETIC VALUING

4.1 Compare and contrast the effective use of specific elements in similar media art works.

4.2 Demonstrate and justify intent in personal media art works.

4.3 Evaluate media art works for clarity of intent in relation to the effective use of elements and principles.

4.4 Describe how production choices enhance meaning in media art works.

4.5 Examine the relationship of form and content in media art works.

CONNECTIONS, RELATIONSHIPS, APPLICATIONS

5.1 Examine and discuss how traditional arts and media arts inform and complement one another.

5.2 Demonstrate competencies for production jobs and careers.

5.3 Consider social implications and responsibilities related to media arts productions.

5.4 Produce media art works that integrate other subject area content.

Notes

1. This article reports on research funded by the John D. and Catherine T. MacArthur Foundation and the Annenberg Foundation. For their support and contribution to various phases of the research, thanks also to Chris Gilman, Rebecca Herr-Stephenson, Heather Horst, Mizuko Ito, Tasha King, Katynka Martinez, Jenn Rogla, Ellen Seiter, Andrew Syder, Alex Tarr, the USC Institute for Media Literacy, the Los Angeles Unified School District Arts Education Branch, and Los Angeles–area middle schools and teachers that allowed us to conduct research in their classrooms.

2. The initiative was referred to as the Wallis Annenberg Initiative. It was a program of the USC Institute for Multimedia Literacy from 2003 to 2006. This chapter focuses only on the third year of the initiative (2005–2006), as the prior years involved only summer institutes without follow-up support for curriculum development and implementation.

3. Total enrollments for the three schools ranged from 1,846 to 3,323 students. The ethnic composition of the schools ranged from 71%–95% Latino; 2%–9% African American; 3%–6% American Indian; and 0–17% White, Asian, or Pacific Islander. The schools' overall Academic Performance Index scores in 2004 ranked them between 1 and 3 on a scale from 1 to 10 (with 1 being the lowest and 10 being the highest), meaning they were classified as academically "low performing" schools. All five schools are also "Title I schools," meaning their students faced high rates of poverty.

4. U.S. Latinos identify themselves in a variety of ways. According to the Pew Hispanic Center's (2009) National Survey of Latinos, more than half (52%) of Latinos ages sixteen to twenty-five identify themselves first by their family's country of origin, be it Mexico, Cuba, the Dominican Republican, etc., whereas 20% generally use the terms "Hispanic" or "Latino" first when describing themselves. There is some controversy about what terms to use when referring to the population as a whole. According to Paul Leonardi (2003), the term "Latino" has come to represent those who identify with a Latin American culture. He explains, "many users of this term find it to be a positive alternative to the term 'Hispanic,' which some believe attempts to homogenize Spanish-speakers of different races" (176). For this reason, I tend to prefer the term Latino when describing people of Latin American heritage (unless I am aware of peoples' specific preferences). In the United States, Latinos are a diverse population including people who are "U.S. born" and "foreign born," as well as "English-dominant" and "Spanish-dominant."

5. This activity was led by University of Southern California professor Ellen Seiter, an expert in children and media (see, for example, Seiter 2005).

6. Youth media experts and practitioners included Tony Streit, Director of Youth Learn, Education Development Center, and Miriam Neptune and Tim Dorsey, then with the Educational Video Center.

7. The LAUSD Arts Education Branch advocated and taught this model of curriculum design in their professional development activities throughout the district.

8. The other ethnographers included Rebecca Herr-Stephenson and Katynka Martínez. The program evaluators included Jen Beck, Cori Groth, and Cheryl Harris. Researchers were all women. Four identified as white, one as African American, and one as Chicana/Latina. Two of the researchers spoke fluent Spanish.

9. Eight families participated in this phase of the research, including seven Latino immigrant families and one African American family. The eight family groups represented 35 individuals, including 11 parents, 21 young people between the ages of two and sixteen, and 3 adult extended family members. Each interviewee selected the primary language for the interview (Eng-

lish or Spanish); young peoples' interviews were predominantly conducted in English, and parents' interviews were predominantly conducted in Spanish.

10. The findings discussed in this section draw, in part, on analyses of the data presented in research and evaluation reports written about the Wallis Annenberg Initiative (Beck, Groth, and Harris 2006; Tripp, Gilman, and Herr-Stephenson 2006), as well as an article about the media practices of young people who participated in the study (Tripp and Herr-Stephenson 2009).

11. Thirteen of fifteen teachers completed the professional development. Two dropped out for extenuating circumstances. Of the thirteen, all succeeded in developing and implementing Media Arts-related instructional units.

12. In a couple of instances, teachers invited IML staff to lead a media analysis lesson with their students.

13. Interestingly, studies of children's classroom-based "free writing" and "authors theater" activities have documented similar trends (Dyson 1993; Willet 2001).

14. The process of developing the standards has involved several iterations, at each point incorporating the input of district stakeholders and national experts in media education. My familiarity with this project stems from participating in two of the "National Study Groups" that advised the development of the media arts standards, in 2005 and 2006, and in one of the panels that provided feedback on drafts of the standards, in 2008.

References

Banks, James A., and Cherry McGee Banks. 2006. *Multicultural Education: Issues and Perspectives.* 6th ed. Indianapolis, IN: Jossey-Bass.

Barab, Sasha, and Kurt Squire. 2004. Design-Based Research: Putting a Stake in the Ground. *Journal of the Learning Sciences* 13(1): 1–14.

Beck, Jen, Cori Groth, and Cheryl Harris. 2006. The Wallis Annenberg Initiative 2005–2006 Evaluation Report. Los Angeles: Institute for Multimedia Literacy, University of Southern California.

Buckingham, David, ed. 1998. *Teaching Popular Culture: Beyond Radical Pedagogy.* London: UCL Press.

———. 2003. *Media Education: Literacy, Learning, and Contemporary Culture.* Malden, MA: Polity Press.

Dyson, Anne Haas. 1997. *Writing Superheroes: Contemporary Childhood, Popular Culture, and Classroom Literacy.* New York: Teachers College Press.

Educational Video Center. 2006. *Youth-Powered Video: A Hands-On Curriculum for Teaching Documentary.* New York: Educational Video Center.

Gay, Geneva. 2000. *Culturally Responsive Teaching: Theory, Research, and Practice.* Multicultural Education Series. New York: Teachers College Press.

Goodman, Steven. 2003. *Teaching Youth Media: A Critical Guide to Literacy, Video Production, and Social Change.* New York: Teachers College Press.

Grace, Donna, and Joseph Tobin. 1998. Butt Jokes and Mean-Teacher Parodies: Video Production in the Elementary Classroom, 42–62. In *Teaching Popular Culture: Beyond Radical Pedagogy,* ed. David Buckingham. London: UCL Press.

Hamilton, Laura, Brian M. Stecher, and Kun Yuan. 2008. *Standards-Based Reform in the United States: History, Research, and Future Directions.* Washington, DC: Center on Education Policy; RAND Corporation.

Herr-Stephenson, Rebecca. 2008. Kids as Cultural Producers: Consumption, Literacy and Participation. Ph.D. diss., University of Southern California, Los Angeles.

Ito, Mizuko, Sonja Baumer, Matteo Bittanti, danah boyd, Rachel Cody, Becky Herr-Stephenson, Heather A. Horst, Patricia G. Lange, Dilan Mahendran, Katynka Z. Martinez, et al. 2010. *Hanging Out, Messing Around, and Geeking Out: Kids Living and Learning with New Media*, John D. and Catherine T. MacArthur Foundation Series on Digital Media and Learning. Cambridge, MA: MIT Press.

Jenkins, Henry, Katie Clinton, Ravi Purushotma, Alice J. Robinson, and Margaret Weigel. 2006. *Confronting the Challenges of Participatory Culture: Media Education for the 21st Century.* Chicago: MacArthur Foundation.

Keengwe, Jared, Grace Onchwari and Jacqueline Onchwari. 2009. Technology and Student Learning: Toward a Learner-Centered Teaching Model. *AACE Journal* 17(1): 11–22.

Leonardi, Paul. 2003. Problematizing "New Media": Culturally Based Perceptions of Cell Phones, Computers, and the Internet Among United States Latinos. *Critical Studies in Media Communication* 20(2): 160–179.

Pew Hispanic Center. 2009. *Between Two Worlds: How Young Latinos Come of Age in America.* Washington, DC: Pew Hispanic Center.

Riel, Margaret, Jennifer Schwarz, and Amy Hitt. 2002. School Change with Technology: Crossing the Digital Divide. *Information Technology in Childhood Education Annual* 2002(1): 147–79.

Seiter, Ellen. 2005. *The Internet Playground: Children's Access, Entertainment, and Mis-Education.* New York: Peter Lang.

Tripp, Lisa, Chris Gilman, and Rebecca Herr-Stephenson. 2006. *The Wallis Annenberg Initiative 2003–2006 Final Project Report.* Los Angeles: Institute for Multimedia Literacy, University of Southern California.

Tripp, Lisa, and Rebecca Herr-Stephenson. 2009. Making Access Meaningful: Latino Young People Using Digital Media at Home and at School. *Journal of Computer-Mediated Communication* 14(4): 1190–1207.

Tyner, Kathleen, and Rhea Mokund. 2003. Mapping the Field: A Survey of Youth Media Organizations in the United States with Discussion of Results, 61–83. In *A Closer Look: Case Studies from NAMAC's Youth Media Initiative*, ed. Kathleen Tyner. San Francisco: National Alliance for Media Arts and Culture.

Warschauer, Mark. 2007. The Paradoxical Future of Digital Learning. *Learning Inquiry* 1(1): 41–49.

Wiggins, Grant, and Jay McTighe. 2005. *Understanding by Design.* Upper Saddle River, NJ: Prentice Hall.

Willett, Rebekah. 2001. *Children's Use of Popular Media in Their Creative Writing, Institute of Education.* Ph.D. diss., University of London.

Afterword

Youth Media Production in the Digital Age: Some Reflections—and a Few Provocations

David Buckingham

For those of us who are old enough to remember the bygone age of analogue media, the advent of new digital technologies can sometimes appear to have precipitated a revolution. My own earliest experiences of youth media production in the late 1970s involved the endless untangling of Super 8 cine film and reel-to-reel, black-and-white videotape, and the frequent inhalation of photographic chemicals. The technology was expensive, cumbersome, and frequently very difficult to obtain. In the world of digital editing, disposable camcorders, and online video sharing, such experiences seem almost prehistoric. Yet many of the questions that were beginning to be raised at that time are still relevant—and in some ways take an even more urgent form in the age of digital media (see Sefton-Green 1995). To what extent does the experience of media production represent a form of 'empowerment' for young people—especially as it has now become so much more commonplace in their everyday lives? What assumptions do we make here about young people's understanding and relationships with media, and how accurate are those assumptions? How do young people learn to communicate through media, and how does creative production relate to the development of a critical perspective on media? What difference does youth media production make, either for young people themselves or in terms of the wider social and cultural environment?

These are not only pedagogical questions: they are also political ones. How we might answer them depends very much on the social and cultural contexts in which youth media projects take place: there is no 'one size fits all' approach. As this book shows, the field of youth media production includes a wide range of

practices, with some quite diverse motivations and approaches; this is especially apparent when we consider the global range of the contributions gathered here. In different local and national settings, different political, cultural, and social imperatives may dominate, which sometimes bear little if any relation to young people's own perspectives and experiences. Youth media production is not a neutral process, a matter of simply providing young people with the tools for self-expression. On the contrary, all such practices inevitably rest on assumptions about media, about young people, and about learning, and they always entail implicit social, moral and political agendas. Indeed, youth media projects are frequently undertaken and supported, not on the grounds that media production may be a valuable and enjoyable activity for its own sake, but rather on the grounds that it can facilitate other objectives—objectives that may range from promoting civic participation and community development through to inculcating particular moral or religious beliefs, preventing violence or substance abuse, or providing training for employment.

Even so, youth media has often had to struggle against the odds. In the context of formal education, it is almost always restricted to the margins of the curriculum or confined to very limited, sanctioned forms. There are still comparatively few countries that have specialist Media Studies courses in schools, and even here, media production has often tended to take second place to media analysis—although this is certainly changing (Buckingham 2003; Burn and Durran 2007). Outside such contexts, media production is likely to be perceived as an occasional 'treat', or as an instrumental aid to subject learning (the video of the geography field trip, the record of the drama production). School magazines, TV production clubs, and school Web sites tend to follow fixed routines, and often amount to little more than official public relations exercises. School timetables, curricular structures, and codes of discipline rarely permit the long-term, student-centred engagement and inquiry that is indispensable for media production.

Beyond formal education, youth media projects are forever dependent on the vicissitudes of government welfare funding and the shifting priorities of charitable foundations (and, in some cases, of commercial companies' *pro bono* activities). In this context, youth media practitioners are constantly having to reinvent themselves (or at least repackage themselves) to accommodate the changing imperatives and fashions of the times. Funding is always precarious, and there are particularly limited opportunities for the professional development of staff. Anyone can, in principle, set themselves up as a youth media organisation and apply for funding; there is little by way of recognised training or certification in the field. As such, it is difficult to build up a body of expertise, to promote critical reflection on practice or to monitor the quality of what is provided (Buckingham 2003, Chapter 12; Harvey et al. 2002).

In recent years, however, youth media production has begun to gain some traction. The increasing interest in youth media projects—and hence the increasing amounts of funding that are available to support them—is not only a consequence of the growing accessibility of digital production tools. It also needs to be understood in the context of broader concerns about the changing social position of youth, about generational change, and about the need to re-engage young people in the public sphere. As such, youth media practices inevitably define 'youth'—as the target or focus of their interventions—in particular ways, which both produce and constrain what it is possible for young people to do. Implicitly or explicitly, they purport to provide some kind of response to the 'problem' of youth, and the ways in which we imagine youth in this context may say rather more about our own adult hopes and fears than it does about young people themselves.

From this perspective, the notion of media production as a form of 'self-expression' or 'empowerment' for young people needs to be questioned. Rather than offering a neutral space for communication, youth media projects inevitably construct specific positions from which it is possible for young people to 'speak' or to represent themselves: they actively promote particular forms of speech or (self-) representation, and restrict others (de Block and Buckingham 2007). Youth media production cannot, in this sense, be seen as simply a matter of enabling young people to 'express themselves', to be 'creative,' or to 'find their voice'. Such notions seem to imply that, once given the opportunity, young people will instantly and spontaneously 'speak', and that they will automatically speak the truth. Apart from anything else, this approach effectively marginalises the significance of institutional settings, the role of educators, and the need for learning.

Similar questions can be raised in respect to notions of youth voice, citizenship, creativity, empowerment and inclusion, which are particularly prevalent in the rhetoric of youth media projects. These seemingly contemporary terms often mask an older moral rhetoric of 'child-saving', in which activities such as media production are seen as useful means of distracting young people's attention from the more dangerous temptations of peer-group or 'street' culture. The implicit attempt to rescue disadvantaged or disaffected youth from their circumstances stands in a long tradition of paternalistic social intervention. Youth are somewhat paradoxically defined here, both as a source of social problems and as somehow at risk from wider social pressures. They are frequently regarded in rather sentimental terms as being uniquely able to 'speak truth to power': there is an assumption that youth media production will necessarily provide an alternative to the mainstream, and that it will always be challenging or politically radical. While such views and assumptions may not necessarily be shared by youth media practitioners themselves, they are certainly implicit in the perspectives of many of the key organisations—both governmental and charitable—that support such work.

There is also a danger of technological determinism here—of assuming that access to technology will somehow automatically 'set people free' to express themselves, to register their needs, and thereby to take power. Rather than seeking to understand wider failures in political institutions, the media—and particularly digital media—are believed to have an almost magical ability to address and resolve these problems. Of course, such claims about the potential of media in terms of democratisation and empowerment are by no means new: one can look back to the arguments being made about cable TV in the 1970s (Streeter 1987), or about portable video in the 1980s (Buckingham et al. 2007), although in fact most new media technologies have arrived amid claims about their inherently radical potential (Marvin 1988). All of these media were apparently going to bring power to the people, undermine the control of knowledge by elites, and enable ordinary people to express themselves and have their voices heard, in precisely the revolutionary ways that are now being seen as characteristic of digital media. And in each case, their ultimate effects were much more complex and equivocal than their advocates proclaimed.

Of course, this rather inflated rhetoric has its uses, and a little utopianism or at least idealism is a necessary dimension of any new social movement. Nevertheless, there is a risk here that looking to media technology as a means of social or cultural 'empowerment' may distract attention from much more fundamental social structural problems. We may assume that youth media production can make a difference to people's lives in ways that are much more profound or far-reaching than is ever likely to be possible. And there is then a danger that this can lead to disillusionment and even cynicism—not least among the young people themselves.

Furthermore, the easy circulation of this kind of rhetoric may well disguise a lack of precision and indeed debate about basic aims. We can probably all agree that participation and creativity are Good Things, but until we define what they really mean, and until we critically examine how they work out in practice, they are merely empty slogans. It is extremely difficult to develop and improve practice if one is driven by the constant need to justify oneself to funding bodies, and to present oneself in the best possible light. In addition to documenting and explaining good practice, it is vital to be looking at the situations where youth media does *not* succeed in motivating young people or promoting its wider aims. Without clear-sighted and rigorous evaluation, the ability to develop expertise over the longer term, and sustained professional training and development, youth media will forever remain in its infancy.

These arguments have implications for the institutions that fund and support youth media work. There is an obvious and urgent need for consistent and longer-term financial support, for professional training, and for clear and coherent proc-

esses for identifying outcomes. Yet these things may not be an imperative for funders, who are often more interested in simple measures of effectiveness—as though getting more young people through the door (and hence, perhaps, off the streets) is in itself a meaningful indicator of success. In a precarious and insecure funding environment, practitioners themselves will understandably find critical evaluation (or even self-evaluation) risky and threatening. Yet there is a difference between objective evaluation and public relations, and if the field of youth media is to develop and mature, practitioners need to have the space to reflect upon and to debate the assumptions that inform their work, and to assess its outcomes in a more rigorous and unsentimental way. Funders need to acknowledge the difficulty and complexity of youth media work and provide sufficient support to enable it to flourish; but practitioners also need to beware of the temptation to celebrate the apparently autonomous self-expression of young people. In this respect, the kinds of critical reflection provided by the contributors to this book should provide a much-needed impetus for the further development of the field.

References

Buckingham, David. 2003. *Media Education: Literacy, Learning and Contemporary Culture.* Cambridge: Polity.

Buckingham, David, Maria Pini, and Rebekah Willett. 2007. "Take Back the Tube!" The Discursive Construction of Amateur Film- and Video-making. *Journal of Media Practice,* 8, 183–201.

Burn, Andrew, and James Durran. 2007. *Media Literacy in Schools.* London: Paul Chapman.

de Block, Liesbeth, and David Buckingham. 2007. *Global Children, Global Media: Migration, Media and Childhood.* London: Palgrave Macmillan.

Harvey, Issy, Megan Skinner, and David Parker. 2002. *Being Seen, Being Heard: Young People and Moving Image Production.* London: National Youth Agency/British Film Institute.

Marvin, Carolyn. 1988. *When Old Technologies Were New.* New York: Oxford University Press.

Sefton-Green, Julian. 1995. Neither Reading nor Writing: The History of Practical Work in Media Education. *Changing English,* 2(2), 77–96.

Streeter, Thomas. 1987. The Cable Fable Revisited: Discourse, Policy and the Making of Cable Television. *Critical Studies in Mass Communication,* 4, 174–200.

Contributors

SANJAY ASTHANA, Associate Professor of Journalism at Middle Tennessee State University, earned his Ph.D. in Journalism and Mass Communication in 2003 from the University of Minnesota. His research has appeared in several journals, and his essays in several media studies books. Dr. Asthana is the author of the book *Innovative Practices of Youth Participation in Media*. (http://www.mtsu.edu/mcgrad/faculty/asthana_rec.shtml)

KARINA KOSICKI BELLOTTI (Ph.D. in Cultural History, State University of Campinas-Brazil), (karinakbellotti@yahoo.com), is Professor of Contemporary History at the Federal University of Paraná (UFPR), post-doctoral fellow at the State University of Campinas (Unicamp), and former Visiting Researcher at the University of Texas at Austin. Currently she develops research on Evangelical media, youth, and the welfare culture in Brazil.

DAVID BUCKINGHAM is Professor of Education at the Institute of Education, London University, where he directs the Centre for the Study of Children, Youth, and Media (www.childrenyouthandmediacentre.org.uk). His research focuses on children and young people's interactions with electronic media, and on media education. His most recent books include *Beyond Technology: Children's Learning in the Age of Digital Culture* (2007); *Global Children, Global Media* (2007); *Youth, Identity and Digital Media* (2008); and *Video Cultures* (2009).

RICHARD CHALFEN, Ph.D. (Richard.chalfen@childrens.harvard.edu), is Senior Scientist at the Center on Media and Child Health at Children's Hospital Boston/Harvard Medical School and Emeritus Professor of Anthropology at Temple University. He is the author of over 100 publications with current interests in applied visual studies, comparative studies of visual culture (United States and Japan), participatory media research, and cross-cultural home media.

LISA DENERSTEIN is a teacher at the High School for Media and Communications in Manhattan. She received a B.S. in Broadcast Communications from Long Island University and a Master's Degree in English Education from The City College of New York. (http://ymln.wikispaces.com/Lisa%27s+Home)

MICHAEL DEZUANNI (m.dezuanni@qut.edu.au) lectures in the Film and Media curriculum in the Faculty of Education, Queensland University of Technology (QUT). He recently completed a doctorate focusing on boys' learning

about video games in a media education context. He investigated how established approaches to media education theory and practice may be reconceptualized in digital media contexts. (http://www.ed.qut.edu.au/users/index.jsp?name=~dezuanni)

JENNIFER DORSEY is a doctoral student at the Harvard Graduate School of Education and served on Wendy Luttrell's research team. She studies youth meanings of mainstream films and television.

DEANNA and **TÉA DRIFT** are Bois Forte Band of Chippewa tribal members who reside on the Nett Lake Reservation in northern Minnesota.

IVANA ESPINET was the facilitator for the Youth Media Learning Network Fellowship. She is working toward a Ph.D. in the Urban Education program at the City University of New York Graduate Center. She has worked as the co-director of the Documentary Workshop for the Educational Video Center, as well as a staff developer.

JOELLEN FISHERKELLER, Ph.D., is Associate Professor in the Department of Media, Culture, and Communication at New York University (http://steinhardt. nyu.edu/mcc). Her research focuses on young people's relationships with all media in the contexts of their everyday lives. She has published a book and several articles in the areas of media and cultural studies, media education, anthropology, and youth media.

LISBETH FRØLUNDE, Ph.D. (lisbethf@ruc.dk), is Assistant Professor at Roskilde University, Denmark. She studies media production, especially machinima (films created in games and virtual worlds), from social semiotic and dialogic perspectives. Her doctoral thesis, *Animated Symbols: A Study of How Young People Design Animated Films and Transform Meaning* (2009), was on film production and literacy.

DAMIANA GIBBONS, Ph.D. (damianagibbons@gmail.com), is Assistant Professor of Educational Media in Curriculum and Instruction at Appalachian State University.

ØYSTEIN GILJE, Ph.D. (oystein.gilje@uv.uio.no), is a post-doctoral researcher on the project "Learning Lives" at Oslo University, Norway. His doctoral thesis, *Mode, Mediation and Moving Images: An Enquiry of Digital Editing Practices in Media Education* (2010), was on remixing and digital editing from a sociocultural and multimodal perspective.

STEVEN GOODMAN is the founding executive director of the Educational Video Center (www.evc.org), an internationally acclaimed leader in youth media since 1984. Trained as a journalist at the Columbia University School of Journalism, he has taught high school, undergraduate, and teacher education graduate courses. He has spoken and written extensively on youth media and critical literacy for numerous publications and is the author of *Teaching Youth Media: A Critical Guide to Literacy, Video Production and Social Change.*

JULIA HAYDEN is a doctoral student at the Harvard Graduate School of Education and served on Wendy Luttrell's research team. She focuses on children's language and narrative development.

MICHAEL HOECHSMANN is Associate Professor in the Department of Integrated Studies in Education at McGill University, whose research and teaching interests are in the areas of cultural studies, literacy, media literacy, and digital literacies.

SANDA HTYTE is Associate Producer for Radio Rookies (http://ymln. wikispaces.com/Radio+Rookies+Project+Overview+-+Story+Development). She has worked as a freelance video editor, director, and producer, as well as a contract producer and video editor for Production Central.

GLYNDA A. HULL's research focuses on the intersection of literacy and new media as well as the design of new spaces for learning, including out-of-school and online environments. The author of *School's Out: Bridging Out-of-School Literacies with Classroom Practice,* she currently teaches at New York University.

PETER LEMISH (*plemish@gmail.com*) is the Development Officer for the Global Media Research Center, located at Southern Illinois University, Carbondale. He is an academic activist and independent researcher whose work focuses on advancing the involvement of artists, educators, NGO activists, journalists, and other media professionals in strengthening civil society through transformative action.

DAVID LEVIN is a Lecturer in School of Media of the College of Management and also member of the Department of Sociology, Political Science, and Communication at the Open University of Israel. His chapter is part of his Ph.D. thesis concerning the cultural identity negotiations among adolescents in a small, peripheral city.

SUN SUN LIM (Ph.D., London School of Economics), (sunlim@nus.edu.sg), is Associate Professor at the Communications and New Media Programme, National University of Singapore. She has researched and published extensively on technology domestication by young people in Asia, with a focus on China, Japan, Korea, and Singapore.

FREDRIK LINDSTRAND, Ph.D. (fredrik.lindstrand@hig.se), is Associate Professor at Gävle University, Sweden. His doctoral thesis, *Making Difference. Representation, Identity and Learning in Teenagers' Work with Film* (2006), focused on youth film production as a platform for learning and other transformative processes. He is co-editor of the international journal *Designs for Learning*.

ANTONIO LÓPEZ is the author of *Mediacology: A Multicultural Approach to Media Literacy in the 21st Century*, and has published numerous essays on media education and sustainability. He lives and teaches in Rome, Italy, and blogs at http://mediacology.com.

WENDY LUTTRELL is Professor of Urban Education and Social Personality and Psychology, Graduate Center, City University of New York and author of two award-winning books about schooling and inequality.

ELMIE NEKMAT (cnmmen@nus.edu.sg) received his B.A. and M.A. degrees in the Communications and New Media Programme, National University of Singapore. His research interests include youths' popular use and adoption of new media technologies and their Internet literacy. He is currently a Ph.D. candidate at the University of Alabama.

LISA ÖHMAN-GULLBERG, Ph.D. (lisa.ohmangullberg@konstfack.se), is head of the department of Art Education at the University College of Arts, Crafts and Design, Sweden. Her doctoral thesis, *Ambiguous Images. Representation and Meaning in Young Girls' Film Making*, focused on young girls' film production as a platform for identity work and learning.

KATINA PARON is a journalism educator with fifteen years of youth media experience. She is the Co-Director of the New York City High School Journalism Collaborative at Baruch College and is the co-founder and former Managing Director of the Youth News Agency, Children's PressLine.

STUART R. POYNTZ is Assistant Professor in the School of Communication at Simon Fraser University, where he teaches graduate and undergraduate courses in youth media, the history of media education, and digital media production.

MICHAEL RICH, MD, MPH, (Michael.rich@childrens.harvard.edu) is Associate Professor of Pediatrics at Harvard Medical School and practices adolescent medicine at Children's Hospital Boston. He is founder and Director of the Center on Media and Child Health and the Video Intervention/Prevention Assessment (VIA) research program. He received the New Investigator Award from the Society for Adolescent Medicine and the Holroyd-Sherry Award from the American Academy of Pediatrics for his contributions to children, adolescents, and media.

URVASHI SAHNI received her Ph.D. from the University of California, Berkeley, and as an alumna was awarded its Haas International Prize for her work as an educator in India. The founder of Study Hall Foundation, Sahni's most recent work explores the use of digital technologies in rural and urban schools.

CARLA SHALABY is a doctoral student at the Harvard Graduate School of Education and served on Wendy Luttrell's research team. She explores ethnic identity politics in elementary classrooms.

ELISABETH SOEP, Ph.D., is Research Director and Senior Producer at Youth Radio (http://www.youthradio.org), a Peabody Award-winning, youth-driven production company in Oakland, California, with correspondents in every region of the United States and around the world. She studies and writes about youth, learning, and digital media culture, including her new book with Vivian Chavez, *Drop That Knowledge* (http:// www.ucpress.edu/book.php?isbn=9780520260870).

AMY STORNAIUOLO is a Ph.D. candidate in the Graduate School of Education at the University of California, Berkeley. Her current research examines youths' multimodal composing practices across contexts, the use of social networking in school-like settings, and teachers' practices around youths' new media compositions.

LISA TRIPP (ltripp@cci.fsu.edu; http://lisatripp.com) is Assistant Professor, College of Communication and Information, Florida State University. She earned her Ph.D. in Communication from the University of California, San Diego, and has been involved since the early 1990s in research and program development related to youth media and media education.

KATHLEEN TYNER (ktyner@mail.utexas.edu) is Associate Professor in the Department of Radio, Television and Film at the University of Texas-Austin. She is author, editor, and co-editor of numerous books and articles about media education, new media, and virtual worlds.

SHOBHA VADREVU (shobhavadrevu@gmail.com) has secondary school teaching experience and holds a Master's degree in Educational and Social Research. Her research interests include the impact of online interaction on the teacher-student dynamic and the use of digital platforms in the development of active citizenship and critical literacy among young people.

KAREN ORR VERED (Karen.vered@flinders.edu.au) is Associate Professor of Screen and Media at Flinders University in Australia. She writes and teaches about children and their media cultures, television, and digital media. She is the author of *Children & Media Outside the Home* (2008), an ethnography of children's media play in Australian after-school care. She holds degrees from University of Southern California, Temple University, and University of California, San Diego.

Index

mediated youth

Sharon R. Mazzarella
General Editor

Grounded in cultural studies, books in this series will study the cultures, artifacts, and media of children, tweens, teens, and college-aged youth. Whether studying television, popular music, fashion, sports, toys, the Internet, self-publishing, leisure, clubs, school, cultures/activities, film, dance, language, tie-in merchandising, concerts, subcultures, or other forms of popular culture, books in this series go beyond the dominant paradigm of traditional scholarship on the effects of media/culture on youth. Instead, authors endeavor to understand the complex relationship between youth and popular culture. Relevant studies would include, but are not limited to studies of how youth negotiate their way through the maze of corporately-produced mass culture; how they themselves have become cultural producers; how youth create "safe spaces" for themselves within the broader culture; the political economy of youth culture industries; the representational politics inherent in mediated coverage and portrayals of youth; and so on. Books that provide a forum for the "voices" of the young are particularly encouraged. The source of such voices can range from in-depth interviews and other ethnographic studies to textual analyses of cultural artifacts created by youth.

For further information about the series and submitting manuscripts, please contact:

SHARON R. MAZZARELLA
School of Communication Studies
James Madison University
Harrisonburg, VA 22807

To order other books in this series, please contact our Customer Service Department at:

(800) 770-LANG (within the U.S.)
(212) 647-7706 (outside the U.S.)
(212) 647-7707 FAX

Or browse online by series at WWW.PETERLANG.COM